D1171176

JEWISH MUSIC AND MODERNITY

AMS Studies in Music

MARY HUNTER, *General Editor*

Editorial Board

Joseph H. Auner
J. Peter Burkholder
Scott Burnham
Richard Crawford
Suzanne Cusick
Louise Litterick
Ruth A. Solie
Judith Tick
Gary Tomlinson
Gretchen Wheelock

JEWISH MUSIC
AND MODERNITY

Philip V. Bohlman

OXFORD

UNIVERSITY PRESS

2008

OXFORD
UNIVERSITY PRESS

Oxford University Press, Inc., publishes works that further
Oxford University's objective of excellence
in research, scholarship, and education.

Oxford New York

Auckland Cape Town Dar es Salaam Hong Kong Karachi
Kuala Lumpur Madrid Melbourne Mexico City Nairobi
New Delhi Shanghai Taipei Toronto

With offices in
Argentina Austria Brazil Chile Czech Republic France Greece
Guatemala Hungary Italy Japan Poland Portugal Singapore
South Korea Switzerland Thailand Turkey Ukraine Vietnam

Published by Oxford University Press, Inc.
198 Madison Avenue, New York, New York 10016
www.oup.com

Oxford is a registered trademark of Oxford University Press

Library of Congress Cataloging-in-Publication Data

Bohlman, Philip Vilas.
Jewish music and modernity / Philip V. Bohlman.
p. cm. — (AMS studies in music)
Includes bibliographical references, discography, and index.
ISBN: 978-0-19-517832-6
1. Jews—Music—History and criticism. 2. Modernism (Music) I. Title.
ML3776.B579 2008
780.89'924—dc22

1 3 5 7 9 8 6 4 2

Printed in the United States of America
on acid-free paper

To Alice Herz Sommer,
Pianist, Inspiration, Friend,
In Celebration of Her Century as a Jewish Musician

> Musik: du Wasser unsres Brunnenbeckens,
> Du Strahl der fällt, du Ton der spiegelt, du
> selig Erwachte unterm Griff des Weckens,
> du durch den Zufluß rein ergänzte Ruh,
> Du mehr als wir . . . , von jeglichem Wozu
> befreit. . . .
>
> —Rainer Maria Rilke, "Musik"

ACKNOWLEDGMENTS

The journeys leading to the many places in which Jewish music took shape as it emerged from modernity have challenged and preoccupied me for much of the past quarter century. Navigating the roads along which those journeys passed would never have been possible had I taken them alone. I relied on the wisdom, guidance, and companionship of others at every step, and accordingly, the debt of gratitude I owe to my fellow travelers is very great indeed.

The present book is the final volume in a trilogy, loosely conceived to follow the history of music in the Jewish communities of Central and East Central Europe from the present to the past. Perhaps counterintuitively, the first volume of the trilogy, *The Land Where Two Streams Flow* (Bohlman 1989a), focused on the ethnographic present of the communities in Israel at the end of the twentieth century. The second volume, *The World Centre for Jewish Music in Palestine, 1936–1940* (Bohlman 1992), concerned itself with the transition from Europe to mandatory Palestine in the 1930s and 1940s, in other words at the historical moment in which the Holocaust led to the virtual destruction of the Jewish communities in Central and East Central Europe. With *Jewish Music and Modernity* I arrive on the eve of the Holocaust and at the end of modernity.

The first volume of the trilogy would not have been possible without a remarkable group of teachers at the University of Illinois at Urbana-Champaign, who were willing to send a graduate student from rural Wisconsin to study a cosmopolitan world he never could have imagined in his youth. I continue to learn from the lessons taught me by the late Alexander L. Ringer, Charles Capwell, Isabel K. F. Wong, and, of course, Bruno Nettl. During fieldwork in Israel I was quickly drawn into a new community, whose lessons were new and different, hence enormously challenging and helpful. I extend my gratitude to my Israeli teachers, Israel Adler, Don Harrán, Jehoash Hirshberg, Ruth Katz, and Amnon Shiloah, as well as my fellow students, Gila Flam and Edwin Seroussi, both now esteemed colleagues. I owe even more to those who guided me through my years in Israel for the trust they invested in me by giving me the opportunity to unravel history from the documents of an almost totally forgotten organization of immigrant musicians, thereby making the second volume in the trilogy possible.

The first concerted field and archival work for the final volume, the present book, began near the very center of German-speaking Ashkenaz, in Freiburg im Breisgau in Germany. It was there that my understanding of Jewish folk music began, for it is in Freiburg that the Deutsches Volksliedarchiv (DVA) is located. I was fortunate to spend two summers and an entire year at the DVA, assembling traces and fragments from the rich collections of folk song gathered there during the twentieth century, from the height of Jewish modernism through the destruction of the German Jews to the historicism that brought Jewish folk music back to Germany at the end of the century. The intellectual hospitality at the DVA was always marvelous, and I especially thank Barbara Boock, Jürgen Dittmar, Ali Osman Öztürk, and Michaela Zwenger. My friendship and collaboration with Otto Holzapfel began in the DVA, and they continue until the present and beyond. Support of my Freiburg sojourns was possible because of fellowships from the Leo Baeck Institute, the Deutscher Akademischer Austauschdienst (DAAD), and the National Endowment for the Humanities (Summer Stipend). Without a full year's support as a Forschungsstipendiat from the Alexander von Humboldt-Stiftung, and then three years of a collaborative Humboldt Trans-Atlantic Cooperation Grant between the DVA and the University of Chicago, the present book would not have been possible. I should also like to express my gratitude to the American Academy in Berlin and its director, Gary Smith, for awarding me a Berlin Prize in 2003 and affording me the opportunity to begin the process of polishing this book.

The cosmopolitan heart of this book beats in Vienna, the city where modernism and music would be unthinkable without its complex Jewish history. It is neither an exaggeration nor a cliché to say that I returned countless times to Vienna during the research for the book, any more than it would be to say that there are countless colleagues and friends in Vienna whose advice and assistance made the book possible. With each visit, whether for research, lectures, or a stint of teaching, I uncovered a new layer and new *lieux de mémoire* that revealed something else about the ways in which Jewish music shaped the past and present of a city that I count as my own, if indeed I still remain a foreigner. My gratitude begins with institutions: The Institut für Musikwissenschaft der Universität Wien, the Internationales Forschungszentrum Kulturwissenschaften (IFK), the Österreichisches Volksliedwerk, the Wiener Volksliedwerk, and the Institut für Volksmusikforschung und Ethnomusikologie der Universität für Musik und Darstellende Kunst all provided me with a place to explore marvelous archival holdings and to join in stimulating discussions. I offer thanks to the staffs at all those institutions and particularly to the directors whose hospitality paved my entrance to them: Franz Födermayer, Gotthart Wunberg, Gertraud Pressler, Maria Walcher, and Gerlinde Haid. I am also extremely grateful to the Council for the International Exchange of Scholars (CIES, Senior Fulbright Professorship) and the IFK for generous fellowship support for my years in Vienna.

In 1995–1996 and again in 1999 I had the opportunity to offer lecture courses and seminars on Jewish music at the University of Vienna, and from the students in those classes I learned a great deal, all the more so because it was the initial chance for all of us to investigate what had been terra incognita at the University of Vienna. Several students sustained conversations and research that, in turn, have

sustained me over the intervening years: Susanne Antonicek, Matti Bunzl, Roland Mahr, Yukokiko Sakabe, Esther Schmidt, Eric Usner, and Billy K. Vaughn. Many scholars across the arts and humanities provided assistance of many kinds to my Viennese and Burgenland research, among them Ardian Ahmedaja, Mitchell Ash, Walter Burian, Walter Deutsch, Ursula Hemetek, Emil H. Lubej, Lutz Musner, and Michael Weber, as well as Alexander Knapp of London. No less crucial to the experience of music in Vienna were the opportunities to listen to those who make music with such beauty and conviction: Special thanks go to "Die Tanzgeiger" and their leader, Rudolf Pietsch, and to "Ensemble Klesmer Wien" and their leader, Leon Pollak. Making my countless returns to Vienna possible, the Pietsch family has become also a part of the Bohlman family. We owe so much to Rudi, Almut, Georg, Johannes, and Kathi, and now to Margit; we, too, miss Franzi and Franzi more than we can fully express.

Since 1998, my historical journeys to Jewish modernism have also been musical. The New Budapest Orpheum Society, a Jewish cabaret ensemble for which I serve as artistic director, may have come into existence almost by accident, but it bears witness to the fact that the results of serendipity are often invaluable. With my fellow musicians, Cantor Deborah Bard, Julia Bentley, the late Peter Blagoev, Cantor Stewart Figa, Iordanka Kissiova, Ilya Levinson, Stewart Miller, and Hank Tausend, I listen to European Jewish popular music in new ways, and together we try to convey our conviction that there are many ways to listen to the past, even to laugh as we sort out moments of triumph from tragedy. In Vienna, the magnificent artistry of Roland Neuwirth and the performance of the cabaretesque by Georg Wacks tell me again and again why Viennese popular music has become inextricable from my soul. Thanks, too, to Mary Jean Kraybill of the University of Chicago and to James Ginsburg of Cedille Records, who generously put their trust in the New Budapesters.

The path of this book intersected with and benefited from the growth of Jewish Studies as a modern discipline at the University of Chicago. Many among my colleagues were also critical interlocutors, whether or not they knew it. Learning from Ariela Finkelstein, Paul Mendes-Flohr, Martha Roth, Jerry Sadock, Eric Santner, Josef Stern, and Bernard Wasserstein is an ongoing process. In the Music Department at Chicago, Martin Stokes always inspired by gentle example, and Travis A. Jackson reveals to me the power of youthful wisdom unleashed by good humor. More than a few Chicago students, past and present, contributed in myriad ways to the research for the book and to several courses on Jewish music; I'm especially thankful to Gregory Barz, Jerry Cadden, Brian Currid, Rich Jankowsky, Bertie Kibreah, Yossi Maurey, Joshua Pilzer, Loraine Schneider, and Deborah Strauss. Jaime Jones and my Harvard University student and fellow fieldworker, Andrea F. Bohlman, offered indispensable assistance as I prepared the final stage of the manuscript.

So numerous are the field consultants whose stories, songs, and critical interventions enrich this book on every page that I am forced to thank them collectively. What I know about the Jewish communities of Burgenland and the Carpathians, about the popular and stage musicians of Berlin and Budapest, about cultural exchange in the Rhine valley and the Jewish cities of East Central Europe, comes

largely from them. You have given life to the history in the pages that follow, and you will help us remember the narrative of modernity that must not be forgotten.

The editors at Oxford University Press, first Bruce Phillips, then Sophie Goldsworthy, and finally Suzanne Ryan, have shown more patience than I have deserved. Paul Hobson and Ilene McGrath clarified the text with their thoughtful copyediting. By stewarding the book into AMS Studies in Music, series editor Mary Hunter pushed me hard to make the book better, and I realize that I am very lucky indeed. The patience of my editors has made it possible for me to bring some measure of closure to this trilogy, and I am deeply grateful to them for allowing me to do just that. How fortunate I was that the OUP's anonymous readers took the book so very seriously, challenging me, in kind, to take their criticisms and suggestions no less seriously.

Several chapter sections and ideas in the book have appeared in very different forms and contexts in other publications. I have extensively reworked some material from chapter 4 for my essay in the *Festschrift* for Israel Adler (Bohlman 2002a) and from chapter 5 for my contribution to the Festschrift for Lenore Coral (Bohlman 2007).

The path I followed into modern Jewish music history changed the moment that I met Alice Herz Sommer in Jerusalem during autumn 1980, and it has continued to change whenever I have found a moment to spend with her since that time. It is for me a great honor to have the opportunity to dedicate this book to her upon reaching the end of a century during which, as pianist and teacher, survivor and chronicler, Alice has epitomized what it means to be a Jewish musician in the modern world. Just as all who know her should have known, the capacity to inspire in her second century has abated not the least.

More often than anyone else, Christine, Andrea, and Benjamin were with me as I undertook the journeys that allowed me to encounter Jewish music in the ethnographic and historical contexts of modernity. In Jerusalem, Freiburg, and Vienna they were there. They crossed international borders and walked the streets of European metropoles with me. They eloquently reminded me that this book was a story about music. They reminded me of the joy that accompanies our life journeys as a family.

CONTENTS

TRANSCRIPTION, TRANSLITERATION, AND TRANSLATION

The songs and texts that appear as citations, illustrations, and commentary in this book represent broadly different traditions of performance and collection, and they come from numerous languages and historical moments. Many have come from oral traditions, requiring that they be transcribed by an original collector or, more often, by me. Others have come from manuscript and archival sources, which in different ways require transcription. Very few texts were originally in English, and many songs in manuscript or in vernacular genres of publication, such as broadsides, did not employ standard notational conventions, thus necessitating further acts of translation.

In the course of the book I have chosen consistency and contemporary usage as my guiding principles for transcription, transliteration, and translation. All translations are my own, unless otherwise indicated. In several instances, when I have used the translations of others, I have quietly made minor changes to ensure consistency and understandability. Transcriptions from music or interviews in oral tradition are those of the collector—mine when I have used my own fieldwork, an earlier scholar when the ethnographic sources appeared previously in print or field collections. When earlier transcriptions intentionally captured the nuance and individuality of songs or poems in the vernacular (e.g., in Viennese cabaret texts), I have respected and retained such intentions.

Because of the abundance of Hebrew and Yiddish words that appear in the book, I have also used transliteration quite extensively. Again, my guiding principles have been consistency and contemporary usage, which in turn have led me to prefer an orthography that facilitates reading ease for the speaker of English. Certain words transliterated from Hebrew (e.g., hassidic) do not use the diacritics upon which Hebrew speakers rely for literal transliteration. Authors' names, whether in the bibliography or in the references in the main body of the text, do include all diacritics common to the languages of those authors.

With rare exceptions I italicize a non-English word only on the occasion of its first appearance in the book or in a chapter in which it has particular relevance. In this way I have sought to reflect the discourse of the multicultural and multilingual

world that the Jews of Central and East Central Europe shaped along their histori-
cal journey into modernity, during which cultural and linguistic differences were
identified, embraced, and tolerated.

PROLOGUE: BEFORE JEWISH MUSIC

1. Ich verkund euch newe mere
vnd wolt ir die verstan
Zu Rom do saß ein herre

Ein Graff gar wol gethan
Der waß reycher habe
Was mylt vnnd tugenthafft
Er wolt ziehen zum heiligen grabe

Nach Eren vnd ritterschafft.

2. Sein Fraw erschrack der mere
Sie plickt den graffen an
Genadt mir, edler herre
Dartzu mein Eelich man
Mich nimbt wunder sere
Was euch die ritterschafft sol

Habt ir doch gut vnd Ere
Vnd alles was ir solt.

3. Er sprach zu seyner Frawen
Nun spar dich got gesunndt
Als wol ich dir vertrawe
Alhye zu diser stunndt
Also schyed er von dannen
Der Edel grafft so zart
Groß kummer stund im zu handen
Eins Kunigs gefangener er wardt.

I give to you some news
And want to make it known to you.
There was a fine gentleman in
 Rome,
A count of the highest standing,
Who had many wealthy goods,
Who was gentle and virtuous.
He wanted to journey to the Holy
 Sepulcher
As befits honor and the way of a
 knight.

The news frightened his wife.
She looked at the count
And blessed the nobleman.
"For this my husband
You have my greatest respect,
For what the ways of the knight
 require
You do as good and noble
And what you should."

He spoke to his wife,
"Now, God keep you healthy
So that I can trust you
Here in this hour!"
And so he took his leave,
The nobleman so gentle,
But great suffering lay before him.
He would become the prisoner of
 a king.

Poised at the threshold of modernity, the European ballad that begins this book straddles the very borders of Jewish music. "Der Graf von Rom" ("The Count of Rome") was one of the hit songs during the transition from the Middle Ages to the early modern era, and its dissemination throughout the German-speaking regions of Central and East Central Europe bespeaks a presence that crossed socioeconomic divisions and had the power to circumvent ethnic and religious differences. A narrative song about centuries-long conflicts between Europe and its Muslim others in the Eastern Mediterranean, "The Count of Rome" provided a connection between European Christians and their Jewish others at the center of the continent. Situated at the core of the modern canon of German folk songs—it bears the classificatory siglum, "Deutsche Volkslieder, DVldr 14"—the ballad is in virtually every way redolent of premodern Germanness: Its text appears in a late medieval form of literary Middle High German, and the earliest printed versions of the "Count of Rome Melody" ("Graf von Rom-Weise") from the early sixteenth century employ *Bar* form (AAB). We can speak with certainty about the ballad's stability within the

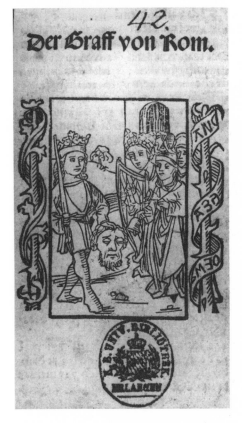
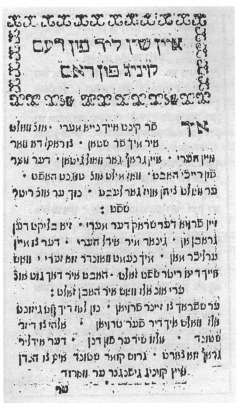

PROLOGUE FIGURE "Graf von Rom"/"The Count of Rome." Woodcut and printed version (verses 1–3) from ca. 1600. (Courtesy of Deutsches Volksliedarchiv, Freiburg im Breisgau)

European canon because it entered literate traditions quickly and extensively, with printed versions, such as that from 1510 that appears as the text above, from the advent of music printing. Oral and written traditions intersected and stabilized each other, narrating a complex history of exchange within and beyond the German ballad repertory, in which it exhibited a signal importance from the early modern era into the twentieth century (for an overview of its main variants and history of transmission, see Bohlman and Holzapfel 2001: 99–102).

And yet "The Count of Rome" announces its appearance also as Jewish. At the same moment that it appears on the landscape of early modern Europe, "The Count of Rome" also appears in Hebrew characters. The print that begins this book was no random curiosity. It already reflected considerable previous circulation in European Jewish communities, not only in Prague, where the song was printed, probably in ca. 1600, but also in southern Germany, through which the song made its way from one personal Jewish library to another (Süß 1980: 18–24). The song text, moreover, expresses Jewishness at several levels, literary and vernacular. The use of Hebrew orthography is obvious, though perhaps not immediately striking is that the printer did not employ the same fonts he would have used for many sacred publications. The language in the text is not Yiddish, or even proto-Yiddish of some kind, but rather Middle High German. The transliteration might seem unremarkable, but the title at the head of the print, "Ein schen lid fun dem keneg fun rom" ("a beautiful song about the King of Rome"), does come from an early dialect of Yiddish, complete with the elevation of the status of the count ("Graf") to king ("Keneg"). That the ballad has musically dismantled the borders between Germanness and Jewishness is evident in the history of its tune, the "Count of Rome Melody," which circulated so widely as a *niggun* (Hebr.: melody) in European Jewish communities by the second decade of the seventeenth century that it became one of the most common sources for the contrafacts of historical Jewish songs, such as those chronicling the Fettmilch Uprising in Frankfurt am Main in 1614–1616 (Bohlman and Holzapfel 2001: 99–100; Meier 1935).

The more fragments we gather to piece together the history of this variant of "The Count of Rome," the more the ballad expresses both Germanness and Jewishness. And the more the musical images and metaphors of Europe and its others become difficult to pull apart. One could argue whether "The Count of Rome" is or is not Jewish music. But argue one must. It conforms to Jewish tradition in some ways, and in others it does not. Few of the histories of transmission through which we can follow it absorb obvious traces of Jewishness, but when it does reflect circulation in Jewish communities, it draws our attention to critical historical moments, when those communities are facing danger or responding to prejudice, or when they may be enjoying a moment of openness in European society. The reception history of "The Count of Rome" locates its many variants on the changing landscape of modernity.

During the course of modern Jewish history that I examine in this book, the question of the Jewishness of music was important because it did not lend itself to simple resolution. Musical repertories that for some were entirely Jewish—say, cabaret at the turn of the twentieth century—were not the least bit Jewish for others. Sacred music became no less controversial in the debates about what was or was not

Jewish music, particularly when Jewish sacred musicians openly expressed diverse forms of creativity and sought to win a place for Jewish music in the European public sphere. Most ironically, the identity of Jewish music was open to debate because it enveloped Jews and non-Jews. In much of the popular instrumental music explored in this book, Jews and non-Jews performed together, in both Jewish and non-Jewish social settings. Klezmer music would not have become a quintessentially Jewish popular music if Roma (Gypsies) and other non-Jews had not joined Jewish musicians to perform a diverse and hybrid repertory.

The debates about Jewish music were nowhere more controversial than in Central and East Central Europe, in those regions where German and Yiddish were the languages of modernity in Jewish communities. At the center of Europe, Jewish achievements were inseparable from modern history and from the Jewish contributions to modernism. Throughout the book, we find that it is modernity that attracts European Jews toward the center—to the metropole, to the cosmopolitan culture of modernism, to the arts and sciences fostered by great universities, to the monumental synagogues, and to the concert halls and cabarets. At the center of Europe, the debates about Jewish music modulated as they were liberated from premodern myths about tradition and authenticity. Any and every music could become Jewish. Modernism was unchecked, and Jewish musicians found their way into the spaces exposed by modern musical practices unencumbered. The closing of those spaces— of the public sphere in which the Jews of Central and East Central Europe found a modern cultural home by the early twentieth century—brought about a collapse of the modernity traced here through the multiple music histories constituting the chapters of this book. At that moment too many questions about the identity of Jewish music were resolved with simple answers, and the fate of Jewish identity in modern Europe was determined with solutions simple because of their finality. It is the Jewish passage through the modernity at the center of Europe that provides me with the narrative framework of this book (cf. Hess 2002; Mack 2003; Meyer 1979; Quinzio 1995).

JEWISH MUSIC BEFORE MODERNITY

The sites at which Jewish music became modern varied vastly in repertory and genre: folk music, sacred music, popular music, world music, and classical music, both European and Mediterranean. At the modernist moment, all these genres became Jewish music. Difference was celebrated as the marker of modernism, and common culture asserted itself as Jewish music. Whatever the potential for common culture, disjuncture rather than commonality characterized the musical and aesthetic practices of Jewish modernity. Throughout this book disjuncture assumes many distinctive forms, all of them conditions made possible by modernity and its aesthetic complement, modernism. Modernity's metaphysics and the ontology of modernism contained both temporal and spatial dimensions, together clashing as aesthetically mixed metaphors. Once endowed with the attributes of modernism, Jewish music crossed the disjunct borders formed between the temporal and spatial realizations of Jewish history. The geography of modern Jewish

history—diaspora—has a radically disjunct relation to that of ancient and post-modern history. Paradoxically, Jewish music provides a means of suturing the aesthetic and historical domains mixed as metaphors through disjuncture, for it is music that allows for the displacement that has so profoundly shaped modern Jewish history.

Before turning to the chapters that narrate modern Jewish history, I should clarify a bit more just what I mean by modernity. First of all, I *do* mean modernity in the more traditional sense of European history, beginning with the Age of Discovery in the fifteenth and sixteenth centuries, passing through the early modern era in the sixteenth and seventeenth centuries, until modernity itself is reached, traditionally regarded as a nineteenth-century response to the eighteenth-century Enlightenment. However historians calibrate modernity, it is a rather long haul. In the history of European Jewry, moreover, there would be no reason to avoid the modernity that increasingly charted the path into European history. It was in the eighteenth century that European Jewish history became inescapably modern.

Europe and the Enlightenment, and its Jewish form, the Haskala (glossed in Hebrew also as "the enlightenment"), are keys to understanding a revolutionary transition in Jewish music and Jewish music history. Music was not only an object of exchange across social and religious boundaries, but fundamentally reconfigured those boundaries. That the Haskala was crucial to that reconfiguration could not be more evident in the activities of its most notable family, the Mendelssohns. With the Haskala it was possible to speak for the first time about an ontology of Jewish music. Before the modernity articulated by Moses Mendelssohn and other *maskilim,* the Jewish Enlightenment thinkers, "music" was largely vague as an aesthetically autonomous object in Jewish society. In a strict sense everything in the synagogue was music—prayer, Torah and Haftorah, cantillation, ritual and liturgical interjection—therefore it was impossible to limit it to any single category. Both liturgy and ritual were extensively cyclical, thereby juxtaposing sacred and secular time. The cyclical nature of liturgical practices bounded music within ritual and prevented it from flowing over into the temporal world outside the synagogue.

If these aesthetic points seem at first glance complicated, that is so because the concepts of Jewish music before modernity existed only to the extent that they specified what music *should not* do. First and foremost, music should not obscure texts, which is to say that, once cantillation and song did obscure texts, they became music and were theologically proscribed. In practical terms for the synagogue, this meant that instruments were not allowed. Similarly, polyphony—multiple voices singing different parts at the same time, which made individual lines of text more difficult to discern—was not allowed. More problematically, women's voices were prohibited in the synagogue, for they drew attention to themselves and away from the texts. The understanding of the voice as human and the potential dangers of employing the voice musically were explicit. Only the body was to serve as an appropriate "vessel," or artifice for the voice, hence song could be the only appropriate use of music.

Most readers, perhaps, will be more familiar with a more modern case of this distinction, that between voice and artifice in klezmer music, which is crucial to an understanding of klezmer within a larger historical framework. The contraction of

the term for voice, *zemer* ("song," but in the German distinction of *Gesang* rather than *Lied,* in other words as a concept rather than an object), with that for the artificial vessel of the musical instrument, *kleh,* first appears roughly in the fourteenth century, on the threshold of early modernism. In the history of modern Jewish music an aesthetic tension about losing voice arose—about abandoning human control over voice in the performance of sacred texts and ritual—and this tension underwent a paradigmatic shift with the onset of modernity.

Music participated in the transformation of Jewish identity on two distinct levels: the individual and the community. Music became part of how one could shape oneself. At its greatest extreme, the individual's relation to music reshaped individual identities by allowing one to become a musician. Becoming a musician was not, however, simply a matter of self-improvement. It resulted from cultural mobility, and it produced various forms of social and economic mobility. To become a musician necessarily led to a redefinition of one's social group, as well as one's relation to other groups.

Historically, modernity forced Jewish musicians to realize the ways in which music itself proliferated into complex identities. The differentiation of Jewish musical practices spread throughout the entire Jewish community in nineteenth-century Europe and indeed contributed to its differentiation. We witness this process even in the most basic evidence from a community's material culture, such as in the publication of unique *siddurim* (prayerbooks, containing the "order" of worship), and, for the first time, songbooks in virtually every synagogue and city. Jewish music came to represent a growing multiculturalism of the nineteenth century. More to the point, Jewish music participated in a new historical dynamic of modernity, yielding radical new ways to express Jewishness.

Jewish modernism took shape as a counterhistory to the rise of European modernism. To some extent this development was inevitable, for since at least the mid-nineteenth century Jews had been implicated in what Fritz Stern has called the "politics of cultural despair" (Stern 1961). Once modernism had been identified as a symptom of all that was wrong with European society in the late nineteenth century, anti-liberal and anti-modernist movements would realize their target by fixing it on Jews and their entry into modern society. The moment of Jewish modernism was distinctively historicist, articulated through Jewish discourse networks, which both reflected and inflected the discourse networks of fin-de-siècle Europe (see Kittler 1990).

There was music in Jewish practice and in Jewish ritual and community life prior to modernity, but it was not called Jewish music. Indeed, it was rarely called anything to distinguish it from the extramusical functions it served. There were boundaries between the musical and the extramusical, but reasons seldom arose requiring that these boundaries be transgressed. Before modernity the boundaries were firmly fixed through separation of cultural and religious domains that were simply incompatible. With the onset of modernity, the boundaries were undermined, and the relation between previously separated domains underwent the radical transformation that became crucial to the modern Jewish music history that this book contains.

FRAGMENTS AND COUNTERHISTORIES
BEFORE MODERNITY

Biblical Origins of Jewish Musical Thought

Psalm 150

1 Praise ye the Lord, Praise God in his sanctuary:
　　praise him in the firmament of his power.
2 Praise him for his mighty acts:
　　praise him according to his excellent greatness.
3 Praise him with the sound of the trumpet:
　　praise him with psaltery and harp.
4 Praise him with the timbrel and dance:
　　praise him with stringed instruments and organs.
5 Praise him upon the loud cymbals:
　　praise him upon the high sounding cymbals.
6 Let every thing that hath breath praise the Lord.
　　Praise ye the Lord.

There are few places in the Bible where the forms and expressions of music are as dense as in the 150th Psalm. In its position of closure as the final psalm, Psalm 150 brings the people of ancient Israel together to praise with both song and instrumental music, alone and together. Praise itself swells in volume and polyphonic richness as each new verse joins in the chorus. The performative structure of the psalm, clearly antiphonal, signifies a performance practice in which a congregation or chorus followed an official precentor with call-and-response, enhancing the psalm's overall musicality. Movement and dance enrich the performativity. The orchestra that will praise God has no fewer than eight classes of instruments, crammed into four verses.

It is hard to imagine a more powerful and eloquent enjoinder to music. Music, however, remains unnamed precisely at that point when its presence is the most undeniable. The making of music and the discourse about music do not compete for the same space; or rather they do, and a choice between one or the other must be made. Already in the Bible, questions about musical identity pose themselves, and they do so in abundance.

There are two accounts of the origin of music in the Bible, both in Genesis. In the first of these, found in Genesis 4:21, it is Yuval, or Jubal as he is commonly known in English, who is the inventor of music. Just how Yuval came to acquire the role of inventor of music is not known, because Genesis refers to him as the "ancestor of all who play the harp and the flute." Some clarification is offered by the epithet that immediately follows, designating Tubal Cain, Yuval's half brother (the son of Lamech and Zillah), as one "who made all kinds of tools out of bronze and iron." Medieval commentators, both Jewish and non-Jewish, regarded this genealogy from Cain as a metaphorical description of the artifice of music, that is, music as created by instruments shaped by human hands. By placing music in the hands of humans, the artifice of music also removed it from God. One could metaphysically experience music without perceiving it only in the voice of God. Music might

issue from the earth and the substances, bronze and iron, forged from the earth. The classification of music and music-making that we find in Genesis persists in roughly the same form throughout the history of Western music and musical aesthetics, as well as in the music history of Islam. Formalized in Greek Antiquity by Aristotle, but continually altered, the scheme influenced Western thinking on the nature of music throughout the Middle Ages. The most basic division in this classification is between *musica mundana* (music of the earth or natural bodies), *musica humana* (human-made music, that is song), and *musica instrumentalis* (music conveyed through instruments).

We observe in the two accounts in Genesis 4 actually two types of instruments, those associated with Yuval, formed, at least figuratively, from human (anthropomorphic) and animal (zoomorphic) shapes and materials, and those associated with Tubal Cain, resulting from the human transformation of the earth. Hollow bones provide much of the earliest evidence for flutelike instruments. Although clay is also used to make flutelike instruments, other "living" substances were more common until recent centuries, especially ivory (or other hornlike substances) and wood. Myths about the origins of harps often describe their strings as dried sinews, human or animal, stretched over a frame or skeleton. Apollo, for example, invented the lyre in this way, discovering a decaying tortoise on the seashore, which then sounded in Apollo's hands. The several contrasts within this biblical instrumentarium became standardized throughout the Bible, surely by the time of the psalms, which contain some of the most compact inventories of music-making in any biblical source (cf. Sendrey 1970: 35–50, and Braun 2002).

The other biblical account to which we trace the origins of music is the *Akeda,* found in Genesis 22, the story known both as the "Sacrifice of Isaac" and as the "Binding of Isaac." In contrast to the artifice and human agency that surrounded the "invention of music" by Yuval and his descendants, the Akeda's formulation of music's ontology is oblique, shifted from human hands to the ram, or more specifically to the ram's horns. The *shofar,* the instrument fundamental to Jewish ritual, is never mentioned as such, though later interpretation symbolically connects it to the ram's horn. In the Akeda it is actually human artifice that God arrests, for it is a human-made instrument, the knife in Abraham's hand, that will execute the sacrifice God has commanded of Abraham. In order to complete the sacrifice, however, "Abraham looked around and saw a ram caught in a bush *by its horns*" (Genesis 22:13). We witness a shift in the designation of the instrument of sacrifice, from the knife to the horns. We therefore can interpret the ram's horns as symbols for the agency of God, indeed the instruments whereby God makes his grace known to Abraham and to descendants of Abraham.

The two biblical accounts of the origins of music differ from each other, but they share several ontological tropes. First, they recognize two essentially different metaphysical conditions expressed through music in the Bible. Music may be fundamentally theogenic, issuing from God and shaped by instruments that make understanding possible. Music may also be anthropogenic, invented by humans and disseminated by the instruments made by human hands (see also the discussion of Jewish music as logogenic below). Second, music itself, in an absolute, objective sense, is never really named in the two Genesis texts. In Genesis 4 we are to assume

that the "harp" and "flute," "played" as they are by the generations that succeed Yuval, are musical instruments. Even the generic character of this first mention of musical instruments in the Bible—there is an almost infinite variety of both harps and flutes—presumes an associative knowledge of music by the reader. The real nature of music in Genesis is left intentionally obscure, to be identified only through acts of reception and perception. From the very beginnings of Jewish history, we do not know what music is, even though the accounts of Yuval and the Akeda provide us with beginnings from which we then depart.

It is not only a matter of interpretation that leads one to Genesis in search of an understanding of where music originates in Jewish thought and history. The more one examines music's ontological presence in the Genesis stories, the more the text becomes a metonym for beginning itself. Ritual music, though unnamed, will be represented by the ram's horn, and its potential as a means of interpretation will result from the acts of both blowing the shofar and hearing the shofar even when it is not named as such. The distinction between making and experiencing music persists in Jewish religious practices, extending to, among other areas, gender distinctions in the liturgical performance in the synagogue. Beginning with medieval interpretation, men were to "give voice" to liturgical texts through cantillation, whereas women were to experience these texts as listeners. The differentiation may well be enforced through the traditional separation of male and female worshipers in the synagogue, but it is nonetheless important to recognize that both components—chanting and listening to chant—are required for the experience of music. Music, as we witness throughout this book, serves as a metonym for the body politic of the synagogue and by extension the Jewish community.

PLACING AND DISPLACING JEWISH MUSIC
IN THE MEDIEVAL WORLD

And we have already explained in the *Commentary on Aboth* that there is no difference between Hebrew and Arabic words; only such are prohibited or permitted in accordance with the meaning intended in those words. And in reality it is the hearing of folly that is prohibited, even if uttered [i.e., accompanied] by stringed instruments. And if melodized upon them there would be three prohibitions: (1) the prohibition of listening to folly (follies of the mouth), (2) the prohibition of listening to singing (*ghina'*), I mean playing with the mouth, and (3) the prohibition of listening to stringed instruments. And if it were in a wine shop [where listening occurred] there would be a fourth prohibition, as in the saying of Him Most High—"And the harp (*kinnor*), and the viol (*nebel*), the tabret (*toph*), and pipe (*halil*), and wine, are in their feasts." And if the singer be a woman, then there is a fifth prohibition according to the [the Rabbis'] saying—"A voice in a woman is a shame." Then how much [greater the prohibition] if she be singing.

—"Maimonides on Listening to Music," twelfth century CE,
translation by Henry George Farmer in Farmer 1941: 16

To understand the meaning of Jewish music requires first that the meanings of texts be clear. In the earliest biblical and historical contexts prior to the diaspora, cantillation and music were fundamentally logogenic, with distinctions between song and instrumental practices being critical to the origins of musical sound in worship. The preoccupation with words and meaning engendered considerable anxiety about misunderstanding, about the failure to perceive correct and authentic meaning. Contact with vernacular languages and with secular practices in oral tradition muddied the meanings of words, for it moved them outside the texts in which they were anchored and, even more important, introduced the voices of those who did not originally create them. The anxiety that the logogenic basis of music would dissipate was magnified with the diaspora, and it shaped a proto-aesthetic of Jewish music in the Middle Ages. That aesthetic, particularly in the formulations of medieval Jewish philosophers, concerned itself primarily with what was not Jewish music rather than with what was. In the expanding multilingual universe of the European Middle Ages, there was much that was not Jewish music in the Jewish community.

The Bible itself contains a complex theoretical framework for the logogenic basis of Jewish music. The most basic of all texts are biblical and liturgical, and the Hebrew Bible itself provides the basis for different styles, genres, and repertories. The *Torah* (Five Books of Moses, or *Pentateuch*) provides a framework for worship through cyclical performance during the year. The performance of the Torah is technically recitation and not music. Reciters are enjoined to follow the musical parameters they encounter in the text, though oral tradition necessarily extends and localizes those parameters. A system for notating the direction and syntax of melodic motion, the *te'amim* (masoretic accents), was implemented in most Jewish traditions during the early Middle Ages. Te'amim and the tropes prescribing recitation permit a common understanding of text while at the same time affording different communities interpretative freedom at the interstices between oral and written transmission.

Variety and variation have increased during the course of Jewish history, but it did not necessarily follow that there was a sharpening awareness that the performance of biblical texts had strayed from an idealized authenticity. Such awareness arose sharply first with modernity, and the responses to it heightened a concomitant anxiety about what was not Jewish music. The logogenic principles of modern recitation departed considerably from those influencing premodern traditions. In several recitation traditions of the twentieth and twenty-first centuries, not least among them the prevalent style of modern Israel, the "Jerusalem-Sephardi Style," musical parameters have become so extensive as to result in the requisite use of specific modes—Arabic *maqāmāt* ("modes"; sing., *maqām*) in modern Israel—in the annual recitation cycle.

The liturgy of the worship service is the source of many musical practices, some of which are common to most Jewish traditions while others vary according to historical period and community practice. The liturgy follows an order determined by the service's position in daily, weekly, and annual cycles, as well as specific holidays and celebrations. These conditions locate liturgy in different temporal frameworks, some within the community, others outside it. Because of the extensive emphasis on

literacy in Judaism, worshipers follow the liturgy in prayerbooks, or siddurim, but also rely on lay leaders (e.g., the *ba'al tefilla,* or prayer leader) and ritual specialists, notably the rabbi and the cantor. Modern liturgical traditions increasingly opened themselves to external influences, such as the variants of the same song appearing in the nineteenth-century anthologies of cantorial music (see chapter 4). In the course of modernity it was necessary for musical leadership in the liturgy to expand, with soloists, chorus, and instruments enriching the texture of worship—and raising new anxieties about what Jewish music might or might not be (Zimmermann 2000: passim, but esp. 91–108).

Sacred musical practices outside the synagogue reflect the theological and aesthetic sensibilities of worship. There are several genres of sacred music practiced in the family (e.g., *zemirot,* or table songs, for Sabbath meals), and many others that have accrued to individual communities (e.g., *piyyutim,* recited or sung liturgical poems, and *pizmonim,* hymns, often with refrains). The soloistic practices of recitation often provide a template for melodic style in paraliturgical genres. Similarly, the antiphonal performance of the Psalms and congregational performance of synagogue song may be reflected in community song. Sacred music outside the synagogue often employed paraliturgical texts, which were specific to a holiday or a community's own celebrations, but at times they drew widely upon and contributed substantially to the celebrations of non-Jewish neighbors. Through paraliturgical texts, the logogenic qualities of Jewish music also opened the doors to musical exchange with non-Jewish cultures. Paraliturgical musical practices were also distinctive because of the ways in which Hebrew texts might be mixed with vernacular texts, be they specifically Jewish—Yiddish, Ladino, or a dialect of Judeo-Arabic—or even non-Jewish.

Gender marks virtually every genre and practice of Jewish music. Even though men and women came to worship in separate spaces of the synagogue, the main sanctuary, as a place in which the community gathered as a whole, acquires a feminine character at the beginning of Friday evening Sabbath services when the song "Lecha dodi" ("Come, My Beloved") welcomes *Shechina,* the feminine presence of God, into the sanctuary (Bohlman 2005b; see chapter 8). The metaphorical arrival of the Sabbath bride during Friday evening services further brings about an orientation of worship toward the altar, or *bima,* which is itself turned toward the east, or *mizrakh,* where the ark containing Torah scrolls stands. Outside the synagogue, women's song repertories reconfigure the home for the Sabbath.

Concepts of community shape Jewish musical traditions at various levels. At the most local level, the synagogue distinguishes the place of music in the local community, or *kehilla.* More geographically expansive regional, linguistic, religious, or doctrinal boundaries may include the traditions of a larger community, and when these reveal continuity through a long history of tradition, they acquire the attributes of *'eda,* community in a broader cultural sense. During two millennia of diaspora, the most expansive concepts of community emerged from the German- and Yiddish-speaking Jews of Central and Eastern Europe (*Ashkenaz*), the Ladino-speaking Jews of the Mediterranean (*Sepharad*), expelled from the Iberian Peninsula at the end of the fifteenth century, and the culture of Judeo-Arabic-speaking communities in North Africa and the Middle East (Eastern). Placement and displacement of Jew-

ish music accelerated in complex historical counterpoint during the modern era, making it also important to consider the ways in which religious, geographical, and cultural boundaries restricted or encouraged musical change.

JEWISH MUSIC'S BODY

> There are melodies that must have words. This is, you under-
> stand, just the first of the steps necessary to produce music.
> There are many other steps that have much greater importance,
> melodies that sing themselves, completely without words: This
> is *pure* melody. But it also requires a voice and lips that can pro-
> duce it! And lips, you know, are nonetheless something bodily.
> And the voice as well—it is indeed made of noble material, but
> it, too, remains nonetheless physical. Let's say for a moment that
> the voice stands at the border between the spirit and the body.
> Be that as it may—if the melody relies on the voice, if it de-
> pends on the lips, it is not yet pure, not *completely* pure, not truly
> spiritual.
>
> True music, however, sings itself, completely without
> voice, rather inside of one, in the heart, in one's guts. And that is
> the secret in the words of King David: All my bones praise the
> Lord. It must sing in the very marrow of the bones, there music
> must live for the greatness of the Almighty, praised be the Lord.
> . . . This is, then, that part of the melody, with which God cre-
> ated the world, that part of the soul, with which he filled the
> world.
>
> — *Jiddische Erzählungen* 1984: 123–24

In his short story "The Kabbalists," the Yiddish writer J. L. Peretz (known as Yud Lamed Peretz), narrates a lesson about the inseparability of music from the body. He turns to music as a metaphor for the only possible way to acquire and express spirituality. In the story, Reb Yekel, the aging head of the Laschtschower *yeshiva,* a religious academy for boys, formulates the lesson with the above passage, which in turn allows him to recount the lessons he has himself learned from the commentar- ies on Judaism in the Talmud. As a good talmudic scholar, Reb Yekel grounds his argument for the location of music in the body in the texts he has inherited from previous religious thinkers and in the human practices that connect God's will to the world. He identifies the fundamental unit of human expression, a musical unit, to which he attributes both musical and spiritual qualities. Oral tradition acquires written authority, myth is transformed to afford authority to history. Music—the purest form of melody—resides in the body, in the very marrow of the bones, and only there does it acquire its spirituality.

Through his reliance on talmudic tradition, Reb Yekel locates the unit that most fundamentally embodies music, that becomes the agent for the purest of musics. As a member of the first generation of Eastern European Jewish writers to elevate Yiddish to a literary language, J. L. Peretz also turns to a story in oral tradition for fundamentally modern ends. In the story, music passes from the intangible to the tangible; it passes from its mute presence in the body to its sounded presence outside

the body. The body—its very physical essence—is fundamental to the way humans interact physically *and* musically. On the threshold of modernity the body extends identity to music, making it Jewish.

Jewish polity, aesthetics, and religious thought accord the body an extraordinarily important and complex relation to the sacred and social spaces comprised by the Jewish community (see Boyarin 1992 and Gilman 1991b, and especially the essays in Eilberg-Schwartz 1992). Basic concepts of the performative transformation of written texts through cantillation, moreover, reveal the ways in which the word of God is fully expressed and clarified through the musicality of the human body. The next level of physical interaction in Jewish polity is the private space of the home, in which the family embodies a musical unit that reflects a different configuration of physical and musical practices, such as at the Passover seder, in which the musical practices are divided among different family members.

A more complex level of physical interaction is the kehilla, the local community. In the community, particularly within its primary structure, the synagogue, musical practices are divided among members in specialized ways, with musical specialists, such as the *ḥazzan,* or cantor, growing in importance during the modern era. One measure of modernity is achieved when musical specialists become inseparable from representations of the community in Jewish political philosophy (see Elazar and Cohen 1985). Finally, there is the social space outside the community, a secular and public sphere, which nonetheless includes musical practices in the vernacular languages of both Jews and non-Jews.

If the four levels of musical practice in the Jewish community seem at first glance static, individuals move from level to level, from musical space to musical space. The body is no less a site of musical practice at any of these levels. The more musical spaces an individual enters, the more complex her musical practices. Not all individuals possess the same freedom to move from musical space to musical space. Social and musical changes do transform these spaces, these "spheres" of social and musical activity, with the result that social structures respond to the actions of individual humans as music-makers, turning them into the agents that are making Jewish music history.

To examine the ways in which the sacred space of the Jewish community, the synagogue, becomes embodied through the musical practices before Jewish music, we turn to the Altneusynagoge (the "Old-New" Synagogue, or in Czech, the Staronová synagoga) in Prague, completed in 1270 CE, and thus the oldest European synagogue still standing. A medieval, orthodox synagogue, the Altneusynagoge symbolizes the religious orthodoxy of Judaism yet situates this in the middle of the Jewish Quarter of Prague, where the synagogue stands directly across from the Jewish town hall. Sacred and secular spheres border each other, juxtaposing different streams from the same history. The inner space of the Altneusynagoge organizes worship in such a way that the bima, or pulpit, stands at the center, with benches for male worshipers surrounding and facing it. The bima also occupies the space commanded by the religious and musical specialists of the synagogue, the rabbi and the cantor. The male members of the congregation who surround the center also define the centeredness of the synagogue's sacred space with their bodies when they pray or chant aloud.

It is the women of the community who embody the margins, indeed, the boundary between the sacred space and the public spaces outside the synagogue. It is their bodies that become the boundary, formed of their physical presence and the voices their bodies produce, both of which are blocked from the center space by thick walls. The woman's voice may be raised in prayer and song, but it may not and cannot enter the central space, just as her body may not. The separation of women and men in the synagogue is generally justified by rabbinical tradition through direct reference to mythical sites of prayer and music. Medieval oral tradition held that, while the Jews were fleeing Egypt during the exodus, Moses and Miriam led separate worship services for the two sexes, even though the songs performed at each were identical. The different bodies of the two sexes, therefore, took precedence over the ontological identity of music itself (see Levy 1966: 43–45).

In the medieval Altneusynagoge male voices penetrated the wedge-shaped slits in the walls to the marginal space, as if through a semipermeable membrane, which focused song outward into the chamber where women formed the boundary between sacred and public spaces. The outside world was effectively excluded by the boundary of worshiping women and the entrance foyer. Music in the Altneusynagoge, therefore, remained symbolically centered, controlled by specialists and male worshipers, isolated from the non-Jewish otherness in the medieval public sphere by a boundary formed by specifically Jewish otherness.

Jewish Music at the Borders of Modernity

Jewish music begins with Salamone Rossi (ca. 1570–ca. 1628). Or at least the modern reception history of Jewish music often leads us so to believe. Rossi himself, as a composer and musician, who sought to earn his living as a professional within and outside the Jewish community, also wanted his audiences to perceive the beginnings of Jewish music in his Hebrew compositions. On one hand, he hoped his compositions would draw attention to the most general questions of beginnings, what Rossi and his aesthetic-theological apologists regarded as a foundational *musica antica,* the ancient music of the Temple in Jerusalem, Jewish music prior to the diaspora. On the other, there were new beginnings, which both Jews and non-Jews in early modern Italy would perceive as a bold *musica moderna.* If Jewish music was to begin with Salamone Rossi, it had to begin anew. By beginning anew, Jewish music would also take its place in early modernism, the stylistic border region between medieval and modern Europe. In these contrasting beginnings lay the contradictions of Rossi's life, which were both musical and Jewish.

Jewish music, in the double meanings that accumulated at the borders of modernity, was the product of crossing borders and negotiating identities. Forged out of both meanings, Jewish music complicated the dilemma of identities we have followed through this Prologue. In modern Jewish music historiography, Salamone Rossi has an eponymous presence in virtually all foundation myths. He was a transitional figure between myth and history. Recovering Rossi from myth was of crucial importance at various moments, for example in the late nineteenth century, when Samuel Naumbourg and Eduard Birnbaum laid the groundwork for modern historiography by finding the missing partbooks for Rossi's great collection of sacred

music in Hebrew, *Hashirim asher lishlomo,* "The Songs of Solomon" (published in two seminal works, Naumbourg 1874 and Birnbaum 1893; for further discussion of Birnbaum see chapter 5).

With Salamone Rossi's historical position as a founding father of Jewish music seemingly rescued, new historiographic traditions proliferated rapidly. Through misinterpretations of the early modern traces of Jewish instrumental music, Rossi even found his way into the literature on klezmer music (cf. Nettl 1923 and Nettl 1963). He also proved essential to modern traditions of cantorial scholarship, which established the cantorate and the discovery of lost synagogal works in *genizot* (sing., *geniza,* repositories for synagogue records; see chapter 5) as genealogical and archival frameworks. A more popular scholarship could and did embrace the genealogical framework that often characterized local Jewish communities, filiopietistically listing Rossi's name first among historical musical influences. In each of these frameworks Rossi's works provided a necessary metonym for the beginnings of modern Jewish music.

Despite Rossi's foundational role, much scholarship on the early modern Jewish composer identifies what many have perceived as disjuncture between Rossi's life and works (see especially Harrán 1999). A modern historiography raises critical questions about Jewish contributions to publishing in early modern Europe, but more cautiously resists making undue speculations about Jewish music. We might ask, therefore, why Rossi should not really belong to the overlapping realms of both myth and history at the threshold between medieval and modern Europe. Securing the answer to that question is the biographical fact that the overwhelming majority of Rossi's compositions were simply not Jewish. In the complete edition of Rossi's works, edited by Don Harrán, twelve of the thirteen volumes contain works that are not Jewish (Rossi 1995–2003). The complete works fall between vocal and instrumental, the first eight volumes of the edition encompassing vocal works with Italian texts, the subsequent four containing instrumental music. The Italian vocal works were notable for employing texts by the most distinguished poets of Rossi's age, revealing the extent to which he moved freely across the aesthetics of his day. Rossi's instrumental music was similarly notable for the contexts of its composition, the Gonzaga court in Mantua and a wide array of public venues in northern Italy.

The Jewishness of Salamone Rossi's music is not simply an aesthetic or theological question, but a historiographic one. Rossi's Jewishness did determine the ways the composer and his music entered Jewish history as phenomena of early modern Europe. First, his Jewishness may account for the fact that during the last decade of his life he virtually disappeared from historical records; we know nothing of the circumstances or date of his death. A luminary in the musical life of northern Italy prior to his mid-forties, Rossi fell victim in those years to a dramatic retrenchment of the borders between the Jewish and non-Jewish communities. This decade also witnessed escalated anti-Semitism in northern Italy and Rossi's shift of compositional attention from "Italian" and "secular" works to "Jewish" and "sacred" works. The real world of anti-Semitism and the emerging world of Jewish music converged to form the image of a historical figure fully deserving of the moniker, "Jewish musician" (Don Harrán convincingly argues for this image in Harrán 1999).

The life and works of Salamone Rossi lend themselves fully to the historiographic borders between medieval and modern Europe. His works display the traits of both *prima prattica* and *seconda prattica* ("first" and "second practices," the former extensively polyphonic, the latter stressing clarity in the melodic voice) and of combinations thereof. Some of his compositions lay bare the sharp distinctions between an earlier and later style, while others allow us to unravel the ways in which Rossi was wrestling with change. In writing polyphonic works for the synagogue that treated the primacy of the Hebrew text in ways distinct from the prevailing Roman liturgical rite in Italian synagogues, Rossi had to account for the ways his compositions for multiple voices did not violate Jewish theological injunctions against precisely that vocal texture that he, as a late Renaissance composer, was attempting to create. The criticism against and debates surrounding Rossi's musical solutions of this Jewish and textual problem echoed in many of those surrounding works intended for the Catholic church.

By the beginning of the seventeenth century, the gulf between Jewish and Christian music was narrowing, so much so that Jewish synagogal compositions reveal that an exchange across that gulf was more common than exceptional (e.g., *Synagogal Music of the Baroque* 1991 in the Discography). Rossi perceived his own role as that of a musician recuperating a much older Jewish music, thus grounding his innovations in conscious historicism. That he found some of these solutions in compositional techniques of the *seconda prattica* (e.g., the textual clarity afforded by use of choral monody dominating his works in Hebrew) reveals the extent to which Jewish music was by no means isolated from the aesthetic debates of early modern Europe.

Rossi's negotiation of the stylistic borders between the Renaissance and the Baroque was inseparable from the historical fact that he was a Jew working primarily in an Italian public sphere that was Christian. Rossi's forays into the *seconda prattica,* therefore, paralleled his own entry into the public sphere of early modern Italy and the reconfiguration of the Mantuan Jewish community as "public" itself, that is, as a culture that extended beyond the ghetto. The transitions between medieval and modern Europe transcended the privileged historical domain of an expanding Europe. We witness "prima" and "seconda" in the historical fissure that opened first during the *reconquista* (the "reconquest" of Spain and Portugal from Islam), accelerating with the expulsion of Jews from the Iberian Peninsula in the 1490s, and that led soon thereafter to the settlement of new Jewish communities in northern Italy. New cultural borders formed—between the indigenous *Italiani,* or Roman, Jewish rites and those of Mediterranean outsiders, between Ashkenazic and Sephardic traditions, and even between responses to the accommodation of Christianity, that is, between orthodox Jewish and Marrano responses (Marks 1996).

The dawn of early modern Italy also marked a new historical era for Jews. New possibilities for entering the public sphere beyond the ghetto emerged, such as the active involvement of Jews in printing in general and music printing in particular. Print culture transformed the social contexts in which identities were formed. For Jewish printers in northern Italian communities this development was particularly important, because just as they entered non-Jewish markets, so too did their presses render sweeping changes within the Jewish community. Salamone Rossi straddled

the borders opened by print culture, and his life as a Jewish musician unfolded through negotiation of those borders. It was this Jewish print culture, thriving also in secular domains, that similarly paved the way for the version of "The Count of Rome" above to enter the public sphere of European modernity. It is hardly surprising, therefore, that Salamone Rossi's works and life emerge almost entirely from his printed oeuvre—for example, from the publication of his *Songs of Solomon* in the last decade of his life—essentially securing his role as a nestor of modern Jewish music.

The *Songs of Solomon,* surely intentionally for Rossi, drew attention to the borders between the secular and the sacred. It was their publication that empowered Rossi to be new while remaining true to the old. Rossi was careful (and surely also clever) in choosing the biblical *Shir hashirim* (lit. "Song of Songs," but more commonly glossed as "Songs of Solomon") to negotiate the sacred-secular divide. On one hand, the *Shir hashirim* are surely the most secular of "musical" collections from the Bible. Many mix metaphors of sacred and secular love. Rossi's choice of a title for the published collection referred to biblical authority but also made clear his own voice as author: the songs of Salamone as well as of Solomon. The Hebrew title employed by Rossi for his published version, *Shir asher lishlomo,* is not a common substitute for *Shir hashirim,* and it surely drew attention when it appeared in 1622–1623. Individual songs possessed multiple functions, affording them liturgical and paraliturgical possibilities, in performances both Jewish and non-Jewish. The *Shirim asher lishlomo* effectively invented multiple spaces within the liturgy. Again, publication and print culture provided crucial forums for border-crossing, for it was through publication that Rossi's *Songs of Solomon* became an encomium of Jewish music writ large. The craft of the composer had transformed the authenticity of biblical texts into Rossi's authority as a modern creator of Jewish music.

Jewish Music at the Borders of History

Two primary themes shape the course of this book. The first is aesthetic and ontological: I concern myself throughout the book with the ways in which Jewish music becomes music when it enters the public sphere. The second theme is historical and ethnographic: The book examines Jewishness as an expression of identity that emerges when music's narrative potential enters history. The two themes are closely related and dependent upon each other, and they ask us to consider questions of identity on two different levels, one represented by music itself, the other expressed by the contexts in which music takes place.

Challenges to the very nature of music—what music really is, in an ontological sense that allows human beings to understand their "being in the world"—not only accrue to the borders that separate these several levels, they actually define those levels, determining whether they facilitate connection or enforce disjuncture. In a word, Jewish music, as I attempt to understand it in this book, both contains Jewishness for its potential to express selfness and also multiplies the ways in which Jewishness makes it possible to negotiate with otherness. The identities of Jewish music are the most complex in the border domains in which the identities of selfness and otherness are most critically important.

The questions of ontology and identity that determine how Jewish music emerges from the history of modernity are further crucial if we are to accept that Jewish music is not just "out there," present at all times and places in the *longue durée* of Jews throughout history. The hopefulness that accompanies the acceptance that Jewish music has always already existed and that its presence has connected the past to the present has played an essential role in shaping various models of diaspora. The transmission of music within the synagogue and within the diaspora has more often than not served as an abiding trope of authenticity, providing assurance that selfness has weathered the storms of history and thus survived their ever-present threats. Many responses to modernity examined in this book—for example, the ethnographically driven recording projects of Abraham Zvi Idelsohn—relied on a deeper motivation to document the connections between Jewish music as it was and as it is (see chapter 5).

In the course of the book we encounter Jewish music in many different places, and it should surprise us not the least that the identity of Jewishness depends on where Jewish music takes place. In Jewish music historiography, place has always problematized identity. There were safe zones for Jewish music, historically the synagogue and the family circle, and more recently the wedding, which has acquired the postmodern burden of defining klezmer music in its most recent revival. No fewer were the zones in which Jewish music represented endangerment, the non-Jewish environs enveloping a traditional community, or the non-Jewish musicians who also have become part of the postmodern burden of essentializing Jewish music realized through the klezmer revival. In the course of this book the identity of place undergoes many changes. The geographic place of Jewish music may be local or translocal, and it is not by chance that we turn frequently to border regions where identities mix and ontologies are hybrid. The place of Jewish music also acquires historical dimensions, for example as "sites of memory" in several chapters (e.g., in the Jewish village of chapter 1) or in the archeological practices of Jewish music collectors (chapters 4 and 5). Finally, the place of Jewish music is powerfully performative, in other words, it comes into being when music shapes the stage upon which its performance takes place (chapters 7 and 9). Jewishness affixes itself to and transforms place when it is performed.

During the course of modernity the ontologies and discourses of Jewish music were formed from fragments, and accordingly I have already represented the prehistory of Jewish music before modernity through fragments. I continue to draw extensively upon fragments throughout the book. The discourse of fragments is itself a product of modernity and its technologies. We have already witnessed the gathering of fragments through modern technologies with "The Count of Rome." The versions and variants, Jewish and non-Jewish components, of that ballad and the many others in this book are the sum of their fragments. The cantors and cantorial journals of the nineteenth century (chapter 4) distributed their musical wares as fragments, and in this sense they were no different from the songsmiths who published covers of Jewish popular songs as broadsides (chapter 7) or the cabaret players who wove caricatures and stolen tunes into skits for the Jewish stage (chapter 9). The fragments of modern Jewish music history, however, resisted isolation and lent themselves to being gathered and assembled to make wholes that

were ever more malleable and mobile. Fragments also facilitate connections across difficult borders. Fragments are often the stuff of Jewish music, and it is for that reason that Jewish music often emerges at the places and moments in which fragments are most abundant.

My rhetorical reliance on fragments also shapes the ways in which this is a book about narrative and history. I avoid seamless historical sweeps that might take us from a moment of origins to an inevitable telos, effecting the culmination of all that has come before. In virtually every chapter, instead, the early modern and the postmodern make appearances, destabilizing the modern rather than framing it. The modernity that provides the historical backdrop for Jewish music consists of bits and pieces, many of them cohering to define moments of efflorescence, others deteriorating to represent processes of destruction. The fragments of Jewish music both undergird and undermine performativity. If I draw together fragments in search of different ways of narrating modern Jewish music history, I do so not to deny history. In the course of the book's nine chapters, the history of modernity unfolds in a complex counterpoint, forming counterhistories, the multiple voices of which shape the chapters into a larger narrative whole (Funkenstein 1994: 22–49). That whole does not represent the unity of Jewish music, but rather the capaciousness of history to embrace the ever-proliferating ways music expresses the identities of Jewishness.

PLACES OF JEWISH MUSIC

THE JEWISH VILLAGE: MUSIC AT THE BORDER OF MYTH AND HISTORY

AT THE EDGE OF TOWN

The Jewish village begins at the edge of town. It is a place of boundaries and peripheries, where centers lie just beyond reach and originary moments remain inchoate. It is a place of borders—physical, religious, and temporal. The music that resonates along the borders that at once insulate and connect the Jewish village is the phenomenon of a place shaped by the intersection of boundaries and peripheries. It is a music that is secular and sacred, Jewish and at times not Jewis It is a music that belongs to a single place, a village or region with its distinctive musical and linguistic dialects. It is no less the music of many places, Jewish because of the ways it signifies an otherness of place and time. Historically, portals of entrance and exit to the town, intersected by the *Judengasse,* the small street along which Jews lived and located their shops, marked the geography of boundaries and peripheries. Building a synagogue was possible at the edge of town. The Jewish cemetery by necessity lay just beyond the edge of town.

The search for Jewish folk song and folk music begins at the edge of town, where it encompasses not one, but many repertories, and where it mixes sounds and styles because of its inclusiveness rather than its exclusiveness. Jewish folk music does not parse into categories that articulate genre and function. Even in the most rural Jewish settlements, Jewish folk music is distinctive because of its instability and its propensity to undergo change. The Jewish village has been almost entirely invisible in the study of Jewish history in the German-speaking areas. The Jewish village of Central Europe differed from the East European shtetl, though in the historical imagination it has fulfilled many of the functions of the shtetl. In modern Jewish historiography the village is invisible because it responded to and represented a domain of in-betweenness.

While encountering the music of the Jewish village, we enter it along a number of different routes. Methodologically crucial for my approaches to past and present, the Jewish villages that spread across the landscape of this chapter have been the subjects of my own ethnographic fieldwork. In several cases, Sulzburg and Mikulov, for example, fieldwork was almost entirely archeological, that is, concerned with

3

uncovering the past by stripping away the visible layers of the present. In other cases my approaches incorporated different styles of oral history: interviews with former Jewish residents and with current non-Jewish residents. Finally, there were several villages to which the Jewish community has returned, actively memorializing the past by revitalizing ritual and relying on an engaged ethnography to remember.

Jewish folk music in rural Europe was dynamic, moving from one repertory to another and from one village practice to another. The music of the village synagogue, transmitted in large part orally, frequently functioned as folk music, and so too did the music of the home and the Jewish tavern. Most important, these musics crossed sacred and social boundaries, providing for Jewish residents of the village a common culture and a culture of community. The boundaries between Jewish and non-Jewish folk musics were not always distinct, raising a critical historical point: Jewish and non-Jewish folk musics often resulted from extensive exchange, and as the Jewish village entered the modern era, folk musics that might have been different were often mutually constitutive.

Individual songs and cohesive repertories conformed to local needs, but they also spread across Central and East Central Europe. The Jewish village fostered the conditions for a much more extensive, diasporic musical world, in which, for example, it was possible to find vocal practices in Western Europe that bore remarkable similarities to those in Eastern Europe. The Jewish village, in both its rural and its cosmopolitan forms, thus provided the foundations for a European Jewish folk music. The foundations might support common repertories of a Jewish vocal vernacular, "folk songs of Ashkenaz," or they might spill over into the cosmopolitan imaginary, as in Jewish popular music at the turn of the twentieth century (see chapter 7) and the klezmer revival at the turn of the twenty-first (see Epilogue).

The historical pattern most often invoked to account for Jewish life in the village is one of Jews trying to leave the village and move to the city, where they were able to take full advantage of all the educational, professional, and economic advantages that an urban Jewish society made possible (cf. Labsch-Benz 1981, and Baumgartner 1988). As Jews diminished in number in the village, they increased in number in the institutions of higher education. Though the high schools (*Gymnasien*) and universities acted as magnets for village youth, they also forced Jews, in disproportionately high numbers, to move from the village to the city, where advanced schools and universities were located.

Few biographies of Jewish composers from rural areas fail to address the attraction of the city for composers such as Gustav Mahler and Karl Goldmark. Biographically, the path of the small-town Jewish musician moved in one direction only, from the periphery to the center. Karl Goldmark, for example, spent most of his youth in Deutschkreutz, one of the *sheva kehillot*, or Seven Holy Cities of Burgenland (see below), thereafter making his career in the imperial and royal capitals of the Austro-Hungarian Empire, Vienna and Budapest. Once he had achieved the status of an urbane and cosmopolitan composer, Goldmark sought to distance himself from the village of his youth:

> My own musical capability revealed itself in a remarkable way. Once, when the waiter at a wedding left some half-filled glasses on the table, I noticed that each one of them,

depending how full they were, produced tones that were higher or lower than other glasses. Using these glasses, I constructed a scale, and with a wand in the hand, I was able to play well-known tunes to the astonishment of everyone there. That is how my "genius" was born. Music in any real sense was absent from my yout (Goldmark 1922: 12)

Absent from Goldmark's own account of his emerging genius is the fact that his father was a hazzan, a professional cantor in Deutschkreuz, and that he was surrounded by the rich Jewish musical life of the *sheva kehillot* (see biographical accounts of Goldmark's life, most of which do not question his own assessment of village musical life, e.g., Pfannkuch and Winkler 2001).

Competing with the historiographic model of flight to the metropole is the portrayal of the Jewish village as a place of refuge during periods when Jewish life in the city was threatened. According to this model, Jewish communities formed in rural areas when those situated in an urban center lost the protection of a friendly court or when the blame for causing a plague or the blood libel for murdering Jewish children was placed on Jewish burghers (cf. Ernst 1987, and Hsia 1988). Jewish villages, as a result, formed as clusters around cities and offered some form of protection against the tribulations inherent in urban existence (see the case of Sulzburg below). Village musical traditions thus were imported and mixed into hybrids in the Jewish village, where they were arguably even foreign to the internal structure of rural, traditional life.

THE FOLK MUSIC OF THE JEWISH VILLAGE

The genres, styles, and repertories of folk music in the Jewish village displayed as much variation as the structures and identity of Jewish life in the village. To speak of Jewish folk music in rural Europe is, therefore, to speak of an extraordinarily complex ontology of Jewish music itself. Some variables constituting a given repertory or song-type might result from sameness (e.g., variants of the same song in a linguistically and culturally unified region), while others might reveal the juxtaposition of variables that are different or even distinct in essential ways. Folk ballads, such as "Die Jüdin" (see below), are as distinctive as the places and dialects in which they are sung, especially when they spill across religious and cultural boundaries. The ontologies of Jewish folk music thus result from the processes that allow individuals and communities, performers and audiences, to accommodate and respond to the complex patterns of identity that shape the musical identity of each song, dance tune, and variant thereof.

Though many processes of contact and exchange contributed to the mixing and remixing of identity in Jewish folk music, three general processes serve as the leitmotifs that will be traced through this chapter and book. First, because many of the songs themselves originated in border regions, it is hardly surprising that their identities bear witness to *border-crossing*. Second, variables within song and dance repertories that intersected because of similar styles and repertories frequently led to *hybridity*. Third, those variables that were less compatible, for linguistic, musical, or religiocultural reasons, still reflected the *interplay of selfness and otherness*. Each of

these patterns of identity arose from the conditions of modernity, and, accordingly, they produced ontologies that were indices for the entrance of Jews into modern European society and into modernity itself.

Even more critical than distinct and distinctive Jewish and non-Jewish cultural geographies in the formation of village culture was the extensive presence of in-betweenness. Any map charting in-betweenness would necessarily highlight border regions and regions that overflow historical and political boundaries. In-betweenness does not result from isolation in shtetls or speech islands, but emerges from zones of exchange and hybridity. The cultural geography of Jewish in-betweenness depends on historical and political realities such as the Habsburg Monarchy, which comprised the larger region known as *Mitteleuropa* (Central Europe), with its several constitutive regions, particularly the more modern regions crucial to this book, Central and East Central Europe. Whereas cultures of in-betweenness may form along borders, they also tend to negate the divisive impact of borders, enhancing the possibility for a new common culture.

The border regions fostering Jewish village music were of very different kinds, and so too were the common cultures of rural Jewish Europe. One of the border regions most symptomatic of rural Jewish culture in the Habsburg lands of East Central Europe was that of the northeast frontier of the Austro-Hungarian Empire. The provinces of Silesia and Galicia constituted a border region along the northern side of the Carpathian Mountains, ranging from Silesia in southwestern Poland and stretching across southern Poland into western Ukraine, where Galicia stretches eastward toward Czernowitz. One of the most distinctive qualities of the two provinces was their multiculturalism and interethnicity. Silesia contained larger numbers of Poles and Germans, Catholics and Protestants. Galicia included Poles, Ukrainians, Romanians, Rusyns, and Austrians. The Jewish population in both provinces was very large, and Jewish contributions to rural, provincial, and cosmopolitan culture dominated many areas of intellectual and artistic life. Jewish music, moreover, was the singular tradition that was significantly present across the region, connecting in extraordinary ways the musical practices of the other cultural and regional groups.

Jewish folk songs document the common culture of the border regions between East and Central Europe for a number of reasons. Silesia was one of the favorite goals of German folk-song collectors and the German civil servants who implemented cultural policy in the provincial cities such as Wrocław and rural parts of the region. Galicia, in contrast, enjoyed more intensive connections with Vienna, and it is not surprising that various official excursions departed from the Habsburg capital in search of folk music in Galicia, such as the 1904 project "Das Volkslied in Österreich" ("Folk Song in Austria"), which was organized by scholars associated with the imperial cultural ministry and Universal Edition. Silesia and Galicia therefore became important regional sources for folk song and folk dance within the provincial metropolis and in the centralized imperial institutions devoted to collecting (see also Vishniac 1999).

Two other border regions have been critical for my fieldwork over the course of the past two decades: Burgenland along the Austrian and Hungarian frontier, and the Upper Rhine, shared by Germany, France, and Basel. The exchange of folk music

in both regions was crucial in the formation of common cultures. *Dreieckland* (lit., Three-Corner-Land) of the Upper Rhine—Baden in Germany, Alsace-Lorraine in France, and Basel and the northwestern cantons of Switzerland—is a true border region with a common culture comprising a shared geography (the Upper Rhine), a regional dialect (*Alemannisch*) stretching across national boundaries, and a Jewish history dominated by small villages connected by an extensive trade and cultural network.

The borders of rural Jewish areas increasingly extended to the city during the modern era, therefore contributing to a process of transferring folk music from the country to the metropole. Urban Jewish districts such as Berlin's Scheunenviertel and Vienna's Leopoldstadt became the crucibles for a common culture precisely at the metropolitan border that was crossed when rural Jews entered the city. The music of urban common cultures is most easily recognizable for the ways in which the markers of rural Jewish life produced cosmopolitan genres of Jewish folklike and popular music at the turn of the twentieth century (chapter 7). In urban border regions, rural common culture underwent dizzying change.

In the historical *longue durée* leading to Jewish modernity, the border regions along which Ashkenazic and Sephardic Europe overlapped also played a role in shaping the common culture of both Ashkenazic and Sephardic folk music. Though Ashkenazic repertories were overwhelmingly characteristic of rural life in Jewish Central Europe, there were also significant concentrations of Sephardic music culture in the northwest (the Netherlands and northern German cities such as Hamburg) and in the southeast (especially the complex border regions where Balkan, Ottoman, and Habsburg cultures intersected). Sephardic music did, furthermore, have a noticeable impact on Ashkenazic vernacular and liturgical traditions. In some more localized Jewish border regions of the Austro-Hungarian Empire, notably Burgenland, Sephardic influences from the Balkans unleashed complex forms of Jewish interethnicity.

Just why should music articulate issues of difference so trenchantly? And why does it also provide a common culture for villagers with different religious backgrounds? To answer these fundamentally ethnomusicological questions, I should like to sketch four areas in which Jewish music is important for its ability to mark and convey difference. First, music is rarely separate from Jewish religious customs, whether from fundamental texts (e.g., in biblical cantillation) or from the many contexts of ritual. This factor may be so obvious that it does not often provide cause for further reflection, but it is an important one to consider here because it reveals difference that originates in Jewish custom rather than from the imposition of stereotypes from the outside. Second, music encodes language differences, not just the Hebrew of religious study in the Talmud schools of Mattersburg and Deutschkreutz in the sheva kehillot, but the Yiddish-Swiss-Alemannisch mixtures in the western Ashkenazic linguistic regions of the Upper Rhine. The vocal music of a Jewish village, when considered as a whole, might well be trilingual if not quadrilingual. These differences, to arrive at the third issue, bear witness to the role of history in channeling the distinctiveness of Jewish musical traditions in each village. Finally, music becomes a metaphor for Jewish metaphors themselves, which often extend beyond the village and the experiences of the villagers. In the Jewish village of the modern era, music became a bridge to a different sense of Jewishness itself.

FOLK MUSICIANS AND OTHER MUSICAL
SPECIALISTS IN THE JEWISH VILLAGE

The common culture of Jewish folk music did not result just from the mobility of repertories and styles. Music traveled at the hands of musicians and through performance practices that resulted from the mobility of amateurs and professionals. If the Jewish village was not musically isolated, that was so because musicians of various kinds connected the village to the metropole and built the cultural conduits facilitating the modernization and professionalization that transformed rural practices into modern Jewish music.

With the rise of modernity that followed the Haskala, or Jewish Enlightenment, in the late eighteenth century, new forms of musical professionalism began to transform the Jewish musical landscapes of rural Europe. The professionalization of folk musicians accompanied the economic transformation of the Jewish community and the growing social interaction with non-Jewish European society. To maintain the complex forms of musical difference and indeed the diverse musical life of the village itself, musical specialists were necessary. Historical accounts of the Jewish village, whether studies of synagogal and community records, travel ethnographies from the nineteenth century (Stauben 1986 [1860]), or folkloristic descriptions from the twentieth century (Grunwald 1924/1925, and Roth 2001), are remarkable for the degree to which village musical specialists captured the attention of the outside observer. Musical specialists acquired toponyms (e.g., Pfeiffer, Geiger, or Kantor; "Piper," "Fiddler," or "Cantor," respectively) in records beginning in the early nineteenth century (see, e.g., Wachstein 1926). Such indices of music-making attracted the chroniclers because these names revealed a high degree of importance to the community, which is to say, the salaries and fees performances were able to command.

It is through their professionalization that Jewish musicians transformed folk music in the Jewish village into Jewish folk music. By the eighteenth century, the Jewish communities in many areas of German-speaking Europe were required to make their financial records available, in part to extract greater taxes from Jewish communities but also to liberalize interaction between Jews and non-Jewish governments. Tax records indicate the presence of specialist musicians, such as those called *cantor* (the latinization of ḥazzan) and *musicus* (the latinization of an instrumental musician) in the intensely Jewish settlements of Burgenland (cf. Pollack 1971). By the nineteenth century, the use of professional titles had spread widely across the European Jewish community itself, where, for example, the term "cantor" largely supplanted the Hebrew ḥazzan (see Schmidt 1998).

As professionalization of Jewish folk musicians expanded across Jewish Europe, three broader areas of activity for musicians increasingly became recognizable: musicians who were active primarily within the Jewish community; musicians functioning at the borders between the Jewish community and non-Jewish society; and non-Jewish musicians playing Jewish music. The musicians active in the latter two areas often escaped the attention of modern observers, but during the rise of modernity they played an extremely significant role, not least because they were the emblems of profesionalization. The musicians performing in the first area are

known to us today because they bear Hebrew names, such as ḥazzan and klezmer (instrumental musician). Traditionally, the ḥazzan and the klezmer are distinguished by the social realms in which they played: the sacred vs. the secular, the center of Jewish ritual life vs. the periphery. As modernity shaped the Jewish village, however, such distinctions became less and less meaningful, for mobility between and beyond Jewish communities accelerated accordingly.

The primary specialist in the religious musical life was the ḥazzan. Compared to specialists in other village domains, ḥazzanim (pl.) were relatively mobile, often coming from outside the village and negotiating at times for salaries that would prevent them from accepting other posts (see Wachstein 1926). Ḥazzanim and cantors also enjoyed wide prestige. The ḥazzan of the Alsatian village Wintzenheim, in the mid-nineteenth century, for example, was the only Jewish resident who spoke French as his exclusive vernacular language. This linguistic limitation, however, did not segregate the ḥazzan into an outsider in the village, but rather elevated him to the status of the local intellectual, further serving him well as a teacher in the Jewish school (Stauben 1986: 49 and 60–61). In the same village the night watchman also performed in several other capacities as a professional musician. We know little about the repertories he performed as a professional, but the French traveler Daniel Stauben did collect songs he sang while passing through the streets of Wintzenheim at night. The following song employs the form of a *Vierzeiler* (quatrain), which is common in alpine Europe but also lends itself culturally and linguistically to the local Alsatian dialect:

> Horiche wos ich eich wett soie,
> Die Glock hett zwelfi geschloie,
> Bewohre Fiir ond Liecht,
> Dos ons olle Gott behiet.
> Listen to what I say to you,
> The bells toll midnight,
> Take care with fire and light,
> That God cares for all of us.
> —from Stauben 1986 [1860], 40

Secular musical specialists also abounded in the village. Historical references to these suggest both a diverse terminology and a complex range of social and musical roles. In his extensive studies of Jewish instrumental music in Central Europe, Walter Salmen has discerned several different names for such musicians, including *letzim* (glossed as dance musicians) in the region of the Main and Rhine rivers in western Germany, and he has detailed the extent to which instrumental musicians performed at dances of all kinds, among them Jewish dance halls (Salmen 1991: 14–15). Jewish instrumental musicians were sufficiently organized in Alsace that they were simply referred to as the "orchestra" at village events, and their diverse instrumentation and repertory proved this to be an apt label. Organization led to visibility and a prominence in regions with extensive Jewish village populations, such as Burgenland and the Carpathians, and in the other boundary regions that fostered Jewish folk music.

Though Jewish and non-Jewish interaction in the performance of Jewish folk music has rarely been acknowledged, it is also important to recognize that non-Jews

also played a role in the professionalization of modern Jewish music-making in rural Europe. Jewish folk songs also circulated in villages where there were few if any Jews, and they entered oral tradition there as well. The well-known German ballad "Die Jüdin" (The Jewish Woman, given the siglum, DVldr 158, in German ballad classification), which will be followed along various historical paths in this book, found its way into variants in the standard German canons (e.g., *Des Knaben Wunderhorn;* see Arnim and Brentano 1806 and 1808), with only tangential Jewish meaning, but also into standard Yiddish canons (e.g., Ginsburg and Marek 1901), where Jewish meanings are heightened. Jewish folk music became public and professional by accompanying the social transformations of nineteenth-century Jewish society. In the nascent decades of the German singing-society movement (from ca. 1830 to ca. 1880), before Jewish singing societies separated from synagogue choirs, Jews often participated in the public choral life of an urbanizing Germany. With the advent of Jewish singing societies, it was also common for non-Jews to participate, not least because Jewish singing societies were themselves constituent members of regional and national choral leagues.

Jewish professionalism also created the permeable conditions for other "Others" to enter modern Jewish folk music. The most notable musicians from outside the mainstream were Roma (Gypsies), who were particularly active with ensembles in the border regions, such as Burgenland and the Carpathian Mountains, where large populations of Jews and Roma cohabited the same folk-music landscapes. In such areas it is impossible to imagine Jewish instrumental folk music (e.g., klezmer music in the Carpathians) without also recognizing that Rom musicians contributed to it. Similarly, Jewish musicians were often active players in professional Rom ensembles (e.g., in Burgenland; see below). As specialization and professionalization fired the engines of modernity, they were increasingly inseparable from intensified hybridization.

ORIGIN MYTHS

> On the first day of Rosh Hashanah, Rabbi Shmelke of Nikols-
> burg entered the synagogue before the shofar was blown and
> prayed in tears. "Oh, my God, Master of the world, all people
> are crying unto you. What, however, should their supplication
> really mean to you, for it arises from their sin and not from the
> exile of *shechina,* the diaspora?" On the second day, he came
> again and wept, "It says in the first book of Samuel, 'Why did
> my song, Isaiah, come neither today nor yesterday to the table?'
> Why did the king, the Messiah, not come, not yesterday, on the
> first day, and not today, on the second day of the New Year?
> And thus, today and yesterday, the people prayed only about
> bread for their bodies and for bodily afflictions!"
> —Hassidic tale, "The One Who Prayed and the Messiah"

The music of the Jewish village comes into being in a zone of in-betweenness, where prayer and melody unite. Myth and mysticism inhabit the zone, with their tales of the past and their trepidation for the future. Music draws attention to the

uncertain narrativity of the zones, through the blowing of the shofar between the end of the Jewish year and its beginning, Rosh Hashanah, or even more metaphorically in the recurrent return and exile of *shechina* (the feminine presence of God, metaphorically representing diaspora through the arrival of the Sabbath bride), welcomed musically by the song "Lecha dodi" at the beginning of Sabbath evening services in the synagogue. It is hardly surprising that the tales of the mystic *hassidim* (plural of *hassid,* from the root *het–sameh–dalet,* ד–ס–ח, glossed as "pious") concentrate such intense emotion and imagination on the origins of music. As the tales construct the genealogies of miraculous rabbis, music becomes the stuff of miracle, the voice of the miracle workers, and the means of conveying their deeds to subsequent generations. The mystical tales draw upon song to map the geographies of myth and modernity.

Writ large across the tales of the legendary Hassidic Rabbi Shmelke (Samuel Shmelke ben Hirsh ha-Levi Horowitz, 1726–1778) is the humanness of voice and music and their power to mediate. In modern anthologies of Hassidic tales (e.g., Martin Buber's published collection of 1949, from which "The One Who Prayed and the Messiah" comes), few *Wunderrabbiner* (miracle rabbis) communicate so often to their followers with music in such complex ontologies as does Rabbi Shmelke. When he travels to Vienna to ask the Habsburg court to mollify its treatment of the Jews, Rabbi Shmelke enacts his miracles with song (see "The Trip on the Danube" in Buber 1949: 318, and at the beginning of chapter 4 in this book). When his metaphors connect the internal rhythms of life to the life of the synagogue and the Jewish community of Nikolsburg, Rabbi Shmelke draws potently on the musicality of the Psalms (see "The Knocking" in ibid.: 310). The texture of Nikolsburg's Jewish life is the rich counterpoint of music, mystical and metaphorical yet direct and real.

The music of Nikolsburg (today Mikulov in the Czech Republic) enters modern history in transit across the heavily layered spaces of myth in a zone that was at once the edge of a Jewish village and the edge of empire. The castle of Mikulov still rises majestically from the vineyards of the Moravian plains, a citadel at the border between the Czech Republic and Austria. Since 1989, Mikulov (population ca. 7,500) has become a hive of activity, with workers repairing cobbled streets and painting old artisan shops, reinvigorating nostalgia for one of the most important Jewish villages of the premodern era. The gold leaf on Baroque statues has been restored, and the museums that occupy the castle grounds are open for business. Modernity, however, does not erase the traces of a village past. By foot, it is possible to walk through the old city of Mikulov (which is to say, the Nikolsburg village) in no more than twenty minutes, circumnavigating the entire citadel. There is more to modern Mikulov, the small industrial city serving a socialist economy, but that lies some kilometers from the center, with apartment blocks hugging factories belching coal smoke.

As a village forged through myth, Nikolsburg claims an impressive Jewish history. For centuries it was the seat of Jewish administration for Moravia, home of the legislative councils ruled by the chief rabbis of Moravia, the so-called *Landesrabbiner.* The great Moravian chief rabbis holding this office are themselves legendary; in addition to Rabbi Shmelke, who ruled in the late eighteenth century, Judah Löw ben

Bezalel (ca. 1511–1609)—most famous as the "inventor" of the Golem in Prague—was chief rabbi in the mid-sixteenth century. Mysticism shrouds Mikulov's rabbis, and yet this mysticism is always slightly transparent because it provides a sacred portal through which one passes on journeys between East and West, between the sacred world of Judaism and a secular landscape historically administered by Prague, Vienna, and the Jewish wine merchants, whose commercial power stimulated the modernization of Jewish life in Moravia (see Fiedler 1991: 114–16).

The mediating power of music and mysticism resided along the edges of Nikolsburg as a village. The Jewish community hugged the citadel, defining it through the synagogues, shops, and Judengasse that ringed its base. The mystical power summoned by Rabbi Shmelke and other mystics with song was not lost on Mikulov's city boosters in the post-Velvet Revolution era, for the modern city fathers have taken great pains and spent considerable money to restore the main synagogue. Since 1989 there have been several attempts to restore the character of a Jewish village, all focusing on the synagogue over which Rabbi Shmelke presided. The first attempt was aimed at converting the synagogue into a museum filled with artifacts surviving from the era of village life. The second sought to reconfigure the sanctuary and other community rooms of the synagogue into a performance space that would accommodate the musical traditions of a boundary region: Moravian, Czech, Austrian, and Slovak musicians from the area might perform frequently on the renovated stage. Jewish musicians too would perform, but they would come entirely from elsewhere (see Klenovský 1994).

Returning to the Jewish village of Nikolsburg has not followed a simple route from history to myt Restoring the synagogue raised questions repeatedly about the exact moment in history that would be most appropriate for representing the life of a Jewish village. The Nikolsburg "Altschul," or "Old Synagogue," has premodern origins, with inscriptions suggesting that its foundations were laid in 1550. It survived assaults from natural disasters, especially fires, and it has responded to the needs of changing Jewish administrations and the mysticism of different rabbinical generations. As in the tale about Rabbi Shmelke that opened this section—a tale about the Messiah and the space where prayer and melody intersected—the past and the present in Nikolsburg/Mikulov overlap through the ritualized musical symbols of beginning and ending, signaled by the blowing of the shofar at Rosh Hashanah and Yom Kippur (see Bohlman 1996b).

A TALE OF TWO JEWISH VILLAGES

The tale of the two villages begins with Otterstadt, today still a small village in the southeastern part of the German province of Rheinland-Pfalz. Otterstadt has no Jewish community today, and it probably had no substantial Jewish community after the Middle Ages. The foundations of a synagogue have yet to be unearthed. Otterstadt acquires its importance as a village type because it lies about three kilometers north of the cathedral town of Speyer, one of the seats of the Holy Roman Empire along the Rhine River. The Jewish history of Speyer is extensive, paralleling that of the various politicoreligious leaders, cardinals and emperors, ruling from the city (see Debus et al. 1981). Otterstadt, the first village downstream from Speyer, served as one village

within the constellation of small towns to which Jews fled in search of a safe haven when the Jewish community in Speyer was under threat, as it periodically was.

As a premodern Jewish village, Otterstadt was inseparable from the Jewish community of Speyer and other Rhine enterpôts, such as the one only a few more kilometers downstream in another imperial seat, Worms. Otterstadt also served as a transit point along a route of cultural exchange between Jewish villages, and there are references to its Jewish inhabitants in accounts of the village's role in river trade. Once the Speyer Jewish community solidified around a new synagogue in the 1830s and 1840s, all evidence to suggest a Jewish presence in Otterstadt disappears. With the onset of modernity, Otterstadt ceased being a Jewish village. The nineteenth century brought with it new patterns of exchange that redirected the Jewish histories of Speyer and Otterstadt. The critical historical point is not that a village such as Otterstadt ceased to have a Jewish community; rather it is the considerable role the village played in making alternative historical paths available in the Jewish history of the German Palatinate.

The historical *longue durée* of a Jewish presence in Sulzburg was possible because of an inner stability there that Otterstadt never offered. Sulzburg's prosperity depended not so much on a client relation with a political-economic center as on its environment and its use of the advantageous resources of its favorable location. Although it relied on exchange with nearby larger cities, Sulzburg maintained control over the products and conditions of exchange. If things were going badly for Jews in Freiburg im Breisgau or Strasbourg, the merchants of Sulzburg could strengthen their relations with the Jews of Basel in Switzerland or Mulhouse in France. Even the music that can be traced to Sulzburg or nearby towns suggests particularly strong patterns of exchange with Switzerland, with dialect words reflecting Swiss inflections combined with western Yiddish and the regional dialect, Alemannisch, of the Upper Rhine River. The tale of Sulzburg unfolds in an entirely different way.

The Black Forest is a land of picturesque villages, which spread like a carpet of folkloric sites across the hills and low mountains of southwestern Germany. Few visitors follow the tourist handbooks into the Black Forest in search of Jewish villages, perhaps because Jewish village culture would seem to have little in common with the touristic images of the region. Still, visitors at the beginning of the twenty-first century might increasingly find it difficult to overlook Jewish village culture on the landscape of Germanness, for the resurgence of nostalgia about the loss of Jewishness has led to the rediscovery of a village culture that quietly slipped away as modernity encroached upon the region's Jewish history.

Sulzburg (population, ca. 2,700) enjoys a fairly unpretentious location, straddling a small stream as it falls from the high hills of the Black Forest, the Hochschwarzwald, into the flood plain of the Rhine River. As one approaches Sulzburg by automobile, the flow of traffic through the village pulls one first through the town gate—a quaint medieval portal made over at various stages in history to look more baroque, along the one main street suitable for motorized traffic, briefly across the stream to the chapel of St. Cyriac, a Carolingian monastery church from the early Middle Ages, and then back to the main thoroughfare, which leads three kilometers up through a valley to Bad Sulzburg, which as a spa at 1414 meters is the goal of most who pass this way.

Most travelers along Sulzburg's single major thoroughfare are probably unaware that it was once a Jewish village. Well into the modern era, Sulzburg's financial and cultural life benefited from, and even depended on, a high population of Jews—probably more than one-third of the total in the favorable economic times during the nineteenth century and a significant proportion even in the difficult years prior to legal emancipation. Population figures for Jews in Sulzburg, and for that matter other Jewish villages, are generally unavailable prior to the nineteenth century, and the limited statistics that are available mention only land-holding or property-owning Jews to whom certain privileges had been extended through a *Schutzbrief* (letter of protection), the document granting protection to Jews in exchange for taxes, goods, or other services. In one of the first nineteenth-century censuses listing Jews in Sulzburg, 229 of a total population of 937 identified themselves as *mosaisc* Sulzburg's Jewish population probably reached its high point in 1864, when 416 residents identified themselves as Jews (see Hahn 1988: 154).

The Jewish history of Sulzburg, at the very least the history of how the village had been transformed into a *jüdische Landgemeinde* (Jewish administrative region), began in the fifteenth century. All Jews were expelled from Freiburg im Breisgau (ca. 20 km. to the north), which had been absorbed into the periphery of the Austrian empire (Vorderösterreich) in 1524. Until the mid-nineteenth century, Jews had been forbidden to live in the bastion of Catholicism, especially with the onset of Jesuit influence in the late sixteenth century. Barred from the university and market city of Freiburg, they settled in a ring of villages around the city, some Jewish in character and others not, a pattern that characterized Jewish settlement in the central Black Forest until the mid-nineteenth century (for a study of Jewish–Catholic relations in the Black Forest of the early modern period, see Hsia 1988).

Sulzburg has a long history of prosperity as a village in which mineral deposits from the high ranges of the Black Forest could be gathered, processed, and distributed to the larger market cities of the Upper Rhine, particularly Müllheim, Freiburg, Mulhouse, and Basel. What can be reckoned of Sulzburg's Jewish history, however, suggests that the village's prosperity took the form of stability for its Jewish population, not suffering onslaughts of pogrom and persecution and maintaining its sizable presence until the twentieth century. The Jewish population of Sulzburg had become so much a part of the village that even the wave of destruction unleashed on *Kristallnacht* in November 1938 failed to erase the physical traces of a long Jewish history. The synagogue and several other buildings used for Jewish community purposes and ritual still stand today. All have new owners, and many have been taken over by the city and restored as *Gedenkstätten,* or memorials. The *Gasthaus zum wilden Mann* (Tavern of the Wild Man) still fronts the main thoroughfare, though its new owners call it the Pizzeria zum wilden Mann, providing scant evidence that it was once Sulzburg's Jewish tavern and restaurant. The large Jewish cemetery, almost hidden on a hillside beyond the edge of town, about a kilometer upstream, serenely survives, acknowledging that it was spared from the desecration that most other Jewish cemeteries endured. In Sulzburg's recent history, a *Campingplatz* largely surrounds the cemetery, thereby adding a measure of protection against new acts of vandalism.

The Sulzburg synagogue stands on a side street, flanked by the rushing waters of the stream that first afforded the village a connection through trade to the outside world. Other Jewish institutions—not just homes, but the *mikve* (ritual bath) and school—have new occupants and functions, and many await the attention of regional historians and archeologists or have benefited from the facelift that proceeded apace with *Denkmal* (memorial) status. The synagogue has stood quietly during most of the past 65 years, although during the late 1980s and 1990s financial assistance from civic coffers and anonymous sources—the usual explanation is "a wealthy former Sulzburger"—have enabled volunteers to restore structural damage resulting from neglect. Inside, the synagogue reveals few traces of its sacred past: no Torah scrolls, no bima (altar), not even benches for the occasional Jewish heritage tourist wishing to pray. There is, however, music in the synagogue, for it has become a stage for special cultural events, especially chamber music and commemorative events. Increasingly at the beginning of the twenty-first century, the visiting ensembles make a gesture toward Jewishness, often with a revival gesture toward Eastern European klezmer, but no one would reclaim the stage for Jewish music itself.

How does one hear the music of Sulzburg today—or of any other Jewish village whose traces lie at the edge of modern European history? Where are the voices of this rich and varied music history? How can one rediscover the meaning of the former synagogue's former music for the Jewish residents of Sulzburg? Did a local band or Jewish orchestra celebrate Jewish weddings in the Gasthaus zum wilden Mann? At the beginning of the twenty-first century, one wonders: Does the silence from Sulzburg's past, its immutable muteness, symbolize the ultimate closure of a unique form of musical life? At best, the voices from the Jewish village may perhaps be heard from a distance and experienced as constituents of village life and its unique everydayness in modern European history.

THE CARPATHIAN VILLAGE AT THE FRONTIER
BETWEEN EAST AND WEST

The Carpathian Mountains—stretching from the Danube at Bratislava through Slovakia, along the Polish and Ukrainian borders, and finally into Romania, where they wrap around one of the eastern Jewish heartlands of Central Europe—have long defined East Central European Jewry in the Western imagination. It is in the Carpathians that regions of German- and Yiddish-speaking Ashkenaz overlap, where the cosmopolitan experiments of modernity in L'viv (Polish, Lvov; German, Lemberg) and Czernowitz (Romanian, Cernăuţi; Ukrainian, Чернівці) pull toward the West and the Yiddish literary renaissance pulls toward the East. The Carpathians, the "dark side of Europe" in Rüdiger Wischenbart's confabulation (1992), connected East to West, realizing the route for Habsburg claims to the East and the road to emancipation for Jews turning toward the West. It was the Jews of the Carpathians whose lives, journeys, and imperial enchantments filled the stories and novels of Karl Emil Franzos, Leopold von Sacher-Masoch, Joseph Roth, and Soma Morgenstern (see various entries in the Bibliography). "Beyond the Carpathians" (Landmann 1995) lay the borderless boundary region of Eastern European Jewry,

the landscape stretching toward but never reaching *mizrakh* (Hebrew: the East), that provided the final destination for the journey of the Diaspora (Pollack 1984; Applebaum 1994).

Jewish folk music in the Carpathians resisted isolation. Historically, it formed repertories that contained the songs and dances expressing the multicultural, multi-ethnic, and multireligious regions of in-betweenness that intersect in the Carpathians. In Slovakia, for example, the folk-song traditions of Jews and Roma expressed a common, rather than a separate otherness, forming, according Eva Krekovičová, a zone "between tolerance and barriers," which in turn shaped the ways in which Slovak folklore portrays religious and ethnic minorities (see Krekovičová 1998). Folk songs from the Carpathians further multiplied the possibilities of multiculturalism because of the frequency with which different languages appeared in the same songs, usually embedding different historical layers within those songs. A region of intense pilgrimage for both Christians and Jews, pilgrimage repertories often attracted songs from different pilgrimage routes and shrines, weaving them into a religious polyphony.

Village structure in the Carpathians enhanced the exchange of traditional repertories between Jews and the multitude of other ethnic and religious groups. Villages had historically been small, with residents relying on them for cultural and economic subsistence. The trafficking of culture between villages, however, was extensive, and traditional music has borne witness to the exchange. Just as Jewish and Rom repertories intersected, so too did Jewish and Rom musicians perform together. The Jewish musicians joining these ensembles brought

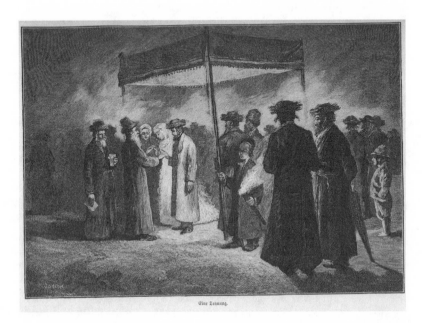

FIGURE 1.1 Jewish Wedding in the Carpathians. (Source: Herzberg-Fränkl 1898: 481)

with them a full range of village music, ranging from the hassidic dances that proliferated in the nineteenth century to the klezmer tunes that entered the Carpathians from regions to the east and southeast beginning at the turn of the last century. The traditional music of the Jewish village in the Carpathians resulted from the transformation of a premodern multiculturalism to a modern cosmopolitanism.

Beyond the Carpathians, Jewish villages stand in stark contrast to the retreating horizon. For the most part, only the most visible traces of village life survive. The architecture of village life, perhaps surprisingly, bears strongest witness to modernity. The synagogues that still stand are modern, built in the nineteenth and twentieth centuries; those that no longer stand were premodern, traditionally made of wood but long since destroyed by fire, the Holocaust, or bot The plains stretching through Moldavia and Ukraine still have sparse Jewish populations. Driving across those plains in pursuit of the possibilities of ethnography, one quickly realizes why it was nearly impossible for the clashing empires of the nineteenth century to lay down permanent borders (Pollack 1984). Instead, villages and cities were built on the lands of Galicia and the Bukovina beyond the Carpathians, rural and urban settlements that often claimed Jewish majorities (see, e.g., Kohlbauer-Fritz 1993). It was here that Jews colonized the Carpathians with a modernity of their own making, one that spoke to the borderlands of Ashkenaz and its music.

Traces of Jewish music survive in Carpathian villages today, the last vestiges of Jewish village life. Jewish music scholars have turned to the region with an especially keen desire to record these vestiges and turn them to the postmodern functions of revival. It is therefore from the Carpathians that Leopold Kozlowski, "the last klezmer" (see Kozlowski, n.d., in the discography) hales, or into which the Hungarian folk ensemble Muzsikás travels in search of "the lost Jewish music of Transylvania" (Muzsikás 1993). My own ethnographic field studies in the Carpathians too have followed a lineage of Rom musicians to the Jewish village, where I have diligently recorded Jewish dance tunes from the family Cioata and followed the tales that led me to the last Jewish farmer along the Romanian-Ukrainian border (see Bohlman 2004a: chapter 6). The musicians playing Jewish music in the Carpathian village are almost entirely Roma, and many learned Jewish folk and popular dances for the rituals, dances, and folkloric events at which Jewish repertories are appropriate. With or without Jewish musicians, the performance of folk music sustains the Jewish village, transforming it into an emblem of the Carpathians as the Jewish borderland between Europe's East and West.

In the course of my Carpathian fieldwork, Jewish villages consistently fulfilled the conditions of memorywork. The innumerable borders of the borderless regions beyond the Carpathians, for example, collapsed in the one remaining synagogue of Suceava, a provincial border city that has historically claimed the social conditions of both village and city. A commercial center of the Habsburg Empire as early as 1775, Suceava was formerly the capital of Moldavia. The collective memory of the Jewish community, which numbered about 200 in the late 1990s, stretches beyond the border to Czernowitz in Ukraine, where German was the language of instruction in the best Jewish schools, the language of negotiation

with the culture of modernism. The splendor of Suceava's one remaining syna-gogue belies the history of this frontier of East Central European Jewry. Built in 1870 and restored in 1991, the synagogue is the sole survivor of a community and its outlying villages that worshiped in eighteen synagogues prior to the Holocaust. The surviving synagogue returns the Jewish community to its premodern village structure. It must be all things to all Jewish residents in Suceava; Orthodox and liberal (Reform or Neolog) Jews alike now pray in the synagogue, together and respectful of their differences. Music too assumes all forms, but quietly, iconically, and ironically. The internal spaces of the Suceava synagogue are adorned with paintings of stylized instruments, the trumpets, celli, and guitars of a modern era. The synagogue of Suceava is all that remains. The music that it contains on holi-days, during rites of passage, and at the times of daily and Sabbath prayer has again become the music of a Jewish village.

BURGENLAND'S SHEVA KEHILLOT: THE JEWISH
HEARTLAND OF EUROPEAN VILLAGE CULTURE

Many boundaries intersect at the heartland of European Jewish culture, the sheva kehillot, or "Seven Communities" (the *sieben Gemeinden,* or more colloquially, the "Seven Holy Cities") of Burgenland. Culturally and historically, the sheva kehillot draw Europe's peripheries to its center, concentrating ethnic, linguistic, and reli-gious difference in a region constituted entirely of borders and boundaries. Geo-logically and topographically, Burgenland forms at the border between the eastern range of the Alps and the great plains of East Central Europe, called Pannonia by the Romans. Politically, the border between Hungary and Austria has run north-south through the heart of Burgenland, that is, when the province did not pass between the two nations (or the two domains of the Austro-Hungarian Empire). The border that parses Burgenland between east and west has also divided Europe itself between East and West, in the second half of the twentieth century during the Cold War.

The diverse multiculturalism of Burgenland owes much to the dual functions of borders, either to buttress a region against outsiders or to permit entry because of selective permeability. The very name of the region, Burgenland (land of fortresses), bears witness to the first of these functions. The diverse cultural groups of the re-gion, which were deliberately brought by the Habsburgs in Vienna to the region in the sixteenth and seventeenth centuries and resettled on the fertile farmlands of Burgenland, bear witness to the second. In the historical *longue durée* of the border region the two functions often overlapped, for the resettlements during the early modern period were calculated to place villages in the sparsely populated areas that lay to the south and east of the imperial capital, Vienna, forming a human shield against the Turkish Ottoman Empire in the wake of the fall of Buda in Hungary in 1541. In the seventeenth century, Europe's very essence was at stake, and Burgen-land was to be one of the last bastions of defense.

The villages and small cities of the sheva kehillot—even today, Eisenstadt, which formerly included the Jewish village of Asch and is currently the provincial capital,

has a population slightly larger than 12,000—attract relatively little attention from scholars of modern history. With the exception of Eisenstadt, the names of the sheva kehillot are unknown outside of Austria, though a few can claim favorite musical sons who once lived there: Franz Joseph Haydn and the family of Fred Astaire (Friedrich Austerlitz) in Eisenstadt, Karl Goldmark in Deutschkreuz, and Joseph Joachim in Kittsee. Franz Liszt and Gustav Pick, the latter the most famous composer of popular *Wienerlieder* (Viennese popular song) in fin-de-siècle Vienna (see chapter 7), also came from Burgenland villages, Liszt from Raiding along the Hungarian border, Pick, who was Jewish, from a non-Jewish village. Though increasingly difficult to recognize, there is still some physical evidence of the Jewish past in Burgenland: the synagogue of Kobersdorf; cemeteries rescued from the ravages of neglect; and streets and walls intended to bound the Jewish quarters of Jewish and non-Jewish villages. Jewish residents, survivors from the Holocaust era, are almost unknown; there are reputed to be three Jewish families still living in Burgenland, but no one knows who they are, and they do not identify themselves, even at remembrance ceremonies and concerts (for a statistical study of the disappearance of Jews from Burgenland, see Gold 1970).

The most ethnically diverse province in Austria, with modern ethnicity consciously historicizing the diverse musical life of the past, Burgenland witnesses almost no Jewish music today. It still has a higher percentage of Hungarians, Croats, Roma, and Protestants (from Saxony in Germany) than any other province in Austria. Ethnic diversity in Burgenland is official—Croatian and Hungarian are languages of instruction in many schools, and villages are often bilingual—and fully present in the public sphere. Multiculturalism has become the overwhelming marker of the ways in which the region's music is collected and performed (cf. Baumgartner, Müllner, and Münz 1989, and the CD *Burgenland* 1993). Jewish musical life, in contrast, effectively has no presence in the public sphere at the turn of the twenty-first century, even as Burgenland increasingly draws attention from the European Union and UNESCO as a regional site for staging festivals for European regions with mixed ethnicity. Burgenland's Jewish music has lent itself only rarely to historicism and revivalism (see, however, Winkler 2006).

In 1989, over 300 years after the victory of the Habsburgs and their allies at the siege of Vienna, it would again be Burgenland that played a key role as a boundary at the very center of Europe, for it was through Burgenland, in the very region of the sheva kehillot, that the first East Germans breached the Iron Curtain dividing Europe in the Cold War. My own ethnographic engagement with the Jewish music history of Burgenland also began in 1989, at precisely the moment the political borders running through the region were afforded new meaning. During the past nineteen years I have returned at least once a year, often several times and for periods of several days to several months, to research the music of Burgenland's Jewish villages. Together, however, my fieldwork and the *lieux de mémoire* (see Nora 1984–1992) have afforded me the chance only to gather a still incomplete picture of village musical life in Jewish Burgenland, a picture that nonetheless richly reveals the complex ways in which the Jewish music of the Burgenland paved the entry into modernity for Jewish village life at the center of Europe.

REMEMBERING THE MUSIC OF THE JEWISH
VILLAGE IN BURGENLAND

> Right in the middle of Deutsch-Kreuz there is a branch of
> the Leopoldstadt. Seventy Jewish families have lived for a
> thousand years in the ghetto of Deutsch-Kreuz. . . . [In his
> home the rabbi] sits at a long table, surrounded by all the
> boys in the community, Jewish kids from sixteen to twenty.
> They study the Talmud, quite chaotically, reading aloud in
> a monotonous sing-song that is occasionally interrupted by
> the screech of the button-box accordion of the tavern keeper
> across the street.
>
> —Joseph Roth, "Die Juden von Deutsch-Kreuz und
> die Schweh-Khilles" [1919], in Roth 2001: 203

"We always got along well with the Jews." "They were our neighbors, and we
never had any problems." "When they made music, we were there." "If we had
a dance, they were invited." "They were taken away so quickly, we had no idea
what was happening to them." Burgenlanders today have not entirely forgotten
their former Jewish neighbors and the Jewish village culture of Burgenland. Their
memory of Burgenland's Jewish past passes through various filters of remember-
ing and recollection. It is a memory, like many memories, that relies on fragments,
pieced together to give shape to the narratives that afford us a fuller understanding
of the past.

One of the most disturbing aspects of my initial encounters with current resi-
dents of Burgenland was that those recounting the Jewish past had memories that
stressed only the positive, as if Jewish village culture had enjoyed a golden age on
the eve of its destruction. Although I always attempted to retain my ethnographic
objectivity and tried not to intrude in the gathering of oral histories with questions
that might unnerve, I found it difficult to believe what I was hearing. Occasionally
I betrayed a bit of my own mistrust, or I jotted down a field note to remind myself
that I should later need to reinterpret a slightly tarnished, if golden past. I had no
idea how literally I might report this mistrust when writing about Jewish music in
Burgenland, but over the course of my many visits I increasingly realized that even
the boundaries between truth and fiction were contested by the memory of music
in the Jewish villages.

Contemporary Burgenlanders were not telling lies. They were not taking advan-
tage of trust they and I had established through my residence in the area, or even
my origins in Chicago, known affectionately as the "largest city of Burgenland"
because it is believed, probably correctly, that more Burgenlanders live in Chicago
than in Burgenland. Nor were the tales of contemporary Burgenlanders only half-
truths about good-neighborliness. Their memory of the Jewish past was positive; it
was also confused by the disjuncture and destruction that they had reformulated to
fit the memory they had constructed. Their memory of the Jewish past had always
been formed from a pastiche of understanding and misunderstanding. This too was
a quality of the fragmentary nature of remembering the villages in which Jewish
neighbors had once lived.

Boundaries were very significant in the Burgenlanders' accounts of the Jewish past. I came to realize this fact when I gradually began to gather accounts of Jewish burial practices and the rituals accompanying them. Older Burgenlanders still remembered the public aspects of Jewish funerals, processions they had witnessed and laments they had heard. Death and ritual practices that mark it have not disappeared from the remembering of the Jewish past. The recounting of funeral practices through narrative serves as a discursive connective between past and present— for example, in the published volumes containing the records left on grave markers (see, e.g., Wachstein 1926; Reiss 1995). Death figures into remembering the past in various ways. At the deepest level, there is the recognition that death in the Holocaust eventually greeted most of the Jews who were taken by transports from Burgenland.

At a surface level, it was the death of a single individual, a small girl in Burgenland, that led to a decision not to erase the final traces of Jewish culture during the Holocaust. I recall the story here because it so trenchantly combines the *lieux de mémoire* of both Jewish and non-Jewish narratives of the past. In order to demonstrate the power of the National Socialist regime in Vienna, a decision was made in 1941 to demolish all the synagogues of the sheva kehillot in a single day, one after the other, with crowds of residents gathered to witness the erasure of Jewish culture. Schoolchildren were marched to the sites of demolition, and when the sixth synagogue, that of Deutschkreuz, was blown up, a brick or stone struck a girl in the head, killing her instantly (a photo of the destroyed synagogue appears in Reiss 1997: 218). The Burgenlanders regarded this incident as sign that the synagogue demolitions were wrong, if not the implementation of some greater evil, and the seventh synagogue in Kobersdorf was spared. In the memories of others, however, this tale was contradicted by the claim that a synagogue in Kittsee was destroyed only after World War II; what remains unclear is whether another synagogue might have been destroyed during the war.

The presence of death in the Jewish past also presses on shared memory on an everyday level, through the insistent presence of Jewish cemeteries, which are everywhere in Burgenland. The ubiquity of Jewish cemeteries is all the more striking because the absence of family members to care for the graves also means that non-Jewish villagers, as a sign of respect, encounter the past as they care for the graves, although when there were still Jewish villagers, non-Jews never passed beyond the boundaries of cemeteries. They did not take part in or observe the rituals that occurred when the community turned to its own religious practices. Just as death had arrested the attention of the Burgenlanders, it allowed them to recall music-making and the musical practices they imagined to have taken place beyond the boundaries. I often recorded such stories: the singing and prayer of the cortège; the singing emanating from beyond the cemetery's walls; the community's care for the bereaved family sitting *shiva* (the traditional week of mourning) after the death or preparing for the *yahrzeit,* or anniversary, a year thereafter.

The fragments of Burgenland's remembered Jewish past are not all the same, and it was the realization of this fact that led me to reevaluate the completeness of the narratives recounted to me. Shifting boundaries have ceaselessly charted the landscapes of memory across which Burgenland's historical past stretches. The

province's cultural geography is less a product of what was or what is than of a constant process of realigning borderlines to separate one political entity from another. The people of Burgenland have themselves seldom been that political entity, but rather have physically constituted the boundaries that serve as the shifting cartographic traces of the past (cf. the essays in Baumgartner, Müllner, and Münz 1989). It was the aggressive settlement policy that first peopled the village culture of Burgenland with difference and otherness. The opening up of the border region by the Habsburgs was particularly attractive to Jews, who had lived in some of the villages, such as Mattersburg, since the late Middle Ages, and who began moving in large numbers to the capital city of Burgenland, Ödenburg (today Sopron). Their favorable treatment in the center of Habsburg power, however, would end in 1683, immediately after the defeat of the Ottoman armies at Vienna. Expelled from Ödenburg, Burgenland's Jews received safe haven in the ring of villages around the city, most of which were under the control of the Hungarian Esterházy family (see Ernst 1987: 233–37).

The shifting boundaries of Burgenland's historical landscape are not unique in Europe, and for the Jewish regions of Europe in which Jewish culture predominated they were relatively characteristic (Applebaum 1994; Wischenbart 1992). "Jewish Europe" has never had fixed boundaries. The location of Jewish communities in Europe has always been that of a region "beyond the boundaries" (Gruber 1992), where the lives of individuals and communities are less the product of regionalism or nationalism than of in-betweenness (Bhabha 1994: 1–9 and passim). We know the names of the regions beyond the boundaries, whose populations have historically been multicultural, but it is almost impossible to locate those regions on the maps of modernity: Burgenland, Galicia, Pannonia, Alsace, the Bukovina (see Applebaum 1994). These are just a few of the regions that lie beyond national borders and outside nationalist histories (see, e.g., Deutsch and Pietsch 1990 and Noll 1991 for studies of the ways music has articulated such histories).

Burgenland represents the many different ethnographic conditions and musical practices that connect the present to the past (Dreo, Burian, and Gmasz 1988, and *Burgenland* 1993). As a *lieu de mémoire,* a site of Jewish history, Burgenland is a place to investigate Jewish music in rural Europe, a region more like than unlike Galicia or Alsace (cf. Baselgia 1993, Bohlman 1993, Dohrn 1991, Stauben 1986 [1860]). Burgenland is a border region, defined not so much by a defined identity as by the processes of change that meant that identity must always be negotiated (see Baumgartner, Müllner, and Münz 1989; for a description of a non-Jewish musician engaged in the negotiation of Burgenlander identity, see Reiterits 1988). There was never a single Jewish identity in Burgenland, and Jewish village culture never lent itself to being neatly circumscribed. The issue examined here, then, is not "finding Jewish identity" but finding the conditions that negated Jewish identity (Gold 1970, Klampfer 1966, Spitzer 1995). To imagine Burgenland's past as a world split between Jews and others might render the region comparable to an ethnic mosaic, with distinctive parts, but it would violate the historical dynamic that resulted from the constantly shifting boundaries between Burgenland's past and present.

LIEUX DE MÉMOIRES AND MOMENTS
MUSICAUX IN MATTERSBURG

1. Ans is 's Chassenehaus	1. "One" is for the groom's house
Wu me esst, wu me trinkt	Where one eats and drinks
Wu me geht ein ün aus	Where one comes and goes
Wu me tanzt, wu me springt	Where one dances, where one jumps,
Wu me lacht, mu me singt,	Where one laughs, where one sings,
Wu ma soch kehrt	Where everything's upside-down
Vün Tisch bis of de Erd'.	From the table to the ground.

Countless paths lead to Mattersburg—historical, ethnographic, musical. When I first visited the former Jewish village, by the end of the twentieth century a rather large town that exported goods, services, and laborers to nearby Eisenstadt and to not-so-nearby Vienna, I already realized that I was not the first to take an interest in the Jewish past and its music. During the long course of Jewish presence in Burgenland, Mattersburg (previously Mattersdorf and in Hungarian, Nagy-Marton) sustained perhaps the most visible history of all the sheva kehillot. As I searched for visible traces of the Jewish past, I knew already that I should find them only in a few sites that were set to the side, preserved almost as a snapshot. It was no longer possible simply to start at the edge of town, where one would have expected to find the cemetery. At the time of the Holocaust, local administrators took pains to destroy the grave markers, to smash them so that any and all could walk across them and thereby crush the past. No other traces remained—no synagogue, no renovation of the former yeshiva (religious school for Jewish boys), not even modern monuments to remember the destruction of one of the most important villages in the rural Jewish heartland of Europe.

I was hardly the first to visit Mattersburg in search of its folk music, none of which survived by the end of the twentieth century. At the beginning of the century Mattersburg had been one of the most intensively studied of all the sheva kehillot, not least in the ethnographic and folkloristic studies of Max Grunwald, the nestor of modern Jewish folklore studies, who published a monograph about the village in 1924/1925. Grunwald, a rabbi formerly of Hamburg, founded the Society for Jewish Folklore in the late nineteenth century before moving to Vienna and relocating the center of his professional folkloristic enterprise. Initiating new research projects in Jewish folklore, Grunwald focused his attention on Mattersburg as one of the most emblematic Jewish villages (for detailed evaluations of Grunwald's contributions to the modern study of Jewish folklore see Daxelmüller 1986a; Daxelmüller 1987; Daxelmüller 1994/1995). His monograph, *Mattersdorf*, gathers a remarkable range of folkloristic documentation. In the Jewish Mattersburg he encountered, centers and peripheries turned in and out upon each other, so much so that it was entirely possible to identify where the Jewish and the non-Jewish really began (see Figure 1.2).

Grunwald approached Mattersburg to uncover and then to write a thick description of the village, an ethnography comprising every type of archeological, folklor-

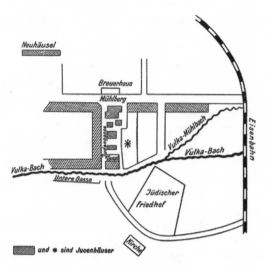

FIGURE 1.2 Map of the Jewish Quarter of Mattersburg in the 1920s. (Source: Grunwald 1924/1925: 413) The shaded areas mark streets with Jewish homes; the Jewish cemetery faces the village church at the southern edge of the village.

istic, theological, and musical evidence he could muster. The very thickness of the ethnographic record would document its complex history and folklore as a Jewish village. Almost 200 pieces of evidence were assembled, ranging from folk sayings in local dialect to songs from sacred and secular settings to extended sections from plays in oral tradition. The ethnographic record allowed Grunwald to document the first appearance of a substantial Jewish community, which was in 1353. The six-century history of the village would be one of constant ebb and flow. There were moments when Jews found the village hospitable, other moments when a change of regime in Vienna, Budapest, or elsewhere would cause many of them to resettle. There were periods when Hungarian influences dominated and other periods when German served as the vernacular. The ethnographer's thick description published by Max Grunwald could not be more varied, which is to say, it could not reveal a more consistently complex historical mixture born of both Jewish and non-Jewish fragments.

Grunwald's gathering of fragments speaks eloquently for a culture of diversity and contradictions. The anthology of Jewish folk songs from early twentieth-century Mattersdorf that he published reveals the extraordinary degree to which musical themes and motifs moved across genres, spurring change just as they provided a common culture of Jewishness. Change rendered Mattersdorf's Jewish folk music at once indigenous and hybrid. Variants and variation were extensive, and local dialects dovetailed with influences from print culture and the constellation of languages within and outside the Jewish community—German and Hungarian, Hebrew and mixtures of Burgenlander and Yiddish dialects.

Most significant, however, is the remarkable degree to which songs from outside Mattersdorf and the sheva kehillot entered the local repertory, documenting the extensive movement of individuals and communities in the heartland of European Jewish village culture. Some songs claim provenance in Mattersdorf itself, though they

are variants of songs in the core repertory of Ashkenazic folk song (see Bohlman and Holzapfel 2001). Other songs acknowledge that they entered the Mattersdorf repertory with immigrants to the village. The Jewish communities in both Szerdahely (Hungary) and Tirnau (Trnva in modern Slovakia) contributed songs to the village music culture, the latter locale documenting extensive channels of contact with the most important center of religious education in western Slovakia. Some songs were traditional, among the most notable being several variants of lullabies and Sabbath songs. Others were contemporary and popular, documents of a Jewish engagement with European modernity, such as "Aj wej, aj wej wa ma schreie," a response to the service of Jews in World War I (see Figure 1.3). The songs form the fabric of a music culture that stretches from the home across schools and synagogues into the streets with the calls of the *Schulklopfer*, who was responsible for ringing a bell or knocking on doors to call community members to the synagogue (Yiddish: *shul*) for worship, and into the taverns and other establishments for public entertainment.

In ways distinctive of the Jewish village, the musical life of Mattersdorf was cosmopolitan. The historical picture that comes into focus from Max Grunwald's anthology of folk song belies any assumption that the Jewish village or the rural areas of Jewish Europe were isolated. Songs underwent variation because of ongoing exchange. Mattersdorf was indeed connected to the rest of the world, and its musical repertory represents, if indeed it does not also symbolize, the music of the Jewish village—in the sheva kehillot, in the border regions between Central and East Central Europe, and across the rural landscapes of Ashkenaz.

THE CENTER AND ITS BORDERS

The synagogue of Kobersdorf, one of the smallest of the Seven Holy Cities of Burgenland, stood empty in 1990 when I first entered it. Directly across the open space of the wide street surrounding the small but newly refurbished castle of the former Esterházy residents of Kobersdorf, the synagogue was plainly visible to the tourists who came to Kobersdorf during the summer to see the outdoor theater productions in the castle courtyard. The summer productions were a new idea, welcomed and eagerly supported by local boosterism, to bring added revenue and recognition to this village of several thousand souls, only a dozen kilometers from the border with Hungary, which had been opened only a year before, in July 1989. Like most villages along the Austrian-Hungarian border, Kobersdorf seized the opportunity to reestablish cultural connections long severed by political borders that made little cultural sense at Europe's multicultural heartland.

Most of those attending the summer festival productions in the Kobersdorf castle courtyard in 1990 were unaware that an abandoned synagogue stood in that village. Although it fronted the broad street, the façade of the synagogue had stood without care since it had been spared from destruction during the Holocaust by local superstition (see above). There was no entrance from the street—traditionally no entrance because it was at this end that the bima, the pulpit and location of the Torah scrolls, stood. Facing these, worshipers were turned toward the east (*mizrakh*) and Jerusalem, but more immediately toward the Esterházy castle and the Hungarian border.

141. Die neue Zeit mit ihren ungewohnten Forderungen (in der Folge, besonders durch die Leistungen der Juden im Weltkrieg, gegenstandslos geworden):

Melodie aufgezeichnet von demselben.

Triste-forte.

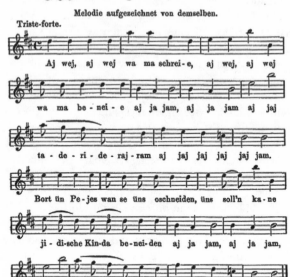

Aj wej, aj wej wa ma schrei- e, aj wej, aj wej

wa ma be - nei - e aj ja jam, aj ja jam aj jaj

ta - de - ri - de - raj - ram aj jaj jaj jaj jaj jam.

Bort ün Pe - jes wan se üns oschneiden, üns soll'n ka - ne

ji - di-sche Kin-da be-nei-den aj ja jam, aj ja jam,

aj jaj ta - de - ri - de - raj - ram aj jaj jaj jaj jaj jam.

a) Oi weh, oi weh wo[ll]n mir schreien
 Oi weh, oi weh won mir beneien.

b) Boart ün Pejes won se üns obschneiden,
 Üns solln keine jidische Kinder beneiden.

c) Groiße Zores [Leiden] won mo hobn,
 Wenn mo won müssen den Tschako trogn.

d) Doichek [Druck] leiden un nit zü essn,
 An der liebn Thoire wom mo ganz vergessn.

e) Herts moch o, meine liebn Menschn,
 Mir won trefe essen ün won nit kenne benschen.

f) Weine ün schreien ün jammern ün klogn,
 Wenn mo won müssn es Gewehr om Puckl trogn.

g) Sicher ün besser in der Erd zü sein,
 Als beim Malches in der Wach zü stehn.

h) Chasonem, Rabonem won mo nix hern,
 Schabbes ün Jomtof won se üns zerstern.

i) Toite Owes solln für uns lafn,
 Daß mo üns solln kenne for Geld auskafn.

k) Jammer ün Klogn, Weinen ün Schreien,
 Mistome is es e Gesere min Haschomajim.

l) Koach ün Kraft soll Schem jisborach gebn,
 Daß mir solln kenne in der Milchome leben.

m) Loßt's üns noch e bissele leben,
 Es is noch Zeit üns in de Kasern zu geben.

n) Menüche w'simche (Ruhe und Freude) won sich andere Jünges schaffen,
 Ün mir won üns müsn mit'n Feind erümhakken.

(Fortsetzung fehlt.) Mitg. v. Feiwel Grossmann.

FIGURE 1.3 "Aj wej, aj wej wa ma schreie"/"We Cry, Oy Vey." (Source: Example 141 in Grunwald 1924/1925: 468–69)

English Translation

141. The new era, with its extraordinary demands (above all in the wake of the world war, to which the Jews contributed without limitations):

[Song with melody]

(a) Oy vey, oy vey, we want to scream,
 Oy vey, oy vey, what's demanded of me.

(b) They shave off our beards and our sidelocks,
 No Jewish children should be jealous of us.

(c) They get their share of pain from us,
 When we have to wear a uniform.

(d) There's pressure on us not to eat,
 And we mustn't totally forget the dear Torah.

(e) Listen carefully, my dear friends,
 We have to eat treif and know nothing of kosher.

(f) Weeping and wailing, moaning and groaning,
 If we don't want to bear a weapon on our backs.

(g) Surely there're better places in the world to be,
 Than standing on guard in the army.

(h) There's no chance to hear a cantor or a rabbi,
 The Sabbath and holidays just pass us buy.

(i) We should a bit of time for fun,
 But then there's no money go make it happen.

(k) Moaning and groaning, weeping and wailing,
 Life's got more than its share of miseries.

(l) Courage and strength should give us our way,
 So that none of us ends up giving up our lives.

(m) Let us live a little longer,
 Let's linger a little longer in the barracks.

(n) Let's work for quiet and peace from the other guys,
 So that we'll be able to have it out with the enemy.

(There is no continuation of the song) Provided by Feiwel Grossmann.

FIGURE 1.3 (continued).

With Manfred Fuchs, the mayor of Kobersdorf but by profession a music teacher and choral director, I fought my way through the tangle of weeds and brush that guarded the synagogue's front door on the west side. Fuchs had brought the keys, but, to his surprise, there was no need to use them; the door was unlocked. Inside, the sanctuary was silent; not even roosting pigeons disturbed the silence. Fuchs and I had entered a temporal space of in-betweenness and a sacred space of emptiness, during which time the synagogue had remained mute since last serving a Jewish community 52 years prior. The synagogue's silence remembered those 52 years, a period during which no one knew what to do with the synagogue of a Jewish village devoid of Jewish villagers.

Questions of ownership had not been answered. The Jewish *Kultusgemeinde* in Vienna (the official administrative body for the Austrian Jewish community) simply did not know what to do with the building, or with the other spaces of Kobersdorf's Jewish community left silent by the Holocaust. Manfred Fuchs, together with his village counsel, had developed a concept for the synagogue, which would turn it into a concert space for the performance of Jewish music. As such, the synagogue might serve the memory of the Jewish past and the civic pride of the non-Jewish present. The acoustics in the synagogue were astoundingly good, though the sanctuary was entirely devoid of pews and human occupants, who might otherwise inflect and distort the acoustically live surfaces of plaster and wood. As a concert hall, not least in conjunction with the summer theater festival, the synagogue would serve to reinstate traces of the Jewish past.

The Viennese Kultusgemeinde had made Kobersdorf aware that the synagogue sanctuary was still sacred, and to use it as a concert hall would mean desacralizing the space. Only the official rabbinate of Austria could do this, but communications from Vienna indicated that there was no simple solution for undertaking an official desacralization. Additionally, a rabbinical official from Israel would have to come to Kobersdorf, and it was not clear whether the synagogue should be stripped of its sacredness anyway. The Kobersdorf synagogue stood, its space silent, not yielding its memories or the music of a Jewish village that once filled it. The synagogue remained a space inhabited by the past.

The Jewish musical past in Kobersdorf resided in many of the town's spaces, and it was a growing sense of these spaces, which I explored during my first years of fieldwork in Burgenland, that gradually allowed me to perceive something of the Jewish music that once filled them. The Jewish spaces of Kobersdorf assumed modern proportions during the eighteenth century when the town's Jewish population grew to almost 50 percent of the total. Kobersdorf was also one of the Burgenland villages that had a large population of Protestants, about half of all the Christians living there, and the village was divided lengthwise on the two sides of the main street into Protestant and Catholic sectors. The Hungarian castle was the major political and cultural landmark of the town. One other political boundary parsed the village landscape in the eighteenth and nineteenth centuries, until the dissolution of West Hungary after World War I, namely the border between Hungary and Austria—the internal imperial border of the Habsburg Empire. In 1921, when Kobersdorf was absorbed by Austria, that border lost its imperial importance, but it continued to possess significance for Jewish ritual practices in the village.

The diverse cultural, political, and religious spaces of the Jewish village created remarkably complex musical spaces. The fact that religious institutions embodied spaces in which different sacred musical practices were maintained at once confirmed and enhanced the function of political borders. Village residents, even through interviews in the closing decade of the twentieth century, remembered musical practices that took place in the village spaces, and particularly in the movement between the spaces. The Schulklopfer, for example, had walked the streets of Kobersdorf, calling Jewish residents to prayer and mustering the children for religious instruction.

Secular musical practices were also mobile and dependent on the fluid nature of Kobersdorf's village landscape. On the same street that separated the synagogue from

the castle, and only a few buildings south of the synagogue, was a building standing at the intersection of the road to the former Austrian-Hungarian border and the main street flanked by Protestant and Catholic sectors. The building epitomized the spatial confluence of Burgenland's history, for it had housed the Jewish tavern, a secular space necessary for the maintenance of Jewish identity in a multicultural society. It had provided kosher meals, overnight accommodations for travelers moving between the different parts of the empire, and a space for public music-making.

Kobersdorfers at the end of the twentieth century remembered many of these moments of Jewish music-making, particularly because many had participated in them. It was in the Jewish tavern that they joined in the everyday Jewish musical life of the village. They participated not as Jews, but as Kobersdorfers and as Burgenlanders. The musical life that animated the tavern was not just Jewish, but Kobersdorfer and Burgenlander. Different dance bands played there, and active exchanges of musical repertory and style were facilitated by the public nature of the tavern's intersection with the village's fluid spaces. The celebrations following Jewish weddings took place in the Jewish tavern, but Jewish musicians alone did not play at these; Rom bands from the area also performed. There was no irony in this circumstance, for Jewish bands played at Rom weddings. Jewish musicians also played at Christian celebrations and with Christian and Rom musicians. The many intersecting borders of Kobersdorf served to connect, not separate, the different subcommunities in the multicultural village between empires.

The most important and publicly visible ensemble in Kobersdorf was the Kobersdorfer Salonorchester, an ensemble that toured widely throughout western Hungary and eastern Austria (see Figure 1.4). The "salon orchestra" was the pride of Kobersdorf, and its members were mostly Jewish—entirely Jewish in the collective memory of villagers at the end of the twentieth century. As a musical ensemble the Salonorchester extended the public spaces of Kobersdorf to the many places it

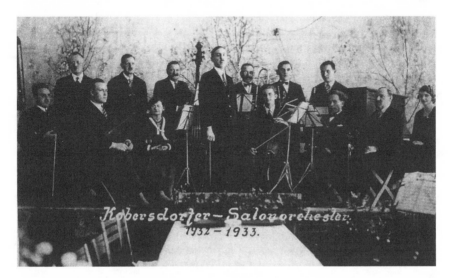

FIGURE 1.4 The Kobersdorfer Salonorchester, 1932–1933. (Photograph courtesy of Karl Pogatscher, Director, Heimatsmuseum of Kobersdorf)

played. The mix of musicians and the complex cultural conditions of music-making in the Jewish and multicultural village were reconfigured at each performance. The Salonorchester's repertories were Jewish and they were not. Like other professional and semiprofessional musicians from Jewish Burgenland (cf. Maurus Knapp in this chapter), the Salonorchester adapted its performances to the occasions on which it

1. Es war ein-mal ei-ne Jü- din, ei-ne wun-der-schö- ne Frau. _ Die

hat- te ei- ne Toch- ter, zum To- de war sie _ be- reit. _ Die reit. _

1. Es war einmal eine Jüdin, eine wunderschone Frau. ‖: Die hatte eine Tochter, zum Tode war sie bereit. :‖	Once there was a Jewish woman, A wonderful woman. ‖: She had a daughter, Who was ready to die. :‖
2. "Ach Mutter, liebste Mutter, mir tuat mei Kopf so weh. ‖: Laß mich nur eine Weile am See spazieren gehn." :‖	"Oh mother, dearest mother, I have such a headache. ‖: Let me only for a while Go for a walk by the sea." :‖
3. Die Mutter geht zum Beten, der Vater tut den so Gang. ‖: Die Tochter eilt zum See, wo sie den Fischer fand. :‖	The mother went to pray, The father took a walk. ‖: The daughter hurried to the sea. Where she found a fisherman. :‖
4. "Ach, Mädchen, liebstes Mädchen, warum denn so allein?" ‖: "Ich suche einen Prinzen, der gestern ertrunken soll sein." :‖	"Oh, young woman, dearest girl, Why then all alone?" ‖: "I'm looking for a prince, Who may have drowned yesterday." :‖
5. Sie nahm vom Hals ihre Kette und gabs dem Fischer hin: ‖: "Nimm hin, du armer Fischer, und kauf deinen Kindern Brot." :‖	She took a chain from her throat And gave it to the fisherman: ‖: "Take it, you poor fisherman, And buy bread for your children." :‖
6. Sie nahm den Ring vom Finger und sagte leis und weint: ‖: "Nimm hin, du guter Fischer, das soll dein Andenken sein." :‖	She took a ring from her finger And quitely spoke and wept: ‖: "Take it, you good fisherman, That should be a token of memory." :‖
7. Mit ausgebreiten Armen stürzt sie in See hinein: ‖: "Ade, du, gute Mutter, du strenger Vater, ade!" :‖	With outstretched arms She fell into the sea: ‖: "Farewell, you good mother, You strict father, farewell!" :‖

FIGURE 1.5 "Die Jüdin"/"The Jewish Woman"—Sung by the Deutschkreuzer Frauen. (Source: Bohlman and Holzapfel 2001: 19–20)

played. Jewish music, like Hungarian dance music or Austrian operetta overtures, might be appropriate or might not. Close to home, and in the other Jewish villages of Burgenland, Jewish entertainment repertories were among those most frequently requested.

At the time that I sought to understand the Jewish musical past of Kobersdorf, in the 1990s, the Jewish tavern was silent. It had been a private home for many years. Rom musicians, crucial to Burgenland musical life at the turn of the twentieth century, were nonetheless infrequent performers in the village. Local wind ensembles and choral groups performed in public, but their repertories were regional and national. The spaces in which Jewish villagers had made music, however, were still there, and it was these spaces that gradually provided me with a means of making Jewish musical life audible again. The Jewish cemetery, virtually untouched except for the sporadic annual mowing, remained open as a space to

FIGURE 1.6 Three Compositions by Maurus Knapp in His Notebooks for April 12–26, 1987 (opening page). (Courtesy of Alexander Knapp, London)

enter; its entrance house, with ritual materials used in caring for the deceased left where they were, exactly like the synagogue, provided me with a transitional space at the edge of town through which I could symbolically enter the past.

The silence I first heard in the Kobersdorf synagogue was everywhere in the village, but everywhere it was different. I entered the spaces of rural Jewish history, and gradually the ways in which music filled them became evident to me. When they joined me in these spaces of the Jewish past, Kobersdorfers of the present remembered them again and returned to them—to dances, to weddings, to concerts of the Salonorchester—and they experienced their village as Jewish again. Crossing the borders into and entering the spaces that had once been filled with Jewish music, the Kobersdorfers of today and I were drawn closer to a Jewish village music that had been silent for half a century.

MUSIC AND THE NARRATIVES OF MODERNITY
AT THE END OF BURGENLAND'S JEWISH HISTORY

> This type of occasion [in the festival hall of the Esterházy
> palace], partly artistic, partly a gathering of socialites, became
> Nagy's image of the backdrop for the debut performance of the
> young pianist, who was virtually a child prodigy. Such a taste-
> ful yet effective opportunity to appear this way in public would
> never come round a second time. He took it upon himself to
> speak to Prince Esterházy and to pave the way.
> —Franz Werfel, *Cella oder der Überwinder,* p. 24

Three images of modern Jewish music-making open the closing section of this chapter, all three of them draw us to the boundaries that converge to form the final chapters of Jewish music history in the sheva kehillot. The three images focus our attention on Jewish musicians in Burgenland, who at first glance would seem to have little to do with each other, but after more reflection exhibit distinctive affinities in the imagination of modern Jewish music. The musical genres that the transcription of "Die Jüdin" from oral tradition (Figure 1.5), the notebook of a Jewish violinist (Figure 1.6), and the eponymous figure in Franz Werfel's novel fragment about the Eisenstadt-born pianist Cella could not be less similar: a folk ballad; popular tunes played for dances in the 1930s and written down by the composer in the 1980s; the classical repertory shaped by and for the Esterházy court in Burgenland's capital city. The degrees of Jewishness too have little in common. Only "Die Jüdin" circulated widely in Jewish communities, though not exclusively, and the repertory Cella's teacher would choose for her debut performance would surely not have included Jewish works.

The differences among these musical epigraphs notwithstanding, there are some striking similarities about the ways they narrate Jewish music history in the Burgenland. First, all three illustrate the prevalence of musics that entered Burgenland's Jewish villages from elsewhere. Though a folk song that had entered even non-Jewish oral tradition in Deutschkreutz, "Die Jüdin" circulated in ballad repertories stretching across Europe. The only thing local about it was the fact of its survival

in a formerly Jewish village in which no Jews had lived for half a century. Maurus Knapp took down his notebooks, admitting full well that they contained the entertainment music that he preferred to play at social occasions in Vienna. Cella's teacher is pushing her toward a career that the Esterházy family will nurture if all goes as expected.

Intensifying the commonness of these contexts is yet another fact, namely that the power of the three figures in these musical aphorisms has been almost entirely fictional. Poised musically at the boundaries interrupted by the very end of Jewish history in Burgenland, they represent the extension of those boundaries beyond the Holocaust through myt Ethnomusicologists and Jewish-music scholars celebrate the version of "Die Jüdin" sung by a typically Burgenland ensemble of three women as a surviving trace of Jewish village music. Perhaps no one is more culpable in this regard than I, even though I also know more about the pan-European distribution of "Die Jüdin" than perhaps any other scholar (Bohlman 1992). Maurus Knapp has been shoved to center stage in the mythology of the klezmer revival that began in the 1970s and has accelerated until the present. He plays second violin in the several photographs of "Jewish klezmer musicians playing for a wedding" that now adorn countless CDs and picture books about klezmer (see, e.g., Winkler 2006); and once again, Maurus Knapp appears iconically on the cover of one my own books (Bohlman 2005a). In reality, however, Knapp and his band were not playing klezmer music in the photograph, and they probably never played anything that sounded like klezmer music in the revival that has appropriated them. Cella, finally, is a character in a novel fragment. Franz Werfel, in fact, never finished her story, but left it, at the time of his death, as a narrative fragment about fragmentary narratives in the Jewish village.

The more musical and narrative fragments that surface through modern memorywork realize the musical past of Burgenland's Jewish villages, the more the weakness of the historical record undergoes a transformation into the strength of the mythical imagination. The genealogy from the Jewish villages accumulates new Jewish musicians with some regularity. The details of Joseph Joachim's childhood in the sheva kehillot—he was born in Kittsee—are enhanced by the pictures of the home in which he presumably entered the world of Jewish village life. The historical plaque on the building notwithstanding (see the photo in Reiss 1997: 112), oral tradition from the family of Maurus Knapp (Alexander Knapp, personal communication) identifies a different birth house, the same one in which the erroneous klezmer musician was born.

In a similar process of joining history and myth, the formerly Jewish village of Lackenbach lays claim to a partial lineage of world-famous cantors. One of the modern purveyors of the Viennese Rite (see chapter 4), Cantor Mordechai Baruch Taube (born 1914), traces his own cantorial patrilineage to Lackenbach, in whose synagogue his father served as ḥazzan. The traces of sacred musical traditions are by no means absent from the surviving evidence. Indeed, it was in Kittsee that a school of *haggada* (the traditional text containing the ritual texts for the Passover seder) illustration thrived well into the modern era. One of the most richly illustrated *haggadot* (pl.) has acquired fame in reproductions as the *Kittsee Haggada,* which, though reprinted in Israel, is available in bookshops in Vienna and Burgenland.

The fragments of myth also accumulate from popular music and popular culture. To what extent is it entirely fair to claim Gustav Pick (see chapter 7) as a Burgenlander? I do, though any associations of hit songs such as "The Viennese Coachman's Song" with Burgenland stretch the imagination, if not going beyond the limits of veracity. The Fred Astaire myth, in contrast, has far exceeded veracity. Contemporary Burgenlanders are wont to claim the star of stage and screen as one of their own, though it turns out that his own immediate family came not from Eisenstadt but rather from the Czech lands. The fact that other Austerlitz families did live in the sheva kehillot, nonetheless, is a matter of historical record. Whether the house I visited in Lackenbach only days before its destruction had previously been home to the uncle of Fred Astaire—or of another Friedrich Austerlitz—as claimed by the local town historian when the two of us visited the site of Jewish memory in July 1990, may never be verified. As a towering figure of cosmopolitan popular music, whose international career stretched across the aporia opened at the end of Jewish music history in Burgenland, Fred Astaire has assumed an unassailable role.

Even at the boundaries between the past and the present, with early modern, modern, and postmodern slippage between myth and history, music enters the Jewish village, scarcely impeded by the rules and regulations about what is or should be Jewish music. The fragments that we now assemble realize a richer historical record and reveal a Jewish village culture in which music was everywhere. If the Jewishness of village music constantly underwent processes of negotiation and change, if Jews and non-Jews made Jewish music and non-Jewish music together, and if myth consorted with history to draw Jewish music from the edge of town to the central square, with its dance hall, tavern, and synagogue, the music of the Jewish village was no less Jewish for all its contradictions and richness.

THE PEOPLE WITHOUT MUSIC HISTORY: REDISCOVERING JEWISH MUSIC IN THE MEDITERRANEAN

ON THE EVE OF REDISCOVERY

> The thing that leaves the most unforgettable impression on the
> traveler upon first setting foot in North Africa is not simply the
> Oriental color, with all its foreignness and variety, which sur-
> rounds one after such a relatively short journey by ship—a day
> and a half from Marseilles, only a few hours from Sicily—but
> rather it is the sudden realization that one is placed back in sur-
> roundings some 700 years old, that is into the Middle Ages.
> —Lachmann 1974: 11

With a rhetorical gesture of unabashed orientalism, the German Jewish ethnomusi-
cologist Robert Lachmann (1892–1939) set the stage for his first field study of "music
in the folklife of North Africa" (Lachmann 1974). By profession the music librarian
of the Berlin State Library, Lachmann had also written widely about non-Western
music and the music of Antiquity (cf. Lachmann 1929). In 1932 he had his first
chance to journey to the Mediterranean to hear the music about which he had been
writing. It was, after many years, his chance to encounter that music firsthand.

The wonder with which he contextualized his past and the reader's future ar-
rival in North Africa arose from the journey itself, a journey that crossed time
just as it traversed the Mediterranean. The world he would discover as a modern
comparative musicologist and time traveler, which would become unforgettable for
the fellow time travelers he addressed, lay outside of history; it had never changed.
Lachmann provided the reader/time traveler only with approximate coordinates in
this passage. Perhaps he did mean to specify 700 years, but his further descriptions
revealed that this was but a familiar historical threshold, a historical handle roughly
equivalent to the European Middle Ages. He stopped short of telling the reader
where he, she, or we would be landing in North Africa. Though the point of dis-
embarkation in the timeless world was probably Tunisia, where he himself had done
intensive fieldwork, he also described his field of study as containing "northwestern
Africa" (Lachmann 1974: 11; for a comprehensive study of Lachmann's immigra-
tion to Jerusalem see Katz 2003).

Lachmann pursued two research goals in his North African fieldwork. First, he collected and studied the music of Jewish communities on Djerba, a Mediterranean island off the coast of Tunisia (Lachmann 1974 [1940]). Second, he endeavored to write a musical ethnography, more or less with the methods of early twentieth-century musical folkloristics, of the distinctive music cultures of North Africa. Illustrating the folk culture to which the title of his posthumous essays refer are photographs, few of which specify place or ethnographic details (Lachmann 1976: 31–43). Time, place, and music form into a past that becomes imaginable only upon one's journeying across the Mediterranean.

The wonder and discovery that we encounter in Robert Lachmann's journey across the Mediterranean have a familiar ring for modern ethnomusicologists. After all, when we embark upon a field study, we also set out on a journey. We would not do so had we "discovered" all that we needed to know about the music and musical practices of a particular place. Wonder and discovery are themselves tropes that appear in the earliest historical descriptions of non-Western music. We find them in the titles of nineteenth-century works, such as Carl Engel's *The Music of the Most Ancient Nations, . . . with Special Reference to Discoveries in Western Asia and in Egypt* (1864). Discovery had two meanings, of course, one for the traveler, the other for the scholar, though in practice these were inseparable.

Discovery has been an abiding theme in Jewish music historiography, above all because of its hold on the possibility that authenticity could be unearthed and the past revealed through music. The journeys of Jewish travelers, sacred or secular, to Jewish communities in the diaspora or in the East (see chapter 3) afforded the opportunity to discover the past (Bohlman and Davis 2007). Similarly, the pursuit of wonder has historically led ethnographers of all types and disciplines to the field in search of a past that was glorious for all its timelessness. In the pursuit of precolonial worlds the tropes of wonder and discovery have interacted to shape Stephen Greenblatt's concept of "marvelous possession," with which he describes the humanistic and political motivations of the Age of Discovery (Greenblatt 1991). For comparative musicologists such as Lachmann, discovery was further important because it meant encountering music as it always already was, for it was in that form that one could record it, retrieve it from the field, analyze it, and possess it. One could journey to and from the point of discovery; one could journey into timelessness and back again.

By the time Lachmann had reached the coast of North Africa, the culture of the Mediterranean had long served as the *locus classicus* for European scholars searching for discoveries in time immemorial. This practice was not only a matter of convenience; indeed, the Mediterranean—its world and universe—were historically imagined and reimagined as timeless. The construction of the West, that is the Occident, with its Judeo-Christian underpinnings, had likewise resulted from the positioning of Europe at a historical and geographic distance from the Eastern Mediterranean, the beginnings of a history for which Europe was the end point and telos. From its beginnings, European music historiography picked up on this contrast and mapped the teleology of musical change itself on the Mediterranean (see Bohlman 1987).

In the modern histories imagined by folk-music collectors and comparative musicologists, and more recently by ethnomusicologists and musical anthropologists, the construction of the Mediterranean as timeless has itself become historiographically

timeless. The timeless quality sustaining the music of the past, moreover, has been particularly crucial for the imagination of what Jewish music was. Authentic Jewish music—not only in practice but also in the metaphysics implicit in the label "Jewish music"—was itself timeless. It had accompanied Jews in the diaspora only in corrupted form, which is to say, historically altered forms necessary for adaptation. Johannes Fabian has trenchantly observed that ethnographers collapse time in order to "make their objects" and to locate in that object the places and time occupied by the other (1982). For the observers of Jewish music, the aura of otherness may be different because it is less easily extricable from selfness, but it is nonetheless a primary motivation for traveling beyond the threshold of history to discover and gather Jewish music. The modernity of Jewish music depends on this timelessness and on the reimagination of Jewish history itself as divided between two eras, one without and the other with history, one ancient and the other modern. Reimagined as timeless, the Jewish music of the people without history came to reside, above all, in the landscapes of diaspora stretching eastward across the Mediterranean.

THE TIMELESSNESS OF MUSIC'S PASTS

It is the imagined unity of the Mediterranean that transforms it into an atemporal world, in which the past has survived unchanged. This timeless quality has been one of the most powerful themes through which the Western historical imagination symbolized the Mediterranean. We witness the theme acted out in the lives of northern Europeans who turn to the Mediterranean to seek out the classical past, among them Lord Byron, Hector Berlioz, and Franz Liszt. The function of "classicism" in the European teleology of music history—the prehistory of a world that survives in the imagination to be recuperated in the present—exemplifies the notions of history that early modern Europeans constructed as an alternative to Mediterranean timelessness. Classicism epitomized the need to journey through time in order to rediscover a temporal otherness. Musical scholars effectively constructed many different ways in which these tropes would distinguish the music of self from that of other. In the European comparative musicology (*vergleichende Musikwissenschaft*) embraced by the work of Robert Lachmann, for example, "Altertum" or "Antike" (both glossed as Antiquity) and "Orient" were virtually synonymous, and for the most part they coupled the chronotope of the two concepts in describing, say, Arabic music in Egypt or Jewish music in Palestine. Robert Lachmann's works, as well as the research of his fellow comparative musicologists, frequently presumed this relation (e.g., Lachmann 1929). Notably, Curt Sachs, one of the most influential of twentieth-century ethnomusicologists, examined the intersections between the musics of Antiquity and those of non-Western cultures (e.g., Sachs 1924).

Modern ethnomusicology and Jewish music studies too have imagined the Mediterranean as a world with the qualities of otherness. Contemporary scholars have sought out and discovered music that bears witness to timelessness, albeit employing an ethnographic rhetoric very different from that of their disciplinary ancestors. In Bernard Lortat-Jacob's studies of Sardinia, for example, music possesses the potential almost to resist modernity, that is, the industrialized Europe beyond the Mediterranean

coast in which many Sardinians are forced to work. Lortat-Jacob ends *Sardinian Chronicles* (1995) by turning the themes and metaphors of Lachmann's account of disembarking in North Africa on their head, decrying the very fact that Sardinians must leave their timeless world, freeing it for those from the outside. What for Lachmann was a beginning has become for Lortat-Jacob an ending:

> Only Sardinian emigrants trapped in their work and tourists, as organized as their trips, renounce from day to day this sharing of common things: at the shipyards of La Ciotat in France or in the mines of the Ruhr valley in Germany, the former pay dearly for having renounced it, while in a bay of Stintino the color of emeralds, the latter take the time to escape it in the early morning, windsurfing freely on the sea. (Lortat-Jacob 1995: 107)

At the beginning of the twenty-first century, past and present remain metaphors for Europe and the Mediterranean, the former with and within history, the latter without history. It has become far more difficult to insist that music of the Mediterranean world has no history; most recently the Balkan conflicts in Bosnia-Herzegovina and Kosovo provide the tragic counterexample. Still, history is not indigenous in the music of the Mediterranean; it emanates from the outside, indeed forcefully so. This explanation of history and timelessness has been particularly resilient for Jewish music, for timelessness provided precisely the historical argument used to map Sephardic music onto the Mediterranean (Idelsohn 1923: 49).

Fundamental to the musical encounter with the Mediterranean was journeying through time and across space to encounter its musics. Early twentieth-century comparativists, consciously endeavoring to extend the field beyond the armchair scholarship of the previous century, discovered the music of the Mediterranean by undertaking field studies. The excursion to the field led to the new possibility of authenticating the conditions of a musical world that had not changed. It is significant that these journeys juxtaposed scientific intent with the sense of discovery characteristic of a traveler. New recording devices, especially wax-cylinder recorders, provided the scientific motivation for the journey, and these made it further possible to bring home unaltered data from the field, adding music to the marvelous possessions that the discoverers of the New World had earlier brought with them (Greenblatt 1991). The field reports of those journeying to the musics of the Mediterranean also made it clear that the unchanged musics could not survive when removed from such places. Abraham Zvi Idelsohn, for example, bemoaned the ossification of Sephardic music that had come into extended contact with European musics, which had sapped all "warmth" from this music.

> The oriental Sephardim have managed to keep the Jewish-oriental character of traditional music intact, at least with respect to its performance and spirit. In contrast, when European influence has come to bear on the inner substance of performance for the Separdic Jews in Europe, it has rendered it cold. (Idelsohn 1923: 49)

Heat and warmth were aesthetic and emotional qualities that Jewish music had absorbed from the Mediterranean but that had dissipated during centuries of diaspora in northern Europe. For the comparative musicologists searching for Jewish music

in the Mediterranean, the discovery of warmth in the transmission of Jewish music provided a means of following history to its very origins. Idelsohn himself was left only with the choice of recording Sephardic music in the "Orient," in other words in Palestine during the 1910s when he made the wax-disc recordings of Jewish musical traditions that constitute his *Thesaurus of Oriental-Jewish Melodies* (Idelsohn 1914–1932; see Österreichische Akademie der Wissenschaften 2005).

The early twentieth-century scholars who chose not to journey across time and space with a field-recording device were less fortunate. The journey to North Africa threatened the imagination of Mediterranean music for some scholars, notably Henry George Farmer. The consequences of discovering that the past and present were not the same might well undermine a life's work. Farmer, whose voluminous studies of Arabic and Jewish music have been standard works in the twentieth century, had almost no field experience. The accounts of his resistance to visiting Egypt (e.g., turning back upon seeing what twentieth-century culture really was at the time of the 1932 Cairo Congress of Arab Music) are legion if sometimes apocryphal.

At the turn of the twenty-first century Jewish music scholarship, taking a distinctively anthropological turn, sharpened its criticism of the ways the field has collapsed time to retrieve an ethnographic object for study. Johannes Fabian has sustained the most sweeping critique of the anthropological manipulation of time, locating its origins primarily in the Hegelian dialectic of history, in other words the distinction between Europe's teleological realization of time and the nonteleological, nonchanging nature of time outside the West (1982). As a Western scholarly discipline, anthropology has historically written the other out of history in order to reify history itself. More recently, anthropologists and historians of anthropology have sought ways of writing other cultures back into history (see esp. Wolf 1982). Obviously, this anthropological wrestling with time has yet to escape the double-bind of writing, the dependence on inscribed representations of the other.

One alternative to the movement into and out of timelessness is the palette of representational methodologies postulated by globalization theory. The historiographic methods of globalization succumb to the incongruities of different temporal frameworks, relishing the impossibility of ever truly reckoning with them. The result is not infrequently a temporal inversion, in which the global character of all culture—the temporal umbrella that covers everything—defies or even negates local calibrations of history. Globalization theory, nonetheless, accounts for new responses and counterresponses to history. There is no reason that the local musical practices might not be contextualized as timeless in order to meet external expectations, for example the revival of music to represent a modern form of nationalism (see the Epilogue). Accordingly, globalization theory might still admit to different forms of timelessness in the Jewish music of the Mediterranean, while urging us to consider explanations for these phenomena more complex than the simplistic claim that they are Western constructions (see, e.g., Appadurai 1996).

MODELS OF TIMELESSNESS

Both geography and history intersect to provide templates for mapping Jewish music's atemporality in the Mediterranean, thereby localizing music histories and

specifying the conditions for the musical connections between past and present. Accordingly, in seeking to understand why timelessness has accrued to Jewish music in the Mediterranean, we determine the processes of a specific music history, not simply a generalized or abstract encounter with the music of the other. I turn now to three of the most persistent models used to chart the geography of encounter in the Mediterranean. In each case the model has served as a real template, which nevertheless assumes a malleable form allowing it to be adapted to different musics in the Mediterranean and to lend itself to different Mediterranean music histories. In each case, Jewish music, whether or not a primary case in point, has provided crucial evidence for constructing the model.

The three models are not isolated from each other, but in fact overlap. Jewish, Muslim, and Christian practices overlap because of similarities; religious and secular histories intersect; the musics of the Mediterranean respond to the in-betweenness of cultures between Europe and its others, in Africa and in Asia, as catalysts whose functions bear striking resemblance. It is precisely their overlapping that provides the connections between local and regional histories, as well as musical identities of timeless pasts and a shared, modern present (for criticisms of these three models, see Davis 1993). I employ the models not because I endorse them, but rather because they have dominated discourses about Mediterranean culture and history. In contrast to Davis's examination of the models (1993), moreover, I am concerned specifically with the ways music is used to represent the Mediterranean and our imagination of how it forms distinctive cultural geographies.

Journey into Timelessness

The first model takes shape from the journey across the Mediterranean into timelessness. The journey passes from a world with history to one without history, and, as we have already witnessed in the opening passage from Robert Lachmann's study of North Africa, the journey is both literal and metaphorical. The origins of this model lie in Greek and biblical Antiquity, but it was with the destruction of the Second Temple in Jerusalem in 70 CE that the model stretched across and then embraced the entire Mediterranean. The journey across the Mediterranean into timelessness took on Jewish, Muslim, and Christian dimensions, resulting in turn from the distinctive ways the three Mediterranean religions charted their sacred geography.

In Judaism, the journey first formed from the historical map of the diaspora. The symbolic connections of Jewish ritual and the performance of metaphors of return to Jerusalem invested the journey across the Mediterranean with an everyday presence, while the great difficulty of return intensified the sense of its timelessness; in the Passover seder, year after year, it was always "next year" that would mark the return to Jerusalem. Jewish liturgy is rich with metaphors of returning to Jerusalem, and many holidays (e.g., the three pilgrimage holidays of Passover, Shavuot, and Succot) contain ritual practices through which one symbolically enacts that return. The journey across the Mediterranean takes place only in ritual time, with historical time being deferred to the future.

The Islamic conditions for the journey across the Mediterranean were spawned during the rapid spread of Islam during the seventh century CE and immediately

thereafter. In order to facilitate the spread of Islam, local traditions were often left intact, with the central practices of the faith located in the institutions of power. This juxtaposition of local and Islamic cultural traditions produced a historical tension, which nonetheless was mediated by the fundamental Muslim pillar of *ḥajj*, the pilgrimage to Mecca. The historical present, therefore, was differentiated and inflected by local practices, whereas the enactment of *ḥajj* served as the enjoinder to make the journey into timelessness (see, e.g., Peters 1994).

For Christians there is no more symbolic representation of the journey across the Mediterranean than pilgrimage, a sacred journey performed as early as the third century to chart a sacred landscape that would lead Europe and the Eastern Mediterranean into contestation for the boundaries of the world. Christian pilgrimage established the extremes of the world, Santiago de Compostela in the west and Jerusalem in the east. That this world of Christian pilgrimage also extended a sacred character to the Mediterranean is obvious. That sacred character acquired even greater significance when Rome, as the seat of the Roman Catholic Church, joined Santiago and Jerusalem as a goal for Christian pilgrims. As a landscape and seascape for pilgrims, the Mediterranean acquired new musical practices, the many repertories of Christians, Jews, and Muslims that served as the narratives empowering them to journey into the past.

In all three major religions of the Mediterranean, musical repertories for pilgrimage mark special ritual occasions and thereby accrue extraordinary importance. In Islam, for example, pilgrimage songs (*talbiyyah*) are less important only than recitation of the Qur'an and the call to prayer (*adhān*). In Judaism the Passover seder meal draws family and community life together with musical enjoinders to realize the journey to Jerusalem.

Temporal Isolation

The second metaphor invoked as a model for the timelessness of the Mediterranean is the island. As a place separated from the rest of the world, an island is imagined to preserve music as it always was, for there is presumably no real chance for contact with other external forces that would render change. An island possesses its own history, and it exists insulated from the larger forces of global history. Islands also possess a historicized geography that permits discovery, and it is for this reason that islands of the Mediterranean have so frequently served as sites where Mediterranean musics survived, awaiting the discoveries of European scholars. The islands of the Aegean, for example, exhibit a long history of discovery and rediscovery, from which archeologists and anthropologists alike transformed prehistory into history. By no means is the discovery of the isolated past only, or even primarily, a scholarly preoccupation. Greek Orthodox Christians, for example, frequently journey to monastic communities, such as that on the island of Patmos, and go on pilgrimages to Mount Athos to find pure forms of their faith and its practice (Lind 2003). Michael Herzfeld has given the name "monumental time" to the capacity of Mediterranean islands to appropriate the past for the present (Herzfeld 1991).

Robert Lachmann's discovery of Jewish music on the island of Djerba has proved nothing short of paradigmatic for modern Jewish-music scholarship. In 1929

Lachmann conducted fieldwork in two "isolated" communities on Djerba, which he chose because he felt assured that their music and liturgical practices demonstrated a further "isolation from foreign influences" (Lachmann 1976: 28). Historians had believed that the Djerba communities formed "immediately after the destruction of the Second Temple," hence making it possible to experience the liturgical cantillation of Israel prior to the diaspora (Lachmann 1976: 27). Important to Lachmann's own historical image was the fact that the residents of these communities themselves believed that their music demonstrated this "great age" (ibid.). First published in English translation in Jerusalem in 1940, albeit posthumously, Lachmann's *Jewish Cantillation and Song in the Isle Djerba* portrayed an island existing outside of history, even resisting history. In so doing, the Djerba study underscored the power of the Mediterranean to contain within it the music of the Jewish past, where it awaited discovery in the present (cf. Bohlman and Davis 2007).

The Historical Dynamics of Ceaseless Wandering

Historically imagined, Mediterranean cultural geography lends itself to being crossed and crossed again, perpetually creating diaspora and the exchange of a culture formed from trade and shipping. Musical practices in the resulting world of ceaseless motion exhibit the qualities of freight, which is to say goods offered in exchange for one another. The fractal model of the Mediterranean owes its modern origins to the writings of Fernand Braudel (1986), whose work provides rich accounts of the historical tension necessary to retain the music of the past by placing it in processes of constant exchange.

The Mediterranean becomes a template for multiple diasporas, wandering through history in such ways that identity is possible only when one carries one's culture—also one's music culture—with one. The trope of wandering was common in nineteenth-century music history, for example, in the writings of G. W. Fink, who titled his 1831 music history *The First Wanderings of the Oldest Music as the Prehistory, or the First Period, of Music* (in German, *Erste Wanderung der ältesten Tonkunst als Vorgeschichte der Musik, oder als erste Periode derselben;* it may well be by chance, but the publisher of this volume was Bädeker, a publishing house best known for its travel guides). Through ceaseless wandering, music itself acquires the multiple layers of meaning that characterize diaspora, the "double consciousness" of past and present that Paul Gilroy identifies in his study of another fractal culture, the Black Atlantic (Gilroy 1993). Diaspora depends on processes of exile and return, which in turn create specific goals for the historical movement that characterizes it. The musical practices of the present, therefore, refer to those of the past, but no less do they hopefully evoke the musical practices of the future. The movement of Mediterranean peoples in the present, not least among them Mediterranean Jewish communities, becomes necessary as a means of effecting the return to the timelessness of the past.

THE CEASELESS MOVEMENT OF CULTURE

The models of musical atemporality that we witness in the histories of Jewish music in the Mediterranean share a common concern about culture and what

constitutes it. I should go so far as to say that it therefore suggests the possibility of a paradigm for ongoing debates about the very possibility of discussing culture and music culture at all. Culture, so modeled, has internal forces keeping it together like the atom whose constituent parts exhibit a dynamic tension that keep the atom itself intact. The historiographic construction of Mediterranean Jewish music functions similarly. Without exaggerating the metaphor, it is possible even to perceive the islands formed by Jewish music cultures in the Mediterranean as a nucleus or a set of subatomic particles, whereas the dynamic, fractal quality results from the constant motion exhibited by the forces of energy. Anything that would disturb the internal dynamics of the Mediterranean culture (e.g., contact with influences from European music or the forces of modernity) would lead to a deterioration of the music culture, thus causing its timeless character to implode.

Such models, however speculative and fanciful, also offer more optimistic ways of understanding the Jewish music histories of the Mediterranean. The dynamic, fractal nature of the Mediterranean allows music cultures charted, for example, as diasporas to respond to modernity by reviving resources and repertories from the past. Modern workers on islands, such as Sardinia or Corsica, live in a world of movement between tradition and modernity, and it is only through that movement that tradition asserts itself in the face of modernity (cf. Lortat-Jacob 1995). It is perhaps one of the special qualities of the dynamic, fractal nature of Mediterranean music cultures that has historically afforded the Mediterranean the capability of resisting the teleological impulse of history in Central Europe. By remaining in constant motion, music cultures resist change, retaining a unique, self-contained dynamic.

The question arises, then, just why would ethnomusicologists and Jewish music scholars wish to imagine the timelessness of the Mediterranean world? Why do they reinvent and reimagine these models at the beginning of the twenty-first century, when the very modeling of culture at all is under attack? Whereas I should not myself claim to propose the models in this chapter to answer these questions, it seems to me that the dynamic timelessness of the Mediterranean embodies something essential about a larger metaphysical value underlying modern Jewish music history. The timelessness imputed to Jewish music represents a past to which modernity cannot return, yet return to that past is imagined as possible within a historiography that establishes thoroughly modern historical connections between past and present. Historiography thus conceived extends the dynamic quality of the Mediterranean world to modern constructions of the musical practices that inform the ways we extend identity to place, which should themselves undermine older, presumably threadbare notions of music culture. The dynamics of Jewish music in the Mediterranean world, formed from contested cultures and conflicting histories, move us out of a monolithic history in which Jewish music changes constantly, forming responses to otherness. In the timeless world narrated by Mediterranean Jewish music, history pulls toward the otherness of the past, but it does so only by retaining the option of returning to the selfness of the present.

IN SEARCH OF AUTHENTICITY: A. Z. IDELSOHN'S
REDISCOVERY OF THE MEDITERRANEAN

When Abraham Zvi Idelsohn (1882–1938) employed a wax-disc recorder from
the Phonogramm-Archiv of the Austro-Hungarian Academy of Sciences to record
Jewish music in and around Jerusalem in 1911, he believed that he would encounter
Jewish music in its most authentic forms. He journeyed across the Mediterranean
in search of a historically absent center, the Jewish music that had not survived
centuries of diaspora in the Ashkenazic world in which European Jews lived. His
motivation to encounter the authentic were personal and professional—Idelsohn
grew up in an observant Latvian family and had studied for the cantorate, in which
profession he had served the Regensburg Jewish community before accepting a call
to Johannesburg—but his journey in search for authentic Jewish music was also a
product of his time.

Idelsohn was an intellectual and a cosmopolitan, whose grasp of Jewish music
crossed denominational and regional boundaries and whose understanding of Eu-
ropean music history and theory was expansive. He had studied for the cantorate
with Boruch Schor in Berlin and Emanuel Kirschner in Munich, and he counted
Zöllner and Kretschmar among his professors in music at Leipzig. Ironically, it
was his broad understanding of both European and Jewish music on the common
ground of German liberalism that led him to rebel. Idelsohn knew exactly what he
did not want Jewish music to become and to be:

> As a disciple of Achad Haam I detested the constant chase after Germanism,
> which I continuously heard in the synagogue song; even [Louis] Lewandowski
> seemed Germanized. The life of the Jews in Germany, too, was Germanized.
> This was not only true of the Liberals, but also of the Orthodox. (Idelsohn 1986
> [1935]: 20)

Idelsohn imagined that he would have to make a historical and historicist move,
searching for Jewish music prior to its "Germanization." The conditions of authen-
tic Jewish music that he imagined at the beginning of his three years in Jerusalem
comprised the following:

1. Jerusalem was the historical and geographical center of Jewish music.
2. The synagogue was the institution in which Jewish music was
 practiced.
3. Jewish music was fundamentally vocal, and the texts that generated it
 were connected to liturgy, ritual, and prayer.
4. In this pure form, Jewish music remained intact through oral
 transmission.
5. Jewish music was timeless.
6. The Jewish communities of Palestine had survived several millennia of
 diaspora because they were tenaciously isolated.
7. The shape of melody and the form of individual songs were uniquely
 Jewish, thus permitted no exchange with non-Jewish traditions.
8. Jewish music encoded and expressed aspects of ethnic/national identity.

Idelsohn adopted methodologies that would assist him in his search for authentic Jewish music. His approach was to be linguistic in several important respects. First of all, from the conditions above, we realize that language and text—the verbal constituents of song—were inseparable from his project. In two ways, these provided him with humanistic approaches from both the distant and recent past. The exegetic concern for language was fundamentally Jewish (e.g., from medieval traditions of Jewish learning), and the philological concern for text was an extension of Enlightenment humanism. Ontologically, Idelsohn combined these concerns, determining that his focus would be *Gesang,* a German formulation of song that is more performative than *Lied.*

Second, Idelsohn's linguistic agenda was supported by technology, namely the latest advances in recording practices, developed and employed by the Imperial Academy of Sciences. One need only compare the numerous charts and illustrations accompanying Idelsohn's publications to witness the impact upon the conditions of authenticity (see previous list). Idelsohn found a way of representing everything that could be music by denying the possibility that a hybrid music could inhabit a domain beyond representation. His modes and melodies were located through transcriptional methods that triangulated them and located them in a space that was reducible to the measurements of cents. The employment of free-rhythm notation—the absence of meter and barlines—also serves as a tactic of filling in the temporal spaces that might be perceived as culturally hybrid.

The music that Idelsohn encountered, recorded, and published resisted the authentic, and it came almost paradigmatically to demonstrate the conditions of in-betweenness of a Mediterranean music. To support his historiographic strategy, Idelsohn actually generated new categories and concepts, and he devoted the remaining years of his life to locating Jewish music in the border areas separating and shared by Jewish communities in the diaspora. The conditions of in-betweenness that dominate the history of Jewish music research include the following:

1. Musical difference fills in the spaces of a historical and geographical map of diaspora.
2. The boundaries between sacred and secular blur.
3. Musical change is normative, thus removing the special privilege afforded to the old.
4. Individual performers, from religious to musical specialists (from cantors to klezmer musicians), leave their imprint on Jewish music, pushing it ineluctably toward stylistic borders.

By discovering these conditions in the Mediterranean, Idelsohn created the paradigms for Jewish music as at once ancient and modern. Although he had mustered the methods and tools that ensure authenticity, Idelsohn reformulated their use; rather than confirming the theories he brought to the field, the methods and tools untethered his imagination. Just as his transcriptions and publications rendered notation exactly, he gathered his transcriptions and published them with steady recourse to comparison. Difference began with pronunciation and accentuation (*Aussprache* in Idelsohn 1917), and his charts therefore made it clear that the sound of song texts shifted away from the core. When he constructed comparative melodic

charts, he determined a middle path, allowing for similarity and difference, opening the conceptual borders for individual creativity and religiocultural exchange (see Figure 2.1). Jewish music in Idelsohn's publications, above all the *Hebräisch-orientalischer Melodienschatz* (published in English translation as the *Thesaurus of Hebrew Oriental Melodies;* Idelsohn 1914–1932), grew from the field recordings he made in Jerusalem during 1911–1913 and from the manuscripts and archival sources he studied throughout much of his career. Together, these sources, contradictory in their representation of authenticity, articulated and occupied complex spaces of in-betweenness in Jewish music.

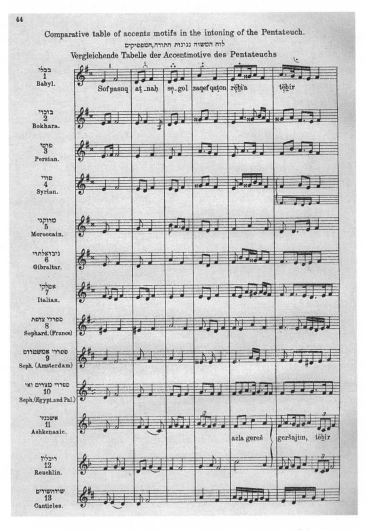

FIGURE 2.1 "Comparative Table of Accents Motifs in the Intoning of the Pentateuch."
(Source: Idelsohn 1922a: 44)

At every stage of his grand recording and collecting project A. Z. Idelsohn turned toward the East, toward *mizrakh*. The diaspora encounter with the Jewish past always took place in the East, so much so that it was ritualized through prayer and music in the weekly Sabbath service (see chapter 3). After the Middle Ages, the synagogue itself was "oriented," literally so, toward the East, with the worshipers facing the Torah ark, the bima, and the altar at the eastern end of the synagogue. Lest there be any doubt about the symbolic meaning of praying in the direction of Jerusalem, the word *mizrakh* is displayed above the bima. The East charts the geography of diaspora itself. It was the place of beginning, or origins, but far more important the telos, or goal, of history. Idelsohn's own goal was to muster Jewish music in service to the telos of return to the Eastern Mediterranean.

At the turn of the twentieth century, A. Z. Idelsohn was by no means the only Jewish intellectual and religious scholar to turn toward the East in search of new approaches to the Jewish past and present (see chapter 3). The Jewish turn toward the East was itself not unique, for it both parallels and offers counterpoint to European orientalism (Said 1978). In orientalist thought the Orient was the great site of otherness. On one hand, European history itself, filtered and interpreted through Hegelian historiography, began in the East, in Asia, from which it then moved toward and culminated in European modernity. The themes of orientalist otherness are well known: simplicity and orality; the predominance of myth and primitive political systems; artistic and musical forms that are at once authentic and unchanging. These were themes too that seduced Idelsohn as he reoriented his recording project toward the Eastern Mediterranean. Indeed, the themes underscored the extent to which recording technology was the most appropriate way to approach the Jewish musical traditions surviving in Jerusalem.

Idelsohn's journey to Jerusalem presaged the modern turn of Jewish music toward the East, even becoming a model for the search of modern Jewish musical identities in the Eastern Mediterranean and Eastern Europe. Already by the 1920s and 1930s, during the establishment of the *Yishuv*, the modern "settlement" of Eretz Yisrael, Jewish popular music began to incorporate the sounds of Jewish music collected in the first five volumes of the *Thesaurus*. In the 1930s and 1940s Yemenite Jewish singers, such as Beracha Zephira, collaborated with European immigrant musicians to create a modern Israeli nationalist folk and popular sound. The European imagination of the East was again particularly important for reorienting the sounds of Jewish music. Beracha Zephira spent considerable time in Europe, for example, working with Max Reinhardt, before returning to Palestine, where she sang together with the great German-Jewish composer Paul Ben-Ḥaim (Flam 1986).

By the close of the twentieth century, the influence of Middle Eastern Jewish music on Israeli popular traditions was so sweeping that the broadly encompassing term *musica misrakhit* (literally Eastern music) was used to describe the popular music of Israel's eastern communities. In the revival of Jewish popular music during the 1980s and 1990s, the Eastern Mediterranean identified a place of loss and nostalgia, and turning to the East raised the possibility of recovery and retrieval. Such motivations were hardly lost on Idelsohn, and they also intensified his conviction that modernity and its latest technologies were crucial to a goal of stemming loss. Modern technologies served nostalgia by capturing an endangered object and

preserving it for the future. The distance to the East only intensified the yearning for the musical treasures it contained.

The two Easts of Jewish orientalism formed a counterpoint of past and future, and of Jewish history realized in the diaspora and in Eretz Yisrael, the land of the Jewish people before and after the diaspora. The historiographic counterpoint defined Idelsohn's recording and *Thesaurus* project, which began with ethnographic fieldwork and recording in the Eastern Mediterranean, resulting in the first five volumes of the *Thesaurus*. In the middle of the project Idelsohn returned to the West, that is, to the Central European traditions with which he was most familiar. That familiarity assumed two forms in volumes six and seven of the *Thesaurus*. With volume six (1932a), Idelsohn returned to the synagogal music of the Central European tradition on the threshold between the past and the present, in other words, on the eve of the Reform movement and the liberal turn toward written liturgical traditions. With volume seven (1932b), Idelsohn returned to the South German synagogal tradition, with which he was professionally most familiar as a cantor. The final three volumes, all published in 1932, mark the full return to the East of the diaspora. All three take Eastern Europe as their subjects, and they range in focus from liturgical and vernacular religious song to Eastern Ashkenazic folk song to the closing consideration of Hassidic folk song.

Considered as a single, historiographic project, Idelsohn's *Thesaurus* circumvents the linear teleology of modern European thought. Its historical and geographical relation to the East lends itself to no single explanation. As different as the Mediterranean and Eastern European volumes were, however, their relatedness cannot be denied. They suggest that shared notions of Easternness also reveal as many similarities as differences: a reliance on oral tradition; the common template of liturgical and ritual time; a core of sameness strengthened rather than weakened by transmission across centuries. The Easternness of Jewish musical practice, reimagined through a thoroughly modern recording and collecting project, reoriented the center of Jewish history in the East itself, thus discovering history—modern history—in the practices of an ancient and modern Jewish music.

THE TIMELESS QUALITY OF MUSICAL DIASPORA

Diaspora charts a musical landscape radically ripped away from time. Driven from the place of origins, a diasporic culture holds on to the music of the past in order to memorialize and eventually perform the return to the place of origins. The musical landscape of the Mediterranean bears witness to numerous diasporas. Surely, the Homeric epics of the *Iliad* and the *Odyssey* are among the earliest musical representations of diaspora in the Mediterranean. It is hardly surprising that epics are common in the Mediterranean cultures of Southeastern Europe, North Africa, and the Levant of the Eastern Mediterranean. The musical genres grounded in diaspora, especially epic, survive through oral forms of historiography. The oral tradition of diasporic music, moreover, provides a powerful means of remembering the past by reproducing it in the present, inseparably from musical performance.

No diaspora has depended more on the Mediterranean and its possibilities for constant movement than the Jewish diaspora. The Jewish diaspora owes its origins to very specific conditions in the past, such as the destruction of the Temple, and the dispersion of Jewish culture demonstrates the capacity of diaspora to respond to changing historical conditions through music. It was Abraham Zvi Idelsohn, once again, who most forcefully argued that the music of the Jewish diaspora was itself the music of a Jewish prehistory. In his earliest publications Idelsohn made it clear that the traditions of the present were necessary for overcoming modern misunderstandings about the prehistory of diaspora.

> Until now we have known next-to-nothing about the history of Oriental Jews. Through its destruction of ancient cultural sites, archives, monuments, etc. Islam has removed all possibilities of locating the sources of history. Therefore, the only sources that remain for the researcher are those customs and practices that still form living traditions for the people themselves. (Idelsohn 1917: 5)

Idelsohn turned to the methods and technologies of early twentieth-century comparative musicology to document the history of diaspora. He was one of the most active members of the generation of Jewish-music collectors whose anthologies were transforming the very ontology of Jewish music (see chapter 5). Jewish music for Idelsohn existed in two contexts: the life of the synagogue, and the world of the diaspora. In the first, music, protected from outside influences, did not change; in the second, music responded to outside influences and therefore became a means of response. In his volumes documenting and anthologizing the music of diasporic Jewish communities, Idelsohn relied on an essential tension between these two musical contexts, and through these processes of documentation he musically invented a modern representation of the diaspora. Again, we witness that it was necessary for him to undertake a journey, to retrace the historical path of the diaspora. What he encountered at the end of that journey, however, was wonder, the realization that he was discovering music that might have sounded the same for two and a half millennia, the case Idelsohn made for the Jewish community of Baghdad.

> Immediately after the destruction of the First Temple [in 586 BCE] an intellectual center formed among Babylonian Jews and blossomed continually throughout the following 2,000 years. That center is today still intact. . . . The oral tradition of the Babylonian Jews could never have been broken, for the dissolution of Talmud academies in Sura and Pumpadita caused Jewish culture-bearers to move to Baghdad, where they established a home for Jewish tradition and learnedness. (Idelsohn 1917: 6)

By musically mapping the Jewish diaspora, largely on the Mediterranean, Idelsohn invested Jewish music with a new historical impetus. The present unfolded through a return to mandatory Palestine, that is, to Eretz Yisrael (the Land of Israel), and, after statehood, to Israel, where new processes of consolidation developed. The music history, formulated from the historical movement in the diaspora, also bore with it the traces of the diaspora and the fundamental tension between past and present. Though returned to modern history, the music of the Jewish diaspora continued to voice its witness to the prehistory of the past.

1492/1992: REVIVAL AND THE PEOPLE
WITHOUT HISTORY

No music culture has historically fitted the models of atemporality in the Mediterranean more completely than that of the Sephardic Jews. The constructed history of the Sephardim is one of ceaseless motion, with the Mediterranean providing the cultural geography that both necessitated this ceaseless motion and created the possibility of refuge from it. Sephardic communities historically formed along the North African littoral, spreading westward before the beginning of Islam, and then accompanying the spread of Islam westward across North Africa and eventually into the Iberian Peninsula. As a component of historical migration across North Africa into Iberia, Sephardic culture developed and flourished, in historical polyphony with Islamic culture.

With the expulsion of Jews from Spain in 1492 and then from Portugal in 1496 and 1498, however, the ceaseless motion of Sephardic culture began again, eventually leading to the formation of Sephardic communities throughout the Mediterranean, in the urban coastal cultures of North Africa and Turkey, and in the insular worlds of the Aegean and Adriatic seas. In these Mediterranean worlds, Sephardic Jews sustained their past, through the ritual life and traditional repertories that connected them to the past, particularly the songs in their own language, Ladino, a Hispanic language written in Hebrew characters and with some Hebrew words. The name "Sephardic" derives from the Hebrew word for Spain, *Sepharad,* and the Hebrew designation of Sephardic Jews literally means "the Spanish." This identity of self, therefore, refers to the past, indeed to a place of residence that Jews have not occupied in large numbers for over five centuries.

When Sephardic music began to attract the attention of musical and folklore scholars in the nineteenth century, the importance of its connections to the Mediterranean world quickly informed the articulation of a new historiography. Sephardic music at once juxtaposed Iberian and Arabic (or Moorish) traditions from al-Andalus, and these together formed a classical stage preceded by the music of the Mediterranean. The importance of this juxtaposition is evident in the architecture of synagogues during the second half of the nineteenth century—Sephardic and Ashkenazic, in Europe and North America—which often bore direct resemblance to a mosque, complete with minarets, thereby openly recalling the connection of Jewish ritual through North Africa to the Eastern Mediterranean, that is to Palestine. By historicizing the past, the architects who built diaspora synagogues in Moorish style consciously accommodated modernity (e.g., the Moorish-style synagogues of Berlin and Budapest, the Oranienburgerstraße Synagogue, and the Dohány utca Synagogue, respectively), the new liturgical practices of Jewish communities worshiping in the monumental synagogues of Europe's metropoles (see Kalmar 2001; cf. chapter 3 of this book). In his collection of Moroccan Jewish music Abraham Zvi Idelsohn began by claiming a connection not only to the dispersion of Jewish communities after the destruction of the Temple, but also to the spread of Jewish communities in "a more than two thousand-year history" stretching back at least to the era of Jewish captivity in Mesopotamia (Idelsohn 1929b: 1). In the Mediterranean Jewish history imagined by Idelsohn there had

never been a time when the North African coast had not attracted Jewish settlement, thereby extending Sephardic music history to a point of origin prior to modern documentation.

If there was no point of beginning for Sephardic music history, recent scholarship has recuperated the culture of Sephardic Jews to ensure that there will be no ending. As preparations began for the celebration of the quincentenary of the Discovery of America by Columbus, the significance of 1492 for the history of the Sephardic Jews also began to attract attention, at first because of the problem posed by joining in the celebrations, but then as a means of recognizing the historical conditions that led to the modern history of Sephardic culture (see, e.g., the essays in Lévy and Zumwalt 1993). Shaping the modern history of Sephardic culture was the Mediterranean itself, which had permitted Jews to form new communities on its islands and along its coasts. Whereas the Mediterranean became the primary site for Sephardic settlement after the expulsion from the Iberian Peninsula, there were other important centers of Sephardic culture, notably the Netherlands and England, but also in the Caribbean. Significantly, however, these centers were also in close proximity to the sea, hence connected to the historical journey to and through the Mediterranean.

The Mediterranean community nonetheless became a site of tension and contestation, of interaction and response between Sephardic communities and those cultures surrounding them. That the surrounding cultures were vastly different from the Mediterranean world of Andalusian and Maghrebi Jewish pasts was significant. That Sephardic communities still maintained their sense of selfness was also significant, for it accounted for a modern form of timelessness. Whether in Turkey, along the Slavic-speaking coastal areas of the Adriatic, or in the cosmopolitan urban cultures of Greece and Algeria, Sephardic culture survived, connecting the past to the present.

The events of 1492 became a context for revival, and it is hardly surprising that Sephardic music served as the primary text for remembering and revitalizing the timeless authenticity of the past. Folk-music ensembles that performed Sephardic music—both Jewish and non-Jewish groups—proliferated. New recordings were released, and old recordings were rereleased, indeed in huge numbers (for a discography see Cohen 1993). Early collections of Sephardic song collections, long out of print, appeared in new editions with critical commentaries (see Seroussi 1993). Sephardic music, in short, was discovered as part of the celebration of the Age of Discovery, and it quickly won international audiences. Sephardic music both entered popular culture and created the possibility for a new historiography dependent on memory and remembrance, that is, on the oral traditions that had been revived for the 1492 events.

This last point is extremely important, for the Sephardic music of 1492 was not the music of a single place or time—Spain prior to the expulsion, for instance—but of many places and many times. Whether it was a music of Ottoman Turkey at the turn of the twentieth century, Sarajevo at the height of the Habsburg Empire, or Tunis during its colonial efflorescence, Sephardic music took its identities from many pasts, which together formed the identity of a Jewish Mediterranean culture. Formed through perpetual contestation, compelled to protect its essential Jewish

character through isolation or migration, the Sephardic music of 1492 embodied a specifically Jewish history, whose identity in the present was indistinguishable from its multiple identities in the past. Revival, as we witness throughout this book, proved crucial to the ways in which Jewish music restored the past to a people long denied their own history.

CHAPTER THREE

――❦―――

EAST AND WEST

THE JOURNEY TO THE EAST

There was no topos more central to Jewish literature in the second half of the nineteenth century than the dual realms of East and West in Jewish Europe. Writers publishing in both Yiddish and German took up the topos, and although they turned to different genres to examine the tension between East and West, they identified a common ground that the characters in their short stories and novels, poems and journalistic reports traversed. The journey between East and West was by no means new in late nineteenth-century Jewish literature. It had been a trope in medieval travel and theological writing. By the turn of the twentieth century, however, it had become so common as to suggest a canon of images and meanings that symbolized a new reconciliation of common Jewish identities and a remapping of the relation between the other in Eastern Europe and the self in Central Europe.

The journey to the East became a parable for the present, a parable like that crafted by Mendele Moicher Sforim in his nineteenth-century Yiddish novella *The Journeys of Benjamin the Third* (Sforim 1978). Sforim (1836–1917), together with Isaac Leib Peretz (1852–1915) and Sholem Aleichem (1859–1916), contributed significantly to the body of narrative fiction in literary Yiddish, which in many ways was a language of modernity. By the turn of the twentieth century Sforim's writings, especially his shorter prose, were circulating in German translation in Central Europe, where they influenced writers turning to Jewish themes, as well as philosophers and theologians, such as the circle around Martin Buber, who turned—or returned—to the East in a search for contemporary Jewish mysticism (see, e.g., Buber 1949; for a study of German-language stories about the relation between East and West see Sebald 1991).

The hero of Sforim's novella, Benjamin, feeling trapped in a small shtetl somewhere in Eastern Europe, takes the key from his medieval namesake, Benjamin Metudella, and from his hero, Alexander the Great, and determines to set out on a pilgrimage from Spain to the East (1165–1173 CE). Sforim's Benjamin is unsure of where he is going, but he knows that he is likely to encounter places with names such as "India, Sambation, Antikuda, Vipernatter, earthworm, donkey, ass, Johannisbrot,

manna, Turk, Tatar, robber, and more of the same" (Buber 1949: 30). When Benjamin asks directions from gentile peasants along the road, he uses the more familiar Eretz Yisrael (Land of Israel), but that name fails to ring any bells for the peasants, who have never heard of this place called "Suel" or "Elessloel" (Sforim in Buber 1949: 47–48). On his journey to the East, Benjamin finds only vague traces of those who have gone before.

"Our hero, Benjamin," as Sforim calls him, heads off to the East, but, as a bumbler and *schlemiel,* he never reaches Eretz Yisrael, instead surviving misadventure after misadventure. Sforim, engaged with the elevation of Yiddish to a literary language, gives us the story of Benjamin the Third as a parable of European Jewry and its confrontation with modernity, hence a shift from Benjamin's timeless past to the reader's historical present. Yearning to break out of the prison of diaspora and the stifling tradition of the shtetl, Benjamin journeys to the East because it offers an alternative. It represents the past and the future at the same time.

Benjamin's travels are really a journey of imagination, for it is in his dreams that we encounter some of the most fantastic images of the Jewish world. The imaginary road takes him to Jewish taverns, filled with the music of the finest klezmer ensembles. As he walks toward the dawn, an abiding metaphor of the East, he hears the songs of birds and animals, which he samples and mixes with his prayers. Eventually, Sforim's Benjamin goes as far as he can and never really achieves his goal, but he is nonetheless content. The failure to reach the East also belongs to Sforim's metaphor, for it reminds the reader that reality and imagination, though easily confused, are not the same. There is a threshold between them, and it is this threshold, between the past and the future, between the ancient and the modern, that produces the historical tension examined in the present chapter.

Benjamin's was a journey to the East on the threshold of modernity. By the time Mendele Moicher Sforim wrote the story in the second half of the nineteenth century, the motifs and symbols of modernity were well along the path directing Jewish history toward the East. These are the motifs not only of modernity, but of modernism, in fact of an emergent Jewish modernism, which we recognize in the birth of Jewish humanism, such as in Leopold Zunz's *Wissenschaft des Judentums* (Science of Judaism), in Max Grunwald's *jüdische Volkskunde* (Jewish folklore), and in the politics of Zionism. These are the images that, in stylized and stereotyped forms, became what Richard I. Cohen has called "Jewish icons," and as such they circulated themselves throughout Europe creating a vocabulary for Jewish modernism (Cohen 1998). Music, too, would be endowed with its own vocabulary of Jewish icons, visual and aural.

The images of the East also reshaped the landscape of European Jewish culture, producing Jewish orientalism, the appropriation and stylization of an aesthetics and science of Easternness, similar to the more sweeping forms of orientalism interpellated by Edward Said (1978), but distinctive because of the specific form, language, and meaning for European Jewish history. In the course of the nineteenth century, Jewish orientalism increasingly entered the European public sphere, for example in synagogue architecture and musical iconography. By the turn of the twentieth century, the motifs and symbols of aesthetic modernism combined to shift the aesthetic center of modern Jewish history from Europe to the East. This literal and figurative "reorientation" is paradoxical, because Jewish modernity arose as a condition of Westernness. Jewish

modernity at once abdicated from and affirmed its claims to the East, and like Benjamin the Third, modern Jewish history found itself trapped between West and East.

Modernity assumes many different forms in the contradictory battles over the position of Jewish history between East and West, and I should like to suggest that music—Jewish music, in ancient and modern forms—was one of the most common means of bringing peace to those battles. Surveys of Jewish music history rarely fail to include a chapter devoted Jewish music's Easternness (see, e.g., Hirshberg 1995: 184–203). Israeli music historians with roots in comparative musicology treat the relation between East and West as the determining dialectic of Jewish music history (e.g., Gradenwitz 1996a: 429–32). Music formed a crucial language within the discourse network of Jewish communities in Europe (Kittler 1990), thus opening a path for entering modernity through a journey into the past, a journey that nonetheless began by turning first to the East.

TOPOÏ OF *MIZRAKH*

The projection of the East on Jewish modernity took many forms, or *topoï,* which in turn began to shape a complex orientalism beginning with the Haskala, the Jewish Enlightenment. There is a long historiographic tradition of interpreting the Haskala as a historical rapprochement between East and West, not insignificantly initiated by the movement of many *maskilim* (Jewish Enlightenment thinkers) across the borders between western and eastern Ashkenazic cultures. The essays in Malino and Sorkin's *From East and West* (1991), for example, flesh out a genealogy of individuals confronting the diversity of Jewish Europe during the Haskala. As a product of the Jewish Enlightenment, Jewish orientalism expressed specifically Jewish topoï and more general forms of European modernity. These processes were unleashed during the Haskala, with its contrastive components, those we could properly call Western and which we find in what became German-speaking Europe, above all the rational, even philosophical Judaism associated with Moses Mendelssohn and his impact on German Jewish history (Sorkin 1996). The Eastern components of the Haskala were even more complex and contradictory, ranging from the most mystical Hassidism to the most secular forms of proto-Zionism.

Significantly for the consideration of modern Jewish orientalism, the complexity of Eastern European Jewish responses to the Enlightenment were overlooked, having been lumped together as a primitive and irrational atavism. In *Inventing Eastern Europe* (1994) Larry Wolff calls attention to the Enlightenment discourses that created a single, undifferentiated image of Eastern Europe, which by extension became legible as a type of European other. The Jewish Enlightenment produced a crucial otherness for Jewish modernity in very similar ways. Just as encounters with Eastern European Jewry increased, so too did the tendency to create a single category of Easternness, which in turn became increasingly undifferentiated and exotic. It was the otherness of Eastern European Jews, ironically, that provided a prism for viewing new identities of selfness. If the images of Eastern and Western Jews became more stylized and stereotyped, they also developed a new interdependency (cf. Aschheim 1982 and Brenner 1998).

The topoï of Jewish orientalism proliferated during the nineteenth century, pervading all areas of European Jewish society and appearing in all domains of Jewish musical life. Images of the East influenced sacred musical vocabularies, for example, in the canonization of cantorial repertories, and they formed stereotypes in the musical vocabularies of Jewish popular music. Figure 3.1 contains a particularly vivid image of Easternness, a song from the popular Jewish stage of fin-de-siècle Budapest and Vienna, "Nach Großwardein" (To Großwardein).

Großwardein—in modern Romania, the city of Oradea (population ca. 206,000) in western Transylvania—appears on the cover of the song by Hermann Rosenzweig and Anton Groiss as a jumble of Easternness, indeed, a juxtaposition of images related only by their representations of the East. During the Habsburg Monarchy Großwardein (Hungarian: Nagyvárad) belonged to the Hungarian part of the empire, and both its Jewish and non-Jewish populations were almost entirely Hungarian-speaking. Großwardein could claim an extremely large Jewish population, perhaps as high as 70 percent of its total, and by the turn of the twentieth century the Jewish population juxtaposed cosmopolitan, emancipated Jews and Hassidic communities. The remaining non-Jewish population was largely Calvinist. In popular Jewish couplets and cabaret songs, Großwardein often served as a stereotype of Easternness and Hassidism (e.g., "Das jüdische Schaffner-Lied," "The Jewish Conductor's Song"; see chapter 7).

FIGURE 3.1 Hermann Rosenzweig and Anton Groiss: "Nach Großwardein"/"To Großwardein." (Cover, published in Budapest, ca. 1900)

The Hassidic Jews on the cover of "Nach Großwardein" dance with the abandon and ecstasy characterizing a premodern Eastern society, but they do so on a stage whose figurative backdrop is both east of Budapest, where the song was published by the well-known music publisher Zipser and König, and east of Europe. Großwardein exemplified border culture in the Habsburg Monarchy, with a significant presence of Hungarian Calvinists and a large Neolog-Reform Jewish community. Taken at face value, the images on the cover of "Nach Großwardein" would seem to be nonsensical. The "East" of Hungary is symbolized by mosques and a landscape that is more reminiscent of Damascus than of Transylvania.

Musical juxtapositions create a language of Easternness and otherness, with long phrases of vocables—literally, nonsense syllables—meant to symbolize Hassidic *niggunim* (sing., *niggun*), or wordless melodies. "Nach Großwardein" itself is a potpourri, a collection of different melodies that can function only as fragments to identify Eastern Jewishness because of stereotype. The composer, Hermann Rosenzweig, intends his potpourri to contain melodies that are familiar, but not too familiar. The listener—or rather the audience in a Budapest or Vienna cabaret—must immediately perceive "Jewish tunes" *nach orientalischen Motiven* (with oriental motifs) but should not feel compelled to locate that Jewishness in any specific Easternness (see Wacks 2002). As popular song, "Nach Großwardein" literally embodies a move from East to West, from the periphery of the Austro-Hungarian Empire to its very center in Vienna's Leopoldstadt, where the cabaret and variety troupe that gave the song its popularity, the Budapester Orpheumgesellschaft (Budapest Orpheum Society), had become the most important Jewish cabaret in Europe by the turn of the twentieth century (see Veigl 1992: 7–58, and Rösler 1991: 29–31).

Because the juxtapositions in "Nach Großwardein" depend on stereotype and parody, they cannot be too subtle. Of all the distinctions whose seams must be evident to the cabaret audience, none is more direct and more crucial to the song's impact than the border between East and West. Formally a march (a *Jux-Marsch,* a joking or farce march), "Nach Großwardein" creates a contrast between the march proper (the A section of an ABA form) and the Trio (the B section). Musically, that contrast maps the march as Western and the trio as Eastern. The march section uses the piano bombastically, opening with octaves and undergirding the melody with relatively coarse chordal structures, augmented sixth chords and modulations that depart from the tonic of G Major (see Figure 3.2, the first page of the march section).

The emphasis on dance relies not on Jewish forms, but rather on the military march, which spread with the Habsburg Monarchy into Eastern Europe, and on the stereotypical social dance of Hungary, the *csárdás.* Both the march and the csárdás enjoyed a cosmopolitan popularity like that of the waltz. In the middle part of the march section, where the text shifts entirely to vocables (doi, dideridi, titam dideriditam, etc.), Rosenzweig clearly avoids composing a passage that would sound like a Hassidic niggun. The vocable part includes some stepwise motion, but it is notable more for its outlining of triads, which unequivocally anchor the passage in D Major, marking a modulation to the song's dominant.

It is with the Trio that "Nach Großwardein" unquestionably lands in the East (see Figure 3.3). The Trio's melody circulated widely in the Eastern European orbit around Bucharest, where it appears in one of the earliest klezmer recordings with

FIGURE 3.2 Hermann Rosenzweig and Anton Groiss: "Nach Großwardein"/"To Großwardein." March section, page 1. (Published in Budapest, ca. 1900)

the title, "Ma Yofus," performed by Belf's Romanian Orchestra (for a modern digital release of the recording from ca. 1908–1910, see *Klezmer Pioneers* 1993: track 5). The modulation to a-minor is the first harmonic clue to the journey across Romania to the Hungarian lands of western Transylvania; the rather destabilizing treatment of a-minor through the frequent introduction of accidentals is the second clue. By the time the voice enters in bar 5 of the Trio, the listener has the feeling of being disoriented about whether the section is in a-minor or E Major. The vocal part displays accidentals from the start, as if to use disorientation to produce a reorientation in the

FIGURE 3.3 Hermann Rosenzweig and Anton Groiss: "Nach Großwardein"/"To Großwardein." Trio section, page 5. (Published in Budapest, ca. 1900)

East. Here the melody may well have undergone a cultural translation to become a niggun; indeed, it is in the melody of the Trio that the "oriental motifs" are most stereotyped. By using the Trio to parody the East most clearly, Rosenzweig was also following the lead of his lyricist, Anton Groiss.

Textually, the trios are character studies that introduce both the residents of and the visitors to Großwardein. The characters in the Trio texts—the complete "Beggars' Society" in the first verse, the Jewish country regiment in the second alternative Trio, or the Hassidic rabbi sneaking a nonkosher meal (see the following translations)—come from a stock used for Jewish couplets and popular songs (see chapter 7 and New Budapest Orpheum Society 2002). Carl Lorens, one of the most popular of the Viennese lyricists, wrote texts for turn-of-the-century broadsides (see chapter 7) on these themes—for example, "Das jüdische Landsturm" (The Jewish Country Regiment) and "Der Leb, Der Hersch und der Kohn" (Mr. Levi, Mr. Hirsch, and Mr. Cohn). Linguistically, too, the march and the Trio sections reflect the distinctions between East and West. Whereas both draw upon Viennese dialects employed for the popular stage, which contain a smattering of Yiddish, it is in the Trio that the density of Yiddish words and pronunciations becomes greatest, marking a shift from literary to colloquial uses of the language. The range of linguistic usage to exploit the melodic Easternness in the Trio is also at a more variable level, and accordingly, the Trio makes the claim for an authenticity built upon stereotype.

As published sheet music, "Nach Großwardein" becomes a focus for the orientalist gaze. At the bottom of the cover page, the publisher indulges in marketing and colportage by listing nine different formats for its editions, ranging from full

". . . Nach Großwardein!" – ". . . To Großwardein!"

Text by Anton Groiss, music by Hermann Rosenzweig

I.

Eine Stadt im Ungarland – doi deridi ridi ridi roidoi,	A city in the Land of the Hungarians – doi deridi ridi ridi roidoi,
Ist deswegen so bekannt – doi etc.	Is for a certain reason well-known – doi . . .
Weil die allerschönsten Madlech dort zu finden sein – doi etc.	Because the most beautiful girls live there – doi . . .
Und e Csárdás können alle tanzen, Gott, wie fein –	And all of them can dance a csárdás, God, how nice –

[: Doi dideridi, titam, dideriditam,
Doi dideridi, titam, dideriditam! :]

Darum reisen voller Freud' – doi . . .	We'll go there full of joy – doi . . .
Männer hin von weit und breit – doi . . .	Men from far and wide – doi . . .

Trio

Aron Hirsch und Itzig Veitel – doi dideridi roi didoi,	Aron Hirsch and Itzig Veitel – doi dideridi roi didoi,
Moische Bär und Natzi Teitel – doi . . .	Moishe Baer and Natsi Teitel – doi . . .

Und die ganze Schnorer-Verein – doi . . .	And the whole Beggars' Society – doi . . .
Fahren erein – nach Großwardein – roi	Take a trip – to Großwardein – roi

2.

Kobi Gigerl mit sei' Schnas –	Kobi Gigerl with his own route –
Will auch gehen auf der Ras' –	Wants to go along on the trip –
Weil der Zonentarif eingeführt ist auf der Bahn –	Because a new surcharge has been placed on that stretch –
Ist das Reisen heutzutag' der allerneuester Schan –	So, the trip is the newest way to show off these days –

[: Doi dideridi, titam, dideriditam,
Doi dideridi, titam, dideriditam! :]

Im Coupé, da sieht man heut' –	One sees a fancy carriage, today –
Drinnen sitzen üns're Leut' –	And our folks are sitting in it –

Trio

Hier in Ungarn ist ein Städtchen –	There's a little city here in Hungary –
Dorten sein die schönsten Mädchen –	Where all the prettiest girls live –
Alle Männer jung und fein –	All the men are young and handsome –
Fahren erein – nach Großwardein – doi	Take a trip – to Großwardein – doi

3.

Wenn ist Markt in Großwardein –	When it's market day in Großwardein –
Seht man Jüden groß und klein –	One sees the Jews, tall and short –
Kaufleut', Schnorrer und Hausirer mit e Povel- Waar –	Merchants, beggars, and hawkers with their goods –
Ganefjüngel und dann Gigerl eine ganze Schaar –	Little thieves and all sorts of ruffians –

[: Doi dideridi, titam, dideriditam,
Doi dideridi, titam, dideriditam! :]

Alle rechnen schon voraus –	All of them look forward –
Auf der Bahn den Rebach aus –	To making some profit on the train –

Trio

Kobi Gigerl mit sei' Dalles –	Kobi Gigerl, who's totally broke –
Will bekücken sich de Kalles –	Wants to see all the young brides –

Und er mant, er kenn' auf Leim –	And he thinks he can manage it –
Fahren erein – nach Großwardein	Take a trip – to Großwardein

Alternative and Extra Trios

4.

Helden sind die Landstürmmänna –	The men of the country regiment are heroes –
Diese Leute müss ma kenna –	One has to know these folks –
Kimmt der Feind in's Land herein –	If the enemy invades the land –
Laf'n se bis nach Großwardein –	They run all the way to Großwardein –

5.

Treffes essen ist verboten –	It's forbidden to eat treif –
So stehts in den zehn Geboten –	That's what's written in the Ten Commandments –
Schinken essen insgeheim –	In order to eat ham on the sly –
Fahrt Reb-Kohn nach Großwardein –	Rabbi Cohn travels to Großwardein –

orchestra and military band to zither and solo voice. The song's visuality is a critical component of its trade in stereotype and use of musical potpourri. The lithograph on the cover is carefully executed to make the scene of the Hassidic dancers and the Eastern urban landscape in the background eye-catching. The prints and graphic illustrations published for broadsides also frequently place a performer on the stage. The consumer about to purchase the sheet music is informed by the cover that this is music for and from the stage, whose footlights, proscenium, and curtains frame the music and dance that are on the stage and place the consumer and potential performer in the audience.

The publishers also lay out the song on the page so that it will most effectively be an object to be read, indeed, so that the musician can fix her gaze on the page and its complex cultural and musical landscapes. At the bottom of most pages and at the top of many pages as well, Zipser and König include, in minuscule but clear print, the first two phrases or sixteen bars of some of the other songs they hope will become hits (see Figures 3.2 and 3.3). These musical cross-references draw the gaze to the back page of the song, a compendium of first and second lines from ten *legujabb tanczdarabok,* or "latest dances," most by other composers in the Zipser and König stable, and among these several by Hermann Rosenzweig, including the march "Emancipirte Frauen" (Emancipated Women), and literally a remix of the medley for "Nach Großwardein," called "Enrevenant de Großwardein."

In a song such as "Nach Großwardein," composed as it was for the cabaret stage, the play of orientalist topoï in Figures 3.1 through 3.3 might seem so extreme that we could dismiss them as parody disguised as a play of stereotypes. It is precisely because they trade in stereotypes, however, that the song's images of the East functioned in such complex ways. We should be cautious, thus, when dismissing

them as parody. The discourse of East and West depended on stereotypes. David Brenner has demonstrated that negative and positive stereotypes coexisted in the pages of the German Jewish journal *Ost und West,* where "positive stereotyping was the flip side of negative stereotyping" (Brenner 1998: 17). Jewish broadsides and popular songs from the turn of the century necessarily employed stereotype and parody, and the tension between East and West was essential to the ways these functioned as fragments in the Jewish popular genres that employed potpourri (see Figure 3.4, the manuscript of a melodic potpourri of Jewish popular songs arranged for piano, probably circulating in the southern Austrian province of Carinthia in the early twentieth century).

The mosques and minarets depicted across the stage's backdrop on the cover of "Nach Großwardein" also signified the East through a mixture of realism, stereotype, and parody, together providing a sort of representational potpourri. Indeed, we must remember that the image of the mosque was very familiar in European Jewish modernity, for it had been monumentalized in the nineteenth century in sacred realms as well, inspiring the architecture of a new spate of synagogue construction. Moorish synagogues also appeared in the communities of nineteenth-century immigrant Jews in North America, where they also became signifiers of Easternness in American sacred architecture. In the 1990s the Moorish synagogues of Berlin, Budapest, and other Eastern European cities were restored to their mosquelike splendor as symbols of reunification in the New Europe. Restoration of the Dohány utca Synagogue in Budapest, referred to as "Europe's largest synagogue," was completed in 1998. The Oranienburgerstraße Synagogue stood just on the edge of the center of East Berlin, and restoration of its façade and cupola, the only significant structural parts to survive the bombing of Berlin in World War II, was completed in the mid-1990s (see Bohlman 2000a for a survey of synagogue restoration projects in the New Eastern Europe). On postcards, tourist posters and brochures, and cassette and CD covers the Moorish synagogues reorient the cityscapes of Europe's metropoles. Though East and West were divided by political ideologies during the Cold War, the restored synagogues today reestablish the images of the East through the stereotypes of a destroyed Jewish past.

Less well-known today is the fact that Moorish synagogues spread across Eastern Europe in the late nineteenth and early twentieth century as responses to reform coming from the West. The Neolog, or Reform synagogue, of Oradea—or Großwardein—also employed Moorish architecture, and though in extreme disrepair today, it stands at the beginning of the twenty-first century as a site at which the rapprochement between East and West are remembered. What, then, do the stereotypes and parodies of the mosque on the cover of the popular song "Nach Großwardein," really mean? With the growing presence of modernity, the landscape of Eastern Jewish culture was remapped onto the European imagination, and music provided a significant tool of cartography.

MAPPING THE JOURNEY OF JEWISH MIGRATION

The journey between East and West was not merely a modernized vestige of historical imagination. The half-century during which the musical representations

FIGURE 3.4 Manuscript of a Jewish Potpourri for Piano from Carinthia, Southern Austria, Early Decades of the Twentieth Century. Among the songs are folk, popular, and political songs, from the Zionist "Dort wo die Zeder" (There, Where the Cedars Grow) on the top of page 1 to the cloying operetta staple "Rosinen und Mandeln" (Raisins and Almonds) from Abraham Goldfaden's *Shulamith,* at the bottom of the first page.

of the East entered Jewish sacred, folk, and popular musics in tandem with other modernizing influences was also the period of the most extensive emigration from Eastern Europe. Prior to the 1860s there had been relatively limited contact between Jews in Eastern and Central Europe, with migration to Germany or Austria being the exception rather than the rule. There were, nonetheless, already stereotypes of Eastern Jews that circulated in Central European communities, of which the *Betteljude* (lit., "begging Jew") was the most common (Brenner 1998: 21–22). Beginning in the 1870s, the number and virulence of anti-Semitic attacks in Russia increased, leading with growing regularity to full-fledged pogroms. As the conditions under which Jews in czarist lands lived worsened, emigration accelerated, so that by 1914 at least 2.5 million Russian Jews had emigrated to settle elsewhere (Brenner 1998: 22). Many passed through Germany on their way to the West— North and South America, especially—and of these, many remained in Germany for longer or shorter periods of time.

The situation in the Austro-Hungarian Empire was very similar. After the 1870s, Jews in the eastern parts of the monarchy, particularly in Bohemia, Moravia, Galicia, and Romania, were not integrated into the political and economic changes of the late nineteenth century, and they responded by migrating to the center, that is, to Vienna and Budapest, where their neighborhoods literally transplanted the culture

of the East to the metropole in the West. Between about 1870 and World War I, some 400,000 Jews moved from the eastern periphery to the cosmopolitan centers of the West (Brenner 1998: 22; see also the trilogy of novels by Soma Morgenstern published as Morgenstern 1999).

The migrations from the East took a variety of forms, ranging from transmigration to transplantation to briefer sojourns devoted to acquiring a university education, but each form necessitated response from Jewish coreligionists in Central Europe. Migration and the responses to it profoundly transformed the relation between East and West. In the largest cities, where migration was most extensively felt, such as Hamburg, which was a major point for debarkation to the Americas, institutions to care for the social welfare of Eastern Jews proliferated in the 50 years prior to World War I, requiring extensive participation from Jews already living in the cities. Erika Hirsch has surveyed the full range of Hamburg's social-welfare institutions and their memberships (for an overview of their membership lists see the appendices at the end of Hirsch 1996: 195–240). Hirsch argues that the sense of selfness (*Selbstverständnis*) in the Hamburg community actually came to depend on the public agency devoted to caring for Eastern European Jews present in the city over the short and long term.

The institutionalization of the relation between East and West in the metropole also extended into cultural activities, which in turn formalized the images and vocabularies that represented Eastern Jews in literature, on the stage, and in music. David Brenner (1998) has thoroughly examined the ways in which one of the most visible cultural institutions, the popular literary journal *Ost und West* (East and West), created precisely this vocabulary of representation in the course of its publication life (1901–1923). Clearly, *Ost und West* made no secret of its aims, and its stories, essays, reports, photographs, illustrations, and occasional musical examples (e.g., Brenner 1998: 123) wrestled with the growing population of Eastern Jews. The staff of *Ost und West* sought to create a compromise, which stressed integration and the potential for a European pan-Jewish identity (Brenner 1998: 54–76). *Ost und West* also sponsored evening song concerts (*Liederabende*), which provided venues for the performance of art-song arrangements of Jewish folk songs from the East. Evidence for such concerts suggests that they were often very successful, and reviews of the concerts appeared in both the Jewish and non-Jewish press. Brenner reports one 1919 concert attended by an audience of about 2000 (Brenner 1998: 102). Among those taking polemical positions against the *Ost und West* song evenings was Fritz Mordechai Kaufmann, who would become one of the most important editors of Jewish folk song from the late 1910s into the 1930s (see, e.g., Kaufmann 1919; Kaufmann 1920).

Ost und West might have formulated its aims more directly than other Jewish literary journals, but it was by no means an isolated case. The journal *Der Jude* (The Jew), the first issue of which appeared in 1916, elevated the debates about Jewish cultural identity to an even more rarefied level, representing as it did the circle around Martin Buber, *Der Jude*'s founder and editor. Jewish music had a considerable presence in *Der Jude,* and more to the point, that presence depended on an editorial calculus that included collections of Yiddish folk songs and analyses of the Jewish melos in Eastern European expression.

It was not by accident that the chief figures responsible for music at *Ost und West* (e.g., Arno Nadel) were also major contributors to the musical sections at *Der Jude*. Nor was it by accident that these figures were themselves transplanted Eastern European Jews. This was true of Arno Nadel (1878–1943), and it was even true of the chief editors, Leo Winz at *Ost und West* and Martin Buber at *Der Jude*. Arno Nadel, for example, contributed to *Der Jude* a nine-part series of essays, with printed musical examples, to inaugurate its first year of publication (see Nadel 1916–1917). The series itself served as a discursive journey to the music culture of Eastern European Jews and did so at a time when Germany and Russia were at war. Leo Winz (1876–1952) had grown up in Ukraine and first moved to Berlin for university studies. While still a student, he founded *Ost und West,* and in the course of his immensely successful publishing career he also founded other Jewish journals and magazines. Winz's staffs were almost entirely transplanted Eastern European Jews, who brought with them—or retrieved from their pasts—the stories, literature, folklore, and folk music of the Yiddish-speaking communities of the East (Brenner 1998: 16–17). In the new literary venues, however, they published these narratives of the East in German, thus establishing a crucial discursive common ground. Indeed, one might interpret the journals as Eastern responses to the Western responses to Easternness.

Illustrated Jewish family magazines (*Illustrierten*) regularly contained reports of journeys to the East, such as those by Viennese reporters who visited Slovak or Moravian villages. The illustrated magazines endeavored to popularize, but they adapted the ethnographic language of travel literature and the more scientific language of nascent Jewish folklore and anthropology journals. The Viennese journal *Am-Urquell* (At the Origins), founded and edited by Friedrich Salomo Krauss (1859–1938), took as its explicit goal the uncovering of cultural "sources" (*Quellen*) in Eastern Europe, and it served as a repository for collections of folk sayings, stories, epics, and songs from the East. Unlike Winz's *Ost und West*, Krauss's *Am-Urquell,* called simply *Der Urquell* (The Origin) by the end of the 1890s, did not confine itself to Jewish ethnographic materials, but such materials enjoyed a special position, both in quantity and quality, because Krauss was able to tap such extensive sources of Jewish academic and lay scholars, many of whom were migrants from the eastern lands of the Austro-Hungarian Empire and had brought their traditions with them, in the representational languages and dialects of the East (for more extensive treatment of Krauss, see chapter 5).

There is a notable tendency even to stereotype the Jewish intellectuals who came from Eastern Europe but established their careers in Central Europe. Friedrich Salomo Krauss's biographer, Raymond L. Burt, begins his sketch of the Jewish anthropologist's life thus: "In its broad strokes, the life of Friedrich Salomo Krauss (1859–1938) is typical for a Jewish intellectual of his generation. He grew up in a small village at the eastern edge of the Habsburg Monarchy and then resettled during his youth in the capital of the Monarchy, Vienna, in order to complete his studies in the hope that he might achieve a better life" (Burt 1990: 9). In the West the scientific languages quickly entered into a complex counterpoint with the stereotypes and popular imagery of Jewish music.

AUTHENTIC DISCOURSE AND DISCURSIVE
AUTHENTICITY

The imagined landscape of the East supported a music culture of the authentic. The music of the Eastern synagogue had presumably remained untouched by reform and unpolluted by women's voices, musical instruments, and the polyphony of newly composed liturgies. The synagogue congregation, whether praying in the direction of the Torah ark, with its unequivocal emblem of *mizrakh*, or listening to the solo voice of the ḥazzan, oriented itself as a community away from the changes in Central Europe and toward Jerusalem, affirming its focus on the East. Even the tenacious hold of Eastern Ashkenazic liturgies on oral tradition symbolically ensured its desire for a firmer grasp on authenticity (see Avenary 1976).

Whereas orthodox liturgies led to claims for an authenticity of sacred pastness, new folk musics engendered an authenticity of secular, but unequivocally Jewish, presentness. The folk songs of the shtetl and the ghetto replaced those that had been lost to emancipation in Western Europe. Most visibly, the folk dances of the ḥassidim came to symbolize a world of true Jewish expression. The discourse of authenticity began to envelop Hassidism already in the late eighteenth century, when Hassidism began to appeal as a means of arresting modernity. By the beginning of the twentieth century, the textless niggunim and the trancelike character of Hassidic dance came to symbolize the most authentic layer of Jewish folk music. Hassidic songs in Yiddish acquired the status of a belletristic literature, not least when they appeared in arrangements for piano and voice in Jewish music presses and literary journals, and were consciously designed to forge entry into the Austro-German art-song, or Lieder, tradition. In the West, klezmer ensembles and Hassidic singing troupes were collapsed into a single category, authenticating the survival of true Jewishness, stimulating intellectuals and literati such as Martin Buber and Franz Kafka to collapse the gap between East and West. Franz Kafka encountered Hassidism in both the literary work of Rabbi Nachman of Bratslav and in the performances of the Eastern European folk-music troupes touring Prague in the early decades of the twentieth century. Accordingly, he formulated a mysticism with both religious and aesthetic dimensions (see Grözinger 1987 and Oron 1987). Buber engaged more directly with the oral traditions of the ḥassidim, translating and publishing folktales in German in anthologies and elsewhere in his writings (see esp. Buber 1949). For both Buber and Kafka, Hassidic music narrated a path to the Jewishness of the present, where the past was as modern as possible.

Among the most familiar transformations of the Eastern landscape to heighten the distinctions between the authentic and the inauthentic were the stereotyped representations of musical life in the shtetl and the ghetto. The shtetl was the rural island of an Eastern European Jewish folk culture. The idealized cartography of the shtetl became familiar during the course of the nineteenth century, with a culturally symbolic "Judengasse" and the socioeconomic life afforded by myriad small shops and by trade and exchange. It was during the nineteenth century that the modern image of shtetl music emerged. That image grew from the music of the wedding and the music of the small shopkeeper. It contained the folk music that emphasized

rites of passage and the klezmer music that reproduced the shtetl through rituals of reproduction themselves, notably the wedding.

In sharp contrast to the shtetl, the ghetto also appeared on the imagined landscape of Eastern Europe. The songs of the ghetto reflected a starkly different engagement with modernity. Rather than perpetuating the timelessness of the shtetl and the flow of life along the Judengasse, the ghetto's musical landscapes formed around the sweatshop and stressed the incompatibility of the Jewish culture of the East with the machines of modernity. By the first decade of the twentieth century, Morris Rosenfeld's *Lieder des Ghetto* (1902) was already a classic volume of poems about life in the "sweatshops"— an English word already incorporated into German and Yiddish—of the Eastern European industrial city. Illustrations by E. M. Lilien (Ephraim Moses Lilien, 1874–1925), the most influential graphic designer to work with Jewish publishers at the time— among them Leo Winz at *Ost und West*—fill the pages of *Lieder des Ghetto* (see the following example). Rather than representing the reproduction of Jewish life, the songs of the urban ghetto stressed the need to escape an irreconcilable East, whether to America or, eventually, in the genres of Zionist music, farther East: to Israel.

"Lieder von der Armengass'" / *"Songs from the Lane of the Poor"*

English translation

The songs from the lane of the poor,
Singing that rings of bitterness!
What brings tears to my eyes?
What grabs my breath? What makes me so pale?
My heart will simply burst.
That is, it is drawn to a song,
Drawn to the song from the lane of the poor.

"Raisins and Almonds"—you know the song,
The mother first sings it at the cradle.
Her eye is so tired as she gazes at the little child,
She is herself so miserable—and yet she sings the song
Of the "Golden, Golden Goat."
And the child is sick, and her husband is dead—
The raisins are in the song, but there's no bread at home.
The children there sing a song
With such innocent faces.
You, youthful song! You won't last long,
You'll turn into a web of pure sound,
The roar of the machines.
Suddenly, the sweet music from a child's mouth
Will fall silent in the noise of the factory.

[Rosenfeld adds a note at the foot of the poem]: The songs, "Raisins and Almonds" and the "Golden Goat," are well-known Jewish folk songs.

At the beginning of the twenty-first century, the topoï of orientalism are no less evident than at the turn of the last century. The music of the shtetl, popular musics performed by seemingly countless musicians designating themselves as "the last

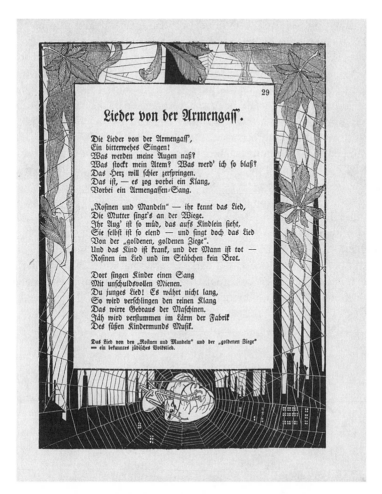

FIGURE 3.5 "Lieder von der Armengass'"/"Songs from the Lane of the Poor."
Jugendstil Representation of the Eastern Ghetto in E. M. Lilien's *Lieder des Ghetto* (1902).

klezmer," and Hassidic music all thrive, reviving a past orientalism and reimagining the possibility of new authenticity. Jewish-music websites trace the new festival circuits and celebrate the reach of the klezmer revival, at long last, to Russia (see Gruber 2002). Music continues to provide an ideal vehicle for the new orientalism, as it did for the modernist orientalism, posing the question, Why music? It is perhaps easiest to answer that question by remembering the metaphysical debates on music's capacity to represent. Music has the power to create a discourse that mixes signifiers and juxtaposes meanings. For these reasons, it provided an ideal vehicle for the hybrid medley employed by Hermann Rosenzweig in "Nach Großwardein." Music takes place in time, and it narrates history, but these qualities afford the timelessness necessary for authenticity. Accordingly, it was not one Jewish music that drew Jewish modernity along a path to the East, but many, and these proliferated at an enormous pace as the pull of the East grew stronger.

Both sacred and secular Jewish music practices made the East palpable and provided the basis for a representational language that undergirded a new discourse of European Jewish modernism. The transformation of Jewish music that had resituated the East in the West in new and modern ways by the turn of the twentieth century asks us to think about the ways in which music provides far more than traces of historical representation. Music participates in the narration of history, and the examples of Jewish music we find on the map of modern Jewish history were constitutive of that history itself. The gaze with which Jewish musicians confronted the East was meant to connect Judaism to the past, but in fact it was made possible by modernity and modernism, and accordingly that gaze was reflected by the mirrors of their own present.

The musical discourse about East and West forces us to query, Where are self and other in all this? Where, indeed, does East begin and West end? The historical narratives of Jewish music might well reveal that these questions are themselves tragically impossible to answer, but in the persistence of such questions in the *longue durée* of Jewish music history we witness the complex ways in which their signification of the authenticity of otherness was crucial to opening the gates to Jewish modernism, in which East and West would indeed be inseparable.

ONTOLOGIES OF JEWISH MUSIC

INVENTING JEWISH MUSIC

The following story is told: "The Imperial Court in Vienna was deliberating terrible measures against the Jews. To derail these evil plans, Rabbi Shmelke from Nikolsburg and his disciple, Moshe Löb from Sasova, undertook a journey to Vienna. The Danube was covered with ice, and the two men climbed into a tiny boat large enough for only two men. As they stood in the boat, Rabbi Shmelke, joined by the bass voice of the Sasovite, started to sing the song that parted the Red Sea [Exodus 15:1–21]. Accordingly, they were able to make their way through the ice floes. In Vienna people ran to the banks of the river with mouths agape, and it was not long before word of the miraculous arrival reached the Court itself. On that same day, the Empress received Rabbi Shmelke and listened to his plea.
—"Die Donaufahrt," Hassidic tale in Buber 1949: 318

San Francisco. Today, when one hears of nothing other than the dreadful acts against the Jews of Russia, it brings some peace to hear about an act of humanity shown previously by the current Czar toward a Jewish boy, who is now the Cantor of the Mason Street Synagogue in San Francisco, Rev. David Meyerson. He was born in St. Petersburg, and already in his youth he was known by the name "Lucca Tenor." This title owes its origins to the following incident: One evening, as the famous singer Lucca was leaving the theater during a heavy snowstorm, Mr. Meyerson spread his fur coat on top of the snow so that the singer's feet would not have to touch the snow and thus suffer from the cold. When Alexander, then still a prince, heard of this romantic deed, he issued an order that the chivalrous boy should be taken from the filthy Jewish quarter and be given a favored position at the imperial palace. The moment the Prince heard the boy sing, he immediately recognized that the boy had a great career before him, and he sent the boy off to Paris, where he was able to study at the Conservatoire for eight years with Rothschild's support. After he had sung successfully in virtually

every European capital, he departed about seven years ago for
San Francisco, where he enjoyed a stunning career. Although
he had never studied the rabbinical tradition, he still possessed
a considerable Hebrew knowledge. He is able to make his way
about the English, French, German, Italian, Spanish, Hebrew,
Russian, and Polish languages, and his colleagues in the cantor-
ate generally call him the "American Sulzer."
 —"Kleine Chronik," *Österreichisch-ungarische*
 Cantoren-Zeitung, November 1, 1891

Music paves the way for encounters with modernity in strikingly similar and dis-
similar ways in the two tales that open this chapter. Separated by a century and a
half, the tales chronicle Jewish musicians at the threshold of modern Jewish music
history. The threshold separates the dreadful conditions in which Jews lived from
the empires that, implicitly in the two tales, were responsible for those conditions.
Music mediates between the Jewish communities from which Rabbi Shmelke and
David Meyerson came, and it affords them an extraordinary power to capture the
attention of an empress and a czar. Music changed opinions and imperial policies,
and it diverted the course of history. At the threshold of modern history, the tra-
ditional music of a rabbi and his disciple in the mid-eighteenth century and of a
ḥazzan at the end of the nineteenth century underwent a transformation of consid-
erable proportions: It became Jewish music.

In both tales Jewish music has an eponymous quality, and it draws our attention
to the music-makers. Rabbi Shmelke enters modern Jewish music history through
oral tradition as a "miracle rabbi." The story of his audience at the Habsburg Court
in Vienna entered history by passing from Hassidic court to Hassidic court, the
circles of disciples around charismatic rabbis that generate the genealogy of Has-
sidism. In the tale itself, Rabbi Shmelke nonetheless remains anchored to tradition.
It is he who can reach into the repertory of Torah recitation and intone the song
that recounted another miracle, the parting of the Red Sea. Giving voice to the
music itself is Moshe Löb, whose presence is distinguished by the quality of his bass
voice. He follows his teacher's lead, but it is Moshe Löb who takes center stage as a
singer, as a musician recognized for his voice.

Traditional and modern repertories also frame the "Brief Chronicle" about
David Meyerson, the cantor of one of the oldest synagogues on the West Coast
of the United States. Published in the journal of the "Austro-Hungarian Can-
tors' Society," the chronicle was directed toward a readership comprising primar-
ily cantors. The miracles that attend Meyerson's rise to professional fame almost
entirely turn around the world of nineteenth-century opera: He catches Prince
Alexander's attention through a chivalrous act outside an opera performance; his
benefactors, Romanovs and Rothschilds, support only his noncantorial training; he
makes his career as a budding young opera singer, capable of conquering the major
houses of Europe. And then he suddenly appears in San Francisco, so well versed
in the cantorate that his chronicler for the cantorial world claims fame for him as
an "American Sulzer," an extraordinary compliment appearing in the newspaper
that extolled Salomon Sulzer at every turn. David Meyerson enters modern Jewish
music history in part because of his role as a pioneering cantor in the American

West, but only in small part. Far more important to his fellow professionals in the Central European cantorate, David Meyerson had embarked on a successful career because of the operatic quality of his voice.

I embark on this chapter by choosing two tales of Jewish musicians because of the ways they illustrate the conditions of invention that came to play a growing role in modern Jewish music history throughout the nineteenth century. In both tales, questions of specialization and professionalism frame the ways music comes into being. For those telling and transmitting the tales, inventing Jewish music was a phenomenon of considerable importance. In the mid-eighteenth century, the conditions for inventing Jewish music were still inchoate. It is still not clear whether it is the song from biblical tradition or the fine bass voice that works the miracle on the Danube: Both are necessary. By the end of the nineteenth century traditional music has come to play a secondary role for a Jewish-music professional. Meyerson's knowledge of traditional music, according to the chronicle about him, results from his mastery of seven modern languages and one biblical language. It may not be clear which repertories require him to know Polish and German, but they contribute in mysterious ways to his prowess as a cantor. David Meyerson alone commands the repertories that account for his fame as a Jewish musician. It is he who has forged their meaning for Jewish musical life on the American West Coast. His position in history has been firmly established because he became an inventor of Jewish music.

DISCOURSES OF INVENTION

In 1848 chaos dominated the music of Europe's Jewish communities. In the cities, acculturation was moving ahead full throttle. In many Jewish villages, there was a growing sense of isolation and abandonment. Jewish identity itself was being questioned from within Jewish society and challenged from without. Traditional music was seemingly falling into decay, the musical life of Jews falling into disarray. The year 1848 was not a moment of passive acquiescence, and the Jewish cantors of Europe, aware of the political revolution sweeping Europe and troubled by the growing awareness that Jewish musical practices differed from community to community, from country to country, turned to the publication of a journal to enact a program of musical reform, founding the *Liturgische Zeitschrift zur Veredelung des Synagogengesangs mit Berücksichtigung des ganzen Synagogenwesens* (Liturgical Journal for the Edification of Music in the Synagogue, with Consideration of the Entire Synagogue Life).

In articles published between 1848 and 1862, the lifetime of the *Liturgical Journal,* European cantors expressed a remarkably broad range of opinions concerning the dire problems facing the musical life of the synagogues. There was no single musical style, no common idea of what synagogue life was anymore. The cantors were confused about the role of instruments and women in liturgical music. They were unsure about the encroachment of secular vernaculars into the sacred service—German, Dutch, Polish, Hungarian, Yiddish—which some believed further stripped synagogal music of Jewish identity. There was particular concern about the absence of musical literacy. There was, broadly speaking, an urgent concern about

how to counteract the vertiginous changes sweeping through the music of the Jewish community, and about who should take this matter in hand. The articles in the *Liturgical Journal* did not simply identify the problems and rail against them, but rather became forums for the cantors themselves to take charge. This was a journal that advocated and took action.

The journal's agenda assumed several forms and identified several specific agendas, all motivated by the open call for "edification." First among its agendas was to establish the nature of music in the biblical past, which would empower cantors to fill in the historical gaps between the past and the present, and recognizable attempts were made to forge a historiography of synagogal music. Europe's cantors proposed new ways to transcribe, notate, and teach Jewish music; most journal issues included extensive sections with transcriptions of standard liturgical settings, as well as a few settings that were thought to be improvements (Figure 4.1).

The *Liturgical Journal* sought creatively to build the future by responding to an ancient past in which Jewish music was bound to the entire community, a past in which choruses of 4,000 and massive orchestras performed. Clearly, this past resembled bourgeois European society during the same period, a society to which Jewish communities were drawing increasingly closer. Would Jewish society retain its own identity? Would some sort of music be recognizable as belonging to that society? Jewish music? Such debates raged in the pages of the *Liturgical Journal,* and accordingly we witness in these pages one of the first modern attempts consciously to invent Jewish music.

There is a palpable sense of anxiety in the words of the cantors writing for their own professional journal in 1848, expressing themselves publicly about the absence of a concept for Jewish music. In earlier cantorial treatises their predecessors had assiduously avoided the term, and many would continue to do so until the twentieth century. The cantors were only too well aware of the abundance of other terms in European languages and in Hebrew: synagogue song; Hebrew song; music of the Bible; even "biblischer Volksgesang" had some currency; Johann Gottfried Herder threw the term "ebräische Poesie" in the etymological pot when he wrote about the aesthetics of the "Song of Songs" (1778). Words do not make the music, but their abundance and contradictions help us understand why the cantors writing in the *Liturgical Journal* were so upset with the musical cacophony they were witnessing.

The first conscious and consistent use of the adjective "Jewish" to refer to specific social practice, hence to some larger notion of culture, appears in the mid-nineteenth century, particularly in the writings of scholars associated with the Wissenschaft des Judentums (Science of Judaism; see Schneider 1834). The writings of Leopold Zunz, for example, employed thematic titles such as "Jewish Names," "Guidelines for Future Statistics about the Jews," and "Jewish Literature" (Zunz 1875–1876). It is hardly surprising that one of the most important philosophical tenets of the Wissenschaft des Judentums was the creation of a Jewish historiography that accounted for variation, change, and modernization (Meyer 1988: 75–77). By the early twentieth century, the verbal babble had subsided a bit, and by the 1920s it had largely dissipated. The term "Jewish music" and its subsets, "Jewish folk song," "Jewish song," and "Jewish cantillation," had supplanted all the other terms (for a discourse history of the term "Jewish folk music," see Bohlman 2005a).

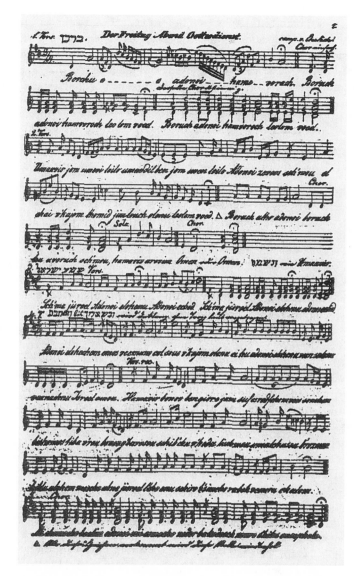

FIGURE 4.1 "Der Freitag Abend Gottesdienst"/"Friday Evening Service." For cantor and chorus. (Source: *Liturgische Zeitschrift zur Veredelung des Synagogengesangs mit Berücksichtigung des ganzen Synagogenwesens,* Vol. 2 [1948], Special Collections, University of Augsburg)

The differences that so disturbed the cantors in 1848 had not really disappeared, but they had been ordered and cobbled together into a neat yet powerful canon. It is difficult to know how this Jewish music would have measured up to that called for so passionately in 1848. In the mid-nineteenth century, Jewish liturgical specialists too resisted the assumption that something called "Jewish music" might exist. By the twentieth century, however, the cultural otherness of Jewish music

had undergone a transformation, which in turn contributed a fundamentally new impetus to Jewish music history. Music was imagined to respond to Jewish history in profoundly new ways, and the growing class of Jewish musical professionals, for which the cantors of Europe served as a vanguard, appropriated those ways toward their own ends. Inventing Jewish music in the first half of the twentieth century became one of the most powerful metaphors for articulating the Jewish confrontation with modernity.

INVENTING MUSIC AND CULTURE

Few modern traditions of historiography claim that history is what appears in history books, that culture is necessarily what anthropologists publish in ethnographies, or that some long-held truth might not in fact be fabricated. History, culture, authenticity in music, the composer's intent. As Eric Hobsbawm and Terence Ranger (1983) illustrate in their interpellation of tradition, history and culture may result from acts of invention, by constructions motivated by ideology and politics. Werner Sollors and the contributors writing in *The Invention of Ethnicity* (1989) demonstrate that basic forms of identity and community-building may have less to do with reality than with the construction of reality. Surely, I could not call this chapter "Inventing Jewish Music" without referring directly to a common awareness of the debates about the invention of tradition, culture, and ethnicity, or about the slipperiness of authenticity in music. I intentionally call into question the nature of what we assume Jewish music to be; clearly, I wish to challenge assumptions about the history that produced such a concept, hence the metaphysical relation of Jewish music to that history. "Jewish music" is, at least for many, "out there." My goal, however, is not to argue that there is no such thing as Jewish music or that it is an artificial construction. Assaults on constructivist historiography are no longer that difficult or revelatory. Nor are they any less constructions themselves. To say that Jewish music is not really the music of biblical times, though perhaps more controversial at first hearing, is not really so different from saying that the operas of the Florentine Camerata were not really the same as Greek drama. I am interested not so much in *what* Jewish music has been assumed to be, but rather with *how* such assumptions acquire an ontology of their own.

Accordingly, I shall be taking the concept of "invention" a bit farther, taking Hobsbawm, Ranger, Sollors, and others as a point of departure but in fact reformulating the concept. To signify my reformulation I have preferred to use the concept as a gerund, "inventing," which then also signifies the more active, ongoing process that I understand when I speak of "inventing music." If we look closely at the various ways in which *inventio* has been used throughout its etymological and poetic history, the concept incorporates two fundamental tenets. First, *inventio* takes something old and makes something new from it. The old does not disappear but rather it assumes a new identity within a different form. For Aristotle, the inevitability of transformation was immanent even in the poetic notion of imitation, which he used in a radically different way from the modern notion of repetition that eliminates the momentum produced by change (Aristotle 1955: 51). Aristotle did, however, argue for a distinction between poetry and history, a distinction that

Renaissance poetics problematized by conjoining aspects from both in *inventio*. The poet can take history as a point of departure, or as Jacopo Mazzoni wrote in 1587, "the poet has before him a wide field in which he can enlarge and particularize the history by introducing his own inventions without fear of transgressing the credible" (see Arbusow 1963: 91–95). Invention exists, therefore, at the interface between history and literature, and it becomes then not just a trope of rhetorics but one of history, or more specifically historiography. The historian's gaze can therefore be fixed in different ways, affording perspectives on the expressive culture lying between history and poetry.

Further important to my reformulation of inventing Jewish music is that it embraces the creative activities of the artist. The historian and the poet are no longer separable; they occupy the same discursive space and work toward the same ends. When I apply a notion of inventing to the history of Jewish music in the nineteenth and twentieth centuries, I do so having observed that those theorizing about music's position in Jewish society and those composing and performing Jewish music were in most cases the same. The cantors writing in the *Liturgical Journal* were the same as those contributing transcriptions and compositions to its musical section. The collectors of Jewish folk song in the early twentieth century were usually poets, often literary theorists, and additionally composers, arrangers, and performers (see chapter 5). It is significant that all these inventors of Jewish music turned to representing large musical systems, in fact large musical subsystems subordinate to the superorganic system of Jewish music.

Inventing Jewish music took its place in both aesthetic and historical domains. In doing so, it generated a new form of music history, one in which both past and present were conflated. Inventing Jewish music depended on the conscious extension of music in nineteenth-century Europe back to that in Eretz Yisrael prior to the destruction of the temples, and if at all possible to the music of the First Temple. As we have already witnessed (see chapter 2), Abraham Zvi Idelsohn managed to discern only the traces of an ancient Jewish music in the music of Eastern Jewish communities returning to Jerusalem in the early twentieth century. European cantors sought connections to the past in their own repertories, whereas Jewish folk-song collectors imagined a music bound to a Jewish "folk" whose oral tradition since the biblical period had been unbroken (see chapter 1). All these musics were placed in a historical context, just as they appeared in the published liturgies, the transcribed cantorial repertories of individual communities, and the folk-song anthologies. The historical context was less and less distinguishable from the contemporary context, and with the settlement of the Yishuv it became the context that Jews returning to Israel were carving out for the future.

JEWISH MUSIC AND MODERNITY
IN HISTORICAL DIALECTIC

With the onset of the modern era, new historical processes were rapidly unleashed as the Jewish community entered into a struggle for control over the signs of power and identity. Modern Jewish history, understood from this perspective, became a

way of "fixing indeterminate meanings" or resolving situations of "cultural contestation" (Comaroff and Comaroff 1991: 18). That music should enter into these forms of cultural resistance was inevitable, not just because it offered a panoply of ways to fix indeterminate meanings, but because it provided a powerful language to negotiate with the other. Music in modern Jewish history assumed a growing importance as a means of establishing identity in a non-Jewish society. If we recognize the importance of responding to the growing encounter and exchange between Jewish and non-Jewish society as fundamental to modern Jewish history, we also understand why inventing Jewish music acquired the potential to make history.

In Table 4.1, I have attempted to calibrate the path of modern Jewish music history, following it through specific stages and responses, specific attempts to establish Jewish identity and represent it musically. The various stages make it possible to recognize the constituent parts of the table as interrelated, not just within a particular historical moment, but to the larger historical sweep that stretches from the Haskala to the full articulation of Jewish music as a response to twentieth-century historical moments, notably the Holocaust and the establishment of the state of Israel.

It was with the Haskala, the Jewish Enlightenment, that the first attempts to establish a modern Jewish identity began to spread throughout Europe. Scholars of Jewish history correctly note that there was not just one Jewish Enlightenment—the one acted out in North German intellectual circles by Moses Mendelssohn—but many, each formulating responses to modernity in different ways. Among Eastern European Jews the Haskala took on the trappings of mysticism and left its greatest impact on the culture of Hassidism. Eastern and Central European responses to the Haskala seem therefore to move in opposite directions, rationalism versus irrationalism perhaps. The responses to modernity were surely different, but they were also similar at a certain level. A common response throughout Europe was that secular vernaculars, German, Yiddish, or other languages, became increasingly widespread in the everyday life of the Jewish community.

From the Haskala, Table 4.1 moves to the first half of the nineteenth century, a period of negotiation with otherness. The compromises in this period of negotiation often took place in musical arenas, such as in the liturgy of the synagogue. The challenge faced by the community was how to respond creatively to the inability of many to worship, pray, and chant in Hebrew. Secular vernacular languages had a growing presence in the synagogue; at precisely the same time, secular music from without entered the synagogue on the coattails of the vernacular. Again, the musical response from within the community was creative, for it was during this second phase that the great liturgical composers, Salomon Sulzer, Louis Lewandowski, and Samuel Naumbourg, working in Vienna, Berlin, and Paris, respectively, invented new liturgies for the synagogue. Newly arranged and composed sacred repertories filled all possible gaps opened by the liberalization of the synagogue, with Lewandowski taking a more radical direction by composing even for large instrumental ensembles and for mixed choruses with women's voices (see Lyß 2007), and Sulzer following more conservative paths, which did not admit women, to a simpler polyphony and only occasionally employing the organ.

The cantor-composers of the mid-nineteenth century chose religious musical solutions to essentially secular problems. By the end of the century the repertory of responses to the challenges to Jewish identity had begun to extend far into the

TABLE 4.1 Historical Stages in the Invention of Jewish Music

Historical Moment	Transformation in Jewish Community	Historical Responses	Musical Responses	New Aspects of Jewish Music
Haskala (Jewish Enlightenment) in the late eighteenth century	Encounter with non-Jewish society in the public sphere	Jewish Enlightenment in Central Europe (Moses Mendelssohn); Hassidism in Eastern Europe.	Local musical and liturgical repertories increasingly canonized through written tradition.	Multiplication of *minhagim* (local tradition) and the localization of *nusach* (community musical style).
First half of nineteenth century	Cultural engagement and negotiation with non-Jewish society	Vernacular languages enter sacred musical life. Emergence of the modern urban community and Jewish sciences (e.g., *Wissenschaft des Judentums*).	Canonization of ḥazzanut. Vernacular in synagogal music. Professionalization of the cantorate.	Composed liturgies. Women and instruments allowed. Choruses and instrumental groups. Treatises on ḥazzanut.
Second half of nineteenth century	Jewish identity acquires new presence in public sphere outside the Jewish community	Secular identities: *Westjuden* and *Ostjuden* together. Zionism, as modern Jewish polity. Modern Hebrew revised as modern Jewish language.	Nostalgic search for Jewish folklore and folk music. *Gesellschaft für jüdische Volkskunde*; St. Petersburg Society for Jewish Music; Jewish broadsides engender popular music.	Collections of Jewish folk-music songbooks with Jewish folk music. Zionist songbooks. Jewish song forms distinctive styles and repertories.
Early twentieth century	Reincorporation of biblical past. Modern encounter of Sephardic and Eastern Judaism	Establishment of the Yishuv in Palestine. *Jüdische Kulturbewegung* (Jewish Cultural Movement) with new genres of Jewish literature.	A. Z. Idelsohn's field collection in the Yishuv. Jewish folk music mass produced. Jewish choruses and ensembles proliferate. Jewish cabarets in the metropole.	Idelsohn publishes the *Thesaurus* (1914–1932). Yiddish becomes standard language of Jewish folk music. Jewish popular music disseminated as mass culture.

(continued)

TABLE 4.1 *(continued)*

Historical Moment	Transformation in Jewish Community	Historical Responses	Musical Responses	New Aspects of Jewish Music
Collapse and destruction of European Jewry: the Holocaust	Jewish identity shifted to the Yishuv through intensified *aliya* (immigration)	New forms of community in the Yishuv (e.g., kibbut-zim). *Jüdischer Kulturbund* in Germany. Cabaret, klezmer, and Yiddish film musicals enter new canons.	Final attempts to preserve Jewish religious tradi-tions in Europe. Eastern Medi-terraneanism in art music of the Yishuv. Emigration of Jewish popular musicians.	New Jewish "art musics" based on Hebrew-Israeli texts (e.g., Keren kayemet post-card songs). Jewish musical responses to the Holocaust. Emergence of exile genres.
Post-Holocaust era and Israeli statehood	Modern institu-tions of Jewish music in Israel, North America, and elsewhere in diaspora	Rapid prolifera-tion of symbols of Israeli na-tional identity. Recovery and revival of Eu-ropean Jewish music. Histori-cism leads to new modes of Jewishness in music.	Proliferation of Israeli musical styles. Media-tion of Jewish popular music in North America (e.g., klezmer). Mu-sics of ethnic communities collected. The Jewish music revival.	Jewish music globalized be-yond Jewish communities. Institutionaliza-tion of Israeli musical life. Modern genres of Jewish music spill into public sphere.

secular realm. The reestablishment of identity referred to in Table 4.1 resulted pri-marily from the employment of secular symbols. This trend will be immediately evident in the column "Historical Responses," where the creation of the modern Hebrew language and Zionism both owe their initial phases to this period. Jew-ish music could even assert identity as a historical response to European national-ism, such as in the Hebrew version of the so-called "Ruhmeslied" to Kaiser Franz Josef I of the Austro-Hungarian Empire, "Mizmor shir" (Song of Remembrance; Figure 4.2).

It was also during this period that the first organizations dedicated to the collec-tion of Jewish folklore and folk music appeared: the Society for Jewish Folklore in Central Europe and the Society for Jewish Folk Music in St. Petersburg; the first "monuments" of Jewish music; the songbooks of Zionist congresses; Ginsburg and Marek's collection of Yiddish folk songs, *Evreiskie narodnye pesni y Rossii* (Jewish Folk Songs from Russia; 1901); and the Zionist and later Israeli anthem, "Ha-Tikva" (Hope; see Bohlman 2004b). These acts of musical invention brought Eastern and

Central Europe together, reinvoking the unity of a common European Jewish culture and situating it in modern Jewish history at the beginning of the twentieth century (cf. Aschheim 1982; Brenner 1998; Bohlman and Holzapfel 2001).

With the nature of European Jewish music established and the mass production of its repertories underway, a bolder historical gesture necessarily followed in the early twentieth century: the reincorporation of the ancient musical past of Eretz Yisrael. Politically and geographically, this gesture entailed the reestablishment of contact with Palestine. Abraham Zvi Idelsohn initially intended to do precisely this. He argued musicologically for a link between so-called "Oriental" Jewish music and those described in the Bible and the talmudic and mishnaic texts (see chapter 2). He made these available to Europeans, confirming through his monumental anthologies, especially his *Thesaurus of Hebrew Oriental Melodies* (Idelsohn 1914–1932), compositions, music-history texts, and musicological argumentation that there was—and had been all along—a larger, all-encompassing Jewish music.

Again we witness a sort of alternation between religious and secular responses. Idelsohn's response was unquestionably religious, as were those of his contemporaries, the philosophers Martin Buber and Franz Rosenzweig, who were laying the groundwork for something they described as a *jüdische Kulturbewegung* (Jewish cultural movement), above all in their new translation of the Bible. In the subsequent phase, the fifth in Table 4.1, secular responses came to the fore again. New definitions of the "Jewish in music" necessarily associated it with Israel, revealing it to be modern rather than ancient. Just as Jewish evening academies in Frankfurt and Munich expanded their language offerings in Hebrew, so did the Jewish choruses in those cities perform the "Old Testament" works of Bach, Handel, and Mozart in Hebrew, in fact, in translations prepared in mandatory Palestine. Hans Lenneberg, who attended a Jewish Realgymnasium, or high school, in Cologne during

FIGURE 4.2 "Ruhmeslied," or "Mizmor shir" (Song of Remembrance). Postcard with song text in Hebrew and a depiction of Kaiser Franz Josef I.

the 1930s, recalled that it offered modern Hebrew as a component of its modern languages (Lenneberg 1991). This would have been impossible only two decades earlier.

The "Eastern Mediterranean" composers centered about Paul Ben-Ḥaim composed songs using modern Hebrew, juxtaposing this with musical vocabularies based on Arabic *maqāmāt,* or modes. Hans Nathan, commissioned by the Keren Kayemet to invent an Israeli national art song, did so in Berlin by using Hebrew folk poems, which were then set to music by Jewish composers on several continents (see Nathan 1994; New Budapest Orpheum Society 2002; chapter 3 in this book). The pioneer songs (Hebrew: *shireh chalutzim*) represented a total conflation of past and present. By 1938 no one was questioning that there had always been a Jewish music. The question that subsequently arose was, What would come after Jewish music?

TOOLS OF INVENTION

All the musical repertories that eventually flowed together as components of Jewish music were transmitted orally until the eve of modernity. Orality is a particularly striking feature of traditional Jewish musics because literacy is an essential component of Jewish life (for observations on Jewish literacy as reflected by Hebrew libraries in the Jewish home in Central Europe prior to the modern era, see Pollack 1971). It is safe to say, moreover, that literacy is extraordinarily widespread, even normative, in Jewish society. Basic rites of passage, bar and bat mitzvah, for example, are so dependent on the ability to read a text that one might interpret these passages from childhood to adulthood as public displays of acquired literacy. Ritual relies heavily on widespread literacy, and in cases such as the reading of the haggada during the Passover seder, becomes the nexus for the overlap of verbal literacy and musical orality.

With the modern era, the relation between oral and written traditions began to shift, to become skewed and consequently to require adjustments that would bring them back into balance. Public prayer and liturgy in the synagogue illustrate precisely this point. The Hebrew texts for synagogal prayer and liturgy appear in books, from which they are read and sung. The melodies for prayer and liturgy, however, were not traditionally notated in the books but rather were transmitted orally; many melodies are well-known, that is, form a shared, community repertory, while others require specialists, prayer leaders or *baalei ha-tefilla* (sing., *baal ha-tefilla;* literally, master of prayer), who nevertheless perform by reading from the written texts. In addition to the *baal ha-tefilla,* a layperson elected to lead the singing of prayers because of a pleasing voice, a prodigious memory, or simply religious and social prestige, the ḥazzan also serves as a musical specialist. With the rise of modernity there arose a parallel literature, often in Hebrew but increasingly in vernacular languages of the Jewish community, that concerned itself with debates about the presence or absence of specialists, the extent of literacy, or the contact among musicoreligious communities (see, e.g., Elbogen 1993 [1913]). In European Jewish communities well into the modern era, oral tradition depended on the overlap and coexistence of all these factors.

The encroachment of secular vernaculars into community life that began in the eighteenth century disturbed the balance between orality and literacy even in the synagogue by the early nineteenth century. To adjust to the skewed balance between oral and written traditions, sacred music specialists, notably Louis Lewandowski in Berlin and Salomon Sulzer in Vienna, set about to compose new liturgies, thus inventing the liturgies by borrowing from the traditional and creating some new aspects of musical style (e.g., polyphony) and organ and instrumental accompaniment. These attempts at adjusting to the skewed balance between orality and literacy, however, often exacerbated it and expanded the roles of the specialist, rendering traditional liturgy increasingly dependent on written traditions. Publishers began to print and distribute the new liturgies, and new choral and instrumental ensembles proliferated at an extraordinary pace. By mid-century the next step in the process of invention had been achieved as oral musical traditions yielded a written musical language.

The creation of specifically Jewish repertories was quick to follow. With the composed repertories of the nineteenth-century composer-cantors, we witness one kind of invented repertory. Attempts to collect Jewish folk music and the appearance of Jewish urban popular music also relied on forms of publication that transformed oral traditions into written traditions and then disseminated them (see chapter 5). The tools for implementing and disseminating traditional repertories of all kinds, sacred and secular, vernacular and liturgical, contributed substantially to their consolidation in recognizable, public forms. It is hardly surprising that during the late nineteenth century, a period described by Eric Hobsbawm as undergoing the "mass-production of traditions" (Hobsbawm 1983), Jewish music rapidly became central to the understanding of tradition itself.

With new repertories came new musical specialists, who were necessary to maintain them. The collections of Jewish folk music, for example, spawned several new musical specialists. Ethnographers and fieldworkers can be identified for the first time. Max Grunwald established the first Society for Jewish Folklore and published volumes of his *Jahrbuch für jüdische Volkskunde* (Yearbook for Jewish Folklore), in which both individual field collections and entire ethnographies appeared (see chapters 1 and 5). Russian collectors, such as Shaul M. Ginsburg and Pesach S. Marek, associated with the St. Petersburg Society for Jewish music, cobbled together the Yiddish repertories of the Pale (Ginsburg and Marek 1901); Moshe Beregovski later added Ukrainian-Yiddish repertories to these in his publications of "old Jewish folk music" (Beregovski 1982). Publishers too began to specialize in the production of Jewish music, both the small, popular presses that churned out Jewish broadsides in Vienna and the large houses such as Schocken that included musical works among its series (e.g., Nadel 1938) and Universal Edition, which created an entire series, Collection Jibneh-Juwal, to publish Jewish art music in the 1920s (see chapter 5).

The new Jewish repertories took their place in new social and cultural contexts, transforming them in the process. This was an extremely important step in the invention of Jewish music, for it created a public sphere for the performance of Jewish music. The lavish publications of liturgical music (e.g., Figure 4.3) loosened the ties to ritual, making it appropriate to shift them to secular settings. Choruses

and instrumental ensembles that originally performed the new repertories in the synagogue frequently began to perform also in the secular sphere, and it was not uncommon for synagogue ensembles to abandon the synagogue in favor of a public musical market place. In Mannheim, for example, both the Liederkranz, the city's Jewish *Männerchor* (men's chorus), with its roots in the chorus of the main synagogue, and the Stamitz-Gemeinde, the city's leading chamber orchestra, were probably entirely Jewish in the early decades of the twentieth century and certainly so in the 1930s, when the Nazis forced the Jewish community to reabsorb the Stamitz-Gemeinde into the Jüdischer Kulturbund (Bohlman 1989a; Herrmann 1954).

Paradoxically, the shift of musical life to an increasingly secular and public sphere also relocated some music within Jewish religious tradition, in essence reinventing its position in traditional Jewish societies. The paradox arose because a real separation of music from Jewish traditions or within Jewish traditions was not possible until the modern era. Prayer was prayer, liturgy was liturgy, biblical cantillation was biblical cantillation. They were not prayer, liturgy, or biblical text conveyed through music. Music was not a separate phenomenon with an ontology of its own, but rather it was embedded in the phenomena of worship. The conscious relocation of music in Jewish tradition required a new historiographic language, and again the cantor-composer invented this language. The contributors to the *Liturgical Journal* in the mid-nineteenth century were the first in a long line of cantors who wrote musicologically, and it was with scholars such as A. Z. Idelsohn and Jacob Schönberg (e.g., Schönberg 1926) that this line was to culminate, that is with cantors who contributed systematically to a musicological discourse on the eve of the Holocaust.

The growing Jewish musicological discourse succeeded remarkably in historicizing music and tradition, setting Jewish music in a particular position vis-à-vis Jewish tradition. We recognize that position today because it also contributes to the ways in which musicologists have attempted to establish links among early synagogal traditions and those of the Western and Eastern Christian churches (e.g., Wolf 1913–1919; Werner 1959). The historiographic arguments were possible only because of the valorization of the past, indeed the ancient past, of Jewish music. Musical scholars of the nineteenth century proposed the conditions under which this ancient presence might be possible; scholars of the twentieth century believed they had discovered these conditions in the Eastern communities, the Yemenite, Iraqi, or Bukharan communities putatively living in isolation for over two millennia. To historicize Jewish music, these scholars conflated past and present, in effect deliberately seeking the presence of the historical present in the past.

The various stages and processes of inventing would have been incomplete, however, had the Jewish music resulting from them not been disseminated back to the Jewish community, had they not been reintroduced into modern Jewish musical life. By transforming oral traditions to written ones, collectors, composers, and publishers also mass-produced them; the means and the results of production were therefore bound together. Accordingly, I should like to argue that the role played by the dissemination of tradition was one of situating Jewish music in everyday musical life. By extension, the consumption of these traditions—buying the new collections, singing Jewish songs in new contexts, acquiring the skills necessary to

perform the new repertories in modern Hebrew—was essential to familiarizing oneself with the tools of invention.

At that moment in the modern era, music made history because the individual in everyday life was actively performing the new texts of Jewish music as representations of their own history. Idelsohn's *Sepher shirat yisrael* (The Jewish Song Book; Idelsohn 1951), the home-use texts in the Schocken Bücherei (Schocken Library) series during the 1930s (e.g., Nadel 1938), and the Yiddish and Hebrew sheet music of the 1920s and 1930s, all these consciously revitalized musical traditions of the home, the extended family, and the individual community. All these represented an ingathering of communities from the diaspora and a return to Eretz Yisrael. All these synthesized diverse traditions by consciously calling them Jewish. The Jewish family in Berlin, Boston, London, or Tel Aviv could sing from the same repertories, could perform music from the same cultural traditions, and could empower the same music history to express their Jewishness.

EXCURSUS I: THE JEWISH MUSIC BOOK

Shir chadash: A New Song at the Moment of Crisis

In a 1937 letter to the World Centre for Jewish Music in Palestine, the chief cantor of the main synagogue in Mannheim, Germany, Hugo Adler (1894–1955), wrote feverishly of a new oratorio, *Shira Chadasha* (A New Song), which he had composed for performances by the orchestra and chorus of the Jüdischer Kulturbund in Mannheim. Adler was enthusiastic about the reception of his *Shira Chadasha,* which he portrayed metaphorically as an emblem of a new spirit of music sweeping through the Jewish communities of Germany. Composed by a sacred composer and professional in the synagogue, the *New Song* had won a broad audience, unified by the public spaces of the Jüdischer Kulturbund. Even in 1937 the ensembles of the Kulturbund could take new compositions on tour to the concert halls in other Jewish communities. From one perspective, one might say that the conditions for the performance of music in the Jewish community had never been better. In Adler's Mannheim, for example, the Jewish community would complete the building of a new opera facility in 1938, which would still support a six-opera repertory season.

The abundance of musical activities in the Jewish community, restricted to the Kulturbund since 1933, was however no cause for optimism. The enthusiasm for his *Shira Chadasha* notwithstanding, Hugo Adler's real purpose for writing to the World Centre for Jewish Music was to sound out the possibilities for publishing his sacred compositions and, with the support of the World Centre as a publisher, to gain an entrance visa for Palestine (see Bohlman 1992). The paradox of a flourishing Jewish musical life in Germany during the 1930s had not been lost upon Adler, nor was it lost upon most of the Jewish musicians whose concerted efforts had made the efflorescence possible. The paradox was not lost upon them precisely because they had been forced to witness the fragility of a Jewish public sphere. The very fact that Jewish musical life could undergo a transition had heightened their awareness of the conditions that had made Jewish music in modernity possible.

In this historical excursus, which brings us to the closing decade of modernity for the Jewish communities of Central Europe, we explore the music book both as the culmination of a history of invention and as a metonym for the Jewish public sphere to which the Jewish community turned to locate—and to enact or perform—its culture and its identity. Without belaboring definitions, the term "music book" refers to works that published music for public consumption, which in turn led to performance of one kind or another, public or private, within a Jewish context or without. The Jewish music book appeared in Central Europe in the late nineteenth century, and it enjoyed its most widespread popularity in the 1920s and 1930s. Throughout its history of slightly more than a half-century, the Jewish music book developed increasingly more varied forms, but in the 1930s these forms proliferated virtually unchecked. The Jewish music book was less a genre or object than a means or process of making music available to a broader public. I want to suggest, then, that as a source for the public consumption of music, the Jewish music book in the 1930s became a public site for Jewishness itself at a moment of imminent danger. Appearing first in the late nineteenth century, the Jewish music book accompanied the attempts to discover and invent Jewish music, and it provided one of the means whereby Jewish society constructed its identity against the changing contexts of German history.

The first music books concerned themselves with musical repertories that addressed Jewish identity. On one hand, there were books that anthologized folk-song repertories, specifically Yiddish folk song from Eastern Europe. Relying on several collecting efforts in Eastern Europe, and even among immigrants in the United States, the Yiddish folk-song book had a specific German Jewish user, the urban Jewish men's singing society or *Männerchor,* the contexts so familiar to Hugo Adler. On the other hand, music books came to serve specific Jewish groups, such as Zionist organizations, which required the composition and arrangement of new repertories. Zionist songbooks required songs in modern Hebrew, which itself was undergoing the process of invention in the 1880s and 1890s (Bohlman 2004b).

The music book initially served the collection of essentially local repertories and then recontextualized them to suit the needs of a larger European Jewish audience. In addition to folk-song collections, other genres of music book illustrate this local-to-European trajectory, such as the mass production of cantorial repertories, which also became possible because of the mass production of books (see below). Earlier nineteenth-century editions, intended for more limited circulation, were supplanted by more lavish editions aimed at a broader audience of both specialists and nonspecialists. The later editions of Salomon Sulzer's *Schir Zion* (Song of Zion), which gathered the Viennese Rite in its pages and led to its dissemination as the most widely used liturgical collection of Reform and Neolog synagogues in East-Central Europe, is one of the most striking examples of this point (Figure 4.3 depicts the title page of the first edition).

Technologies and Genres of the Jewish Music Book

The Jewish music book would not have been possible without new print technologies and the new modes of representation that these ushered into being. This point

might seem all too obvious, but it is critical to remember that the Jewish music book became possible only when audiences were willing to accept that repertories that had been transmitted and learned orally for centuries suddenly could lend themselves to written representation. Sacred repertories, transmitted through the performance of "mystical speech," to borrow a term from Michel de Certeau, now could be purchased in a music store or bookstore (de Certeau 1976). The processes of inscription, of course, demystified these repertories, and to some degree they also desacralized them at this moment in European Jewish history.

If indeed the core of Jewishness in Jewish music depended on oral tradition, it is impossible to underestimate the importance of the technologies of notation that created a new potential for the representation of Jewishness itself. One of those technologies of notation was the wax-cylinder or wax-disc recorder. The wax-cylinder recorder made it possible to collect a folk song in Lithuania or Ukraine, to reproduce that recording in Germany, and then to transcribe it for an anthology published in Berlin or Leipzig. The translations made possible by sound recording extended to both text and music. It was a recording project and its publication in music books that produced and then confirmed the modern notion of what Jewish music really was: the ten-volume *Hebräisch-orientalischer Melodienschatz* (Thesaurus of Hebrew Oriental Melodies) edited by Abraham Zvi Idelsohn and published between 1914 and 1932 (see chapter 5). Through extensive processes of linguistic and musical translation of the recordings he gathered in Jerusalem, Idelsohn was able to

FIGURE 4.3 Salomon Sulzer, *Schir Zion* (1st edition; 1840–1841). Title page.

determine categories for the organization of Yemenite music "in the synagogue," "in the Divan," or "outside the sacred spaces" of the community, ordering these for suitable publication in book format. The *Thesaurus* collapsed a 2,000-year history and innumerable song variants, whether in Arabic, Persian, Ladino, Yiddish, or even Hebrew, into the pages of a book. Cantors, ʿud players, and miraculous Hassidic rabbis appeared virtually side by side, all performing a music unified through the same processes of transcription and representation (the sound recordings are available as CDs on Österreichische Akademie der Wissenschaften 2005).

Jewish music books mediated differences by creating a new sense and awareness of a Jewish public sphere. Despite the fact that different types of music books brought together different types of Jewish music, they all came to function in similar ways in the 1930s. The different types of music books fall rather schematically into different types of genre. Folk song lent itself to publication not only in complete anthologies but also as individual songs, inserted, for example, in the Jewish literary journals (see Brenner 1998).

It is critical to consider three brief points about the importance of folk-song books to situate them in historical context. First, the folk-song book had both specific and general functions. Its audience was both fixed—say, a Zionist youth group such as the Blau-Weiß youth group—and fluid. As a genre of book, it had the added value of portability, which meant it could be used just about anywhere. Second, the folk-song book represented a middle stage in the processes of translating culture. Many folk songs from these anthologies appear in piano arrangements, or new choral versions. The possibility of further translation for use around the piano in the home was not lost upon editors and publishers in the 1930s. Arno Nadel, for example, arranged sacred and secular melodies for piano and voice, thereby making them available for the bourgeois parlor (see, e.g., his *Zemirot shabbat* (Table Songs for Sabbath), Nadel 1938). Third and so obvious that it is easy to overlook, the folk songs in question were not those of the users of the folk-song book, rather they provided Jewish folk song to a society that had lost its own folk songs and desperately turned to traditions from elsewhere to find this essential element in the construction of self-identity (see Bohlman 2005a).

Contrasting with the folk-song book was the new publication of Jewish art music. Perhaps the best example of such a publishing venue was the "Jewish list" at Universal-Edition, the major Austrian music publisher (see Weisser 1983 [1954]: 72). "Collection Jibneh-Juwal" flourished in the 1920s and into the late 1930s. Its administration was largely Jewish, and Jewish—and some non-Jewish—composers turned to Jibneh-Juwal as a place to publish their works. Jibneh-Juwal contains Jewish music largely by virtue of providing a space for the works of Jewish composers, who set Yiddish texts or used Hassidic melody (see the list of song arrangements appearing as Figure 4.4). In the 1930s other publishers followed this example, Anton Benjamin in Leipzig and Niggun in Tel Aviv and New York, to take just two well-known examples.

Different aspects of genre converge with the publication of cantorial music, which significantly increased in the 1920s and 1930s. Increasingly, the tradition of *a* cantor or *a* community began to appear in book form. We have already witnessed aspects of this transformation in the dramatic shift from the oral to the written, but I should like to extend this point further, observing that the

inscription of the cantorate in books made possible a new kind of historiography, one that narrated the history of a Jewish community by reformulating its fundamentally oral character. The musical notation of the ḥazzanut came to represent both time and space, not least because of the performative nature of music itself,

FIGURE 4.4 Advertisement for Collection Jibneh-Juwal in Leonid Sabanejew's *Die nationale jüdische Schule in der Musik*. The notice for this "Collection of Jewish Music" continues with the notice that the publications are distributed through Friedrich Hofmeister publishers of Vienna and Leipzig. Ssabanejew 1927: 26.

which requires an ontology that takes place in time. The inscription of the ḥaz-zanut acquired a particularly powerful meaning in the 1930s as it came to have the capacity to evoke the spaces of the past and represent them, if indeed futilely, in the present.

THE PARADOX OF THE MUSIC BOOK'S
PRIVATE–PUBLIC SPHERE

The transformation we see in its final phase with the publication of cantorial rep-ertories in the 1930s had been underway since the mid-1920s as a response to the rise of fascism. The transformation continued the proliferation of new forms of publishing Jewish music in the mid- and late 1930s. Other forms of Jewish music found their way into the popular press, where they could be consumed in new ways. Later in the 1930s the newspapers of the Jüdischer Kulturbund contained sections in which songs appeared, sometimes printed so they could be learned prior to a social or cultural gathering in the community. This was the function, for example, of the "Kinderecke" (Children's Corner) in the *Monatsblätter* (Monthly Magazine) of the Berlin Kulturbund. Published folk songs, such as the circus song in Figure 4.5 ("Das Zirkus-Knorke-Lied," glossed from Berlin dialect as "The Song of the Circus Hoity-Toities"), provided Jewish children with a repertory they could learn in order to respond to the restrictions placed on the Jewish public sphere. These songs provided a musical vernacular, albeit one acquired first from written tradition.

Already by 1933 the major publishing houses of the Jewish press, Schocken and the Jüdischer Verlag, began to publish more and more music, placing it in their most popular series, such as the "Schocken Bücherei" (Schocken Library). Almanachs and other popular series published by these houses frequently included music, again signaling that it was increasingly a part of the everyday literary prac-tices in a Jewish community in crisis. It was in the 1930s that the music book became the means for exporting Jewish music from Germany. Songbooks such as Jacob Schönberg's *Shireh Eretz Yisrael* (Songs of Eretz Yisrael) and Fritz Mordechai Kaufmann's *Die schönsten Lieder der Ostjuden* (The Most Beautiful Songs of the Eastern Jews) began to appear in published editions in the Yishuv, and then later in Israel, where one can still purchase them today. At the beginning of the twenty-first century these Jewish music books serve historicism. Israelis do not sing from these books, but rather recognize in them the narration of the past. Their function as songbooks in modern Israel, paradoxically, is not essentially different from that in 1930s Germany.

The Jewish music book became the site for inscribing a new public Jewish music. The importance of this shift cannot be underestimated at the moment of destruction in the Jewish community of Germany, for the music book became an essential link for the oral transmission of music. It also became an essential link to the music cultures constructed by emigrants from Germany in North and South America as well as in Israel. Without the music book, much of what we know to be

Abbildung 1: „Zirkus-Knorke-Lied", in: „Kinderecke" 1934, S. 12

Wir sind der Zirkus Knorke!
Wir zaubern, stemmen, schlagen
wir biegen Eisen wie nen Draht, [Rad,
ganz knorke, edelknorke.

Wir sind der Zirkus Knorke!
Wir haben einen prima Clown,
det so wat jibt, det jloobt man kaum,
janz knorke, edelknorke.

Wir sind der Zirkus Knorke!
Bei uns tanzt Lilo Filorin,
die Akrobatiktänzerin,
ist knorke, edelknorke.

Wir sind der Zirkus Knorke!
Wir führen Tierdressuren vor,
ne Sensation für Aug und Ohr,
ganz knorke, edelknorke.

Wir sind der Zirkus Knorke!
Der Schützenkönig Orizon
ist unsre größte Attraktion,
ist knorke, edelknorke.

Wir sind der Zirkus Knorke!
Bei uns ist jedermann ein Star
und jede Nummer wunderbar,
ganz knorke, edelknorke.

Wir sind der Zirkus Knorke!
Was Sie hier sehn für wenig Geld,
ist einzig in der ganzen Welt,
ganz knorke, edelknorke.

We're the fine hoity-toities of the circus!
We make magic and put everything in a row,
We bend iron as if it were but a wire [wheel],
Very fine, very fine indeed.

We're the fine hoity-toities of the circus!
We have a first-rate clown,
No one could believe that there is such a thing,
Very fine, very fine indeed.

We're the fine hoity-toities of the circus!
Lilo Filorin dances at our circus,
She's an acrobatic-dancer,
Very fine, very fine indeed.

We're the fine hoity-toities of the circus!
We present you with the wild-animal show,
A sensation for eye and ear alike,
Very fine, very fine indeed.

We're the fine hoity-toities of the circus!
Orizon, the strong man,
Is our biggest attraction,
Very fine, very fine indeed.

We're the fine hoity-toities of the circus!
At our circus everyone's a star,
And every act's fantastic,
Very fine, very fine indeed.

We're the fine hoity-toities of the circus!
What you see at our circus for almost no money
Is unique in the entire world,
Very fine, very fine indeed.

FIGURE 4.5 "Das Zirkus-Knorke Lied"/"The Song of the Circus Hoity-Toities." In the "Children's Corner" of the *Monatsblätter* of the Berlin Jüdischer Kulturbund.

European Jewish music today would not have survived the Holocaust. The Jewish music book provided a means, however paradoxical, of negotiating the destruction of the Holocaust and World War II, and accordingly, it moved Jewish music into the global public sphere in which we now know it to exist.

EXCURSUS 2: COMPOSING THE CANTORATE,
INVENTING OTHERNESS

Worlds of Musical Otherness

The invention of Jewish music in the modern era exposed its otherness and in-
scribed that otherness in such ways that it would circulate in a modern public
sphere. Modernity was predicated on an expanding public sphere that comprised
ethnic, religious, and racial difference, but its anxiety about the proximity of oth-
erness also expanded exponentially. As Jewish music entered European society, it
paved the way for the entry of musicians who had not previously participated as
musicians outside the Jewish community. There were few more important agents
of musical engagement with the public sphere than the cantor, one of the most
modern of all inventors of Jewish music, and a musical professional who pushed at
the very boundaries between selfness and otherness.

Otherness in European music history has historically assumed many different
forms. Prior to the rise of modernity, otherness occupied positions primarily at the
peripheries of Europe. During the modern era, however, the otherness of the pe-
riphery increasingly shifted toward the center. We witness that shift in the increasing
presence of Rom music and musicians in the musical styles and traditions of nine-
teenth-century Eastern Europe. Franz Liszt both celebrated and decried that pres-
ence; Béla Bartók, repelled by the Romness of *magyar nóta,* urban popular music,
inveighed against it in highly racialized language. Europe's musical others have not all
been imagined in the same ways. The other at the center and the other at the periph-
ery are quite different, and that difference is essential to an understanding of how
Europe has constructed otherness in defining—and defending—its selfness. Funda-
mental to these different forms of otherness are the ways in which they configure
Europe's sense of its own geographic and historical spaces. The other without exists
at the "edges of Europe," even at the "rim of the world." Encountering and gazing
upon the other at a distance, even when enclosed in museums or inscribed as some-
thing mysterious in a travel book, generate both awe and wonder. The self is thrown
into sharper focus and historically redefined with rubrics such as civilization.

With the rise of modernity, many came to view European history—and music
history—as a dialectical conflict between selfness and otherness. A challenge to Eu-
rope's spaces resulted from this conflict and from the different ways in which other-
ness increasingly intruded upon those spaces. Modern European history is legible, it
follows, as a competition for spaces, and urbanizing Central Europe, which figures
in the historical narrative of invention, encountered the competition in increasingly
complex forms as its peripheries were reined in during the nineteenth and twen-
tieth centuries. Music marked and narrated the competition in Central Europe in
many ways. The broadside sellers and street hawkers performing popular music
on the streets made the encounter with the other impossible to avoid, and indeed
it was often in popular songs during the eighteenth and nineteenth centuries that
Europeans encountered otherness as it entered the public sphere.

If it is the transformation of spaces within Europe that creates the encounter
between self and the other within Europe, the capacity to enter the public sphere

afforded Jewish musicians the chance to enter Western music, itself a sphere of self-ness. Cantors changed the nature of the spaces that musically defined the Jewish community and that then became an extension from the community into the non-Jewish world. The processes of musical invention were considerable, especially with the effect of the cantor on the demystification of the musical speech understood to characterize Jews. The use of secular vernaculars, the absorption of tonal harmony to give voice through new polyphonic textures to the entire Jewish community, and the performance of new compositions in public, all were major transformations of the musical speech of European Jews. The demystification of Jewish musical speech symbolizes the conditions of confrontation between self and other, which in turn led to the attempt to end the history of that confrontation: the Holocaust. Understanding the role of music in that history, however, requires that we imagine the public spaces created by the musical specialists of the Jewish community, the cantors, who were intensely aware of their growing proximity to European musical selfness.

The Cantor's World

In the nineteenth century the cantor's world became that of the stage. The stage empowered the cantor to transform both the sacred spaces of the synagogue and the public spaces outside the synagogue. It was from the stage that the cantor was able to enact the transformation that was so crucial to changing otherness in the Jewish community. Historically, the stage upon which the cantor performed changed in the way it permitted the musical specialists of the community to mediate identity, an identity ascribed by different representations of Jewishness through music. The cantor's world expressed itself as a stage not merely metaphorically, but quite intentionally, because the raised pulpit of the synagogue from which the cantor sings has the Hebrew name *bima* (the area of the pulpit). In theatrical usage, the bima is quite literally a stage, as in the name of the Israeli national theater, *Habima* (The Stage). The Yiddish *bine* (stage, related etymologically to the German *Bühne*) further complicates the etymological mix. The cantor's stage also functioned as a catalyst because of the identity of professionalism that it ascribed to the cantor himself. From the stage, the cantor could shape his own profession, serving the community but also providing consumable goods, for which he could expect financial compensation. The increasing value of those goods during the nineteenth and early twentieth centuries went hand in hand with the cantor's capacity to identify himself as a professional and an inventor of Jewish music: as a composer of the cantorate.

Already in the early Middle Ages the position of the cantor in Jewish life was one of the most important professions embedded in the polity of the community. In community records, as well as in rabbinical discussions concerning the nature of Jewish polity, the cantor was first identifiable as the ḥazzan (from the root ḥet–zayin–nun [ח–ז–ן]), the Hebrew word that today exclusively identifies the cantor. Prior to the modern era, however, the ḥazzan was responsible for diverse activities in the community, ranging from the religious education of young males to the general maintenance of the synagogue (see Elazar and Cohen 1985). Among these early ḥazzanim were those who also had musical duties, but these were in no sense aesthetically separable from community life. The ḥazzan was in reality more a figure

whose professionalism was defined by service to the community, witnessed by the later use of the terms *Diener* (one who serves) or *Tempeldiener* (one serving in the synagogue) in Yiddish and German.

The specific professional connection of the ḥazzan to music first developed during the modern era, after the Reformation when European Jews gradually began to acquire rights to participate in social and financial activities outside the Jewish community. Still prior to the Enlightenment, the figure of the cantor, often with this Latin form, appears in the official records of Jewish communities because they paid taxes, signaling a turn in the degree of their professionalization (see the discussion of Burgenland cantors in chapter 1). During the Enlightenment the position of the cantor increased significantly. It was also during the Enlightenment that the cantor began to assume a central role in the musical life of emigrant communities, particularly those in North America. Mark Slobin has observed that the cantor appears far more often in early American synagogue records than does the rabbi, a fact Slobin interprets as reflecting the role played by the cantor in building new Jewish communities around synagogues in the New World (Slobin 1989: 29–50). During the early nineteenth century the Central European cantor also acquired a more dominant public presence than that of the rabbi, and by the end of the century this public presence developed to such extreme popularity that those with great voices or those particularly active as singers outside the community, for example in opera, had achieved the status of stars.

The changing world of the cantor unfolded according to local variants. In Vienna the financial position of the cantor improved substantially throughout the nineteenth century. At the beginning of the century it was impossible for a Jewish artist or musician to earn money in any sort of public capacity. With the passage in 1817 of an Edict of Tolerance, Jews gradually won the possibility of holding so-called free professions, though these were subjected to taxation. Finally in 1848 Vienna officially removed the heavy tax burden placed on Jews earning money outside the Jewish community, and Jews could hold positions in the public sphere without special burden (Avenary 1985: 72–75). It was precisely during this period that Salomon Sulzer's career spread well beyond the Jewish community and his status as one of Vienna's leading musical figures was assured. At the same time, other musical positions in the synagogue underwent professionalization; for example, some members of the chorus also earned a living as musicians outside the Jewish community. By the end of the nineteenth century a musician in the service of the synagogue could earn his living as a professional musician in Vienna as well as in other Central European urban centers with growing Jewish populations.

Modernization of the Ḥazzanut

Whereas the ḥazzan had occupied a position in the polity of the Jewish community since the European Middle Ages, the cantor was a nineteenth-century invention. It is entirely appropriate to refer to the cantor and his modern profession as inventions, for the cantor owed something of his position in Jewish communal life to the myriad tasks of his predecessor, the ḥazzan, but he was able to recombine these tasks, to discard those that had little to do with music, and to participate in the invention of a modern tradition, the ḥazzanut, or cantorate. The modernity of the cantorate is

central to Slobin's history of the American cantorate (Slobin 1989: xi–xii and passim). The rise of the cantorate signaled a change in the position of music in the life of the community, fundamentally a shift to the center. That shift is clear even in the ontology of the cantorate itself, in other words how we might understand what the cantorate became during the course of modernity. On the one hand the ḥazzanut was the tradition of music performed by the cantors, who by extension embodied the music of a community, be it a city such as Amsterdam, be it a regional tradition, be it the specific repertory of a synagogue (Bloemendal 1990: Vol. 2). On the other hand, the cantorate was a genealogy of ḥazzanim and cantors, the very lineage of musical leaders who passed the musical tradition from one generation to the next (see Bloemendal 1990 for the genealogy of the Ashkenazic cantorate in Amsterdam from 1635 to the present). The convergence of these two concepts of liturgical music—one growing from repertory and ritual practice, the other from the agency of performance and professionalism—paralleled the accelerated spread of modernity through sacred Jewish music, particularly in Europe and as a condition of European modernity. Cantors thus embodied the musical essence of the community, and I emphasize *musical* essence. The Jewish community turned to the cantor when it participated in a public celebration, and when it made a gesture that reached out to those holding political power. Among the gifts to Empress Elisabeth of Austria-Hungary on the occasion of her wedding to Franz Josef I in 1854, for example, was a composition by Vienna's Chief Cantor, Salomon Sulzer (see Figure 4.6; cf. with the "Song of Remembrance" to the same emperor, Figure 4.2).

The emergence of cantorate in the nineteenth century allows us to recognize explicit changes in the creation and transmission of music. The cantor had become a professional, whose livelihood could depend on the performance and creation of music for his community and beyond. By the late nineteenth century the rise of the cantorate had further led to the invention of a public sphere for Jewish music itself. The cantor's role in establishing a new Jewish musical public emerges in the spate of cantorial publications that began to appear in the middle of the century and accelerated sharply by the end, for example, the *Österreichisch-ungarische Cantoren-Zeitung* (The Austro-Hungarian Cantorial Newspaper). A biweekly publication, the *Cantoren-Zeitung* owed its initial success to German cantorial newspapers from mid-century, such as *Der jüdische Cantor* from Hamburg and the *Liturgical Journal* examined in the opening pages of this chapter.

At first glance, the cantorial newspaper of the Habsburg cantorate might look like any other late nineteenth-century professional journal. There were guides to better singing, ads for religious and nonreligious books, and even serialized novels, some even with titles such as *Der Baal-Tephillah* (The Prayer Leader). The professionalism of the Habsburg cantorate was evident in the advertisements that filled the final pages of each issue (e.g., Figure 5.2 in the next chapter). The *Cantorial Newspaper* signaled musical exchange between Ashkenazic and Sephardic traditions. Its editor, Jacob Bauer, was the ḥazzan at the Türkisch-Israelitische Synagoge, the largest Sephardic synagogue in Vienna. The *Cantorial Newspaper* also contained new compositions, with suggestions for incorporating them into the sacred service (see Figure 5.1). Each issue contained news items about performances in Vienna, Budapest, Sarajevo, Baghdad, Jerusalem, or San Francisco (e.g., the "Brief Chronicle"

FIGURE 4.6 Salomon Sulzer: "Psalmodie" (1854). Composed as a wedding gift for
Empress Elisabeth of Austria-Hungary.

about David Meyerson at the beginning of the present chapter). In the *Cantorial
Newspaper* the local stretched its boundaries beyond the regional and the national to
the international and the imperial.

The *Cantorial Newspaper* leads me to make a crucial aesthetic point: By the end of
the nineteenth century the modernity of the Jewish public sphere had undergone a
transformation to the modernism of Jewish music (see Schorske 1998, esp. chapters
8–11). Aesthetically, the modern shifted from the social conditions of music-mak-
ing to the music itself, effecting a transformation from object to aesthetic practices
determined by complex subjectivities. Modernity had endowed Jewish music with
the capacity to express an aesthetic that was independent of its Jewishness. Jewish
music had been dislodged from the sacred time of the synagogue.

Conversely, the sacred traditions of the synagogue had themselves undergone
the transition to Jewish music, allowing musicians from outside the synagogue to

perform them as Jewish music in a vocal style entirely independent of synagogal tradition. An essential paradox arose, however, namely that this autonomous aesthetic allowed the music to be Jewish but not to be subject to questions about what makes it Jewish or whether it is Jewish at all. This aesthetic autonomy lies at the core of Jewish musical modernism. Precisely that autonomy opens up the discussion of musical modernism and the decisive contributions of Jewish composers, musicians, and critics to it.

Cantorial Conversations between Jewishness and Westernness

As it was for the musical professional of the Jewish community, the nineteenth century was a time of transformation for the Central European synagogue. Throughout the century many new synagogues were built, but just as significantly the new structures led to an intersection between sacred and public realms (for contrasting perspectives on the Viennese Stadttempel, the city's central synagogue, as a symbol of religious, social, and musical transformation during the nineteenth century, see the chronicle of its rebuilding after World War II; Israelitische Kultusgemeinde 1988). For the first time, men and women mixed in the liberal synagogue, which meant that musical voices mixed within the spaces of the synagogue, not only male and female voices within the new polyphonic texture of the liturgy, but also the voices of musical instruments (e.g., the organ) and of musical specialists. Because the new musical voices within the synagogue drew attention to major issues of religious conflict, they also became the focus of new questions about the public sphere within the Jewish community. We witness the importance of these debates in articles such as the one devoted to the *Orgelstreit* (battle over the organ), which appears in the major dictionary of Jewish culture in German-speaking *Jüdisches Lexikon* (see Max and Seligmann 1930: columns 601–4; for a study of the significance of the organ in Viennese synagogues, see Frühauf 2003; Frühauf 2005; Frühauf 2008). What was, then, the music of the synagogue, and how was it distinguished from other types of Jewish music outside the synagogue?

The polyphony of the music in the synagogue, its new form of mystical speech, symbolizes the structural transformation of the Jewish community itself. For the first time, the sanctuary was truly a public space. Prior to the nineteenth century such a structural transformation would not only have been unthinkable but also entirely improbable, for the partition between the sanctuary, representing the Jewish world, and the secular realm of the non-Jewish world was absolute. Already in the 1820s and 1830s the boundaries around the sacred space of the synagogue were becoming permeable, with movement across them into the public sphere frequent (Elbogen 1993 [1913]: 297–333). Among those who most often enjoyed the new permeability of these boundaries were cantors. It is not exactly the case that the public activities of cantors should be understood as secular, but rather they were politicized through participation in a public sphere that had begun to tolerate a Jewish presence. In the case of Salomon Sulzer, who was active in the liberal politics that followed upon the heels of the Biedermeier Era in the nineteenth century, we witness a clear example of just how extensively Jewish, public, and political musics

could enter into a new mix. At the height of his career Sulzer set many texts that stressed an open nationalism, particularly during the revolutionary year of 1848 (e.g., the "Nationalgarde-Lied," whose text appears in Avenary 1985: 107–12). Sulzer's musical fame was transformed through his activities in the public sphere. He sang not only from a stage bounded by the symbols of the sacred Jewish world, but also from the public stage of Viennese society.

By no means was the transformation of the music in the synagogue an isolated phenomenon; rather it was symptomatic of a fundamental transformation in the life—and musical life—of the Jewish community. The sweeping cultural change within Jewish musical life reflects the historical processes Jürgen Habermas traces from the European social spaces of the Enlightenment until the present, with private domains persistently giving way to an omnipresent public sphere (Habermas 1962). Habermas further portrays the unfolding public sphere as a space in which cultural practices are popular in the broadest sense, that is, accessible to the public as a whole. Prior to the historical transformation of the Jewish community, one could not have spoken of a musical life that was popular in this sense, because music took place in the family or within the *kehilla,* the Jewish community in a historical sense.

In Vienna the transformation made possible other cultural developments, notably the integration of Jews from the eastern parts of the Austro-Hungarian Empire, who were settling in growing numbers in the imperial capital. These new immigrants brought other musical traditions with them. The responses to these new traditions varied, ranging from acceptance as the true Jewish folk tradition to parody, but they spread through the public sphere nonetheless. In so doing, they provided the complex basis for new forms of popular Jewish music-making (see chapter 3). One of the most important conditions for the complex new popular music was language. Each stream of immigration from a different part of the empire brought with it different dialects, which in turn were distinct from the other dialects found in Vienna. Dialect differences often appear in popular songs, marking not only the variety of characters and ethnic types but also social and class distinctions. In Viennese Jewish broadsides, dialect distinctions also lend themselves to representation in different melody types, with Eastern European melodies far more embellished, indeed more mystical, than those of assimilated Viennese Jews (for examples see Bohlman 1989b).

Speech and language played a further role in the historical transformation of Jewish music, not least because of the partial supplanting of Hebrew with German in the synagogue. The linguistic transformation of the synagogue took place only slowly, and in Orthodox synagogues one cannot properly speak of a disappearance of Hebrew; in fact, within the larger community the proper use of language increasingly became a source of strife, thereby creating rifts and factions (Elbogen 1993 [1913]: 308–19). For the musical life of the larger Jewish community this linguistic strife had two immediate results: first, the creation of new repertories to accommodate different languages, and second, the emergence of new forms of musical specialization. The polyphony of synagogal music itself became a metonym for the many voices now constituting the Jewish community.

The proliferation of Jewish dialects of German and different dialects of Yiddish in Vienna had a profound impact on the city's popular culture. Although the

initial transformation of Vienna's public sphere predated the massive immigration of Jews in the nineteenth century, there can be little doubt that Jewish culture, in the process of becoming Viennese culture, was primarily responsible for spurring on the transformation by the turn of the century. The *Wiener Mundart* (Viennese dialect) that contributed to the formation of the genre known as *Wienerlied* (literally, Viennese song, but referring to an extensive repertory of popular song in Viennese dialect) bears direct witness to the specific influences of Jewish dialects (see Wacks 2002: 40–55; see the essays in Schedtler 2004). It was in the public sphere that such linguistic exchange necessarily took place.

In order to transform Jewish music, the cantorate first needed to establish the groundwork for a new popularity. The music itself had to embody recognizably popular traits, in its melodies, in its forms, and in its capacity to connect the listener's experiences of other musics. The performance of liturgical music, moreover, radically recontextualized music within the synagogue, making it resemble the music inside the synagogue and yet represent the much larger world outside. The mixed chorus, for example, symbolized a cross-section of society, and its members increasingly performed not as religious specialists but rather as musical specialists. Performance, arguably, replaced worship, or at least expanded it; the practices of ritual increasingly came to resemble the concert, with its concomitant distance from those listening, who were both worshipers and audience.

The popularity of Jewish music would not have been possible without a growing dependence on print culture, that is, the publication and sale of printed music. The publication of Jewish music took place in three different venues, which require quite different ways of understanding Jewish music. The first venue was the professional world of the cantor. Some cantors sought to use print media to create standard repertories, for local and regional use but also for performance within new liturgical canons. Salomon Sulzer's *Schir Zion* (Song of Zion), the first and most famous of these new anthologies, also demonstrates the ways in which such volumes connected the professional world of the cantor to a popular world beyond the synagogue, and even beyond the Jewish community. The first edition appeared in 1840 and 1841, published privately by Sulzer himself (Figure 4.3). A liturgical anthology such as *Schir Zion* opened numerous possibilities for different liturgical works. A cantor would use the anthology to mix and match, albeit within the appropriate religious guidelines. Each anthology contained numerouscompositional styles, thus allowing the cantor freedom to adapt its contents to his own congregation. The Sulzer *Schir Zion* became the core of a canon known as the *Wiener Ritus* (Viennese Rite). This entirely composed and composite rite functioned within the Austro-Hungarian Empire like other symbols of Vienna, namely as a center of power. It contained compositions not only by Jewish music professionals, but also by non-Jewish composers well-known in Biedermeier Austria—famously, for example, Franz Schubert, whose setting of the 92nd Psalm in Hebrew appears in the first edition of *Schir Zion*. Habsburg cantors did not need to employ the rite, but it was impossible to ignore its impact on Jewish music, its presence within the monarchy, and its expansive influence on Central and East Central Europe.

Print culture also formed the basis for a second kind of Jewish popular song, the broadside. Prior to the mid-nineteenth century, Jewish themes appeared in broadsides almost entirely as anti-Semitic parodies. By the late decades of the century,

however, Jewish broadsides began to appear, revealing that composer, publisher, and consumer were Jews. Some of these broadsides had religious contents, common also for published popular songs, which historically had often relied on moralistic narratives. At an opposite extreme, finally, there were new songs in which intraethnic satires provided the narratives (see chapter 7).

At first glance these new genres of popularizing Jewish music may seem unrelated, but they derived from and were integrated into what Friedrich Kittler has called "discourse networks" (Kittler 1990). Cantors did not compose Jewish broadsides, nor to my knowledge did they appear in the narratives of these popular songs, though there were examples of Jewish broadsides with more traditionally religious themes (see Bohlman 1989b). Still, all these genres relied on the same modes of production and dissemination to create a popular music culture. Composers, whether Viennese cantors or tunesmiths, created a music that was identifiably Jewish, but in the creation of a Jewish identity they took variation and changeability for granted. Though dependent on print culture, the musical genres of nineteenth-century Jewish discourse network were never independent of oral tradition. Each form of musical print medium undergirded new possibilities for what it could mean to be Jewish in the new public sphere of nineteenth-century Central Europe.

The Ḥazzanut as Discursive Space

With more publishing resources at their disposal, Central European cantors re-created their own selfness through their compositions, which increasingly came to represent the cantorate. In Hebrew, the ḥazzanut literally bears the sense of "that created by cantors," though it might be glossed as "the cantorate," meaning the larger group of musical specialists comprising all or most cantors (see Slobin 1989). Both meanings are present in the ḥazzanut created by Central European cantors. On one hand, the anthologies of new works composed for the synagogue were described as components of the ḥazzanut, whereas on the other these works served to reproduce the cantorate itself, the individual creators. In some twentieth-century European traditions, volumes of transcriptions and composition were published simply as the ḥazzanut for a particular community, tradition, or region (see Idelsohn 1932a and 1932b; cf. Bloemendal 1990). The discourse of the ḥazzanut emphasizes passing the tradition from cantor to cantor, each cantor therefore representing the musical life of the community through the living out of his professional service.

As Central European cantors compiled their compositions within the text itself, the compositions that were contained within that text increasingly became a metaphor for the ḥazzanut. The text of the ḥazzanut therefore represented the changing public role of the cantor when, in published form, it circulated in the public sphere. It represented the shrinking Austro-Hungarian Empire through its reconfiguration of different communities, for example as the Viennese Rite that could be purchased and performed in Budapest or Prague. It represented the emancipation of the Jewish community, for the ḥazzanut provided a text from which all members of the community, as well as non-Jews outside the community, could select compositions and perform them in various contexts.

The ḥazzanut invented a discursive space in which the separate metaphorical domains of space and speech came together, in fact were inseparable from each other.

Historically, the ḥazzanut plots a history of the European Jewish community. That history began with the composition of new works to dedicate the new synagogues, with their reconfigured space for musical sound. Cantors gathered compositions from diverse sources to represent the liberal attitudes of these synagogues. When a cantor had composed a sufficient body of works to serve the liturgy of his synagogue during the course of the daily and weekly services and the holidays, these were generally gathered and published as a musical monument, a spatial metaphor appropriate to an age in which monuments symbolized cultural achievement. Sulzer's *Schir Zion* was one of the first examples of a composed cantorial monument; in 1871 and 1876 Louis Lewandowski's *Kol Rinnah u' T'fillah* (Voice of Worship and Prayer) and *Todah W'zimrah* (Thanks and Praise) monumentalized the Reform Movement in Berlin in similar fashion.

THE HISTORIOGRAPHY OF MUSICAL MODERNISM

Few themes of Jewish historiography are as symbolically and ideologically important as the assertion that the present is an extension of the biblical past and that Jewish history has an inevitable teleological culmination in Israel. By no means does the present chapter or the concepts it extends to the entire book undermine this assertion, but the concepts of inventing music I apply here do subject the nature of the relation between present and past to a different type of scrutiny. Modern Jewish music offers no more than a reflection of the past, for it was a modern historical imagination that made that reflection possible. Most striking is the powerful mentalité that willed this reflection into being and then invested it with shared historical meaning.

Similarly, the representation of the historical past with specific musical symbols that preserve music in oral tradition also undergoes a challenge. Perhaps no single construction of music-historical symbols made that fact more evident than A. Z. Idelsohn's use of Arabic classical music to show the connections with the past. Idelsohn based his historical construction on the idea of isolation of Babylonian or Yemenite Jews from *other Jewish communities,* but we hear in the wax discs he brought from the field that these communities were not isolated from their non-Jewish neighbors. A *bashrav* (a piece of instrumental music) played on the 'ud does not, then, symbolize the earliest stratum of Jewish music. It does, however, symbolize a remarkable ability of Jewish communities in Muslim lands to negotiate culturally with their neighbors (cf. Idelsohn 1917 and Österreichische Akademie der Wissenschaften 2005). Similarly, the liturgical repertories composed by Sulzer and Lewandowski symbolize a musical and cultural negotiation with nineteenth-century Romanticism, not a reconstruction of the music of the Second Temple.

The diversity of Jewish music realized for modernity symbolized change, not stasis, and accordingly it challenges yet another theme fundamental to Jewish historiography, the notion of tradition rendering Jewish society unchanging. I do not espouse structuralist models of history, but I might point out that the binary opposition of myth and history that they claim was, in fact, characteristic of some modes of Jewish historical thought until the modern era, and we witness the opposition of myth and history in the assertions that the connection between any Jewish music

of the present with that of the past is timeless. The invention of Jewish music, however, could not have taken place in a timeless, myth- and past-bound society, for it dynamically articulated responses to change within and without Jewish society.

Accordingly, yet another tenet of Jewish historical thought stands on shaky ground, namely the assertion that any engagement with the other inevitably brings about assimilation and victimization. The musics discussed in this chapter were anything but assimilated; in fact, they intentionally resisted assimilation. Jewish musical culture had never been more diverse or more consciously distinct than it was in the late nineteenth and the early twentieth century. Accordingly, inventing Jewish music also embodied forms of resistance to victimization. At a moment in modern Jewish history when the forces outside the Jewish community made victimization most imminent, the intensive musical activity of the community resisted victimization most vigorously. Jewish musical life was never more vital, never more inventive, than on the eve of the Holocaust. The meaning of Jewish music as cultural identity and historical presence was never more trenchant.

The ways in which I use Jewish music to question certain assumptions common in Jewish historical thought are by no means limited to modern Jewish history. Surely, there is an even greater challenge to Western music historiography. The musics addressed in this chapter may be unfamiliar to most Western musicologists and ethnomusicologists. They do not constitute a canon of Jewish music; they do not appear in chapters devoted to Jewish music in our music-history textbooks; they are musics we do not hear; they are musics "without a history." My purpose here is not to return these musics to history; nor do I return history to them. I have, however, spoken primarily about music history, but about a very different music history. This Jewish music history, ironically, unfolded at the same time and in the same places as modern music history in the West. Many of its historical agents were also active in that modern music history.

Just how, then, did Jewish music make Jewish history? First of all, Jewish music inevitably took its forms from an awareness of the past, but it did so with a creative eye turned toward the present and the future. The fundamentally inventive forces that led to the creation of a modern Jewish music, distinguishing its modern historical context, were the same that shaped a modern Jewish identity and a modern Jewish history. Jewish music was not something that was "out there" or "back then," waiting to be discovered in its authentic forms and presented as if "that's the way it was." Music history and its meanings for us are far too creative, far too vital and shot through with difference, simply to await our acts of discovery. Music makes history because it cannot be reduced to the way it was, but rather in its diversity it provides understanding of the past and present. It was because of Jewish music's remarkable diversity that composer-cantors in the nineteenth century, Jewish folk-song collectors and ethnomusicologists in the early twentieth century, and Israeli composers in the sixty years since statehood all turned to music—to Jewish music—to invest it with the meanings that would empower it to make their own history.

SELF–REFLECTING–SELF: JEWISH MUSIC COLLECTING IN THE MIRROR OF MODERNITY

> When it comes to collecting, what is truly decisive . . . belongs
> to the category of completeness. What is meant here by "com-
> pleteness?" It is the remarkable attempt to come to grips with
> the totally irrational by giving order to its very presence as a
> newly constructed system, in and of itself. For the collector
> every single thing in this system turns into an encyclopedia for
> learning about the historical moment, the landscape, the indus-
> try, and the owner from which it came.
>
> —Benjamin 1982b: 271

MODERNITY AND MEMORYWORK

Jewish museums are troubling edifices on the historical landscape of modern Europe. The greater the distance from the Holocaust, the more troubling the building of Jewish museums becomes. Since the end of the Cold War and the reunification Europe, the Jewish museum has moved from the historical ghetto to the public sphere, literally, that is, from former synagogues on the Judengasse at the edge of town to the center of the metropole, where the traces of World War II were at long last being erased. Immediately after the war, "abandoned" and partially destroyed synagogues and Jewish community centers seemed like the obvious place to locate Jewish museums, gathering the remnants of a broken past. The "Austrian Jewish Museum," for example, was built in Eisenstadt, the provincial capital of Burgenland, rather than in Vienna. The "Jewish Museum of Vienna" would not be completed in its present form until the early 1990s. The architecture of Jewish museums unleashed public debate and criticism, which often threatened the building of the museum itself and, as famously in the case of Daniel Liebeskind's design for Berlin, delayed construction for years. The post-Holocaust Jewish museum possessed an aura of authenticity and agelessness, as if the Jewish past might survive if Jews had not.

By the 1990s, the processes of collecting the Jewish past had outstripped the capacity of the modest, post-Holocaust Jewish museums to contain them. New quarters

were needed because there was more to house. The memorywork that would re-
store the Jewish past to the New Europe was proceeding at a frantic pace. Jewish
families that had survived the Holocaust were more willing to make their collec-
tions public. Those who had escaped or emigrated were motivated by repatriation.
Rebuilding Jewish museums became an act of collecting and recollecting. Urban
planners sought to build the new museums in a postmodern public sphere—in
Vienna's First District at the site of a synagogue destroyed in the Middle Ages, for
instance—and in so doing they aimed to fill a historical void. Would filling the void,
however, remove it? Would modern architectural designs and state-of-the-art display
concepts enhance the meaning of the collections from the past or mask them?

There were also questions raised by the collections themselves. Whose were they,
and for whom should they be made public? What kinds of meanings can case after
case of religious objects project when they are ordered by function or connection
to a particular holiday so that those with little understanding of Jewish life can
have a glimpse into the past? Do public collections necessarily make memory col-
lective, and if so, does collective memory erase the individual memory embodied
in a collected object? Questions about collective memory fill the catalogues and
museum publications (see, e.g., Jüdisches Museum der Stadt Wien 1997/1998).
Beyond the questions of ownership the debate about Jewish museums concerns
itself with agency: Does the museum visitor who has never experienced the past
represented by a collected object engage in remembrance, or does she witness the
past only as a tourist gazing at its traces (for the full range of these issues confront-
ing the Berlin Jewish Museum, the most controversial of all Jewish museums in the
1990s, see Bendt 1997/1998)?

The postmodern debates swirling about the new Jewish museums are them-
selves by no means new. The motivations for displaying the past in collections of
all kinds were crucial also to earlier Jewish responses to modernity. The collections
themselves contributed substantially to the language of Jewish modernism. Jew-
ish music, as a component of Jewish modernity, was also a product of collecting
the Jewish past. During the half-century prior to the Holocaust, collecting Jewish
music had accelerated and reached a feverish passion by the 1920s. As in the build-
ing of Jewish museums, collecting Jewish music required an act of displacement.
What was previously private and functional became public and objectified. In some
respects Jewish music collecting arose from traditional practices, not least among
them the intense respect for ritual objects and for literacy. When the pace of Jewish
entry into the public sphere quickened at the end of the nineteenth century, col-
lecting intensified, making Jewish music collecting a response to the nontraditional,
or more specifically, to the confrontation between the traditional and the nontradi-
tional that formed the tension of modernity.

In this chapter I shift focus to the products that lead to our constructions of
Jewish music history. Perhaps uncharacteristically for an ethnomusicologist, I am
here less concerned with processes than with products, with the "things" collec-
tors collect (Appadurai 1986). I regard collecting and the metaphysical revolution
it brought about roughly from the 1870s onward as crucial to the formation of
Jewish music history. Jewish music and Jewish music history assumed a reified, ob-
jective status during the age of Jewish music collecting.

Music collecting does not just happen. As crucial as the collected object is, the collector, the passionate individual who devotes his or her time (and money) to gathering and ordering the collected object, is a more crucial agent for collecting. In this chapter I look at four case studies of particularly passionate collectors: Friedrich Salomo Krauss, Konrad Mautner, Eduard Birnbaum, and Abraham Zvi Idelsohn. Common to the endeavors of the four collectors is that music collecting became truly modern and that their collecting passion led to a truly modern memorywork devoted to reflecting on the past, on Jewish music history.

Memorywork and modernity are made possible by what I here call a "virtual museum of Jewish music," borrowing and varying Lydia Goehr's concept of an "imaginary museum of musical works" (Goehr 1992). The terms "collecting" and "collection" should be understood to have the broadest range of meanings, as, indeed, they were employed in the age of Jewish music collecting. Collecting, at root, is an act of individual compulsiveness, "an unruly passion" (Muensterberger 1993). Collecting is inevitably a very physical act, with bodily and psychological implications. Collectors are restless, and they occupy their spare time by visiting places where they may find objects to add to their collections. The collection becomes a reified object, with exchange value in a capitalist political economy of modernity. Collecting, finally, requires conscious, rather than random, technologies and discourse of dissemination, which transform collecting into a means of cultural translation. Jewish music collecting, considered in the broadest sense, spawned a new metaphysical discourse, which objectified Jewish music and laid the foundations for Jewish music history as an essential foundation for Jewish modernism. The contributions of Friedrich Salomo Krauss, Konrad Mautner, Eduard Birnbaum, and, above all, A. Z. Idelsohn were crucial, even catalytic. We cannot overestimate the legacy of such passionate and unruly collectors as we turn our attention from the nineteenth to the twentieth century.

JEWISH HISTORY AS COLLECTION

The Jewish passion for collecting was first evident in the emerging print culture of early modern Europe. Jewish musicians in late Renaissance Italy, such as the distinguished Mantuan composer Salamone Rossi (ca. 1570–ca. 1628), entered the public sphere as Jews *and* musicians primarily in the forms of published collections of their works (Harrán 1999: 201–41). Though Rossi was active musically in the Mantuan Jewish community throughout his life, it was only in the last decade, roughly 1818–1828, that his "Jewish works"—compositions with Hebrew texts, intended for use within the Jewish community—appeared in print. During the same period, anti-Semitism was dramatically rising in Mantua and northern Italy, and publication of Rossi's Italian vocal and instrumental works, which had dominated his output entirely for three decades, fell off sharply.

Early forms of Jewish music books too bear witness to the propensity to collect. In early modern Europe books were used to gather the *minhagim* (Hebr., "customs") of different communities or to connect a community's cantorial genealogy as a single ḥazzanut. The number of books bearing titles beginning with the words "collection" or "Sammlung" is quite remarkable (see, e.g., Ulrich 1768,

and Eichborn 1834). Printed books were elaborate and costly, and they preserved Jewish traditions so that readers could visit them again and again to gaze upon the past. Not insignificant as a further factor for the use of printing to support collection is the exceptionally important role played by Jews in the expanding print culture of early modern Europe. Jewish printers, among them music printers, were extremely important in Italy, especially in the cities and regions settled by Sephardic Jews. Early printing endeavors flourished in other regions of Europe with relatively heavy Jewish settlement, such as in the *sheva kehillot* of Burgenland.

In European Jewish communities during the early centuries of print technologies, rabbis and merchants often collected books and prints and then kept their libraries intact as sources for communal history. It is through such collections that we frequently find our way to a more complete understanding of the Jewish community of early modern Europe. The first ballads and broadsides employing Hebrew orthography survived because they were part of collectors' libraries. The earliest "Jewish version" of a German ballad, "Graf von Rom," from ca. 1600 was preserved in the library of the rabbi of Fürth, Henoch Levi (Süß 1980; cf. Bohlman and Holzapfel 2001: song 13; see also the "Prologue" to the present book). We are indebted, indeed, to many early modern Jewish intellectuals for collecting printed and manuscript versions of folk songs (see Rosenberg 1888).

As European Jews encountered modernity, the collection provided a means of negotiating between tradition and entry into the public sphere. Eighteenth-century communities had begun to accumulate enough collected materials, including cantorial manuscripts and music of other kinds, that they created what have been called *genizot,* areas used to store manuscript and printed materials bearing the divine name, thus making it improper to discard them. The term *geniza* (the Hebrew root *gimmel–nun–zayin* [ג–נ–ז]) specifies a range of meanings from concealing and hoarding to archiving and storing) and refers to the practice of the Cairo Jewish community. Modern scholars have used the documents of the Cairo geniza to reconstruct the community's history and musical life, and attention has recently been focused on use of the document collections of the European genizot to enrich the histories of many European communities. Critical to the role of the geniza for the history of collecting is therefore a shift of intent and function, from the premodern depot, whose contents would not be reused, to a modern recontextualization as a place of collection and historical utility (see Goitein 1967–1993).

In nineteenth-century Germany it was one goal of the Wissenschaft des Judentums to establish a tradition of gathering in fragments of identity and changing identity to create a new virtual museum of selfness. Leopold Zunz, transforming the historicist, activist agenda of the Wissenschaft des Judentums into publications for consumption by an educated nineteenth-century public, gathered and printed diverse collections of different genres from religious writing, ranging from liturgical and poetic works, subsumed under the designation *Poesie,* to the collected sermons of important rabbis (cf. Zunz 1832 and Zunz 1855; see also Wiese 1999).

One of the most striking conditions of the collection at the turn of the twentieth century was that, despite its institutional superstructure, it was fundamentally the activity of an individual. Eduard Birnbaum (see below) is an obvious case in point, but he was not an isolated case, as the sketches of Friedrich Salomo Krauss

and Konrad Mautner illustrate. Max Grunwald collected extensively under the auspices of his Society for Jewish Folklore, but most of his collections appeared under his name alone. Collectors came in all sizes and shapes, and this was no less true for collectors of Jewish music than for other types of collector. Theories of collecting focus on either the personal or the public side of the collector's motivations. Many collectors are driven by the personal need to gather as much as possible to enable intensive self-reflection (e.g., Pertinaz 1996 and Muensterberger 1993). There are other collectors who seek to make gathered materials available to the public, and it is for this purpose that the museum is best suited (e.g., Elsner and Cardinal 1994, and Pearce 1998).

Among the diverse sizes and shapes in which Jewish collectors come, there is the collector who gathers traces of his or her own selfness (Muensterberger 1993). We might think here of the cantor collecting works that together constitute a community's liturgical corpus (see, e.g., Bloemendal 1990). There is the collector located at historical, geographical, and psychological distance from the object to be collected (Elsner and Cardinal 1994). Another type of collector is interested in filling the museum to flesh out the skeleton of history (Pearce 1992). We might think of the inveterate collecting activities of Abraham Zvi Idelsohn, seemingly aimed at collecting *all* of Jewish music. Jewish collecting has been partially theorized—by, among others, Walter Benjamin (e.g., 1982b)—but it still remains necessary to turn closer scrutiny toward Jewish music collectors to expand and refine the theoretical framework, and to locate the great Jewish music collectors in it.

THE JEWISH MUSIC COLLECTION BETWEEN
TECHNOLOGY, GEOGRAPHY, AND DISCOURSE

In the early decades of the twentieth century it was the formation of a concerted discourse that could be applied to a wide range of collections that marked the emergence of Jewish music history as a condition of modernity. The turn-of-the-century collection, having initially spawned journal reports and articles, began to yield a new genre, the monograph devoted to Jewish music. Such monographs located Jewish music in time and space and anchored Jewish music in the empirical evidence of the collection. These monographs form the basis for twentieth-century Jewish music historiography, but attempts to establish the extent to which they were made possible by collectors and collecting still remain inchoate.

As cantors and liturgical scholars began to use the monograph to survey religious music, they drew upon generations of cantors who had preceded them. An enormous tradition of collecting, for example, lay behind Aron Friedmann's widely disseminated *Der synagogale Gesang* (1904). Secular Jewish music histories too were the products of lifelong collectors, as was the case with Paul Nettl's *Alte jüdische Spielleute und Musiker* (1923). Paul Nettl was an inveterate collector, and his seminal study of Jewish instrumental traditions takes shape as an interpretive exegesis of the crucial works on Jewish music that were in his personal library, not least among them, publications by Eduard Birnbaum about Birnbaum's own collection.

The age of Jewish music collecting underwent a transition of enormous proportion in the decade after Eduard Birnbaum's death in 1920. The age did not so much come to an end as enter a stage of technological revolution, in which recording machines collapsed distances and reconfigured the geographic and historical distances collectors needed to travel in pursuit of their object. New technologies also engendered new ontologies of Jewish music, or rather a confluence of different ontologies, creating the possibility for a single, expansive ontology of Jewish music. Idelsohn's fieldwork in the Yishuv is an obvious case in point, for it was made possible by the wax-disc recorder made available by the Austrian Academy of Sciences and designed to facilitate state-of-the-art comparative linguistic analysis. Several other scholars used wax cylinders to expand existing sound collections, for example Gotthold Weill, who conducted field studies of Jewish prisoners of war during World War I and whose recordings still survive in the Lautarchiv of the Humboldt University in Berlin (see Weill 1925, and the Lautarchiv Web site, http://www.hu-berlin.de/lautarchiv).

During the 1930s the collection of Jewish music had fully entered a new era, not least because of the newly perceived need to move the collection from imminent danger. The collection of Jewish music itself underwent a process of objectification, allowing it to be freighted across the diaspora. This was surely the case for the World Centre for Jewish Music in Palestine, which defined its mission as that of collecting Jewish music and musicians on a massive scale (Bohlman 1992). The fact that the World Centre's founders, Salli Levi, Hermann Swet, and Joachim Stutschewsky, failed in their attempts to house the music and many of the writings gathered for the World Centre made it a virtual museum. The two numbers of the journal *Musica Hebraica* and the archival materials for two subsequent numbers, which never appeared in print, were the most concrete form assumed by the virtual museum in the 1930s. Looking back on the age of Jewish music collecting, it would seem almost as if the passion to collect Jewish music presaged survival and led to the formulation of an archeological vocabulary for the memorywork with which we approach Jewish music in a post-Holocaust world.

COLLECTING, COMMUNITY, AND THE ONTOLOGY OF JEWISH MUSIC

If the collection was an ontological precondition for Jewish music and Jewish music history, it proves enlightening to turn briefly to the metaphysical prehistories of Jewish music, the protocollecting stages *avant la lettre*. It is hardly surprising that the consolidation of the cantorate in the public sphere during the eighteenth and nineteenth centuries provides some of the most obvious evidence for just such a metaphysical prehistory. When the cantorate entered the public sphere—initially the public sphere of the Jewish community but then spilling over beyond the boundaries of the Jewish community—it used collections of cantorial music as a means of engendering cultural and musical translation. The collections of cantorial music, which for many remain one of the staples of the music collection, serve to gather tradition from specific places, replete with dialects and variants. As cantors began to introduce their traditions into the public sphere during the nineteenth century,

collections such as Sulzer's *Schir Zion* (1841) came to function as virtual museums, even to the extent that exhibitions were expanded and modernized during the nineteenth and early twentieth centuries. It lay both within and outside tradition, for example, that cantorial anthologies accumulated more versions, composed and borrowed from other traditions. The cantor therefore assembled different services by drawing from the collections that were increasingly available (see chapter 4).

Pushing the metonymic relation between the cantorate and the Jewish music collection a bit farther, we might imagine the cantorial journal and other means of public communication between and among cantors as museum catalogues. Indeed, it is critical not to underestimate the importance of journals and publications as means of dissemination—or making collections available—in the age of Jewish music collecting. Some of Eduard Birnbaum's most important essays, as well as descriptions of his collections, appeared in *Der jüdische Cantor*, such as his "Briefe aus Königsberg" ("Letters from Königsberg") during 1883–1884, and he published regularly in the *Allgemeine Zeitung des Judentums* and with some regularity in the *Österreichisch-ungarische Cantoren-Zeitung*. Even Birnbaum's initial study of Jewish musicians at the Mantuan court appeared in the *Kalender für Israeliten*, an annotated "calendar" but also a genre of periodical (Birnbaum 1976).

Several of the Jewish music collectors discussed in this chapter relied on journals as the foundation for a new discourse. Both Friedrich Krauss and Max Grunwald relied extensively on the journals they themselves published, first as a combination of bricolage and colportage, but later as a means of redisseminating Jewish music as an objectified whole (e.g., Grunwald's *Mattersdorf* volume of 1924/1925). It is precisely the dual processes of collection as bricolage and colportage that were fundamental to the ways in which cantorial journals functioned (see, e.g., figures 5.1 and 5.2, two pages from the *Österreichisch-ungarische Cantoren-Zeitung* from the early 1880s). In Figure 5.1, chief cantor Abraham Baer publishes lithographs of two versions of the "Hodu le-Pesah," a liturgical genre for Passover. The two versions, reduced for cantor, choir, and organ, contribute to the bricolage of the *Cantoren-Zeitung* more than to its liturgical function, appearing at considerable distance from Passover in the liturgical year (i.e., in the early spring). The advertising pages of the *Cantoren-Zeitung* provide striking instances of colportage, for they juxtapose advertisements in which the cantors themselves offer their wares—compositions and entire anthologies (e.g., Baer's *Baal T'fillah* and Goldstein's *Schire Jeshurun*)—and competitions (*Concurs*) for new posts, with advertisements for wares sold by businessmen, be those wares books, pianos, or H. Bauer's "least expensive source of shoes for men, women, and children" (see Figure 5.2, upper left-hand corner). By serving as a means of colportage for goods of all kinds, even with its emphasis on liturgical music and cantorial concerns, the cantorial journal also served as a means of collecting something for everyone.

LOSS AND RECOVERY OF SELF: FRIEDRICH SALOMO KRAUSS

From his youth Friedrich Salomo Krauss (1859–1938) collected everything from the world around him. Born in a small Jewish community along the current Serbian-Hungarian border, Krauss grew up in the multicultural and multireligious cultural

FIGURE 5.1 Abraham Baer: "Hodu le-Pesah," as a "Musikbeilage." (In *Österreichisch-ungarische Cantoren-Zeitung,* July 22, 1883)

environment of the Habsburg Monarchy. His father was a small shopkeeper but also a village intellectual, whose command of five languages made it possible for him to accumulate tales and customs from the multiethnic world at the northern fringes of the Balkans. Friedrich Krauss was one of the founders of modern Austrian folk-loristics, but he was also a radical intellectual, one of the first Viennese scholars to research sexuality and deliberately to employ feminist perspectives.

Krauss's interest in music was grounded both in the study of Balkan epics and instrumental music traditions and in the publication of Jewish folk songs from throughout the Habsburg Monarchy. Also shaping his interest in music was a

FIGURE 5.2 Advertising page in *Österreichisch-ungarische Cantoren-Zeitung,* April 19, 1884: 8). The advertisements on this single page run the gamut from clothing at the top to three volumes of cantorial works (Rubin, Goldstein, and Baer) on the left-hand column, to printing and pianos in the right-hand column, to competitions for cantorial posts in the two advertisements in the lower right-hand corner. Both secular (shoes and pianos) and sacred (synagogue robes) wares and professional undertakings are advertised. The advertisements also reach from the capital Vienna to the imperial provinces (Trnva, Slovakia, in the lower right-hand corner) and beyond (to the cantorial compositions of Abraham Baer for Göteborg, Sweden, in the lower left-hand corner).

passion for dialects and languages, which he had acquired from his father. Among the journals that he edited during his diverse career was *Volksmund* (literally, mouth of the folk), which served as a repository for folklore and folk songs in dialect. Krauss's research into sexuality also intersected with his folk-song collecting, for he demonstrated a special passion for genres that, in one way or another, had sexual themes, especially *Schnaderhüpfl* (glossed as quatrain; cf. the *Gestanzeln* in chapter 9).

His publications dedicated solely to folk song were not from the multicultural periphery but rather from the center, that is, from the alpine areas of Styria in central Austria, where he gathered songs that were explicitly sexual and scatological (cf. Blümml and Krauss 1906; Krauss 1890). These collections, when compared with others from the turn of the twentieth century, succeeded in diversifying the canon that Austrian folk-music scholars were attempting to construct at that time.

Krauss's collecting accrued an impetus all its own. Variation was seen as natural, and the anthology of folk song was no longer of interest simply because it confirmed a national canon, but rather because it documented a vast range of differences. The collection, therefore, turned notions of tradition inside out. Friedrich Krauss is even more interesting as a collector than as an ethnographer ideologically engaged in shifting Jewish culture from the periphery to the center of the European public sphere. Living in fin-de-siècle Vienna, he saw himself drawing in the margins and gathering as many traces as possible from the Monarchy's others. Krauss used his ethnographic journals, notably *Am-Urquell* and *Der Urquell,* to gather in collections from professional and amateur folklorists, who would send him collections, and he in turn would publish them intact under titles such as "Judendeutsche Volkslieder aus Russland" (Jewish-German Folk Songs from Russia; e.g., Peretz 1898: 27–28). These collections and columns were heavily annotated, with Yiddish words printed in the footnotes in their proper Hebrew orthography. For the six songs sent by L. Peretz to the first number of *Der Urquell* in 1898 there are 107 footnotes. Krauss worked with his collectors, directing editorials to them, with titles such as "Ein offenes Wort an Sammler" (An Open Word to Collectors), effectively creating a team of collectors. At the end of a journal issue, he regularly included a column of "Mittheilungen" (Communications), which was particularly devoted to the "Sprichwörter galizischer Juden" (Sayings of Galician Jews).

Friedrich Krauss used the collection toward political and polemical ends, to provide convincing ethnographic evidence that Jews were not Europe's internal others. *Am-Urquell* and *Der Urquell* provided Krauss with an intellectual weapon against anti-Semitism, for he published collections that refuted claims that Jews had no folklore and no folk songs, especially women's repertories (Burt 1990: 77). Krauss struggled tirelessly to combat prejudice, not only against Jews but also against women and ethnic minorities in the Habsburg lands, such as the Bosnian Muslims. He used the collections that he published as the most effective weapons against prejudice, leading his biographer, Raymond Burt, to observe that "for Krauss, everything he did in the name of science, which cut across all his interests, was in reality an extension of his political engagement and his polemic against anti-Semitism" (1990: 80). Krauss arrogated the collection to the status of a political weapon that opened new spaces for the public tolerance of Jews in turn-of-the-century Central Europe.

KONRAD MAUTNER: THE JEWISH COLLECTOR
AND HIS OTHER

Konrad Mautner (1880–1924) was not a collector of Jewish music. He was, however, the most extraordinary collector of folk music in Austria during the first

quarter of the twentieth century. As a collector Mautner demonstrated no tendency to gather the objects from the Jewish cosmopolitan culture that surrounded him, but instead he turned to the Alps of Styria and the small resort town of Bad Aussee and in the tiny settlement of Gößl on the Grundlsee. Konrad Mautner focused his music collector's passion not on the tradition from which he had come, but rather on the tradition from which he did not come nor could he have come. He committed his life to collecting the music of an other that was for him as exotic as anything beyond Europe's borders.

The history of Konrad Mautner's family reads like that of many of the Jewish families whose fortunes paralleled the rise and fall of the Habsburg Monarchy. In 1867, at the age of fifteen, Mautner's father, Isidor, arrived in Vienna, where he was entrusted with developing sales for his own father's nascent textile concern in Silesia (today southwestern Poland). Isidor Mautner enjoyed immediate success at a time of accelerating immigration from the eastern lands of the Monarchy, and he built the family's textile business into a multinational concern, based in Vienna but with factories in Eastern Europe. The Mautner family took advantage of its financial strength fully and entered the cosmopolitan world of the Habsburg Monarchy, opening its doors to artists and intellectuals, a noticeably high number of whom were Jewish. Through marriage the Mautners developed even closer ties to many of the Jewish artists and intellectuals (Maurer 1999). At the time of his early death in 1924, Konrad Mautner had become one of the most visible collectors and publishers of folk music in Austria. After his death, the family's financial fortunes would change, and like most Jewish families they would suffer from the growth of anti-Semitism in Austria. In 1938 Mautner's wife, Anna, and his children emigrated from Austria to England, from where some later went to the United States (see Mosley-Mautner 1999).

For Konrad Mautner collecting was a passion that removed him from the everyday world of the Viennese industrialist. Like many Jewish intellectuals and industrialists, he spent long periods every year in the mountains as a so-called Sommerfrischler (glossed as summer vacationer), enjoying the fresh climate of the alpine summer. His summer neighbors included, among others, Gustav Mahler. Friedrich Krauss, as we have already seen, also spent summers near Bad Aussee, and he was the co-collector of at least one volume of songs from the area (Blümml and Krauss 1906). As a Sommerfrischler, Mautner was more ordinary than extraordinary in the waning decades of the Habsburg Monarchy.

Mautner was not, however, an ordinary collector, and his most famous publication remains perhaps the most extraordinary of all collections of Austrian folk songs in dialect. The *Steyerisches Rasplwerk* (Mautner 1910a) is a 372-page volume that, according to its subtitle, contains "quatrains, songs, and street rhymes from Gößl on Grundlsee, a collection of word and melody, transcribed and illustrated with pictures." The extraordinary in the *Rasplwerk* lies not only in its hand-notated and hand-illustrated songs in the limited initial print run of 400 volumes. The extraordinary lies not only in the extreme care with which the local dialect is represented, with a special orthography of its own. The extraordinary lies not even in the realism with which the local musicians and residents of Gößl emerge from the pages (Haid 1999). The extraordinary is a culmination of all these factors and what they tell us about the collector and what he collected.

Konrad Mautner's own cosmopolitan Jewish world and the alpine Catholic world he memorialized in the *Rasplwerk* could hardly have differed more. Mautner's exposure to the world he collected, however, probably would not have been possible if he, like many other cosmopolitans of fin-de-siècle Vienna, had not chosen to spend the summer on the Grundlsee (Preßl 1999). His approach to collecting was that of the participant-observer: He donned the local *Trachten* (traditional clothing); he did all that was possible to blend in with the local residents, speaking their dialect and learning their music; and he appropriated their world as his own in the *Rasplwerk* and other publications. Though a textile industrialist, he apprenticed himself to local fabric craftspeople, and he turned his summer home into a studio for printing fabric, as if to suggest that his profession in Vienna were a sort of mirror image of local craft (Reischauer 1999). As an emancipated Jewish intellectual, finally, he wrote about all these collecting activities in the journals of folklore and ethnology (e.g., Mautner 1909; Mautner 1910b).

Directly and indirectly, Mautner's passion for folk-song collecting owed much to the age of Jewish music collecting. With or without Mautner's intensive efforts, the folk music of Bad Aussee and Grundlsee would be well documented today. Whether or not there would be a *Steyerisches Rasplwerk,* however, is a different matter, for its extraordinary design owes much to textile design and, at a much deeper level of tradition, to the use of personalized text and decorative commentary used also in handwritten Torah scrolls or hand-painted haggadot for the Passover seder. The tools and traditions upon which Konrad Mautner drew were remarkably indebted to the age of Jewish music collecting (see Mautner 1918).

EDUARD BIRNBAUM: THE JEWISH MUSIC
COLLECTOR IN SEARCH OF SELF

So vast are Eduard Birnbaum's (1855–1920) collections of Jewish music that they both demand and defy full assessment. To state simply that he collected everything understates what motivated Birnbaum and what he achieved. To draw upon his own assessments of his collections—the more than fifty articles and the books and pamphlets he published, as well as the roughly 10,000 note cards that he prepared to guide himself through the collections—seems also to add one form of collection to another. For Birnbaum, his collection of Jewish music was both a mass of details, gathered through personal experiences and bricolage, and a unified whole, sold at the end of his life intact to Hebrew Union College of Cincinnati. To speak of Eduard Birnbaum as a figure of Jewish music history is to speak of "The Birnbaum Collection."

One measure of the importance of Birnbaum's collecting projects is the fact that they remain ongoing. Projects to catalogue the Birnbaum Collection at the Klau Library of Hebrew Union College and make it available for scholars have continued for some 60 years. A. Z. Idelsohn, who was indebted to Birnbaum for early cantorial work, was the first to draw attention to Birnbaum's collections (see Idelsohn 1925), and materials from the collections find their way into volumes six (Idelsohn 1932a), seven (Idelsohn 1932b), and eight (Idelsohn 1932c) of the

Hebräisch-orientalischer Melodienschatz. Birnbaum's biography too reads like a process of ceaseless collecting, accumulating one experience after another, each stage and each position expanding the potential for gathering new experiences. One set of experiences is that of a European cantor, working within the expansive landscape of Ashkenazic minhagim.

Eduard Birnbaum was born in 1855 in Kraków, at the time very much a cosmopolitan center for Jews benefiting from its border position between the Austro-Hungarian Empire and Poland. In the course of his early studies, Birnbaum worked with Salomon Sulzer in Vienna and Moritz Deutsch in Breslau (modern Wrocław); later he developed extensive relations with Samuel Naumbourg in Paris and Hirsch Weintraub. There was scarcely a distinguished teacher of ḥazzanut in his day with whom he did not have extensive contact. Birnbaum also enjoyed opportunities to study Talmud and Jewish learning with such luminaries as Adolphe Jellinek (1820–1893), Moritz Steinschneider (1816–1907), and Leopold Zunz (1794–1886). His collecting activities, therefore, were always informed by the most modern traditions of Jewish scholarship, not least among them the Wissenschaft des Judentums (Werner 1943/1944: 400–401).

Birnbaum's cosmopolitan musical and intellectual background notwithstanding, his career as a cantor unfolded in relatively traditional fashion. Clearly precocious, Birnbaum assumed his first cantorial post in 1872 at Magdeburg; two years later he took another position at Beuthen, in Upper Silesia; and only four years later he succeeded Hirsch Weintraub as the chief cantor (*Oberkantor*) of the extremely important Jewish community in Königsberg (today Kaliningrad on Russia's Baltic coast). In short, from the age of 17 to 24, he moved quickly through the ranks, landing one of the most coveted positions for a European cantor, and he was granted that position with tenure for life. The tendency to ascribe almost supernatural abilities to Birnbaum notwithstanding, there were also ways in which he was unlike some of his cantorial colleagues. He was not, for example, a cantor who devoted time to composing. The liturgical works he contributed to the Königsberg tradition were almost entirely arrangements. Birnbaum was instead a synthesizer, and it was his devotion to collecting that undergirded his distinctive contribution as a synthesizer.

The extent to which Birnbaum's passion for collecting made synthesis possible is quite extraordinary. His book on Jewish musicians at the Mantuan court, first published in 1893, established the fundamental argument for recognizing a Jewish presence in early modern Europe. He gathered the published works of well-known musicians and intellectuals, but he was no less diligent in collecting the manuscripts of small-town cantors, as well as Yiddish tales. His attention to the details necessary for fleshing out a larger Ashenazic musical tradition is crucial for establishing the music history of Central and Eastern Europe, but his eager embrace of Sephardic materials is no less crucial for the reconfiguration of a more expansive model for the diasporas of Europe and the Mediterranean. In the hands of Eduard Birnbaum, the Jewish music collection was a metonym for the ingathering of traditions. Jewish music could become inclusive rather than exclusive, and Birnbaum thus transformed the very meaning of Jewish music history. His collection became the context for that history as it entered the twentieth century, and as such it also formed a new context for Jewish music and musicians challenged by and responding to modernity.

ABRAHAM ZVI IDELSOHN: THE COLLECTOR'S COLLECTOR

When I interviewed Israeli composers during research for my book *"The Land Where Two Streams Flow"* (1989a), I formulated a number of questions that would nudge them to discuss the musical decisions they made when making the transition from thinking of themselves as European to being Israeli composers. "What were the characteristics of an 'Israeli' melody?" "What led you to choose a musical language that could reflect the diversity of the new land?" "What were your primary resources for choosing new materials?" Inevitably there was one common answer—or rather one common theme—that each composer offered in response. Upon immigrating to Israel, each had turned to the ten-volume thesaurus published by Abraham Zvi Idelsohn between 1914 and 1932—also in a Hebrew copublication in Jerusalem—and each had plumbed the collections made by Idelsohn and brought to the Hebrew University by the former music librarian at the University of Berlin, Robert Lachmann, to constitute the core of his "Archive of Oriental Music," now the Jewish Music Research Centre of the Hebrew University (Gerson-Kiwi 1938). Here the composers could discover a marvelous stock of Jewish melodies. Here they could discover the authentic relationship between melody and the Hebrew language. From these materials, collected from all the Jewish communities of the diaspora and in Israel, a composer could create an Israeli music founded on the principles of Jewish music as it had survived since the destruction of the temples in Jerusalem.

In the eyes of composers wishing to craft a new Israeli music, Idelsohn had performed an invaluable service. His collections, his anthologies, his scholarly writings, and his popularization of a new Jewish music had a profound effect on the composers, musicians, and scholars who immigrated to the Yishuv during the generation before Israeli statehood. Idelsohn not only shaped the new models for Jewish music, but also published them in usable collections, ready to attract composers longing for a new musical language. It will be helpful to turn to Abraham Zvi Idelsohn at this point and look in somewhat greater detail at his activities as a collector of Jewish music. On one hand Idelsohn was typical of the collectors in this chapter. He was trained as a cantor; he not only composed new liturgical music but tried his hand at composing in genres of the mainstream, such as with his 1922 opera *Yiftah,* and he indulged his scholarly bent by writing about Jewish music, sometimes making it difficult to separate his composer's voice from his scholar's voice. On the other hand Idelsohn's contributions came at a critical moment in modern Jewish music, a moment during which modern Jewish history was linked to ancient Jewish history, when the dilemma of the diaspora was being resolved by the return to Eretz Yisrael. Idelsohn seized that moment by gathering its musical traces in a single place, thereby transforming Jewish music into a metaphor for the modernity of the past.

Abraham Zvi Idelsohn was born in 1882 in Latvia, where he received a traditional religious education and was trained as a ḥazzan in Liepaja. Upon finishing his cantorial studies, he moved to Germany, studying first at the Stern Conservatory in Berlin and then at the Leipzig Conservatory. After a traditional musical *Ausbildung*—

among other courses, he studied musicology with Hermann Kretschmar—Idelsohn took a position as cantor in the long-established Jewish community in Regensburg. Idelsohn's career as an active ḥazzan, however, lasted only three years, for in 1906 he determined to undertake a major project of collecting the religious music of ingathering Jewish communities in the Yishuv, a project that was to occupy him, in one way or another, until the end of his life in 1938 (e.g., Idelsohn 1929a).

Idelsohn differed from the earlier collectors in one fundamental way: he was the first to employ ethnomusicological field recordings and methodologies. He subjected his recordings to numerous forms of analysis. Because linguists at the Imperial Academy of Sciences were particularly interested in the languages of the modern Middle East and their relation to the classical languages of the region, Idelsohn created pronunciation keys and engaged in cross-cultural comparison of Hebrew pronunciation in different communities. The linguistic charts were based on field recordings, usually wax discs for which Idelsohn's field consultants read special texts or simply pronounced words so that Idelsohn could determine the variants between dialects of Hebrew. The field recordings went through further transition as they passed from transcriptions in his 1917 report to the Academy of Sciences to charts that appeared later in the *Thesaurus* and other publications (see chapter 2).

Idelsohn's ethnomusicological acumen extended even into the latest systematic realms, for he subjected his recordings to interval measurements after consulting with Erich von Hornbostel in 1913, when Idelsohn worked on his field recordings during a visit to Vienna. Idelsohn used at least three different systems of measurement from comparative musicology: the conventional measurement of wave length; the establishment of an interval value in cents; and the representation of the "tone" or "timbre" resulting from the breadth produced by pitch variance in a single tone, "Helligkeit," or "brightness," to use the terminology of comparative musicologists such as Hornbostel and Carl Stumpf (see Schneider 1991).

His process of transforming oral tradition into published collections was therefore scientifically—ethnomusicologically—correct. Accordingly, Idelsohn could ground his field recordings in a larger system of Jewish music, that is to say he could "prove" ethnomusicologically that there was a system of Jewish music. He could then adapt his scientific system to collecting the music of each community—whether in Europe, North Africa, the Middle East, or Central Asia—and demonstrate the connectedness of one community's music to that of other communities. And of course he could show that this was Jewish music. Even the volumes of the *Thesaurus* that were based on "Traditional Songs of the South German Jews" (Vol. 7, 1932b) and "Songs of the Ḥassidim" (Vol. 10, 1932e) relied on oral tradition, its transcription into written tradition as an act of collecting and its resilience during long stretches of history. Volume 7, for example, is not a random or even selective cross-section from the South German minhag, but rather Idelsohn's publication of collections assembled by several notable South German cantors. Idelsohn recognized that these cantors were themselves preserving the traditions and that these acts of preservation—the collection of collections—constituted Jewish music history. He could therefore make the argument in the volume's "Preface" that "only [in South and Southwest Germany] was ancient synagogue song transmitted

in unbroken fashion, whereas in the North and East synagogue song had been strongly influenced by Eastern European and modern elements" (1932a: v).

In his employment of collections to construct a grand narrative of Jewish music history, Idelsohn relied almost entirely on a historical mode that had three basic components: isolation during the diaspora, preservation through oral tradition, and revitalization in the modern era. The combination of isolation and preservation through oral tradition is a familiar theme in traditional folk-music theory, but Idelsohn went a step farther, namely in his attention to some form of revitalization, and it is precisely this step that leads to a more thorough understanding of the ways in which new historical discourses emerged from his collections.

Idelsohn's primary concern was with music that recovered an ancient history through the active performance of a living tradition. He wrote, for example, of the Yemenite Jews: "According to their tradition the Yemenite Jews immigrated to the Arabian Peninsula soon after the destruction of the First Temple (586 BCE). At any rate, we can be certain that they played a leading role in Arabia long before the time of Muhammad, particularly in the southern part of the peninsula. . . . It can be stated without any doubt whatsoever that they were never directly influenced by any other Jews" (1917: 5). Likewise the Persian Jews had lived in isolation, this fact further bolstered by biblical authority: "The Bible reports to us that there were Jews living in Persia already after the destruction of the First Temple. . . . We can further presume that they never once left Persian soil to return to Jerusalem" (1917: 6). The Babylonian, or Iraqi-Jewish, community provided Idelsohn with the most incontrovertible evidence of what he imagined to be an unbroken tradition of music: "The oldest Jewish settlement outside of Palestine, for which there is historical proof, is most surely the Babylonian. . . . The oral tradition of the Babylonian Jews could never have been broken, for upon the closing of the Talmud academies in Sura and Pumpadita, the bearers of Jewish culture [*jüdische Kulturträger*] moved to Baghdad and built there a home for Jewish tradition and learning" (1917: 6).

The nature of the preservation and revitalization of oral tradition predetermined for Idelsohn that Jewish music was religious. He divides his field recordings into three genres: biblical cantillation; synagogue melodies; and songs outside the synagogue. The margins of Jewish music are therefore defined in relation to the center. At first glance these categories might seem remarkably unexceptionable. Listening to Idelsohn's recordings, however, challenges what we might imagine the three categories to include (Österreichische Akademie der Wissenschaften 2005). We witness the conflation of Idelsohn's categories in a Yemenite song Idelsohn describes in his field notes as being of "religious content" (Figure 5.3). "Alhamdu lillāhi" is in Arabic, and Idelsohn's field notes contain both an Arabic trancription of the text and its romanization. The romanization is in Idelsohn's hand, but the transcription is not; rather it is clearly in the hand of a native speaker. Indeed, "Alhamdu lillāhi" has folk religious content for Palestinian Arabs—the text concerns the fruitfulness of the soil—but including it as an example of Jewish music might well have raised more than a few eyebrows in 1914. Some singers on the field recordings even framed their performances with traditional Muslim invocations, such as "allahu akbar," "God is great," thus reflecting the blurring of borders between Jewish and Muslim traditions.

FIGURE 5.3 A. Z. Idelsohn's Fieldnotes for his recording of "Alhamdu lillāhi," Jerusalem, March 5, 1913.

A rather different history and context are evident in another example of Jewish music from Idelsohn's collections, this one an example of religious music "outside the synagogue" (Figure 5.4). This performance by an ʿud player in *maqām sabā* (the mode sabā in Arabic classical music) might also have raised even more eyebrows in 1917, when Idelsohn published a transcription of it. Here the issue is even less a matter that we hear a *bashrav* performance from the Arabic classical system, which influenced traditions across the Yishuv. Idelsohn broadens the parameters of his collections so that it would be possible to understand strictly instrumental music properly, with no text in either Hebrew or Arabic, as religious, and by extension as Jewish.

The scope of Idelsohn's collecting project—indeed, of his entire career—was much larger. The critical issue here is not whether the performance of a bashrav itself expresses something fundamentally Jewish, but rather that it belongs to a larger musical system that encompassed Jewish music. The ʿud player, Ḥaim Ashriqi, is called "Sephardic" in Idelsohn's field notes; the musical style suggests that he was

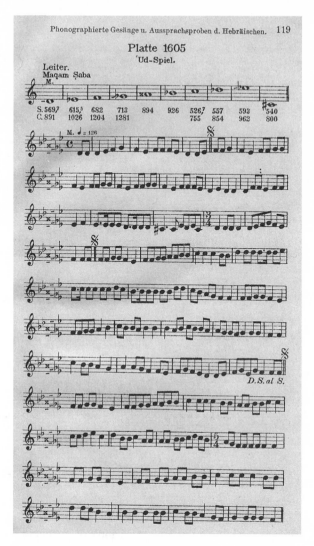

FIGURE 5.4 Transcription of *Bashrav* in *Maqām Sabā*. (Source: Idelsohn 1917: 119)

Egyptian or Levantine. Idelsohn also records other performances on the ʿud, which clarify his intent even more, and I refer here to the discs that include the systems used for tuning the ʿud and several maqāmāt. These maqāmāt, in Arabic music theory generated by tunings of the ʿud (the medieval Arabic derivation from the Greek monochord), were also employed by Idelsohn's consultants. Idelsohn sought a way to explain why his "unbroken traditions" in the Yemenite, Persian, and Babylonian communities were Jewish. He needed to explain the survival of these traditions in a modern context, namely the musical culture of Palestine in the first decades of the twentieth century.

The reception of his *Thesaurus,* as embodying musics at once religious, Jewish, appropriately Palestinian, diverse, and systematically unified proved that he achieved his goals. The ethnomusicological fieldwork, organization of repertories according to communities, and the construction of Jewish music in Israel as a metaphysical ingathering from the diaspora have become paradigms for Israeli scholarship and for contemporary Jewish music as a juxtaposition of old and new. The Idelsohnian concept of collection as a metaphorical gathering of diasporic musics was transferred back to Israel with Robert Lachmann (Katz 2003; Davis forthcoming). It found a new life after statehood when scholars such as Edith Gerson-Kiwi recorded the songs of new immigrants as they descended onto the tarmac at Ben-Gurion Airport outside of Tel Aviv. The ethnomusicological correctness of Idelsohn's collections resonates in all contemporary Jewish music research, which now treats collecting as essential for constructing modern Jewish musical identities.

END OF AN ERA

> My father sat Sunday after Sunday at the main, or at a branch synagogue of the Berlin Jewish Reform Community above the *Bimah,* hidden by a curtain, cranking up the gramophone and changing the records.
>
> —George L. Mosse writing about his father,
> Hans Lachmann-Mosse, in Mosse 1997: 7

From 1928 to 1930 Hermann Schildberger, music director of the Berlin Reform Congregation, supervised the recording and publication of the complete liturgy used for the sacred service of his congregation. Not only did Schildberger muster the full choral and instrumental forces of the community—the choir numbered more than 100 voices, and there were two organists—but he was able to enlist solo appearances by some of the most impressive talent of the day, among them Paula Lindberg and Joseph Schmidt, both of whom would enjoy brief, meteoric careers in the 1930s, Lindberg with the Berlin Jüdischer Kulturbund and Schmidt as the first tenor to gain fame as a film star. The project was financed by one of the community leaders, Hans Lachmann-Mosse, head of the Mosse publishing concern. One of the most powerful publishers in German-speaking Europe, Lachmann-Mosse had developed a passion for collecting the synagogal traditions of Reform Judaism. Lachmann-Mosse (1885–1944) had assumed control of the Mosse publishing house in 1920 and directed it until 1933, when it was taken over by the Nazis (for the importance of the Mosse house see Fritzsche 1996; Freeden 1987; see also George Mosse's autobiography, Mosse 1999).

Like all collectors, Hans Lachmann-Mosse took a great personal interest in the project. The liturgy of the Reform Congregation was eclectic, including not just the works of Louis Lewandowski, but also those of Salomon Sulzer. Mixed with works by Jewish composers of the nineteenth century were adaptations of works by non-Jewish composers, especially Ludwig van Beethoven and Robert Schumann. Hebrew and German texts mixed freely; sacred and secular styles mixed even more freely. No expenses were spared to take advantage of the most up-to-date technologies available in Berlin's Lindström Studio.

The Reform recording project was a deliberate attempt to modernize a musical tradition that was already consciously modern. George Mosse (1918–1999), writing of the Reform Congregation's commitment to an innovative liturgy, has gone so far as to suggest that the liturgy "was supposed to be a response to modernity, a more radical response than that of mainstream reform" (Mosse 1997: 7). It is not by chance that Lachmann-Mosse's secular musical passion was modern music and that he financially supported German composers and the avant-garde (ibid.). It was not, however, the sound or the individual components of the Reform liturgy that for Lachmann-Mosse was modern, but rather the mode of gathering, anthologizing, and reproducing. With the gramophone, which Lachmann-Mosse believed could be made available to "small new Reform congregations" and "old age homes and hospitals" (ibid.), the liturgy could be transformed into a perfectly reproducible object, available in the everyday world. As an object transformed by mechanical reproduction, the liturgy could also be returned to the liturgical setting, indeed to the raised stage behind the synagogue bima, where record after record could be placed on the turntable. In every respect, the recording project of the Berlin Reform Congregation was a perfect collection.

The age of Jewish music collecting in Central Europe culminated—and came to an end—through the completeness and the perfection of collection itself. The virtual museum of Jewish music had become a real museum, in which the objects that preserved the liturgy might assume the functions of the liturgy itself. Accounts of the final years of the Berlin Reform Congregation take note of the survival of the recordings themselves, even after the destruction of the synagogue on Kristallnacht in 1938 and the total dissolution of the community in 1942 (Levi 1997: 4). The metonym for the end of the age of Jewish music collecting is the museum, but, as a metonym, it is a museum that functions as a complex set of symbols that signify historical processes in contradictory ways. The museum also proffers new meanings because it provides new contexts. On a complete recording of the Berlin Reform liturgy, for example, compositions by Beethoven and Schumann might become Jewish music. Most complex of all the museum's metonymic functions is historicism. Tradition becomes contemporary; the past becomes reusable in the future; the experience of the present selectively samples the past as a means of contextualizing the future.

The age of Jewish music collecting in Central Europe did not just end of its own accord, but rather culminated in a new age, that of Jewish museum-building. During the 1920s Jewish museums began to appear across Ashkenazic Europe, both as a repository for existing collections and as a means of consolidating new collecting efforts. Some notable museums first opened in the 1920s, but others, such as the Berlin Jewish Museum, were years in the planning and opened only in the early 1930s. The Berlin Jewish Museum, for example, opened its exhibit spaces in the Oranienburgerstraße, near the large synagogue named after that street, on January 24, 1933, a week before Hitler's ascent to power. Jewish museums represented a modern, cosmopolitan attempt not only to preserve Jewish culture but to celebrate it, and to do so publicly. In Berlin there were open discussions about whether collections of art by Jewish painters became Jewish when they entered the museum. Should the paintings of artists who were Jewish but who did not work with Jewish

subjects, such as Max Liebermann, be displayed? The response to such questions, in the wake of the age of collecting, was generally affirmative. In other words, it was the context of the museum itself, rather than the objects in it, that was Jewish. Finally, it was necessary to transform the concept into action and to finance the redesigning of a building for exhibition spaces.

Jewish museums were, more often than not, initiated and organized by collectors, among them several of the collectors discussed in this chapter. Max Grunwald, for example, was the major impetus behind the creation of a Jewish museum in Vienna (Daxelmüller 1994/1995; cf. Kohlbauer-Fritz 1994/1995; Harel-Chosen 1994). Collectors such as Eduard Birnbaum were intent upon keeping their collections intact, motivating them to donate or sell them to institutions willing to preserve them. With the 1930s and after 1933, when the Nazis assumed power, the still inchoate age of Jewish museums entered a new phase, one of accelerated consolidation of collections. The institutions within European Jewish communities turned to the collections of the past and housed them so they would become increasingly available to a new Jewish public sphere. Within this shrinking yet concentrated public sphere of the 1930s the availability of collections through museums, literal and figurative, was all the more immediate.

Collecting Jewish music hardly ended with the Holocaust, and to suggest that it was arrested or replaced by the efforts to use museums as institutions of preservation would tell only an incomplete story. The history of ethnomusicology in the Yishuv and in Israel, for example, is really a report about collectors and collections. The ingathering of Jewish communities during the early years of statehood was greeted by massive efforts to collect. In the 1990s, after the end of the Cold War, Jewish music collectors seized the opportunity to undertake collecting excursions in Eastern Europe to find lost or hidden klezmer musicians and record the performances of surviving Jewish liturgical traditions.

What does this tell us about the memorywork that the virtual museum of Jewish music unleashes? Are we revisiting or historicizing the age of Jewish music collecting? Do collectors today give voice again to the lively debates about Jewish music collections that unleashed a new discourse of Jewish music history during the age of Jewish music collecting? Or has that age become ageless in a new and different way, transforming the narration of Jewish music history that the age of Krauss, Mautner, Birnbaum, and Idelsohn engendered into agelessness, where the bricolage of the music collection becomes just so many fragments gathered from a disjunct, global landscape? At the beginning of the twenty-first century controversies about the museumization of these collections provide counterpoint to the debates about Jewish museums in general and how they transform the past into a meaningful present.

PATHS TOWARD UTOPIA

Dort, wo die Zeder schlank die Wolke küßt,
Dort, wo die schnelle Jordanswelle fließt,
Dort, wo die Asche meiner Väter ruht,
Das Feld getränkt hat Makkabäerblut,
Dieses schöne Land am blauen Meeresstrand,
Es ist mein liebes Vaterland!

There, where the cedar reaches to kiss the clouds,
There, where the Jordan's waves rapidly flow,
There, where the ashes of my fathers lie in peace,
Where the fields have drunk the blood of the Maccabees,
That beautiful land at the edge of the blue sea,
It is my dear fatherland!

> —"Dort, wo die Zeder"/"There, Where the Cedar"
> Melody by "Ostermann," Text by "Dr. Feld"
> (in Loewe 1894: 14–15)

Oy, nem, guter klezmer, dayn fidl in hant
Un shpil mir dos lidl fun goldenem land!
A mol flegt mayn mame mit harts un gefil
Dos lidl mir zingen—oy, shpil es mir, shpil!

Oy, good fiddler, take your fiddle in your hand
And play me the song of the Golden Land!
When she cared for me with her heart and soul,
My mama sang me the song—oy, play it for me, play!

> —"Dos lidl fun goldenem land"/
> "The Song of the Golden Land"
> by Mordechai Gebirtig (in Vinkovetzky,
> Kovner, and Leichter, vol. 2, 1984: 81–82)

The efflorescence of Jewish musical modernism could not survive the rapidly shifting ideological climate of the interwar period. Modernism, so crucial for the further shaping of musical repertories that were Jewish in context rather than text,

was a threat to the fascist tendencies of Central European society, and the aesthetics of modernism were beginning to function as a liability for many Jews who had embraced modernism as a potential force for shaping their own history. Modernism had generated a palpable aura of danger by the late 1920s, causing many Jewish musicians to search for alternative responses to the path along which modernity seemed to be moving. In this chapter we consider a series of responses to modernism, all of which reflect retreating from the historical present while diverting it toward a utopian moment. By resituating the aesthetic achievements of modernism within utopian moments, many Jewish musicians signaled a retreat from modernity. The Jewish musical responses to the historical transformations are reflected in a series of historical moments, the utopian, dystopian, and heterotopian moments that constitute the sections of this chapter. By no means did such moments arrest historical change and reintroduce the *ennui* of timelessness. Quite the contrary, many of them were particularly timely, for they charted alternative historical paths toward a new musical life in the utopia of a "New Jerusalem" in the Yishuv, the settlement of mandatory Palestine.

Utopia occupies the borders between traditional Jewish society and the modernity to which it increasingly aspired. Striving to achieve utopia was hardly a uniquely Jewish preoccupation. Utopian imagery, however, bore witness to the *longue durée* of Jewish history, for diaspora generated new meaning and impetus for utopia, investing history with the telos that was synonymous with utopia. In medieval Jewish society there had been no more common landscape for realizing utopia than the "New Jerusalem," with its full range of historically figurative and geographically literal meanings. Throughout the course of European Jewish history, centers of Jewish culture—Worms in the Middle Ages, Vilna in the nineteenth century—were celebrated as new Jerusalems. A New Jerusalem possessed the attributes of both past and future, which the present idealized rather than realized. In the more apocalyptic vision of European Christians, the New Jerusalem was not a place in their own world, but rather it would become habitable only after the destruction of that world. George Mosse portrays the opposition of paradise and apocalypse in the realization of utopia as a fundamental dialectic in European utopian thought, and by extension that dialectic accounts for the persistence of utopia in modern European thought (Mosse 1974: 50–51). To a large extent, the New Jerusalem signified a site of struggle, a site that would be truly realized only after a moment in which struggle had overwhelmed history.

Though it assumed many different forms, utopianism provided a crucial component to the common culture of modern Jewish societies. Images of utopia filled the folk and popular songs that swept across fin-de-siècle Jewish Europe, be they lullabies or Zionist songs, as in the epigraphs to this chapter. Songs provided an ideal medium for framing the visions of a world capable of surviving the eschatological fears that accompanied passage to a new century or the imminent danger of a headlong plunge into modernity. The places summoned up in the emerging repertories of Jewish song provided an escape from the known to the unknown, from the present into the future, from the struggle against prejudice and pogrom to the harmony of a classless society. Utopian images rapidly came to fill other genres of music in Europe's Jewish community, undergirding the autonomy of

secular Jewishness in a larger public sphere. Chamber music, in which Jewish musicians throve, also embodied the world-unto-itself that characterized utopian perfection. "Chamber music was," as Adorno states, "the refuge of a balance of art and reception which society denied elsewhere" (Adorno 1976: 86). It is to reflect the utopian aesthetics of chamber music that the organization of this chapter traces a narrative musical form that itself reflects the symbolism of chamber music for the Central European community of Israel. In other words, the chapter traces the multiple musical responses to the erosion of Jewish modernism as we would follow the movements of a string quartet or other instrumental genre. Central European Jews took the narrative power of music to transform their own lives very seriously. Through musical performance, they transformed themselves into historical actors, who might, when fortunate, acquire a certain measure of power to effect real change, if perhaps only in a utopian moment.

THEMES OF UTOPIA

The themes upon which the Jewish immigrants in the Yishuv would draw to shape the new world in the Yishuv were not new at all. They were, rather, ancient motifs, bearing witness to a musical modality redolent of pastness. In the liturgical music of the synagogue and in the sacred music of the Jewish community, these motifs were recognizable in a melos that signified the past. That melos was one of remembrance, which achieved narrative meaning through repetition, in other words through the capacity of Jewish music to allow European Jews collectively to revisit the past. The themes that transformed the awareness of history into utopian vision, however, differed sharply from the leitmotifs of the past. Rather than ritualization and repetition, the new themes bore witness to invention, a term I have used throughout this book to embody both the functions of *inventio* in classical rhetoric and the reimagination of the present from the past (see esp. chapter 4). The themes that shaped the first stages of utopian vision—a period from the 1880s until the 1920s—formed in the interstices bounded by oral and written traditions. In the music of the Central European synagogue, for example, the themes passed through the process of invention as oral traditions were inscribed in the printed volumes of local liturgical rites, such as Salomon Sulzer's Viennese *Schir Zion* (1841). Similarly, Jewish and non-Jewish folklorists gathered collections of folk songs that would bear witness to a larger cultural geography of Ashkenaz on the verge of modernity (see chapter 5). The St. Petersburg School of Jewish Music similarly sought to rescue folk music from the danger posed by oral tradition by reimagining traditional song and dance as a newly composed music (Nemtsov 2004; *The St. Petersburg School* 1998). As Jewish music in the utopian stages of modernity acquired an identity of its own, an entirely new vocabulary of Jewish music coalesced, a vocabulary that mapped in great detail "the East" and the paths that led toward it.

The invention of a modern Jewish music, using the motifs and images of the past, had a powerful impact on just how the European *aliyot* (sing.: *aliya*, literally rising up), or immigrations to the Yishuv, would remap the musical landscape of mandatory Palestine and later of modern Israel. A representational vocabulary was already in place by the first decades of the twentieth century, in both Central and

Eastern European Jewish musical modernity, which is all the more remarkable precisely because music is the form of artistic expression often claimed to be nonrepresentational. By the 1920s there were already identifiable canons of Jewish music, which together bore witness to the present and to modern European Jewry, just as they expressed anxiety about its fragility. Through the reproduction of folk-song anthologies and the publication of Abraham Zvi Idelsohn's *Hebräisch-orientalischer Melodienschatz* (1914–1932), music—Jewish music—was closing the historical distances between Europe and the Yishuv. A new discourse about Jewish music was taking shape in the pages of Martin Buber's *Der Jude,* in the organ of the Society for Jewish Folklore, Max Grunwald's *Jahrbuch für jüdische Volkskunde,* and in the compositions of the St. Petersburg School of Jewish Music (see *The New Jewish School* 1999; Nemtsov 2006).

The new publishing endeavors that enhanced the initial processes of discovering and inventing Jewish music laid the foundations for composers to create Jewish music itself, emancipating themselves from the age-old prejudice that Jewish musicians excelled as performers and improvisers but failed as creative artists. Collection Jibneh-Juwal (see chapter 4) first split among publishers in Berlin and Vienna, but, distributed by the Leipzig firm Friedrich Hofmeister and then united under the corporate umbrella of Universal Edition in Vienna, it was the most visible of these new Central European endeavors (see Figure 4.5 in chapter 4). The St. Petersburg School of Jewish Music (often called also the "New Jewish School") was the most visible of the Eastern European endeavors.

The St. Petersburg School came into being as a top-down response, in which musicians and intellectuals turned to Jewish folk music as a source for an art music that drew inspiration from a past idyll. Neither the scholars, such as Ginsburg and Marek, who consciously rescued a canon of Yiddish folk songs through their publications (Ginsburg and Marek 1901; see also Bohlman 2005a: 59–76), nor the musicians and composers, such as Lazare Saminsky (1882–1959), Mikhail Gnessin (1883–1957), and Joseph Achron (1886–1943), claimed as their own the music they preserved and created as the sound of a contemporaneous world. Through their collections and performances they envisioned an alternative world in which Jewish music acquired a distinctive identity, which did not exclude Western formal conventions but transposed them to an alternative, utopian universe. The influence of New Jewish School compositions may well have been localized in Russia and later the Soviet Union, but its symbolism for the first generations of composers in the Yishuv was considerable. The compositions of Saminsky, Gnessin, and Achron, as well as Solomon Rosowsky (1878–1962) and Joel Engel (1868–1927), served the composers of the Yishuv with a style to emulate, indeed, milestones on the path to the utopia they believed they could musically realize (see the essays in Kuhn, Nemtsov, and Wehrmeyer 2003, especially Karpinski 2003 and Matwejewa 2003).

It is important not to underestimate the role of publishing endeavors in Central and Eastern Europe as we look at the impact of modern European Jewish culture on the Yishuv and Israel, for without the early attempts to publish music, modern Israeli musical life would have developed along historical paths that were very different from those it did follow. Emerging technologies of musical representation were also shaping the landscape of Jewish modernism by the 1920s. Recording

technology made it possible to preserve the present, which may have been imagined as the past but which nonetheless revealed the extent of modernism. By the mid-1930s a modern discourse of musical engagement with the present was underway in the Yishuv, changing the very metaphysics of Jewish music itself. That new metaphysics would be catalytic in determining how the foundations of a modern music culture would be laid in the still-utopian Yishuv.

VOICES OF THE NEW UTOPIA

> The master arose and passed through the hallway. Silently, he opened the door to the music room, into which the two women had earlier retired. At that moment, a marvelous song issued forth from the room. Miriam, unaware that anyone was eaves-dropping, sang to Lady Lillian songs by Schumann and Rubin-stein, by Wagner, Verdi, and Gounod—the music of all people in the world. The melodies flowed forth without restraint, and Friedrich was overcome by a feeling of being blessed in the midst of these learned spirits: blessed by beauty and wisdom. Then, Miriam sang the song that he loved above all, the song of longing from Mignon.
> "Kennst du das Land, wo die Zitronen blühn . . ." to which Friedrich responded quietly:
> "This is that land!"
> —Theodor Herzl, *Altneuland* 1935 [1904]: 386

Music is envoiced to signify utopia in the Yishuv at several critical moments in Theodor Herzl's novel *Altneuland* (Old-New Land). Music is notable in Herzl's utopian vision for the new culture of the "Old-New Land" because of its universality; in every sense, the music of Herzl's land would be universal and utopian. Music, such as that referred to in the brief passage above from the closing chapters of his book, acquired transcendence as it brought about the spiritual conversion of the novel's protagonist, Friedrich Löwenberg. The context for Miriam's song, however, would seem to contrast with the universality of song that embodied "the music of all people in the world" (ibid.). It was the music of the salon, indeed the Jewish salon, the setting designated for chamber music, the utopian landscape of Lieder most familiar to the cosmopolitan Jewish past.

Herzl was hardly a stranger to utopian imagery. He repeatedly gives voice to utopia in his writings, providing him with a set of imagined social structures on which he could perform rhetorical and ideological experiments. Herzl frequently refers to his imagined Jewish worlds as "experiments," as in the subtitle of *Der Judenstaat,* "an Experiment [*Versuch*] at a modern solution for the Jewish question" (1896). *Versuch* can also mean "attempt," and some elements of this meaning reside in the fluidity with which Herzl realized a Jewish social structure through a mixture of pragmatic and utopian forms. Herzl's major belletristic writings all attempt to recognize the path to utopia in Zion. His play *Das neue Ghetto* (The New Ghetto) relies on the earlier themes of the ghetto as a site for both the cultivation and the repression of Jewish culture. The new ghetto in the play, nonetheless, fails to permit

full liberation from the old ghetto. In his novelistic treatment of an Old-New Land the options for crossing between the old and the new are more readily available, not least because the utopia lies in the future rather than in the present, as in The New Ghetto. The bulk of the action in the Old-New Land itself is set several decades after the novel was published, that is in the Yishuv of the 1920s, the image of which is deliberately futuristic, even with mild touches of science fiction.

In his most influential political tract, *Der Judenstaat* (The Jewish State), Herzl took pains not to confuse his model for the Zionist state with a utopia. He proceeded to give structure to the financial workings of the Jewish state, without, however, laying out a detailed plan that might prove to be unworkable. His justification for such planning was possible precisely because the Jewish state of the future would be utopian: "Would one propose an outline for finance laws for a utopia without knowing whether it is possible to stick to the proposal?" (Herzl 1896: 45).

When Herzl and the cultural Zionists imagined a new world inhabited by modern Jews, they turned to utopia and the way in which music might contribute crucially to the Jewish utopian thought and aesthetics. Their envoicement of a new aesthetics was really quite simple, and yet it contradicted the assumptions that generally account for the vision with which many European musicians had come to regard the Yishuv. During the early decades of the twentieth century, Jewish musicians and artists increasingly imagined the possibility of a utopian world that would then provide the context for their future musical life. They approached the musical life of the Yishuv as if it were to arise in a land full of new possibilities. This was not the imagery of the desert or of the wasteland, but rather a land where song was untethered from history, thus capable of empowering all to sing a new song—a *shir chadash*—in the utopian world where past and present—*alt* and *neu*—converged on a single utopian landscape.

Utopia appears in the imagery and imagination of the Yishuv in two forms. First, it assumes the form in which it is most commonly understood and applied, namely as a society that is in some way perfect and unique to a particular culture, which is to say, cut off from the rest of the world. Second, utopia in the Yishuv resembles a more complex vision, similar to the way it was originally used by Thomas More in his 1516 book of the same name (More 1965), for which he coined the word *utopia* (Greek: ο•, "not," and τόπος, "place") from *oitopia* (a good place) and *outopia* (a place that does not exist). Writing in the Yishuv during the 1940s, Martin Buber developed More's middle position by introducing the human will to forge utopia: "The utopian picture is a picture of what 'should be,' whereby the individual shapes such an image because he strongly desires it to come into existence" (Buber 1985: 29). The eschatological and utopian therefore have the potential to dovetail as prophecy and philosophy, precisely because they have what Buber called a "realistic character" (ibid.: 31).

Utopianism was by no means a new concept in Jewish thought, even in the modern era. Turning to music as the spiritual language for utopia, in contrast, was quite new. For the European *maskilim*, the adherents to the Haskala, the onset of modernity in the eighteenth century heightened eschatological concerns about the end of history, and it was from those concerns that a counterhistory of utopianism emerged during the Haskala. Enlightenment thinkers regarded the music of utopia

as emancipated from history, but they found it particularly seductive because of its untrammeled naturalness. Johann Gottfried Herder, for example, included more songs from the periphery in his seminal anthologies of folk song than songs from the German-speaking regions of Central Europe, using folk song itself—Herder coined the term *Volkslied* (folk song) in these publications—to chart the sites of global common culture and not the borders of nations and nationalism, as is often assumed (Herder 1778/1779). Historically, utopia was always imagined as an alternative that liberated one from the timeboundedness of the historical moment (see, e.g., Manuel and Manuel 1979).

Crucial to all utopian models is that they bring about an end to history; the counterhistory that they offered in return was metaphysically distinct, ranging from the "eternal" stasis of a paradise to the eschatological closure of a religious colony. Music, especially sacred music and music derived from nature, shored up the insular nature of the utopia, transforming time itself through the formation of new liturgical practices or narrative hymn texts. For the outside observer the music of the utopia was at once its greatest emblem of strangeness and its most powerful icon of transcendence from European history. The members of Nathan Shacham's *Rosendorf Quartet,* a novel whose sections give voice to the performers in a fictional string quartet in the Yishuv of the late 1930s, state this idea succinctly:

> For a European, the overwhelming pride in everything here, whether something of significance or only relatively insignificant, must seem quite remarkable. Even in the most unimportant occurrence, one is supposed to hear the wings of history beating. . . . Here, houses are not built, rather a fatherland. Here, books are not written, rather a culture is founded. . . . Every melodic fragment has the potential of turning into a masterpiece, and the worker's song of today can turn into a Psalm for tomorrow. (Nathan Shacham, *Rosendorf Quartet,* 1990)

The music that marked the transition from Europe to the new world of the Yishuv was replete with utopian voices, and in this way the music culture of the European Jewish communities underwent a process of "reorientation," of turning again to the East. Utopian imagery was both literal, embedded in song texts or in the iconic representation of the Yishuv in musical publications, and figurative, transformed through entirely new theories of harmony (*Harmonielehren*) crafted for Jewish music. Utopia did not just acquire a symbolic presence in the music of the Jewish community; music itself became one of the most powerful icons for utopia.

VARIATIONS ON UTOPIAN THEMES

The utopian visions of Eretz Yisrael formed one of the central themes for European Jewish musicians who sought a musical engagement with the Yishuv. The richness and power of that utopian vision was realized through countless variations, which together expanded the cultural possibilities for European Jews turning toward the Eastern Mediterranean. The full range of these variations is surveyed with considerable historical detail in Jehoash Hirshberg's social history of music in the Yishuv (Hirshberg 1995). The variations that spun off the themes of utopia were integrated

into specific musical forms and practices, through which it was possible to make the abstract palpable. The new music, indeed the biblical "new song," or *shir chadash,* possessed the semiotic potential to endow utopia with a powerful new language.

The new language of utopia owed much to the earlier stages in the invention of a modern Jewish music. Increasingly, there was exchange back and forth between European Jewish communities and those of the Yishuv, which the utopian vision-aries consciously elevated to a bridge—and the Hebrew *gesher* (literally, bridge) emerged as a symbol—between East and West. In the first decades of the twentieth century, European anthologies of Jewish folk music picked up the folk songs and dances of the Yishuv, first in appendices, but by the 1920s as new genres consciously designated as "Jewish music." European Jewish composers formulated a vocabulary of melodic patterns and motivic meaning that allowed some of them, notably com-posers such as Ernest Bloch, to create repertories that contained specifically Jewish symbolism (cf. Móricz 2001 and Schiller 2003). The variations, moreover, came to constitute an international science of comparative musicology, which to some extent even acquired a distinctively Jewish core by the end of the 1920s, particu-larly through the publications of Abraham Zvi Idelsohn, Jacob Schönberg, Robert Lachmann, and others.

Perhaps no other set of variations illustrated the full potential that European Jews recognized in the music of the Yishuv more than the attempt by the Keren Kayemet le-Yisrael (the precursor of the Jewish National Fund) to provide musical resources for the cultural work of nation-building in the 1920s and 1930s. The fulcrum of this project depended on postcards published and distributed by the Keren Kayemet, which were intended to inspire Jewish composers throughout the world to set folk songs as a nationalist repertory of Israeli songs, almost from one day to the next. The anthology of national songs should have appeared in Berlin in the late 1930s, probably under the general sponsorship of the Jüdischer Kulturbund. Hans Nathan, a musi-cologist active in the Kulturbund, brought the manuscript material with him when he immigrated to Boston in 1938. Though several "pioneer songs" did appear in the United States in 1938, the full edition did not appear until 1994 (Nathan 1994).

The variations that unfolded from the Keren Kayemet postcard theme might be summarized as follows. Songs designated as folk songs were gathered from the new communal settlements in the Yishuv, the *kibbutzim* and *moshavim,* during the 1920s. In reality, these songs possessed few of the characteristics usually associated with folk songs, such as circulation in oral tradition or uncertain authorship (see Figure 6.2). Most consisted of composed melodies, which had been used to set composed poetry, relatively modern works by the first generation of poets to write in mod-ern Hebrew, among them Chaim Nachman Bialik and Nathan Alterman. Hans Nathan managed to solicit settings by Aaron Copland, Darius Milhaud, Erich-Walter Sternberg, Stefan Wolpe, and others, so that they might be published together. Cor-respondence between Nathan and several of the composers survives, revealing that the compositional process under discussion was one of "arranging" folk songs for piano and voice (see Nathan 1994: xi–xii). The songs did, in fact, find their way into written tradition by the mid-1920s, appearing in the new volumes of Jewish folk songs published by German houses such as Jüdischer and Schocken Verlag. As in the earlier periods, the written traditions of folk song consciously provided

repertories that might be learned and introduced into oral tradition (see in particu-
lar Natan Shahar's thorough examination of kibbutz choruses and composed folk
songs; Shahar 1978 and 1989).

Atop a hill in Galilee
A guardsman sits, and merrily
He plays upon his flute a song
To lamb and kid the whole day long.

He plays: I greet you cordially;
Come hither, kid and lamb, to me.
My flute is rich in melodies,
Like Galilee in mysteries.

There was a giant of sturdy stock;
He cleft the cliff, he moved the rock.
With a song of life the conqueror
Defeated hordes in ruthless war.

"'Tis good," he said, "to die at the post,
To give to our new land our utmost!"
There as a giant formerly,
A mystic man—one arm had he.

(English translation by Harry H. Fein, adapted by Philip V. Bohlman for Nathan 1994: xvii)

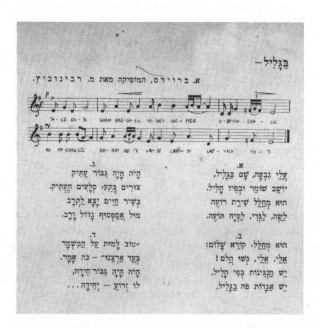

FIGURE 6.1 Stage 1 along the Path toward Paul Dessau's "Alei Giv'a, Sham Bagalil"/
"Atop a Hill in Galilee.": Postcard of the Keren Kayemet le-Yisrael. (Text: Abraham
Broides; Tune: Menashe Ravina Used with permission of A-R Editions, Inc.)

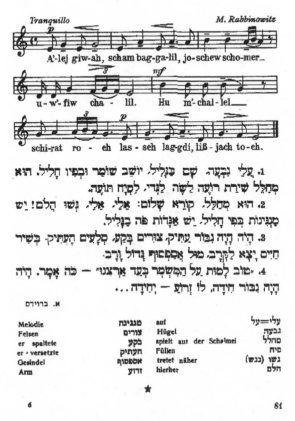

חלק שלישי:

שירי נוף ומולדת.

Tranquillo M. *Rabbinowitz*

A'-lej giw-ah, scham bag-ga-lil, jo-schew scho-mer_

u - w'-fiw cha - lil. Hu m'-chal-lel_

schi-rat ro - eh las - seh lag-gdi, liß - jach to-eh.

1. עֲלֵי גִבְעָה, שָׁם בַּגָּלִיל, יוֹשֵׁב שׁוֹמֵר וּבְפִיו חָלִיל. הוּא
מְחַלֵּל שִׁירַת רוֹעֶה לַשֶּׂה לַגְּדִי, לַסַּח תּוֹעֶה.

2. הוּא מְחַלֵּל, קוֹרֵא שָׁלוֹם: אֵלַי, אֵלַי, גְּשׁוּ הֲלֹם! יֵשׁ
מַנְגִּינוֹת בְּפִי חָלִיל. יֵשׁ אַנְחוֹת פֹּה בַּגָּלִיל.

3. הָיָה הָיָה גִּבּוֹר עַתִּיק, צוּרִים בָּקַע, סְלָעִים הֶעֱתִיק. בְּשִׁיר
חַיִּים יָצָא לַקְּרָב. מוּל אֲסַפְסוּף גָּדוֹל וָרָב.

4. "טוֹב לָמוּת עַל הַמִּשְׁמָר בְּעַד אַרְצֵנוּ" – כֹּה אָמָר. הָיָה
הָיָה גִּבּוֹר חִידָה, לוֹ זֵרוֹעַ – יְחִידָה...

א. ברוידם

Melodie	מנגינה	auf	עלי=על
Felsen	צורים	Hügel	גבעה
er spaltete	בקע	spielt auf der Schalmei	מחלל
er · versetzte	העתיק	Füllen	סיח
Gesindel	אספסוף	tretet näher	גשו (נגש)
Arm	זרוע	hierher	הלם

★

6 81

FIGURE 6.2 Stage 2 along the Path toward Paul Dessau's "Alei Giv'a, Sham Bagalil"/
"Atop a Hill in Galilee": Published version in Jacob Schönberg, *Shireh Eretz Yisrael*. (Text:
Abraham Broides; Tune: Menashe Ravina. Used with permission of A-R Editions, Inc.)

The rules for these variations on a common nationalist theme were actually
quite rigid. The melodies were not to be altered from the composed folk melodies,
and the syntax of the Hebrew language was to guide the composers—whether they
in fact knew Hebrew or not. The composers were permitted to use their own styles,
but they were asked to craft piano accompaniments from those styles that would
best evoke the character of a folk song. The variations that the nationalist theme
produced are stunning indeed (see Nathan 1994). The utopian geography that the
songs inscribe is quite remarkable, particularly because the imagined landscape of
a timeless biblical past has been replaced with a map of real places—Tel Aviv as a
city, kibbutzim that are devoted to certain types of agriculture, regions with mod-
ern historical meaning. Utopia assumed mythical and historical forms, sometimes

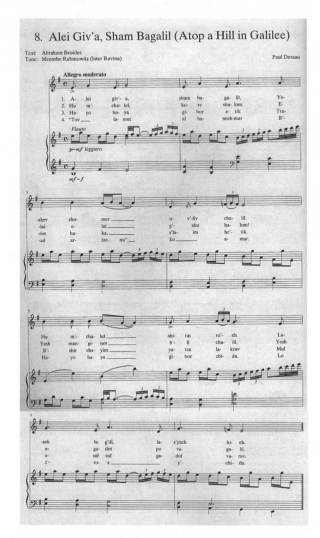

FIGURE 6.3 Stage 3 along the Path toward Paul Dessau's "Alei Giv'a, Sham Bagalil"/ "Atop a Hill in Galilee": Composition by Paul Dessau. (Text: Abraham Broides; Tune: Menashe Ravina. Used with permission of A-R Editions, Inc.)

vying for space in the same song, such as "Tel Aviv," which Stefan Wolpe set for the Keren Kayemet songs to an alternative text, "Lamidbar" (To the Desert). Wolpe was himself an immigrant from Germany to the Yishuv, where he briefly gathered a group of compositional students about him before immigrating again to the United States (for his reflections on the possibilities for creating a new music in the Yishuv, see Wolpe 1939). The authors of the texts for both "Tel Aviv" and "Lamidbar," moreover, were unknown, thus affording the poems with the same sense of an authentic, albeit utopian, folklore. The two song texts conveyed two different visions of utopia, which were nonetheless historically complementary. Specific places in the Yishuv both from the mythical past and from the historical present were treated

with realism, and thus they came to realize a new form of utopia, a modern and modernist utopia (see Shahar 1989).

"Tel Aviv"

Tel Aviv is a Jewish city
None but Jews there dwell;
Rich men, poor men, intermingle;
Working men as well.
It's good to live in Tel Aviv
And there to find a home;
To live and patiently to wait
Till the redeemer comes.
Then let your voice with praise resound
For Tel Aviv wherein abound
Delight and pleasure all around!

"Lamidbar"—"To the Desert" (alternative text)

O take us to the desert
On camels' backs aloft.
Upon their necks will tinkle
The bells in cadence soft.
O take us, O take us,
O take us to the desert.
Don't play upon your flute, for
The shepherds are asleep
While on the paths, the winking
Bright stars their vigil keep.

(English translation by Harry H. Fein, adapted by Philip V. Bohlman for Nathan 1994)

DETOUR TOWARD DYSTOPIA

The realities of modernity all too often necessitated a passage through a social world that was the obverse of utopia: dystopia. Whereas European Jewish musicians drew inspiration from utopian thought to map a new cultural landscape in the Yishuv, it was through dystopia that the growing fascism in Europe arrested the potential of music to imagine a new land. The dystopian world of the early twentieth century emerged from the implosion of the imperial cultures of Central and Eastern Europe in World War I. The slide from utopian vision to dystopian reality accompanied the struggle to rebuild German and Austrian national identities from the ashes of empire.

The dystopian world to which I now turn briefly was forced upon German Jews in the 1930s, formed from legal and cultural constraints and bounded in the fullest sense of the word. The Jüdischer Kulturbund was the cultural ghetto ordered by the Nazis in early 1933. It is particularly difficult to assess the accomplishment and tragedy of the Kulturbund in any objective way (see Hirsch 2006). On one hand, musical life—paradoxically, Jewish musical life—underwent a massive transformation in the Kulturbund and flourished, even through 1938 in some cities. On the other hand, the conventional interpretation of the flourishing cultural life in the

Kulturbund is that it dulled the perception of the real tragedy already unfolding. Optimism and despair, hopefulness and anxiety, flowed together in the plans laid by those in charge of the Kulturbund, men such as Kurt Singer, the head of the Berlin Kulturbund and director of its orchestra (cf. Bohlman 1995: 54; Steinberg 2008):

> The charge and goal of the "Kulturbund Deutscher Juden" can only be that of trans-
> forming cultural isolation into the fruitfulness of forming a united front, thus saving
> us during this emergency. Those who give and those who receive will be united in
> a single collective for the common spiritual interest of the whole. We must think in
> specifically Jewish terms, but we must also not lose track of the great German artistic
> and spiritual value. Everyone must give of his own and of her best to serve the whole.
> (Singer 1934: 1)

Every type of musical activity possible took place at the Jüdischer Kulturbund. The orchestras developed an extraordinary level of performance, and during the first three years of the Nazi period (1933–1936) they were able to travel from city to city, even at times to orchestral festivals. So successful were the musical undertakings of the Mannheim Kulturbund that it was able to build and dedicate a new complex of con-cert facilities in 1938, a year in which it boasted an opera *abonnement* with six different operas. The Frankfurt am Main Kulturbund orchestra would become well-known after World War II, above all because it provided the core for the Palestine Orches-tra, the future Israeli Philharmonic. The Kulturbund provided a context for public performances of all kinds, and recording and publishing projects developed and even expanded until the late 1930s. Hopefulness drove the spiritual engine for many musi-cal activities in the Kulturbund, especially those that instituted new programs of music education for children and established lecture series and practical courses for adults.

The transition of the Frankfurt Kulturbund orchestra into the Palestine Sym-phony was only one of the ways in which direct connections between Germany and the Yishuv were implemented. The staff of the nascent Palestine Broadcasting Service, Kol Yerushalayim (Voice of Jerusalem)—for example, the music director, Karel Salomon—left Kulturbund organizations in southwestern Germany (Baden-Baden) to take positions in the new radio, which began broadcasting in 1936. Kol Yerushalayim was established by the British Mandate, reflecting the model of the BBC. In the 1930s, radio performances were still live, which meant that musicians would be required for studio broadcasts, thus providing a small but significant job market for immigrant musicians. The relation between the musical organizations of the Kulturbund and those in the Yishuv nonetheless was imbalanced. In Germany, the seemingly flourishing Jewish musical life notwithstanding, there was a dysto-pian collapse into history, indeed into the Holocaust. In the Yishuv the impetus of a utopian disentanglement from history was accelerating.

DYSTOPIAN DISJUNCTURE

The slide from utopia to dystopia was fully apparent in one of the most wildly ambitious attempts to transplant the musical life of Central European Jews to the Yishuv: the World Centre for Jewish Music in Palestine, which was called into life in 1936 before passing into a chapter of forgotten history in 1940. The World

Centre was the inspiration of Salli Levi, a Frankfurt dental surgeon and amateur conductor of the Kulturbund chorus, who determined that a musical organization based in Tel Aviv or Jerusalem might stand a chance of gathering Jewish musicians and Jewish music and transplanting them to the soil of the Yishuv, where it would grow and blossom as the musical life of a new nation (see chapter 8). Levi had written a number of polemical essays about the need for a world center in the final decade of the Weimar period, and he had begun to circulate these in pamphlet form during the early Nazi period (much of the documentation—correspondence, plans for concerts and publications, and the essays for the WCJMP's journal, *Musica Hebraica* (1936)—appears in English translation in Bohlman 1992).

Many of the musical institutions in the Yishuv failed to take Salli Levi seriously, or perhaps better, rejected his utopian vision. The World Centre never fully established ways to collaborate with the Palestine Orchestra or with the small but growing community of German-trained musicologists in the Yishuv, above all with Robert Lachmann. Collaboration with the conservatories in Jerusalem and with Kol Yerushalayim was more productive, above all because the World Centre could partly fulfill its goal of building up the resources of performers, teachers, and new musical compositions. If the founders of the World Centre took specific steps to realize a utopian vision, we are nonetheless left with questions about how to interpret the influence—or noninfluence—of the World Centre.

The World Centre displayed all the traits of Jewish musical life in the nineteenth century. Its two original founders, Salli Levi and Hermann Swet, the latter a Berlin music critic, built it on a structure of public education and cultural enlightenment. The World Centre was a classic example of *Bildungsbürgertum,* the educated and upwardly mobile middle class. If Levi and Swet represented the amateur periphery of Central European musical life, the third member of their organizational triumvirate, Joachim Stutschewsky, represented the center, where professional performers prevailed. Stutschewsky, a cellist of considerable international reputation, was a product of the Habsburg Monarchy. He had come of musical age in the eastern domains of the Austro-Hungarian Empire but had built his career in Vienna.

The World Centre was to make it possible for such different types of musicians to join in the common goal of fostering Jewish music. Through its extensive web of correspondence, through its semi-successful attempts to create a publishing house for Jewish music and criticism, through its publication of two numbers of journal in 1938, and through its sponsorship of concerts in the Yishuv, most of them modest but several with considerable visibility, the World Centre succeeded in jerrybuilding a single institutional structure for the support of Jewish music. Musicians from throughout the diaspora were corresponding with its founders in Tel Aviv, with the hope, even the conviction, that the World Centre would attract musicians from the diaspora to lay the foundations for a new Jewish music. At the height of the World Centre's successes in 1938, there was growing hope even that practical goals too might follow. One of the most important of these practical goals was to help Jewish musicians—not just chamber musicians and composers in the Kulturbund, but also cantors and music teachers in Jewish high schools—obtain entrance visas from the British. To some seeking help, the World Centre promised concerts and sought channels that might open teaching positions. The World

Centre, however, was trapped in the world of dystopian disjuncture, and its attempts to achieve practical goals proved to be too few and too late.

The World Centre did open a new musical landscape in the Yishuv, and it charted new possibilities for locating the practices of Jewish music on that land-scape. On this uncharted landscape of Jewish music we witness the imprint of music as a fundamental dimension of European Bildungsbürgertum. Music would be at once vital to any citizen's identity and stripped of any elite trappings. By draw-ing attention to the dystopian disjuncture, the World Centre also reinstated many conditions of music's modernist response to history, thus bequeathing that response to a new generation of immigrant musicians who might suture past history to the present in the wake of the Holocaust.

PARALLEL ROUTES TO HETEROTOPIA

Parallels!

By Else Lasker-Schüler

> It was in the springtime
> Of the year eighteen hundred and fifty-three
> As the young Brahms set forth into the German lands
> And with him came—bound in friendship—
> Reminiy, the young violinist from the land of the Magyars.
> At the time, young Johannes counted only nineteen years of age!
> The journey brought money and fame
> To both of the music makers;
> The impact on Brahms's creativity was one of great success.
> This quickly established him a place in Schumann's "Neue Bahnen."
>
> • • •
>
> That was ninety years ago!
>
> • • •
>
> Now, the young Pressler wishes to travel through the "Holy Land,"
> With pianistic virtuosity and temperament,
> Bringing joy to the moshavim and the kibbutzim,
> Enchanting the Jordan Valley with Handel, Liszt, and César Franck;
> At nineteen, courageously, fresh, and unrestrained
> He then returns to the cities with Mozart, Schubert, Schumann, Haydn,
> (Just as Brahms once had done!) – – –
> The whole of Givat-Hashlosha raves, full of spirit,
> It's the same at Ramat-Gan, when Max (Menachem) masters the keyboard!
> The press reviews are full of praise,
> First and foremost from Dr. Gradenwitz, da Costa, and Paul Riesenfeld!—
> And beyond that (the parallel must be perfect!):
> A violinist-friend from Hungary—called Wettenstein—
> Was also with him. – They played violin and piano together
> And they brought with them after a complete artists' tour,
> After much work—difficult and hard—
> Success and money and sanguine cheeks to Tel Aviv.

("Parallelen!" Unpublished poem by Else Lasker-Schüler)

The very fact that a mixture of utopian and dystopian aesthetics did take root in the Yishuv raises the question of synthesis and symbiosis, first whether European Jews effected a synthesis, and then what the nature of a symbiosis might have been. Questions of synthesis do not lend themselves to straightforward positive or negative answers. Simple answers would suggest that synthesis is evident in concrete products. Synthesis does not reveal itself in products, but rather in the ongoing processes that fall under the conceptual category of heterotopia, contrasting thus with the concepts of utopia and dystopia, which dominated the paths from the old to the new land of Israel. Heterotopia itself represents a domain of in-betweenness: a place between utopia and dystopia, representing a lived-in world where utopian visions become realized in human lives. Because of their palpable reality, heterotopian images also reroute the historical path around the destruction of dystopia.

The heterotopian turn toward multiple styles and practices in the music of the new world inevitably concerns itself with questions of compositional style, which manifest themselves in the musical language of heterotopia crafted by European immigrants in the Yishuv. That language took shape and was then aesthetically inscribed through musical counterpoint and polyphony that juxtaposed the old and the new, traditional tonal approaches to counterpoint combined with a Jewish and modernist aesthetics. Heterotopia unfolded as an aesthetic path that made possible the return to modernism. The heterotopian realization of a modern music for the Yishuv was first made possible by the enrichment of musical materials determining the earliest stages of Jewish musical modernism. Literally all musical materials were made available to composers, arrangers, and other musicians, such as the composer-cantors of the German synagogue, and what they understood as the language of European and Jewish modernism allowed them to transform these materials in radically new—and sometimes atavistically ancient—ways. The various Jewish traditions and communities to which counterpoint gave voice came from across the landscape of Jewish history and modernity. At a basic level, counterpoint served as a language for juxtaposing East and West. Counterpoint permitted a modern, multicultural conversation and made it possible to negotiate the morally incompatible borders between sacred and secular Jewish practice (on modernism in Jewish music, see the essays in Bohlman 2008).

German-Jewish composers who talked about their experiments with counterpoint recognized the ways in which it could at once enhance a work's Germanness but do only within the contexts of an Israeli aesthetic world. The Königsberg-born and German-educated composer Hanoch Jacoby succinctly expressed his commitment to counterpoint. The potential of the Middle Eastern melos, the Arabic classical system based on maqām, underwent a modernist transformation when it was realized polyphonically. The modernist transformation made it possible, according to Jacoby, to create a musical style that was specifically Israeli, "like the *Inventions* of Johann Sebastian Bach" (quoted in Bohlman 1989a: 201). Among the first generation of composers to settle in the Yishuv during the 1930s, the heterotopian vision for a cultural symbiosis in a truly modern *and* modernist Israeli music was most sweepingly fulfilled by Josef Tal, who varied his compositional palette to achieve virtually any combination of techniques, media, and sonic landscapes. Tal paved the way for the first Israeli experiments in electronic music, and yet he was the

composer of his immigrant generation who most aggressively rejected the more restrictive craftsmanship of the so-called "Eastern Mediterranean School." There is no single Tal style or series of style periods. Rather, Josef Tal is a composer whose work is in flux and constantly in search of new materials. In operas, such as *Ashmedai* (1970) and *Die Versuchung* (1975), we witness symbolic processes of searching through his deliberate juxtaposition of a post-1945 modernist voice, both German and Hebrew, with the mixture of musical traditions that was possible only in modern Israel. The heterotopian vision that Josef Tal has bequeathed to modern Israel has the multiple dimensions that evoke the present and the future, while affirming, not denying, the past (see Tal 1985).

BEYOND THE BORDERS OF UTOPIA

Ultimately, it was in the multitude of musical voices that the sheer impact of European contributions to the musical life in the Yishuv was most visibly striking, for there was virtually no domain on the musical landscape of modern Israel that does not bear witness to the transformative touch of the German-speaking aliyot. We might even say that it is possible to measure this transformation as the metaphorical path toward a "Musical New Jerusalem." Indeed, the language of many in the immigrant generation employs precisely this imagery. Beyond the borders of utopia the themes that have already become familiar in this chapter proliferate to reconverge as multicultural and hybrid, modern because of the new soundscape of the nation-state.

The influence of the immigrant composers in search of utopia is clearly evident in the cosmopolitan practices of music-making. The materials for these practices came from the attempts to create, in some cases to invent from whole cloth, new genres of Jewish song, among others the *shireh eretz yisrael* (songs of the land of Israel) of popular music. Choral movements on the kibbutzim picked up these songs and built entirely new repertories. Natan Shahar's research has traced the history of these choral movements with great clarity (Shahar 1993). Music education and music publishing were not only transplanted from German and Austrian models, but they were cultivated to yield a new harvest of musics and musicians.

It is also crucial to a full recognition of the Central European musical contribution that its Germanness—its ethnic particularism or parochialism—not be exaggerated. Indeed, there is nothing to gain by separating Central European contributions from those of other communities. Many of the most significant undertakings of the Central European musicians resulted from their deliberate engagement with practices of Jewish and world music that were the most foreign. There was a critical openness to engaging with the music of the other Jewish communities and of Palestinian Arabs and the religious diversity of the Levant. The extraordinary traditions of historical musicology and ethnomusicology in Israel bear witness to the transformations of European models initiated first by the generation of German immigrants, particularly Robert Lachmann and Edith Gerson-Kiwi.

The true character of the modern musical culture beyond the borders of utopia, symbolized by the birth of modern orchestras, the Palestine Orchestra and

the Israeli Philharmonic, might well be described as the non-Germanness of their Germanness. I wonder, indeed, whether we—and surely I have done this more than any other—have not for too long exaggerated the historical topos of transplantation from Central Europe, the direct relation between the Palestine Orchestra and the orchestras of the Jüdischer Kulturbund. In their attempt to emphasize the role of the orchestra as an ensemble of refugees (see, e.g., von der Lühe 1998), music historians may have diminished the more complex meaning of modern Jewish history in the European symphonic tradition. The heterotopian musical life in the Yishuv and Israel was far more significant because it eventually transcended its underlying Austro-German traditions into the modern territories that lay beyond them.

REBIRTH INTO UTOPIA

> It is in the mixture of justified positions and of setting their
> results in motion that I recognize the rebirth of the community.
> Rebirth, not return.
>
> —Buber 1985: 255

The closing gesture of this chapter does not so much bring closure as leave us with an open form, a beginning or "rebirth" in the sense of Martin Buber's assessment of the opening of utopia in the Yishuv. This chapter's conclusion unfolds through contrapuntal voices joining together in the historical transformation from one form of musical modernism to another. Those voices have moved toward the historical "stretto" of arrival in Israel, that moment when difference gives way to unity, when, to follow Martin Buber, the community as society—the *Gemeinde*—is reborn (1985).

Was the Central European Jewish contribution to the musical life of the Yishuv and Israel an open or closed form? Did it open toward heterotopia, or was it mired in dystopia? How did it reconcile the seeming contradictions between the ancient and the modern? Throughout this chapter, literally and figuratively, I make a case for the openness of an Israeli music history in the 1930s and 1940s that was profoundly affected by the contributions of immigrants from Central Europe. Born of flight, the efforts of Central European musicians were reborn of a coming-together, not a unity of sameness but rather a counterpoint where utopian themes and heterotopian variations alike contributed to the shaping of a whole. Although utopia, dystopia, and heterotopia in vastly different forms, contradictory and parallel, constituted the historical narrative of the chapter, historically they overlapped to connect the parts to the whole, the stretto of a new musical modernism. Modernism and postmodernism, orientalism and occidentalism, vernacular and art music, all still resonate with the *shir chadash ba-naharayim,* the "new song in the land where two streams flow," the utopian imagery that is at once biblical and contemporary. It is symbolic of the ultimate utopian voices of the immigrant generations to the musical life of modern Israel that they continue to resonate at the beginning of a new century and millennium.

BEYOND JEWISH MUSIC

PARABLES OF THE METROPOLE

Original German, in Viennese dialect

1. I fuhr' zwa harbe Rappen,
Mein Zeug dös steht am Grab'n,
A so wie dö zwa trappen
Wer'ns net viel g'sehen hab'n.
A Peitschen a des gibt's net,
Ni jesses nur net schlag'n,
Das allermeiste wär tsch', tsch'.
Soust z'reissens gler in Wag'n.
Vom Lamm zum Lusthaus fahr' i's
In zwölf Minuten hin;
Mir springt kauns drein net in Galopp,
Da geht's nur all weil trapp, trapp, trapp,
Wanns nachher so recht schiessen,
Da spür i's in mir drin,
Daß i die rechte Pratzen hab,
Daß i Fiaker bin.
A Kutscher kann a jeder wer'n.
Aber fahren kinnans nur in Wean.

> Mein Stolz is i bin halt
> An echts Weanakind,
> A Fiaker, wie man net
> Alle Tag findt,
> Mein Bluat is so lüftig
> Und leicht wie der Wind.
> I bin halt an echt Weanerkind.

> Mein Stolz is i bin halt an echts Weanakind,
> A Fiaker, wie man net alle Tag findt,
> Mein Bluat is so lüftig und leicht wie der Wind.
> I bin halt an echt Weanerkind.

FIGURE 7.1 Gustav Pick: "Wiener Fiakerlied"/"The Viennese Coachman's Song."

English Translation
(for lyrics prepared for American performance see New
Budapest Orpheum Society 2002: CD 2, track 1)

1. I drive two fine black horses,
My coach stands there on the Graben,
Those two riding along
Don't see much at all.
It's no good to use a whip,
Or to strike them in any way,
The most I can do
Is say, "giddy-up, giddy-up,
Move out and give a pull."
From the Lamb Street to the casino,
It only takes twelve minutes;
We spring ahead
Rather than remain in a gallop,
The whole time they go, klopp, klopp, klopp,
As if someone were shooting,
And I get that feeling inside,
That I've got just the right touch,
That I'm a real coachman.
Anyone can drive a coach,

But to drive a carriage in Vienna, that's something else.

Refrain

> What makes me really proud is that I grew up a kid in Vienna,
> To become a coachman, not your everyday coachman,
> But my blood flows freely and lightly like the wind.
> I really am a true child of Vienna.

2. As a kid I was a stableboy,
For Prince Esterházy,
The biggest treat for me
Was the big stable with stallions.
According to the Prince's wishes,
I should have been a horse trainer,
But I much preferred driving a carriage
For I didn't want to ride horses.
The old Prince was very fine,
A master with a truly good heart,
But I didn't like wearing livery,
It just bothered me to no end.
When I sit up on the carriage seat,
Covered in a fur like a bear,
Clean-shaven as I can be,
As if I were an actor.
One isn't just born this way,
And that's why I became a coachman.

Refrain

3. To be a coachman, one must become
What people call "delicate,"
One must listen, agree, and keep quiet,
One must be clever and—very still.
I often drive for the finest men
Out to "Number One,"
In other words to Count Lamezan's place—
But nobody's to know it.
Two lovers often come along,
And climb on board my coach,
I see right away,
That it's not entirely proper,
But I'm so very delicate—
And if someone follows me later,
Wanting to know who rode with me,
The horses give me a hand,
For they won't let anyone else get in.
If grandpa wants to show off
With me—why not, I can't lie about myself—

Refrain

4. Every year on Ash Wednesday,
We have a coachman's ball,

Everybody lets go a little there,
But still there's no scandal.
Many counts and many coachmen
Sit nicely together there,
Because we're the only ones
Who have an elite ball for Fasching.
The young people dance,
We older folks just look on,
We take pleasure
In that alone;
A band strikes up a "duliah,"
The Schrammel Quartet joins in,
And those still single sing along,
And when our ball is over,
The dawn is already breaking.
Only coachmen have something like that,
It's a genre we have all unto ourselves—

Refrain

5. The great Gaudi a famous actress
Rode with me in my carriage,
That's what the Viennese really love,
So they flock in droves to watch.
Twenty starting gates stand there,
Jammed altogether and orderly:
Today, the coachman and the horses
Are being cheered on by everyone.
The starter gives the sign,
And everything takes off like lightning.
At first, the Ollas
Runs back and forth,
As if swinging by
Grandma's looking glass.
On the other hand, I keep the horses under control,
Away from all the excitement,
Once the others are away, then I'll take off—
That's an old joke.
With my hat over my eyes I just sat here,
While ten thousand people shouted "Vivat"—

Refrain

6. Today, we have an anniversary,
Because a hundred years ago today,
A coach for the first time
Was allowed to drive in Vienna.
Today, we count at least a thousand,
And anyone who knows anything
Has to admit that a coachman is
A specialist.
But a hundred years from today,

That'll be a different story,
Then, they'll be flying
More through the air,
I've heard already,
As if they were floating on water:
Do you hear that, George,
Fly over to the Baron's,
He needs a hot-air balloon
Over in Freudenau.
A vehicle like that is pretty dumb,
For your stomach will start churning—

Refrain

7. When I remember in the old days
What it was like on May 1st,
When Vienna was Old Vienna,
No Ringstraße—No Bastei;
Riding to the Prater
Kept Vienna in one nice piece,
I see each handsome carriage,
Just as if it were today.
From Trautmannsdorf to Schwarzbraun,
Now that took quite a rig.
And everybody went anyway,
As if they were crazy fools,
Because the only way to go
Was with a carriage hitched to eight horses.
That sounds like it's too much
For only one man,
Today you simply wouldn't do it,
Because there aren't rigs like that anymore.
Mr. Sándor was there, all alone,
Nobody knew him, big or small.

Refrain

8. I'm almost sixty years old.
For forty years I've driven from this carriage stand,
A coachman and his coach
Were well matched to each other.
And when my time comes to travel on,
And I'm carried off to be buried,
Hitch up my horses
And carry me off to my grave.
Just let them walk along,
Pulling the carriage to its goal.
I only ask that
They keep to their pace,
Just because of me,
They should also pass the corner—
It's a "Must-Do,"

Traveling to the last resting place,
And all the people should take note,
That it's a coach that's carrying me along.
And on the gravestone should be written,
So that everybody can read it plainly:

Refrain

—Gustav Pick: "Wiener Fiakerlied"/"The Viennese
Coachman's Song" (1885)

JEWISH CITY MUSIC

"The Viennese Coachman's Song" was the great hit song of fin-de-siècle Vienna. Immediately after it was composed and published in the mid-1880s, the *Wienerlied* (literally, Viennese song, a popular song in Viennese dialect) won phenomenal success, first as a signature tune for Alexander Girardi, the renowned songster of the day, and then in the myriad covers and arrangements that flooded Vienna's amusement parks, popular theaters, and entertainment sites, among them the city's famous wine gardens, or *Heurigen* (a restaurant at which local wines from the most recent harvest are served), that filled the newly incorporated suburbs. The "Coachman's Song" recounted a rags-to-riches tale that drew attention to the shifting boundaries between the elite, aristocratic world of the Habsburg Monarchy and the workaday world of the lower classes and urban immigrants. The song's narrator comes from simple stock, and he finds opportunity bestowed upon him by the Esterházy family of Hungary, whose lands spread across western Hungary into present-day Austria. Through hard work and the discretion of a servant who sees much but says little, the coachman enjoys more successes than his father's and grandfather's generations could have imagined. He transports the rich and famous about Vienna, and he is witness to the marvels of a modernizing society. The "Coachman's Song" chronicles transformations within his own class, among them previously unknown events such as a Viennese ball for coachmen, where counts and coachmen rub elbows, and the most popular musical ensemble of late nineteenth-century Vienna, the Schrammel Quartet, plays until dawn (Egger 1989). In the closing verses, however, the coachman remains true to his position in the imperial metropole. He asks only that his horses take him to his final resting place at the city's edge, where his gravestone will serve as a testament to a life of dedication and labor.

The "Viennese Coachman's Song" was an allegory for many who had entered the Habsburg metropole in the nineteenth century, not least among them the song's composer, Gustav Pick (1832–1921). Born in the Jewish communities of west Hungarian Burgenland, Pick followed his way to fortune as an industrialist in Vienna. His interests were less prosaic than that of the hero of the song that made him famous, for Pick's real interest lay in the composition of *Wienerlieder* (literally, Viennese songs, hence popular songs in Viennese dialect). The "Coachman's Song" may have contained more allegory than autobiographical fact, but there can be little doubt that Pick's own life followed a course vaguely reminiscent of the coachman's. The coachman was not Jewish, but his youth in service to the Esterházy family would have been familiar to

a Jewish urban immigrant from Burgenland, where the Esterházys had protected the Jewish communities for centuries (see chapter 1 for discussion of the sheva kehillot, the Seven Holy Cities of Burgenland). The coachman followed a social trajectory paved by hard work, one that demanded submission to the social barriers that Jews, even in the growing Jewish districts of Vienna, Budapest, or Prague, were facing. By the beginning of the twentieth century Pick's successes were themselves declining, and by the time of his death in the years after the collapse of the Austro-Hungarian Empire, many had forgotten the composer of the hit song (Pressler 1995).

There was, in contrast, no decline in the fame of the Viennese coachman in the song. He had become the subject of covers and broadside variants throughout Europe and even in the Americas. He became both a working-class hero and a buffoon, the subject of songs paying homage to a humble laborer and songs poking fun at a poor stiff oblivious to what society really thought of him. The images of the Viennese coachman proliferated as the society that produced him became more cosmopolitan and the simple world from which he had come receded farther into a past separated from the modern metropole. A flood of popular songs and poetry covered the life of the Viennese coachman, intensifying its reach as both parable and parody. Even Hugo von Hoffmannsthal penned a poetic cover of the "Fiakerlied," which he called "Lebenslied" (Song of Life), transposing its meaning to the aristocratic class of fin-de-siècle Vienna.

Den Erben laß verschwenden	An eagle [noble], lamb, and peacock
An Adler, Lamm und Pfau	Squander their fortune,
Das Salböl aus den Händen	The ointment from the hands
Der toten alten Frau!	Of the dying old woman!

Hardly surprising, the Viennese coachman found his way quickly into the popular music of the rapidly growing Jewish populations of the Habsburg metropole. His journeys through the city streets might have been those of immigrants from the shtetl, the eastern provinces of the Austro-Hungarian Empire, or even from the urban ghettos, the Salzgries or Leopoldstadt neighborhoods in Vienna. Jewish popular songs too remade the image of the coachman so that it reflected both self and other. The "Jewish Coachman's Song" was probably one of the most popular broadside variants of the "Viennese Coachman's Song"—there were "Bohemian Coachman's Songs" and the like—not least because it was printed by Carl Fritz, one of the most successful popular-song presses in fin-de-siècle Vienna. The song is crudely crafted satire, mixing admirable and laughable attributes. The world of the metropole through which the Jewish coachman takes his passengers, however, is not crudely charted, because fin-de-siècle Viennese listeners, both Jews and non-Jews, would recognize the neighborhoods and the real-life characters at the urban crossroads. If the song's texts—and those of countless other covers of the "Coachman's Song"—represent the fantasy of the city, they also include specific references to a new cosmopolitan reality. As Jewish immigrants flooded the metropole, a new Jewish popular music was rapidly taking shape, and it traded in stories that were at once true and fictional, stories that chronicled a new city culture in the liminal space between tradition and modernity.

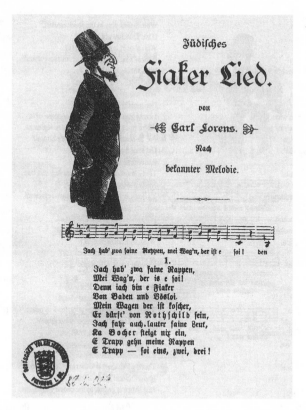

FIGURE 7.2 "Jüdisches Fiaker Lied"/"Jewish Coachman's Song." Text by Carl Lorens for the tune by Gustav Pick. (Used courtesy of the Deutsches Volksliedarchiv, Freiburg im Breisgau)

1. Iach hab' zwa faine Rappen,
Mei Wag'n, der is e soi!
Denn iach bin e Fiaker
Von Baden und Vösloi.
Mein Wagen der ist koscher,
Er dürft' von Rothschild sein,
Iach fahr auch lauter fainer Leut,
Ka Bocher steigt nix ein,
E Trapp gehn meine Rappen
E Trapp—soi eins, zwei, drei!
Iach fahr als wie e Dampfmaschin',
In zwa Täg bin iach schon in Wien.
E Tax thu iach nich kennen,
Steigt ein e Passagier,
Laß iach bei zwa Gülden handeln,
Sag: "Geb n Sie halt e Einserl her!"

Statt Geld nehm' iach auch Werthpapier,
Versatzzetteln, ist Aner stier,

> Denn iach bin e Fiaker a koscheres Kind,
> Gebor'n auf'n Salzgries und leicht wie der Wind.
> Mei Mame, mei Tate hab'n mit mir e Freud'.
> Denn ich bin e Fiaker von ünsere Leut'.

English Translation
(for lyrics prepared for American performance see New
Budapest Orpheum Society 2002: CD 2, track 6)

1. I have two fine black horses,
My carriage, it's quite fine!
For I'm a carriage driver
From Baden and Vößlau.
My carriage is kosher,
It could belong to Rothschild,
I drive also only the finest people,
Not just any guy climbs on board,
Clip clop go my horses
Clip clop—it's one, two, three!
I drive just like a steam engine,
In two days I'm already in Vienna.
I don't know anything about a taxi,
A passenger gets in,
I agree on a fare of two Gulden,
Saying: "Just give me a single!"
Instead of money, I'll take an I-owe-you,
It's even better to get a little tip,

> For I'm a coachman and an observant child,
> Born in the Salzgries and slight as the wind.
> I'm a joy for my mother and my father,
> For I'm a coachman for our folks.

2. Iach, war als klanes Jüngel
Vor'm dreinundsiebziger Jahr
E Laufbursch an der Börse,
Bevor der Krach noch war.
Dann bin iach wor'n e Kutscher
Beim reichen Silberstein,
Hab' geführt e Equipasche
E soi! Nobel, superfein!
Doch wie der Krach gekümmen ist,
Püh! haben Sie gesehn!
Kapores war der Fleckeles,
Der Silberstein, der Schmeckeles!
Das war e groiß' Gewurre!

Iach muß es frei gestehen,
Man hat uns Alles weg' gepfänd',
's war nix mehr da am End.
Sechs Jahr hat kriegt der Silberstein,
Iach bin gestanden ganz allein.

 Denn iach bin, usw.

2. When I was a little boy
Before '73,
I was a messenger boy at the stock market,
Before the crash had happened.
Then I was a coachman
For rich old Silberstein,
I drove a carriage
It was elegant! Super fine!
Still, as the stock market crashed,
Pooh! Then they say!
Fleckeles was ruined,
So too were Silberstein and Schmeckeles!
It was a huge tragedy!
I had to be let go,
One took away everything we had,
At the end nothing was left.
Silberstein received six years,
I was left standing entirely alone.

 For I'm a coachman and an observant child,
 Born in the Salzgries and slight as the wind.
 I'm a joy for my mother and my father,
 For I'm a coachman for our folks.

3. Gebor'n bin iach am Salzgries
Mei Tate war e Jüd,
Der hat gelebt, gehandelt,
Das liegt soi im Geblüt,
Mit alte Hoisen, Stiefeln,
Zerbroch'ne Paraplui.
Mein Mame war ä Ganslerin
Am Salzgries, vis a vis.
Mich hat nix gefreut das Handeln,
Hab' g'sagt zum Tateleb'n:
"Iach möcht emal Fiaker werd'n."
"Zerbrach den Krag'n, iach werd Dich lehr'n!"
Hat er zu mir geschrieen, doch
Iach hab nix aufgepaßt,
Iach bin gleich auf e Bock gestiegen,
Und auch Fiaker blieb'n.
Beim Wettfahr'n bin iach Erster g'wiß,
Weil mei schöne Nas die längste is.

 Denn iach bin, usw.

3. I was born in the Salzgries
My father was a Jew,
As he lived, so he traded,
It was in his blood,
With old pants, boots,
And broken umbrellas.
My mother was a shopkeeper
Just across from the Salzgries.
I didn't like selling and buying,
So I said to my father:
"I'd like to become a coachman."
"I'll break your skull, that'll teach you!"
He screamed at me, still
I didn't pay attention,
I climbed right into a carriage seat,
And have been a coachman ever since.
At racing I'd surely be in first place,
Because my handsome nose is the longest.

> For I'm a coachman and an observant child,
> Born in the Salzgries and slight as the wind.
> I'm a joy for my mother and my father,
> For I'm a coachman for our folks.

Source: Viennese broadside by Carl Lorens, sung to a "well-known melody" (Gustav Pick's "Fiaker Lied"). Printed by C. Fritz in Vienna, Rudolfsheim, Dreihausgasse 17. Preserved in the Österreichisches Volksliedwerk.

THE METROPOLE, TRADITION, AND FOLK MUSIC

For the most part, the search for Jewish folk music historically approached the metropole and its city culture as hostile territories (see, e.g., Landmann 1985). Jewish folk music should have been rooted in traditional, religious life that provided the texts and images for musical practices dependent primarily on oral tradition. Rural Jewish culture, so the themes of Jewish folk-music scholarship have held, is at farthest remove from culture contact and exchange. The traditional models of Jewish folk music, as witnessed in the previous chapters (see esp. chapter 1), often fail to take account of the reality that it has seldom proved possible to identify genres, styles, or repertories with no evidence of outside influences. So prevalent are non-Jewish melodies that it becomes virtually impossible to distinguish what a Jewish folk melody should be. One might argue, as I and others have (e.g., Bohlman 1989b; Bohlman and Holzapfel 2001, passim), that cultural exchange is the rule rather than the exception in Jewish folk music. Accordingly, it is a question not only that separating the Jewish from the non-Jewish is difficult if not impossible, but that doing so actually serves as a detriment to determining what Jewish folk music really is. Hybridity, exchange, mixed repertories and styles, and bricolage in virtually every possible manifestation constantly shape tradition. In so doing, these processes break down the barriers to modernity.

Exchange is therefore normative, so much so that its impact on modern folk- and popular-music repertories for the Jewish community of the metropole enriches

rather than dilutes. New historical forces come to bear on the Jewish community, and folk music serves as one of the most powerful forms of enhancing those forces. We turn in this chapter to a particular historical moment, from the 1880s until World War I, followed by a brief historical epilogue that lasts until the early 1930s, in which Jewish folk music became a phenomenon of city culture and the metropole in which Jewish modernism was emerging. Multiplying as urban genres, Jewish folk music itself underwent a transition to popular music, the functions of which were sweepingly cosmopolitan, while retaining many attributes of folk music.

The transformation of Jewish folk music depended on the shifting demography of European Jewish culture, in particular its extensive urbanization, which took place during the half century that provides the historical backdrop for this chapter. The process of musical transformation is itself one of urbanization, and therein lies a paradox and a question: Can folk music really serve as a means of accommodation and adaptation to modernity? Folk-music scholars have by and large responded negatively to the question. Much European folk-music theory regards the city as the site of hybridity and the decline of folk music's meaningfulness to traditional society. In formulating theories for modern Hungarian folk-music scholarship, Béla Bartók and Zoltán Kodály turned away from the city, disparaging the "mixed style" that its culture facilitated. Jewish folk-music scholars, confronting a sense of loss in the early twentieth century, turned almost entirely away from the city. In the anthologies and collections that were examined in chapter 5, songs from the city simply had no presence. Quite the contrary, many of the collectors saw it as their mission to protect folk music from the metropole, which, they believed, would overwhelm the music and sap it of its Jewishness.

The traditions of Jewish folk music examined in this chapter have never fully won a place in studies of Jewish modernity. They chronicle change, more often than not the unchecked change of the city. They locate their Jewish subjects in a position between tradition and modernity, and as such they fully recognize the liminality of Jewish selfness and its splintering into otherness. They rely on the stock-in-trade of satire, and to do this they employ stereotype and play with the objects of satire using the conventions of *Spottlieder* (mocking songs), genres that poked fun at otherness, usually playing on the naïveté of rural life. Satire and stereotype paved the way to the public sphere of the metropole, the musical stage and the cabaret, which increasingly attracted Jews, even becoming a distinctive purview of Jewish urban culture by the early twentieth century. Jewish folk and popular music of the metropole mixed sympathetic images of coreligionists with bitter satire, but that mixture too formed a new tradition out of the old. It is the mixture that we witness in Jewish modernism, such as in Gustav Mahler or in Jewish cabaret, and it is the mixture that attracted fascist ideologues in the 1920s and 1930s. Separating the historical strands of such a mixture may be daunting and disturbing, but it is necessary if we are to understand Jewish life in the metropole and to explore the paths from tradition to modernity.

PARABLES OF URBANIZATION

As the Haskala, the Jewish Enlightenment, gave way to the nineteenth century, new Jewish literary and musical practices responded quickly to the challenges posed by

the new migration to the city. For the generations after Moses Mendelssohn, responding to the crisis of urbanization demanded a new reflexivity, even a turn toward self-criticism and an attempt to account for the sacrifice of tradition at the cost of winning a place in the modern city. Among these responses Heinrich Heine's novel, *Der Rabbi von Bacherach* (1987 [1840]), was one of the most vivid and trenchant parables of the cultural quandaries confronting urbanizing Jews, and we turn briefly to a closer reading of that parable, which, in its broadest outlines, would serve as a model for the popular songs and broadsides of the mid- and late nineteenth century.

Narrowly escaping the massacre of his small community by zealous Christian flagellants, who arrive at the Passover seder to murder the Jews of the rural Rhineland village, Rabbi Abraham of Bacherach spirits his wife, Sara, to a small boat on the Rhine, which bears them first to the Main River and then to the great metropole of Frankfurt in search of refuge in the walled Jewish quarter. The allegorical Rhine journey facilitates a journey across a historical boundary separating the medieval isolation of the village from the early modern cosmopolitanism of the city. Frankfurt symbolizes a world apart from Bacherach. Unlike in the intimate community of relatives and close acquaintances that Rabbi Abraham and Sara knew in the village, they find themselves enveloped by the din of strange languages, perplexing customs, and wildly confusing variants of folk songs now turned inside out as street songs. Even the most sacred practices bear witness to secular currents flowing through the Jewish quarter. Jewish life, as Rabbi Abraham and Sara have known it, seems no more than faint tracings on the panorama of city life.

Notably, there are moments in Heine's novel in which parable extends to the urban transformations through which Jewish music passes. Not only do the voices of the Jewish quarter speak with different accents and dialects, even in different languages, but they sing songs that lay claim to an unfamiliar Judaism. The ḥazzan in the synagogue comes from elsewhere, and as an imported professional he is the focus of both criticism and praise from the congregation, who would prefer a Dutch cantor. Still they cannot complain too vociferously, because their present cantor seems happy enough receiving only 400 Gulden per year. The traditional Jewish music of Bacherach seems no more than a distant echo in Frankfurt. Who in the village would have expected that the rabbi and Sara would have to suffer through an irreverent rendition of the Passover song "Chad Gadya" (One Kid), croaked by a half-crazed ghetto gatekeeper? Urbanization had touched even the most sacred and had conflated traditions in ways that Rabbi Abraham had never before imagined. And yet it was to this Jewish culture of the city that the rabbi had turned out of necessity, out of the need to find refuge in the only Jewish community available as the pogrom swept through Bacherach.

The encounter with the city in Heine's parable deliberately reflects an earlier chapter in the history of Jewish Europe to intensify its allegorical meaning for his contemporaries. Though Heine intended the story to be timeless—historical details are either absent or veiled—the general historical framework is clearly that of early modern Europe. Heine was himself writing on the eve of a new phase of urbanization in European Jewish history, in which the confrontation with modernity was no less necessary than in the allegorical journey of Rabbi Abraham and Sara. The novel also reflected a personal transition in Heine's life, his own decision to encounter Judaism in a new way, for *Der Rabbi von Bacherach* was directly

influenced by Heine's participation in the Verein für Kultur und Wissenschaft der Juden (Society for the Culture and Science of the Jews), itself a manifestation of the nineteenth-century urbanization of Jewish society much like Leopold Zunz's Wissenschaft des Judentums (Science of Judaism), whose influences we have witnessed elsewhere in this book (see Sorkin 1987). Heine was not only looking back on the past, but also looking forward to the urbanization of European Jewry (Heine's quite extensive writings on Jewish topics—poetry, fiction, and nonfiction— are gathered in Heine 1997).

This history of nineteenth-century Jewish urbanization found its way into countless parables that celebrate and defile its impact on the modern era. At the beginning of the century, Jews emigrated from rural Europe in massive numbers, largely abandoning the *Landesgemeinde* (rural community) for the many social, professional, and cultural opportunities of the city. The demographics of the modern metropole changed dramatically with the arrival of rural Jews, with new Jewish quarters transforming the urban landscape, sometimes appearing near the older ghettos but also locating near the center of the metropole. The Leopoldstadt (Leopold's city) of Vienna largely occupied the city's second district, between the Danube River and the Danube Canal. The Scheunenviertel (the quarter of the barns) of Berlin stretched northward from the center of nineteenth-century commerce, Alexanderplatz. These city neighborhoods directly juxtaposed traditional Jewish life and cosmopolitan culture, blurring the boundaries between them.

A considerable belletristic literature chronicles the migration of rural Jews to the city during the nineteenth century. The migration serves as the central leitmotif in Joseph Roth's novels, where it also parallels the collapse of the Austro-Hungarian Empire, the history of which provides Roth with a rich field of metaphors for the nineteenth century and its experiment with European multiculturalism (see, e.g., Roth 1978). Writing in the wake of urbanization and during the Holocaust and its aftermath, Soma Morgenstern employs fiction to write even more nostalgically and critically about the cultural dilemma facing rural Jews in the modern city (see, e.g., his novel trilogy *Funken im Abgrund* (Sparks at the Abyss), published as Morgenstern 1999).

Urbanization gave birth to many of the themes that characterize Jewish modernity: assimilation, secularization, Zionism, the Jewish intellectual and artist as catalyst for modernism. Such themes, even when treated dispassionately, imply the disappearance of the traditional. The traditional, however, especially the conscious and concerted search to understand and foster its components (e.g., folk music), was very much a part of the urbanization of Central European Jewish culture. Indeed, one can say that the conscious concern for tradition within the new urban environment was widespread in the Jewish metropole. Urbanization empowered a preoccupation with the traditional in its new, modern forms. Accordingly, folk music occupied a new and more complex position in the city, undergoing a transition to popular music and playing a critical role in the articulation of new meanings and identities.

THE JOURNEY TO THE CITY—"THE JEWISH CONDUCTOR'S SONG"

1. Es sogt zu einem kosher'n Jüngel
Der Tate Jeinkef: "Haft e Geld,

Du bist schon groß, hast e guts Züngel,
Du fahrst hinaus in die weite Welt,
Nach Großwardein werst Du dich wenden,
Dort gibt's zu schachern allerlei."—

Der Jüngel sogt: "Mein lieber Tate
Bei'm schachern bin ich schon dabei!"
Doch wie er einsteigt—o du Jammer,

Hat er verfehlt die Eisenbahn,
Anstatt nach Großwardein ist kommen
Bei uns am Nordbahnhof er an.
Waih!

Refrain

Ach, lieber Schaffner,
Was haben Se gemacht?
Se hab'n mich her nach Wien,
Anstatt nach Großwardein gebracht!
Führ'n Se mich nur schnelle
Nach Tarnow wieder zurück,
Denn a koscher's Jüngel
Hat in Wien ka Glück.

Refrain im Chor wiederholen.

2. Es thun die Leute alle lachen,
Wie se das Jüngerl hab'n geseh'n,
Am Kopf die Beijes, e langen Kaftan,
So bleibt er ganz verzweifelt steh'n.
"Was soll jach machen da in Wien hier?
Das is ka Stadt for unsere Leut'!
Wo schon das allerklanste Jüngel
Am Salzgries "hoch Lueger!" schreit."
Und weil er sich nix weiß zu helfen,

So fangt er an zu lamentirn,
Lauft wieder z'ruck zur Bahnhofhalle,
Hat d'rin vor Kummer Schmerz geschrien
Waih!

Papa Jeinkef once said
To an observant boy: "Take some money,
You are already big enough and can speak for yourself,
It's time to go out into the world,
You'll take a trip to Großwardein,

You can haggle over all sorts of things there."—
The boy said: "My dear father,
I already know how to haggle!"
But how he got on board—oh, my goodness,
He took the wrong train,
Instead of going to Großwardein

He arrived at the Vienna North Train Station. Vey!

Oh, dear conductor,
What have you done?
You brought me to Vienna,
Instead of to Großwardein!
Take me quickly back again
To Tarnow,
For an observant boy
Is out of luck in Vienna.

The refrain should be repeated as a chorus.

Everybody is laughing,
As they saw the boy,
He had sidelocks and a long caftan,
He just stood there totally confused.
"What should I do here in Vienna?
This is no city for our kind!
Where the smallest boy already
Cries out "hail Lueger!" in Salzgries."
And because he doesn't know how to help himself,

He starts to lament,
And he runs back to the train station,
Totally miserable he cries out when there,
Vey!

Refrain—Same as verse 1

3. Doch was e echtes koscher's Jüngel

Thut sein, geht auf der Welt nicht
 zugrund';
Der Jeinkef ist in Wien geblieben,
Lebt ganz zufrieden und ist gesund.
Jetzt geht er Abends in der
 Le'poldstadt
Mit Saf, Pomad' und Wichs hausirn,
Und thut am Rennplatz denen Leuten
Die Rennprogramme offerirn,
Und wenn er Abends thut
 z'sammenrechnen,
Was er hat für e Rebbach gemacht,
Kann man ihn seh'n im Café Abeles,
Wie er dort schmunzelt, wie er lacht—
Waih!

Still, as you would expect from an
 observant Jewish boy,
He did not fall victim to his
 circumstances;
Jeinkef stayed in Vienna,
And remained happy and healthy.
Now he takes a walk in the Leopold-
 stadt in the evening,
And peddles soap, hair creme, and polish,
And hawks racing programs
To the people at the race track,
And he counts up in the evening,

To see how much profit he's made,
One can see him in the Café Abeles,
As he sits there smiling and laughing—
Vey!

Refrain

Ach, lieber Schaffner,
E gescheidter Mann Se sein!
Viel schöner ist's in Wien—
Was hätt' ich gemacht in
 Großwardein?
In meinem ganzen Leben
Geh' ich nix mehr zurück,
E gescheidter Jud' bleibt da
Und macht in Wien sein Glück!

Oh, dear conductor,
You're a clever man!
It's much nicer in Vienna—
What would I have done in
 Großwardein?
With the rest of my life
I'll never go back,
A smart Jew stays here
And makes his fortune in Vienna!

Source: Viennese broadside, written by Carl Lorens and sung by the comedian, Adol-
phi, at the Viennese cabaret, Gesellschaft Hirsch. Printed by Carl Fritz in Vienna,
Dreihausgasse 17. Preserved in the Österreichisches Volksliedwerk; catalogued as B1 12
416 in the Deutsches Volksliedarchiv, Freiburg im Breisgau.

The broadsides of the Jewish metropole took very precise aim at the disjuncture between
tradition and modernity. Many broadsides depicted stereotyped immigrants whose assim-
ilation into the city was not so much a matter of a rags-to-riches tale, as in Gustav Pick's
"Viennese Coachman's Song," as serendipity. For the hero of "The Jewish Conductor's
Song" (Figure 7.3 it was altogether a fluke that he reached Vienna as a young man and
built there a small fortune catering to the cosmopolitan culture of a growing Jewish
population. He had intended, instead, to climb on the train in Tarnow (Trnva, Slovakia),
a small traditional Jewish city in the western foothills of the Carpathian Mountains, and
to travel eastward to Großwardein in the foothills of Transylvania. The life journey he
and his family envisioned should have taken him even further into orthodoxy, literally to
the east and the eastern regions of Ashkenaz (see Figure 3.1 in chapter 3).

The train boarded by the boy, however, was traveling westward rather than east-
ward, and it deposited him at the traditional site of disembarking in Vienna, the
North Train Station, rather than in Großwardein. The train, as the metaphor for

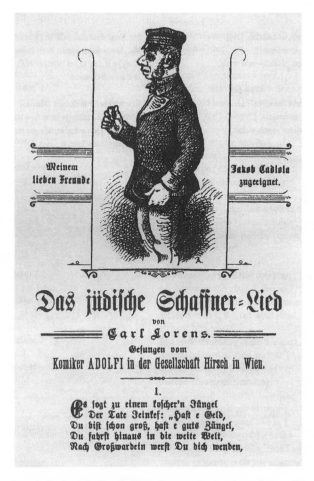

FIGURE 7.3 "Das jüdische Schaffnerlied"/"The Jewish Conductor's Song." Text by Carl Lorens. (Used courtesy of the Deutsches Volksliedarchiv, Freiburg im Breisgau)

modernity, intervened and wrested orthodoxy from the hands of the traveler seeking tradition. Confronted with virtually no alternative, the unwilling immigrant to the city capitulated willingly to the allure of making his fortune. With modernity as a catalyst, serendipity turned into good fortune. "The Jewish Conductor's Song" expands upon the parable of encountering the city in some very striking ways. On one hand there can be no doubt that the lyricist, Carl Lorens, one of the most prolific broadside composers of fin-de-siècle Vienna, traded in stereotypes (Wacks 2002: 186; Schedtler 2004). The protagonist of the song makes his fortune by engaging in professional activities that made the fortunes of other immigrant Jews, such as selling clothes and betting on racing. Another clear example of stereotype is the relatively insignificant role of the song's eponymous character, the Jewish conductor, who appears on the print used for hawking the song and as the human face of serendipitous modernity, but then disappears.

On the other hand, the geography of this journey from tradition to cosmopolitanism is very precisely mapped by the song. Traditional centers of Jewish life in Eastern Europe, Tarnow and Großwardein, have specific rather than general meanings. So too does the urban Jewish cityscape of Vienna, with its historical interplay between the Salzgries and the Leopoldstadt. The anti-Semitic mayor of Vienna, Karl Lueger (1844–1910), makes an appearance, thereby allowing Lorens, the lyricist, and performers at the cabaret stage of the well-known Hirsch Gesellschaft (literally, Hirsch society, a Viennese cabaret) to turn their parody to the non-Jewish public sphere. The text of the song, however, turns inward rather than outward. Unlike the "Viennese Coachman's Song" and its Jewish cover, the language of the "Jewish Conductor's Song" employs the Jewish dialect of Vienna rather than Viennese dialect. The linguistic borders between the two dialects often blur, not least because of the Hebrew and Yiddish expressions that Viennese dialect contains, words such as *Masal* (Yiddish, luck, from the Hebrew *mazel*) and *Mischpoche* (Yiddish, family, from the Hebrew *mishpacha*). The "Jewish Conductor's Song" itself followed a centripetal trajectory inward, where it entered the repertory of Jewish Vienna as a modern song bearing a message of self- and social criticism.

INVENTING CITY MUSIC: *MINHAG* AND LOCAL JEWISH LITURGY

In the transformation to early modern and then to modern Europe, Jewish sacred music increasingly became connected to urban spaces. Virtually every kind of music that began to acquire cultural markers of Jewishness displayed discrete processes of urbanization. Traditional concepts of local or city character in sacred Jewish music—particularly that of the synagogue, the genealogy of cantors, and other Jewish musical specialists—absorbed the customs and laws, written and unwritten, known as as *minhag* (Hebrew, customs; plur. *minhagim*). Minhag includes a folkloric or ethnographic system of customs that gives identity to a community in a particular place, and it also describes a canon of written work distinguishing the Jews of a particular city. Among the uses of minhag are those that describe a traditional genre of literature, with subgenres that describe the many aspects of life and culture in the Jewish community. In this form, a minhag effectively serves as a repository, the many parts of which record the life of the community. Within the larger minhag of a community music takes its place, embracing oral and written traditions, such as the cantorial repertories of a community preserved in manuscripts passed from cantor to cantor.

Musical style can also generate a discourse about place, in other words the markers of a city music. Most important is the concept—a fairly modern concept—of *nusach,* the musical style and melos that grows from the music of a particular community and its performance practices (Summit 2000; Slobin 1989). Not only is nusach passed from generation to generation, but one acquires it or even learns it when entering fully into that community. The urban qualities of traditional (premodern) Jewish music also depend extensively on genealogy, for example of the ḥazzanut and liturgical practices. The urban ḥazzanut possesses qualities of both fluidity and stability, with change being inherent in the repertories, especially the

oral aspects, and stability being anchored in the demands and written traditions maintained by the community itself (see Bloemendal 1990).

Throughout the course of modern Jewish history there have been institutions that have turned traditional repertories into city music. One of the earliest European examples is the *shomrim la-boker* (usually glossed as watchers of the dawn) in early modern Venice, for whom Salamone Rossi and others composed their most specifically Jewish works (cf. Harrán 1999). In the Central European communities of the nineteenth and twentieth centuries, Jewish choral and orchestral societies functioned in the same way. In Mannheim, for example, there was an active tradition of ensembles both within the Jewish community itself and at the boundaries with non-Jewish communities. It was in this way that Mannheim's Stamitz-Gemeinde initially took shape as an instrumental ensemble in the liberal Jewish community and began to perform outside the community after World War I, before being forced to retreat into the Jüdischer Kulturbund after 1933 (Bohlman 1989a: 79–99; Herrmann 1954?). In a very different way, the kibbutz choruses and other institutionalized musical organizations were responsible for the urbanization of folk and traditional musics in Israel. By the mid-twentieth century Jewish musical tradition had become distinctively urban and modern (see Roskies 1999).

BROADSIDES AND *FLIEGENDE BLÄTTER:*
PRODUCTIONS AND REPRODUCTIONS
OF CITY MUSIC

The transformation of Jewish folk music to Jewish popular music did not just happen *sui generis* as rural Jews entered the metropole. Musical practices underwent fundamental changes, eliminating the functions of many genres of folk music while generating entirely new roles for vernacular music to fulfill the needs of urban spaces. One of the most critical vehicles for the appropriation of the rural folk tradition and its production, reproduction, and dissemination as a cosmopolitan urban tradition was the broadside, a song printed on a single sheet of paper, often with an accompanying woodcut or etching but less often with the notation for an accompanying melody. Known in German as *fliegende Blätter* or *Flugblätter* (literally, flying pages or flying leaves), broadsides were narrative contrafacts relying on well-known stories and melodies. A new broadside often referred to a new event, usually of more general political or cultural interest, but it presented the event by using well-worn images and characters.

Broadsides were printed in large numbers and hawked on the street at prices even the working class could afford. Broadside hawkers might advertise their wares through fairly elaborate performance—for example, when a German *Bänkelsänger* (literally, singer on a bench) performed and illustrated them with different episodes displayed visually on a large placard. Broadsides are known by other names too, for example broadsheets in English or *Moritaten* in German, a term revealing that broadsides were used to teach a moral lesson. Such distinctions have less to do with the printed song itself than with a site and mode of distribution and performance,

that is, with the ways in which these songs themselves enter, represent, and transform the public sphere (Braungart 1985; Petzoldt 1982; Shepard 1978).

For social groups undergoing rapid transition, broadsides were of particular significance, for they occupied a social space between the working class and the middle and upper classes. The broadside narratives depended on geographical mobility, and they traced social movement. Accordingly, they found their way into the social, cultural, and religious groups for whom mobility and movement were particularly marked. For European Jews in the nineteenth and early twentieth centuries, this was particularly the case. As their own social movement increased, so too did the ways in which broadsides represented their movement to the metropole.

The broadside narrative possessed the qualities of both story and history (see Brednich 1974–1975). It might follow the lives of specific individuals—the coachman or conductor—but it used such lives to chronicle the sweep of history. Because of these dual narrative functions, broadsides opened particularly complex ways of connecting the stories of individuals to the historical dramas within which they constituted the dramatis personae. Broadsides, therefore, constituted a discourse network, a means of reproducing diverse forms of communication and technology that are woven together as discourses for an extended historical period (Kittler 1990). To understand better the lives of some of those individuals, whose names we may or may not know but whose migrations to the city provide the historical substance of this chapter, we now turn toward the broadside, following an excursus that allows us to explore a counterhistory of Jewish modernity that has remained virtually unknown.

From the late decades of the nineteenth century to the World War I, and then again during the interwar period, Vienna's inner districts were transformed by the influx of many different groups, arriving from the multicultural lands of the Habsburg Monarchy and settling in the city as laborers, businesspeople, students, and in general a new type of Viennese citizen. Even at the time of the Monarchy there was a concept of multiculturalism, though the term "multiculturalism" (*Multikulturalismus*) was relatively uncommon. The contemporary term describing Habsburg cultural diversity was *Vielvölkerstaat* (literally, a state with many peoples), which clearly connoted the hegemonic presence of the nation as a cultural center (see, e.g., Rupp-Eisenreich and Stagl 1995).

The songs whose settings, imaginary and real, appear in the present chapter bear witness to the ways in which broadsides contested the public sphere of the metropole from the late nineteenth century until the eve of World War II. During this period the broadside became a complex of performance practices whose confluence remapped the urban spaces of Vienna, Berlin, and Frankfurt, of Budapest and Prague, that is, of an urbanized Central Europe whose empires were imploding in the years leading to World War I. The broadside became a vehicle for the voices of the new groups—immigrants and minorities, a new working class serving the expanding industrial base of the city—that were occupying those urban spaces. As a musical genre and practice in which different forms, repertories, classes, and communities overlapped, the broadside was a simulacrum for the public sphere upon which it depended for dissemination as serials and songs (see Reisenfeld 1992).

In some ways the broadside had situated itself in the public sphere throughout its history, although it also underwent specific changes in the German and Austro-

Hungarian empires from about 1890 to 1930, the period of the most intensive mass migration of Jews to the metropole. Perhaps no other genre of artistic production so completely negotiates between public and private spheres during this period, because of its serial character. The reason for this is the simple fact of a broadside's potential for performativity. Unlike many other print products of the late nineteenth century, the broadside is not just the visual object of a public's or individual's gaze, but it must be performed in order to convey its meanings. The broadside does not circulate as a printed object without specific functions in public musical discourse, rather it emerges from oral tradition and depends on the undergirding of oral tradition for dissemination through the process of production known as serialization. To understand the relation between oral and written dissemination, we turn first to the history of the broadside as a serial.

The history of the broadside is coeval with that of printing technology, though it is interwoven with many different aspects of that technology (Brednich 1974–1975). As soon as the first broadsides began to circulate in significant numbers in the sixteenth century, they included most of the techniques of reproduction that they maintain until the present. The use of a woodcut or engraving to represent the narrative or scene in the song is already a fifteenth-century phenomenon. Engraved representations and their narratives became more elaborate during the sixteenth and seventeenth centuries. Still, many printers continued to employ simpler techniques of reproduction, signaling consumption by those with modest financial means. We might understand these different degrees of elaboration also as two different historical trajectories for the broadside, one within the private sphere and the other within the public sphere.

The private and public spheres in which the two different types of broadside circulated further represented socioeconomic distinctions. There can be no question that one condition of these distinctions was class. Another related to what modern folklore studies and sociology call ethnicity. It is no exaggeration to say that broadsides represented and serially reproduced human experience in just about every way possible: in production, in form, in distribution and consumption, in the structures of the music, and in performance. One encountered, viewed, read, and performed the broadside as a narrative story expressed by a series of unfolding scenes. In the German *Bänkelsang* (literally, bench song) the narrative of the song text reproduced a series of scenes displayed for the audience on painted posters (see Braungart 1985). Even the sale of such songs might require a group of several performers, usually a singer, maybe an instrumentalist as well, always someone to point out the scenes on the placards, and of course one or several individuals who plied the assembled crowds to sell the texts. In addition, there was the behind-the-scenes production team: engravers, printers, and perhaps also painters and illustrators.

The songs of broadsides are most often ballads, and they are always some kind of narrative genre. As the texts of broadsides tell stories, they use very specific musical and textual devices to do so. The verses of a ballad often follow different scenes and moments in a story. Dialogue is split, often in alternation, between different verses. It is important to keep this process of serializing narrative in mind to understand the ways in which a broadside can represent real events and multiple levels of local meaning. A broadside from fin-de-siècle Vienna thus might, in its first

published version, tell the story of a disaster in a particular village in the Bukovina (today, western Ukraine), but in later versions it might gradually come to symbolize the ways in which administrative injustice plagued the eastern part of the Austro-Hungarian Empire.

Music contributes in other ways to the serialization of broadsides. The melody of a broadside is indicated in three distinct ways. First, many broadsides use a melody that appears on the printed page itself, despite the extra costs involved in setting musical notation. Even published melodies depend to some extent on oral traditions and widespread public knowledge of popular and folk melodies. The broadside version of "The Jewish Coachman's Song," for example, announces that it is based on a "familiar melody" and then includes the first phrase—the upbeat and the first four measures—of "The Viennese Coachman's Song" (Bohlman and Holzapfel 2001: 124; cf. performances of both on New Budapest Orpheum Society 2002). Published melodies rarely contain more than a skeleton, and most performers and consumers would understand that these serve only as the basis for elaboration and improvisation. Second, broadsides often rely on widespread knowledge of folk and popular tunes circulating in oral tradition. When this is the case, the publisher would note before the new text that the song is to be sung "im Ton von" (in the musical setting of) or "nach einem alten Volkslied" (following an old folk song). In a third instance, the melodies might not be circulating in oral tradition, but rather potential purchasers are given information about where the appropriate tune can be heard, if not purchased. When the publishing tradition is urban and relies on popular rather than folk songs, the printed page may also announce that the broadside is based on a couplet-song sung by a well-known star at a particular theater (see "The Jewish Conductor's Song" in Figure 7.3; see also chapter 9). In these ways the music of any given broadside enters a specific history of transmission and performance.

By the turn of the twentieth century, Central European broadsides had come to depend on other performance traditions, which in turn disseminated the broadside in other domains of the public sphere. Popular theater—in the case of Jewish broadsides, Yiddish theater from Eastern Europe—generated new traditions, which spread quickly and widely. Couplet singing and cabaret were particularly important for the production and serialization of popular song in Vienna. In the middle of the nineteenth century these venues for popular entertainment were more often located in the outer districts of Vienna. It was in these outer districts, where rural and urban overlapped, that new musical practices formed in the inns and on the local stages (Maderthaner and Musner 1999). Here stage bands took up folk dances and made them popular, local singers took up folk songs in rural dialects and recast them as Wienerlieder. Ensembles such as the famous Schrammel Quartet participated in this transformation of the cultural boundaries between the city's borders and the world beyond (Egger 1989). By the turn of the century, however, these musical practices had moved toward the center, and with their entrance into the center came a new mixture of popular musical traditions and performers. In the metropole, song itself had participated in the remapping of the urban cultural space, serving as a conduit for otherness and difference as surely as the streets that radiated outward from the Ringstraße of Vienna or Alexanderplatz in Berlin and yet focused inward from the diverse regions of the Austro-Hungarian and German empires.

The urban soundscape of the fin-de-siècle metropole was very different from that of preceding centuries. Prior to the mid-nineteenth century, the city was a mosaic of music cultures, some of them virtually microscopic, others far more public, albeit for a very restricted and elite segment of the public. In Vienna the music cultures of the Biedermeier home, of myriad Jewish communities, and of the sundry aristocratic circles were remarkably rich but nonetheless distinct. The soundscape was an amalgam of private spheres. As music cultures in themselves, these mosaic pieces of the urban soundscape were not disconnected from other segments of music-making, even though the patterns connecting musical practices did not integrate them into a larger public sphere. There was, for example, no modern public sacred music culture in Jewish Vienna at the beginning of the nineteenth century, but by the end of the century the Viennese Rite had spread from the Habsburg capital to dominate much of Central and East Central Europe, creating a super-regional, even international Jewish public sphere marked by distinctive musical practices.

The new urban sound mix at the end of the nineteenth century resulted from the overlapping of performance spaces and the musical practices that constituted these spaces. The overlap, in turn, fostered new technologies, which eventually came to shape and be shaped by the new musical practices of the metropole. It was characteristic of the new urban soundscape that the mix happened in different ways, or, more to the point, kept happening in different ways. There were different processes and procedures of mixing, and the broadside had the capacity to participate in many of these. One of the most important transformations of the urban soundscape resulted from the ways in which the city's new ethnic communities mapped their musical practices onto emerging communities. In Vienna the sound mix at the end of the nineteenth century could be perceived as a text for the ethnic history of the city. I could argue this point with countless examples—the E^b clarinet or trumpet as emblems of Czechness in dance styles, the *Jodler* (yodeling song) as a template for popular polyphonic practices—but these are more the products than the processes of mixing.

Where these processes took place was in fact in the spaces in which popular music was performed on the periphery of the city. *Why*, that is, the reason, these processes took place was that the periphery—its inns, Heurigen, and the new entertainment establishments—employed musicians from the outer regions of the empire, at first because they were forced to live outside the center, but later because these institutions provided a sort of staging area for remixing the urban soundscape.

The ethnic musical mix is very evident in the broadsides that appeared in the late nineteenth century. To some extent, ethnic differences had always been part of broadside traditions. Anti-Semitism, not surprisingly, was one of the most persistent themes throughout the history of broadsides. It is hardly surprising that anti-Semitism took new forms in the late nineteenth century because a new wave of vicious anti-Semitism was unleashed in Vienna with the election of Karl Lueger as mayor in 1893. Songs such as "The Jewish Conductor's Song" (Figure 7.3) openly responded as indices to rising ant-Semitism. Similarly, it should not be surprising that a new tradition of Jewish broadsides emerged at this same time. A Jewish couplet tradition was noticeable in theaters along the suburban periphery already in the mid-nineteenth century (see Schedtler 2004). On one hand the Jewish broadsides

were produced by Jewish composers for a growing Jewish middle class with the means to consume them. The broadsides also reveal a growing confrontation with differences inside the Jewish community. On the other hand, these public Jewish musical practices voiced a type of resistance by taking charge of the dissemination of their own images of self-identity in the metropole.

Broadsides also took politically contested spaces in the city as their themes. In fact, the different constituents that engaged in contesting the space often lent themselves to representation through a broadside's serialized narratives. Many broadsides contained stories that played out the stories of those in power, the public figures who had placed themselves in the position of maintaining public order. Some broadside publishers seem to have created special series with military themes. Songs produced by the printing firm Moßbeck, one of the largest Viennese broadside printers, contained numerous examples that referred to the exercise of imperial material power. Frequently, there were also broadsides with narratives of political resistance. Such narratives might take the form of more panoramic representations of, say, the so-called "Peasants' War," which was the subject of many sixteenth- and seventeenth-century broadsides (cf. early modern examples in Brednich 1974–1975 with modern counterparts in Buhmann and Haeseler 1986). Serial songs also constituted an important medium in workers' movements and labor protest, both of which depended on performance in the public sphere as means of voicing class resistance. Workers' songs contributed the processes of mixing cultural groups and remixing musical repertories to respond to class divisions.

If broadsides function as agents in the political contestation of the public sphere, they require that we rethink the ways in which regionalism and nationalism are configured. Rather than reinforcing nationalism, broadsides more often challenge its hegemony, or even poke fun at its more overtly pompous sides. In effect, the political songs of broadsides alter the nature of nationalism, varying its texts and introducing variants into public performance. It is not the case that all broadsides assume positions against the modern nation-state. Positions that might be considered both conservative and radical find their ways into broadside texts. Broadsides nevertheless bump up against the state, challenging it from both the left and the right. In fin-de-siècle Vienna there were broadside repertories that called for the reconfiguration of the nation as something akin to a multicultural society, but there were also those that rejected such national realities. Broadsides needed to represent nationalist positions from both the left and the right, and from the continuum between these extremes, in order to contest the political and ideological principles of the state. Broadsides represented the stages on which the conflicting narratives of nationalism were enacted, in which various agendas for the state were musically performed.

Questions of gender and the position of women, in the private and the public sphere, are among the most important themes in the broadsides of the fin-de-siècle metropole. Many songs depict women in the home or on the street, patiently awaiting a lover-gone-to-war and afraid to leave the home, or less patiently weighing the consequences of abandoning the domestic space of the home. Further depictions idealize women in the private sphere or ridicule them in the public. Such narratives of women's lives may cross ethnic divisions, reminding us that the female other—the young Jewish woman in fin-de-siècle European society—might have been doubly removed or encumbered from entering the public sphere. The surfeit

of broadsides concerned with the woman's position in Central European urban society clearly identifies gender as a contested arena. Through the diverse paths that these broadsides represented for women, popular song entered contested arenas and problematized them further by raising public awareness.

The usual historiography of broadside discourse networks, particularly studies of English broadsides, claims that individual buyers consumed the songs by singing them (see, e.g., Shepard 1978). It would follow, then, that the song is an object and that it passes into and out of oral and written tradition by being inscribed on the page and then sung anonymously as a folk song. The circulation of Jewish broadsides, however, suggests that such historiographic assumptions are oversimplified. The broadside was not simply a product—an objectified song—but a process with agency to make the process possible. The patterns of dissemination, consumption, and performance that constitute this process differ from song to song, from theme to theme, from public space to public space, and from performer to performer. Each song enters and then becomes a means of responding to the public sphere in very individual and complex ways. Some songs are representational texts, perhaps read by the members of a certain group for whom they are intended, or perhaps read as if they mediated the events of the day. In the Jewish broadside tradition there were broadsides that clearly functioned as popular songs, containing songs made famous by a well-known star (e.g., Alexander Girardi with the "Viennese Coachman's Song"). Once in the public sphere, such songs might lend themselves to performance on cabaret stages throughout the city. There were songs whose dissemination was more locally urban; others that may well have been distributed over a large area of Central Europe. Finally, there were songs that entered quickly into oral tradition from the printed page—for example, those with more detail in the printed musical notation or covers of hit songs. In contrast, other broadsides were picked up by other printers or by the compilers of songbooks, where they were further serialized in written traditions.

At the beginning of the twentieth century the print traditions of popular song had begun also to transform the vernacular into serious and socially critical musical and literary production. When we search for broadsides in twentieth-century literature we quickly arrive at the literary works of Bertolt Brecht—for example, his composition of the six *Hitler-Choräle* (Hitler Chorales) with highly political texts based on existing chorale melodies that had entered the oral traditions of broadsides. The "Ballade vom 30. Juni" (The Ballad of June 30th), for example, uses the melody and textual skeleton of the broadside "Heinrich schlief bei seiner Neuvermählten" (Heinrich Sleeps with His New Wife). From the same period between the world wars Carl Zuckmayr's 1931 play stages a true story from 1906 in *Der Hauptmann von Köpenick* (The Captain of Köpenick), employing 21 scenes that consciously depict the serialized pictures in a Bänkelsang. The story of an upstart shoemaker turned captain who had subverted Prussian military order had previously entered the public sphere through hundreds of broadsides, which then served as a model for Zuckmayr's play.

These complex patterns of consumption both transformed and were transformed by the changing nature of the public sphere. At moments when the transformation of the public sphere was extensive and contested, broadsides have responded accordingly, whether by supplying the cabaret singer with new materials or intensifying the voices of workers protesting on the street. It is hardly surprising, then, that broadsides were crucial for the shaping of the Jewish cabaret stage in the fin-de-siècle

metropole. At the beginning of the twenty-first century we may not always see these songs as printed objects, but we hear them when repertories change and popular song refuses to yield its politicized voice, even as Jewish cabaret undergoes revival. Because of its responsiveness to the contested nature of the public sphere in Central Europe, the broadside also historicized that public sphere throughout the twentieth century. Whether on the broadsides of concentration camps, or on the broadsides of workers' and student movements in the late twentieth century, the processes of performance and resistance embodied by the broadside have remained present as markers of the soundscape of modern Europe. We may imagine the histories voiced by these songs as local, individual, or inconsequential, but they are histories that play themselves out on the much larger stage of the public sphere of a modern metropole increasingly accessible to European Jews in search of modernity.

SUCCESS STORIES

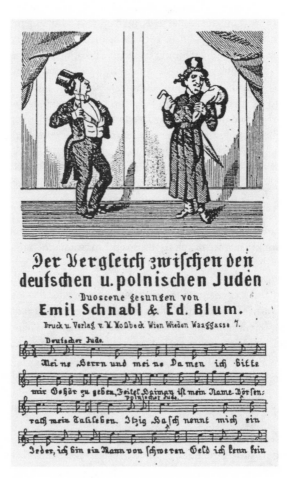

FIGURE 7.4 Emil Schnabl and Eduard Blum: "Der Vergleich zwischen den deutschen und polnischen Juden"/"The Comparison of the German and Polish Jews." (Used courtesy of the Deutsches Volksliedarchiv, Freiburg im Breisgau)

Verse 1

Deutscher Jude

Meine Herrn und meine Damen
ich bitte mir Gehör zu geben,
Feitel Haiman ist mein Name.
Börsenrath mein Tatileben.

Polnischer Jude

Itzig Hasch nenn mich ein Jeder,
ich bin en Mann von schweren Geld
ich kenn kein Buch und kenn ka Feder
und doch beschwind se ich die Welt.

Duo

Kurz wir hab'n uns nicht schämen,
die Sache ist ja gar nicht neu,
wenn es gibt wo Geld zu nehmen,
sind wir Juden gleich dabei.

English Translation

German Jew

Ladies and gentleman,
Please give me your attention,
My name is Feitel Haiman.
I make my living as stock adviser.

Polish Jew

Everyone calls me Itzig Hasch,
I come by money with great difficulty,
I can neither read nor write
And I still get along in the world.

Duo

We have nothing to be ashamed of,
There's nothing new at all,
If there's money to make,
We Jews will be there right away.

Verse 2

d.J.

Ich bin berühmt in Süd und Norden
Hab' Gott sei Dank auch meinen Sohn.
Stehst du da die Brust voll Orden
Bald wird's heißen, Herr Baron.

p.J.

Auch ohne Titel ohne Orden
Lebe ich in Haus und Braus.
Durch handeln bin ich reich geworden.
Jetzt lache ich die Welt mir aus.

Duo

Kurz wir hab'n uns nicht zu schämen, u.s.w.

G.J.

I'm famous from North to South,
Thank God, I've got my son.
You stand there with decorations on your chest,
It won't be long before I'm a baron.

P.J.

Though I have neither a title nor decorations,
I own my home and can afford to be extravagant.
I became rich through trade.
Now, I can just laugh at the world.

Duo

We have nothing to be ashamed of, etc.

Verse 3

d.J.

Fülle ich denn kein schönes Leben
Stets im Theater beim Ballet
Bälle und Concerte geben
Mein Sprichwort ist, ich nehm' und geb!

p.J.

Bast e Esel, hast e Chammer
Muß soll mir die Narrischkeit
A Fläschle Schnaps zum Katzenjammer
Und dazu mein koscher Weib.

Duo

Kurz wir brauchen uns nit schämen, u.s.w.

G.J.

Don't I lead a wonderful life,
Always seeing ballet in the theater,
Holding balls and concerts.
My motto is, I give and take!

P.J.

> Call me an ass, call me shameless,
> I don't need such craziness.
> A bottle of schnaps makes good fun,
> On top of that my kosher wife.

Duo

> We have nothing to be ashamed of, etc.

Verse 4

d.J.

> Ich halt' mir feine Equipagen,
> Maitreffen hab' ich auch bei mir.
> Bezahle meinen Dienern Gagen
> Und wohne in ein fein' Quatier. [sic]

p.J.

> Dazu hab' ich keine Büchse
> Kommt bei mir nicht vor im Haus
> Ich begnüg' mich mit a Schüchse
> A Rippenstoß und Wurf heraus.

Duo

> Kurz wir habn uns nicht zu schämen, u.s.w.

G.J.

> I own fine carriages,
> And at my house there are the finest May gatherings.
> I pay my servants a livable wage
> And live in a fine home.

P.J.

> In my case, there's no cart
> That parks in front of my house.
> I'm content with a kick in the pants,
> A poke in the ribs, and tossing them out.

Duo

> We have nothing to be ashamed of, etc.

Source: Viennese Broadside. "Duoscene" sung by Emil Schnabl and Eduard Blum. Published by M. Moßbeck, Vienna, Wieden, Waaggasse 7. Deutsches Volksliedarchiv, Freiburg im Breisgau (Bl 8384).

Jewish broadsides celebrated the successes of the urban immigrant but rarely failed to do so without considerable doses of parody. Financial success was a measure of acculturation, thus making it one of the most common topoï of the rags-to-riches parables in Jewish broadsides. The immigrant who could tell a success story found

his way to the popular stage, displaying to the world all that made him a cosmo-politan. The parable of urbanization, needless to say, was never as simple as those portrayed in the broadsides. The successes enjoyed by the broadside protagonists were, instead, hard-won. Once achieved, they rarely led to complete acculturation. The mark of difference remained; further paths to success remained to be traveled.

Of the countless Jewish broadsides that poked fun at those on the slow road to success, few present the various sides of acculturation from the several perspectives evident in Figure 7.4, "Der Vergleich zwischen den deutschen und polnischen Juden" (The Comparison of the German and Polish Jews). Popularized by two well-known stars of the Jewish stage, Emil Schnabl and Eduard Blum, the comparison in the song relies on role playing, rendered as unequivocally as possible on the printed broadside. The print at the top of the broadside leaves little doubt that the song's two singer/actors assume their roles on the stage, with curtains drawn and in full costume. The text of the song also begins by setting the stage and addressing the audience, surely a fine audience comprising a full complement of "ladies and gentlemen." The two im-migrant stereotypes play their roles throughout the song's four verses, splitting the first eight phrases between them but joining together for the last four phrases. The two characters sing with sharply differentiated accents and dialects, though the subjects of each verse mirror each other. We witness a type of thematic antiphony, which then resolves when both singers join and sing in two-part harmony.

The sharp distinctions notwithstanding, more subtle difference also deserves at-tention. Whereas the melodies sung by the German and Polish Jew are fundamen-tally the same, not least because they reveal few of the melodic conventions that would mark the melodic outline as Jewish, the Polish Jew's part contains suggestions for ornaments (grace notes at the top of melodic arcs) while the German Jew's part appears without ornaments. The octave range of the main melody, sung by the two characters in their four-phrase solos, is already fairly extensive in this genre. The duo section extends the melody by a third at the top and the bottom, effectively con-necting the song even more to professional performance on the stage. If the song openly invites comparison, it also permits comparison to tell several stories more complex than first meets the eye. Whereas the German Jew lists the evidence for his numerous accomplishments, the Polish Jew counters by claiming that, though he has followed a different route, he has arrived at many of the same places. The stereotypes cancel each other out; or perhaps they neutralize each other, drawing the two urban caricatures closer together. The stage of the broadside and the duo scene performed for the cabaret in Vienna proves large enough for both urban immigrants. So too does the new metropole in which they find themselves living side by side.

URBAN NETWORKS TORN ASUNDER

Ich bin a armer, kleiner Jud
und hab ka scharfes Messer.
Du bist aus altem Vorstadtblut,
ans nix von meiner Liebesglut,
und wahrlich: dir ist besser.
Ja, mir, dir geht es gut.

I am a poor and hapless Jew
Without a sharp knife of my own.
You come from the blueblood suburbs,
Where love never glows as does mine,
In truth: You have it better.
To me, you're still Okay.

Du kennst die Spittelberger Buam
mit Mahagonipratzen.
Die sind sie der Novembersturm,
allweil fidel und hoch in Furm,
und hab'n statt Mädchen "Katzen."
Die Spittelberger Buam.

You know the Spittelberger stock,
With mahogany roots.
They're like a storm in November,
It keeps you fit through thick and thin,
Playing with "kittens" not girls.
The Spittelberger boys.

Die treten dir im Maienwind
verliebt ins weiße Bäuchlein,
und machen dir ein Sonntagskind
Flugs hinterm Fliedersträuchlein.

They come to you like wind in May
In love with their white tummies,
And on every Sunday
With a visit behind a lilac bouquet.

Dazu fehlt mir die innre Kraft,
so heiß kann ich nicht werben.
Jedoch von deiner Jungfernschaft,
die schon vor langer Zeit erschlaft,
da sammle ich die Scherben,
weil ich bin in dich vergabt.

For such things I have no inner drive,
In that way I can't court you.
But still from your virginity,
Which fell asleep long, long ago,
I'll pick up all the pieces,
For I give my all to you.

Ich bring dir süße Mehlspeis dar
(Auch die ist nicht verächtlich),
und sind wir auch nicht ganz ein Paar,
ich denk an dich, allnächtlich.

I'll bring you sweet desserts and all,
(That's not without suspicion).
And then we'll be a real couple,
All night I'll think about you.

Das Naserl streich ich dir zurecht
und dann die Augenbrauen.
Doch kann ich dir, selbst wenn ich möcht,
und wär' ich auch total bezücht,
die Pappen nicht zerhauen,
drum bin ich dir zu schlecht.

> I'll stroke your nose so gently
> And then turn to your eyebrows.
> Still, if I really wanted to,
> And if I'd totally flipped for you,
> I'd not crudely attack your lips,
> But for that I'm not good enough for you.

Sei mir auch so ein bisserl gut,
auch wenn ich werd einmal gresser!
Zwar fehlt es mir nicht Liebesglut,
weil ich kan seh'n kein frisches Blut,
ich hab ka scharfes Messer,
und nennt man mich auch Professor,
für dich bin ich a armer klaner Jud.

> If you give me a little good,
> I'll have some good to give to you!
> It's not that I don't glow with love for you,
> But I can't change what's in my blood,
> Without a sharp knife of my own,
> And no one calls me professor,
> For you I am a poor and hapless Jew.

Source: Peter Hammerschlag: "Liebeslied an ein Proletariermädchen"/"Love Song to a Proletarian Girl" (Keil 1995: 121)

First written as a poem in colloquial Viennese in the heady days of Red Vienna, the interwar period dominated by socialist and communist cultural activity on the eve of the Holocaust, the "Love Song to a Proletarian Girl" found its way to the cabaret stage first after the fragile world it chronicles had truly fallen into the abyss. The song literally and figuratively enters the widening space between the cosmopolitan world to which urban immigrants aspired and that which was realistically open to them (Keil 1995: 121). The lyricist, Peter Hammerschlag (1902–1942), was one of the most important Jewish social critics to write in the years following the collapse of the Habsburg Monarchy. His work, which appeared in a variety of genres and venues, from journalism to popular poetry circulating through broadside networks, attacked social inequality, particularly the dashed hopes of workers in the metropole, workers whose hopes had been crushed by financial struggle and rising fascism.

The two characters in the love song, a suitor and the upwardly mobile target of his affections, might have been the German and Polish Jews in an earlier broadside tradition. The sense of the suitor's appeal, as if it were couched in the language of epistolary broadsides (e.g., in the "letter to a mother" topos), is not one of desperation, but rather of resignation. Cosmopolitan Jewish society, even in Red Vienna, has succumbed to class differences, many of which can no longer be bridged. New

family relationships may have formed, but they have led to the unraveling of urban Jewish society. New lineages have taken root in the suburbs, rendering family allegiances exclusive rather than inclusive. The bloodlines of the nouveau riche and the suburban elite are closed to the suitor, even were he to take up the knife of Jewish tradition, symbolically the knife enabling circumcision or wielded for sacrifice by Abraham as a sign of his faith. For the proletarian girl, the suitor is no more or less than "a armer klaner Jud"—"a poor and hapless Jew."

Peter Hammerschlag contributed extensively to the popular literature of his day, and his written work was distinguished by a capacity to enter into counterpoint with oral tradition. More than perhaps any other Viennese writer, he inherited the tradition established by Karl Kraus in his journalistic endeavors, such as the literary magazine *Simplicissimus* (for the years 1896–1944, see the online edition at http://www.simplicissimus.com/), and he translated it—or retranslated it—into a colloquial style accessible to a broad public of both working-class and bourgeois origins. The texts of poems such as the "Love Song to a Proletarian Girl" brilliantly capture the colloquial tone of urban Jewish discourse, raising it to a level that no longer relies on stereotype or the sprinkling of Yiddish words and phrases. Hammerschlag was not, however, attempting to create a written genre as he was filling the gap between vernacular and classical forms of discourse. He took inspiration from the popular traditions of the Jewish stage and cabaret, and he captured the spirit of those traditions in his written works, injecting them with new life in a fragile age for Vienna's Jews. Although he spent shorter and longer periods in exile, Hammerschlag returned to Vienna even as the Nazis seized power after the *Anschluß* (the annexation of Austria to Germany) in 1938. The biting satire and criticism in his writings necessarily attracted attention, and Hammerschlag was taken into custody by Austrian Nazi officials. The exact circumstances of his death, like those of many Jewish public figures who drew attention to themselves, are not entirely known, but it seems most likely that he was deported to Auschwitz, where he was probably murdered in 1942.

The socially critical tradition to which Peter Hammerschlag had so trenchantly contributed was not destroyed with him. In particular, it was rediscovered and revitalized for the revival of cabaret in post-Holocaust Austria. The version of the "Love Song to a Proletarian Girl" in this chapter comes from one of the most distinguished of all cabaret revivalists, Gerhard Bronner (1922–2007), who had studied with Oscar Straus in the 1930s before immigrating to Palestine in 1938 (Ammersfeld, Bronner, and Freeman 1997). To the extent that it is possible, Bronner has again sutured together a popular Jewish song tradition that had been rent asunder by the Holocaust and the destruction of Vienna's Jewish city music. From our own historical viewpoint we realize that the irony of the song seems all the greater in the veracity of its narrative: The world to which the song's narrator aspired ultimately would be closed to him and all other hapless Jewish immigrants to the city.

PEOPLING THE PARABLES OF THE JEWISH
METROPOLE

The more we unravel the parables in the songs that illustrate the encounter with modernity in the metropole, the more their similarities are even more striking than

their differences. The tales of the city follow clearly similar paths in their passage from a traditional to a cosmopolitan world, but there they confront the recognition that acculturation is ultimately impossible. The parables themselves, whether in Heine's unfinished novel fragment or in the resignation of the suitor in Hammerschlag's "Love Song to a Proletarian Girl," are distinctive because of their conscious lack of resolution. Heine's *Rabbi of Bacherach* ends abruptly as the incomprehensible experiences of the city piled one upon the other, and the text appeared with the subtitle *Romanfragment* (novel fragment). The fact that Heine published it when still a relatively young writer, who was very much in a position to finish the text before publishing it, makes it clear that he deliberately left the encounter with Frankfurt's Jewish city culture unresolved. Formally, the parables circumscribe the world of what was knowable and achievable. The narrative song traditions containing the parables may have differed, but they increasingly converged in the course of the late nineteenth and early twentieth centuries. For the Jewish character types portrayed in the songs, similarity increasingly also meant familiarity.

The popular songs that articulate the urbanization of European Jewish society lend themselves to interpretation in two ways, and it is important to consider both of these. On one hand the extensive use of stereotype and caricature indicated that the cosmopolitan Jewish society witnessed in the songs was frequently, even normatively, reduced to parody. The images on Jewish broadsides and the skits acted out on the stage of the Jewish cabaret rarely shy away from unfavorable portrayals of urban immigrants entering the foreign culture of the metropole. Both successes and failures brought about laughter. Parody, however, relied on a strategy of distancing the public from the familiarity they witnessed in the songs. Those who viewed and otherwise consumed the songs about Jewish coachmen and conductors did not so much see themselves on the stage as they perceived a nascent otherness. Caricature in the broadsides and cabaret songs also drew attention to the elements of reality that most songs included: the names of specific places or the references to historical events. The encounter with the city also required a response to the hegemony of empire and the impassability of routes long closed to Jewish social mobility. Parody becomes poignant as the resignation in individual songs provided a sober reminder of the real presence of anti-Semitism and professional restrictions. Perceiving that one had at times been quite hapless was surely not foreign to many in the audience at the cabarets in the Leopoldstadt or the Scheunenviertel.

The parables of Jewish popular music issued from a growing social poetics of cultural intimacy (Herzfeld 1997: 15). The very stereotypes in the language of the broadsides and cabaret songs revealed an increasing awareness within urban Jewish society of the complex position it occupied within the changing world of modernity. That changing world sometimes welcomed the urban immigrant, but it was also frequently inhospitable. There were those who enjoyed successes, and those who were shunned by the very world they so willingly sought to embrace. Some urban immigrants quickly joined the labor force of the working class, while others entered the business or professional classes. All immigrants to the modern metropole participated in the transformation of its character, which at once opened up to the contributions of Jews from throughout Europe and reacted with trepidation to what many shunned as foreignness. The people of the parables, identifiable as Jews because of differences and similarities alike, had established themselves in the metropole from which their popular music was increasingly inseparable.

JEWISHNESS IN MUSIC: MIRRORS
OF SELFNESS IN JEWISH MUSIC

By the end of the nineteenth century, the stakes for determining Jewish identity in music had grown dramatically. The debates about whether music could be Jewish or not had shifted, on one hand because of the growing currency of a discourse that accepted Jewish music as a fact of modernity and, on the other, of an anti-Semitic discourse that identified Jewishness in music as one of the dilemmas faced by modern music itself. Finding Jewishness in music and connecting it to the aesthetics of modernism generated both positive and negative results. As pogroms intensified in Eastern Europe and the metropole in Central Europe attracted a growing immigrant population, Jewish musicians discovered new territories to cultivate, but they were greeted by a newly virulent resistance to Jewishness in music. Modernity itself and Jewish modernism in the arts had their detractors, indeed their critics whose aesthetic agenda required stemming Jewish music and Jewishness in music before they spread too far. Response and counter-response followed, enriching the aesthetic debate about the immanent danger Jewish music posed to modernity. By the twentieth century, few could ignore the pressing questions about the impact of Jewishness on music and of Jewish music on modernity.

Modernity in Europe and modernism in twentieth-century music also led dramatically to a reframing of the meanings of selfness that we have been following throughout this book. Fundamental to the aesthetic tenets of modernism is its capacity to be self-referential, thus to be emancipated from historical and cultural context. If Jewish musical modernism was to be possible, Jewish music would necessarily enter a phase of emancipated identity itself. The paradox about Jewish music's selfness has generated self-reflective questions throughout this book: Was the selfness of Jewish music evident in its Jewishness or in the music? Questions of selfness, accordingly, lead to questions of otherness. Did the mirrors of a modernist musical aesthetic bring contrasting images of self and other into focus, or did they eliminate their differences? Was the Jewishness in music that so motivated aesthetic and musical struggle at the beginning of the twentieth century about the abandonment of traditional selfness in order to discover a modern otherness that too was realizable as Jewishness in music?

It is not by chance that the images of Jewishness in music are contrastive and contradictory in the present chapter. Some are images of selfness reflected from the mirrors of modernism; others are images of otherness refracted through the mirrors of modernity. Paradox characterizes each instance, but so too do the efforts to resolve paradox, the attempts to resolve the disjunctures between musics that are thought to reflect the multiple identities of Jewishness in music.

TRACES OF THE JEWISH COMPOSER

Already in the first volume of Martin Buber's literary and religious-philosophical journal, *Der Jude* (The Jew), the Czech music critic, composer, and philosopher Max Brod (1884–1968) wrote an essay entitled "Jewish Folk Melodies" (1916/1917: 344–45). In the essay, Brod, the future champion of Franz Kafka, dramaturg for the Israeli national theater, Habima, and author of Israel's first history of music (Brod 1976 [1951]) established the conditions for the Jewishness in Gustav Mahler's music and by extension in modern Jewish music. Brod's essay was notable because it turned the Jewish question many were posing inside out by claiming that what was presumably the most German trait of Mahler's style, the march, was an expression of Jewishness. By writing in a leading forum for a self-consciously Jewish intellectual movement, which identified Jewish tradition in order to modernize it, Brod was also making a deliberate decision to revise the reception of Mahler's Jewishness. Explicitly, he claimed that the musical traits most often associated with Germanness were instead Jewish. Implicitly, he defused one of the primary weapons of critics who perceived Mahler's Jewishness as a mere surface trait (for a reprint of Brod's essay and further analysis of its role in the modern Jewish intellectual history, see Bohlman 2005a: 219–22).

Brod's attempt to appropriate and revise the Jewish question for Mahler is striking for a number of reasons. First of all, it is based only loosely on analytical evidence in the music. Second, Brod is fully aware that the "Jewish folk melodies" he perceives in Mahler's marches had never been experienced by Mahler himself. Their source was an immigrant community of Galician Jews who had settled in Prague during World War I. The march style Brod ascribed to Mahler was religious and hassidic, even further removed from the firsthand experiences of Mahler's lifetime. Mahler's musical connection was possible, therefore, because of his "Jewish soul," which was internal and thus contrasted with his merely "external consciousness" of German music. For Brod and his generation of Jewish intellectuals writing in *Der Jude,* this revelation would stand the Jewish question on its head by reclaiming it and rephrasing it with a traditional language of selfness:

> No! Ever since I heard hassidic folk songs, I have come to believe that Mahler could only have drawn subconsciously from the same sources and that he had no choice but to make music in this way, in other words, springing forth from the most beautiful hassidic songs that he never could have known. The strangest thing of all is that these songs contain the clear rhythm of a march, even when their texts sing forth about the noblest of all things, God and eternity. Even cantillation and the Psalms are performed in this way. In these marches, however, there is nothing unholy, banal, or

military, but rather they joyfully symbolize far more the confident, upright pace with which one carries a soul filled with God. . . . Apparently, Jews have long maintained a great variety of nuanced march styles that allow them to express a complex range of feelings. Only to non-Jews do these appear monotonous; Jews feel the differences. (Brod 1916/1917: 344–45)

The rush to associate Gustav Mahler with the Jewish question was already in full swing in the composer's own lifetime. On one hand, such attempts bear witness to Mahler's own famously self-proclaimed marginality, in which Jewishness joined other conditions of Central European or Habsburg multiculturalism. On the other, we must think of the growth of psychological and racial sciences in fin-de-siècle Habsburg culture that sought to map character on the internal personality (see, e.g., Efron 1994). The psychological impetus to provide to the Jewish question musical evidence from Mahler parallels the work of Sigmund Freud, but we also find it in a remarkable range of writings on Jewish culture that were entering and shaping a new public sphere. Later critics continued the tradition of discovering the Jewish question in a psycho-musical portrayal. Theodor Adorno searched for the inner identities of the composer Mahler by reflecting on his "musical physiognomy" (Adorno 1992). More recently Carl Schorske has eloquently expanded the explication of psychological pathways between the internal and the external, particularly in the contrast between low and high art.

Thus in the same era when his older contemporaries, Nietzsche and Freud, opened the intellectual and moral order of reason to the psychological claims of repressed instinct, Mahler opened the musical order of reason to the existential claims of the musics of the common man, past and present. (Schorske 1998: 173–74)

In general, the search for Jewishness that preoccupied Brod and other twentieth-century Jewish observers has produced a constellation of themes that allowed them to reflect on the Jewish question from modern perspectives of selfness. They claimed that Mahler's music included specifically Jewish gestures, presumably absorbed from growing up in the Jewish soundscape of provincial Moravia. Such gestures might manifest themselves in real musical materials, not least because of Mahler's intentional references to vernacular form, style, and content, from the folk dances and folk songs he set as *Ländler* or in *Des Knaben Wunderhorn*. In more psychologically analytical vocabulary such gestures appear as Adorno's notions of *Stofflichkeit* and *Innerlichkeit* (together glossed as the inner substances of music), thus privileging the internal quality of the composer's self-identity. Mahler's music revealed the afflictions experienced by a victim of anti-Semitism, to which he responded in particularly personal ways. Mahler's marginality as a Jew, so his late twentieth-century champions claimed, exposed him to cultural contexts distinguished by jarring juxtapositions and pieces that failed to cohere as wholes. Mahler therefore employed the musical language of bricolage, somehow characteristic of a Jewish preference for hybridity over unity. Critics searching for Mahler's Jewishness, Germanness, Austrianness, or Moravianness made him modern by emphasizing the internal and the processes of taking the external and making it internal, not least among them

the acts of religious and musical emancipation that might lead to self-identity and self-referentiality.

This chapter, in contrast to many approaches to Mahler's Jewishness, does not solely turn inward to a hermeneutic or psychological interpretation of the music. Instead, I want to suggest that discovering cantillation or klezmer music in Mahler leads us to pose questions about Jewishness in music in misleading ways. It imposes our own postmodern, revivalistic soundscape on the modern music culture of Mahler's East Central Europe. We have become preoccupied with hearing Jewishness in Mahler and then attributing that to Mahler's musical selfness. Jewishness in the music of early twentieth-century Europe provided new and contradictory contexts for modernism, which in turn provided a mirror for the otherness of tradition. The point we need to confront is simple: There was a great deal of Jewishness in the vernacular music of the day, and it revealed that the boundaries between self and other were shifting.

MODERN MYTHS OF MORAVIA
AND THE METROPOLE

The search for Jewishness in Gustav Mahler's music usually begins in the land of his youth, Moravia, which has already appeared in chapter 1 as a border region of premodern Jewishness. Quite by chance, which is to say, because of alphabetical order, the entries for "Mahler, Gustav" and "Mähren" (Moravia) stand one after the other in the *Philo-Lexikon,* a "Handbook of Jewish Learning," published by the Berlin publisher Philo Verlag in 1935. Though the two entries are brief, they connect Mahler to the Jewish question in ways that nonetheless intersect. After a brief menu of Mahler's achievements as a composer and conductor, his biographical entry leaves the reader with a final judgment: "Prototyp des jüdischen Musikers"—Mahler was the "prototype of a Jewish musician" (*Philo-Lexikon* 1935: 428). Moravia, the reader learns in the subsequent entry, contains one of the oldest Jewish communities of Ashkenaz, settled in the tenth to the eleventh centuries CE. And the Jewish community that is presumably the oldest in Moravia? Iglau, the city in which Mahler grew up (*Philo-Lexikon* 1935: 429).

The *Philo-Lexikon* entries may seem to be no more than random lexicographical footnotes, but they make it clear that Mahler's Jewish upbringing was unexceptional, even traditional. In Iglau and elsewhere in Moravia, Jewishness had long juxtaposed the sacred and secular culture of a border region, making it difficult to separate one from the other. Moravia had provided the raw substance from which the Kabbalists of the sixteenth and seventeenth centuries imagined the formation of the Golem, the speechless, artificial automaton of Prague (see chapter 1). Moravia was well-known as the home to great Talmud scholars and famous rabbinical dynasties. Less well-known were the myths about music that had become crucial to Jewish legend in Moravia. In the stories about Jewish folk culture in Moravia, fantasy and power had accrued to Jewish music, informing the folktales that provided the oral tradition of Jewish centers such as Iglau and Nikolsburg. We have already encountered two tales about the great Rabbi Shmelke from Nikolsburg/Mikulov

(see chapters 1 and 4). A third tale about the Moravian rabbi reveals more about the human impulse in bringing music to life:

> A very old man, once a choirboy for Rabbi Shmelke, told the following story: "It was customary to prepare all the tunes before singing, so that by the time one reached the pulpit to pray it would not be necessary to fabricate a tune from scratch. The Rabbi, however, did not follow this custom, singing instead brand-new melodies, which no one had heard before. We singers were dumbfounded by his remarks. We could not comprehend how this could be, and we asked: From where do such melodies come?"
> ("The New Melodies," in Buber 1949: 303)

The miracle of Jewish music in Moravia was restricted not only to its Jewish communities. Jewish folktales, such as these from border regions like Moravia with large and complex Jewish populations and extensive multiculturalism, are rich in metaphor and allegory. It is not necessary to stretch the imagination too far to recognize that the allegory in the Moravian tales about Rabbi Shmelke might be extended to the myths about Mahler's identity. First there is Mahler the inventive composer. Then there is Mahler the miraculous journeyman on his way from Moravia to Vienna. Music constantly provides opportunity and paves the road from Moravia to modernity. Metaphor and allegory draw us closer to the vernacular culture in Mahler's Jewish world, and they allow us to connect traditional Jewish narratives to modern Jewish practices, which in turn employ allegory in different ways to assemble and then disguise meaning.

Jewish folk music was not isolated from non-Jewish traditions, especially in border regions such as Moravia or in the Jewish metropole. There were repertories in which the same song type, for example, included Jewish and non-Jewish variants. German ballads, such as "The Count of Rome," circulated widely with Jewish and non-Jewish variants (see the Prologue). In the first chapter we encountered another ballad, "Die Jüdin" (The Jewish Woman), which circulated extensively in Europe's border regions with German and Yiddish texts (see chapter 1) and which was well known as a German ballad in High German, with versions in Arnim and Brentano's *Des Knaben Wunderhorn* (1806/1808) and in a choral setting by Johannes Brahms (Bohlman and Holzapfel 2001: 15–23).

Painting a more complete picture of the popular culture of fin-de-siècle Vienna would surely lead to a deeper awareness of the ways in which the metaphors and discourses of Jewishness were at play in Gustav Mahler's music. Mahler could not have remained deaf to the popular-music soundscape of the metropole, and it is highly likely that he experienced it as a series of fragments, all of them competing for his attention (see, e.g., Botstein and Hanak 2003, esp. the accompanying CDs). Again, we discover rich allegory in the hit song of Mahler's own day, Gustav Pick's *Wiener Fiakerlied,* which we have already examined as a narrative framing chapter 7. The "Viennese Coachman's Song" is allegory writ large across the metropole of the Austro-Hungarian Empire. Its rags-to-riches story about the coachman who drove the rich and famous through Vienna achieved popularity not in small part because Jews and immigrant others identified with it. This song was covered countless times and circulated in most European languages. It entered a Jewish tradition, with both Jewish and non-Jewish components.

As we turn to "The Viennese Coachman's Song" again and again (see the contrafacts in New Budapest Orpheum Society 2002: tracks 1, 6, and 14), it is clear that the images of the Viennese coachman, whose life takes him from the cultural boundaries to the center of a world shaped by Central European modernism, could not be sharper. And yet they are also blurred. Indeed, the differences between what is Jewish and what is non-Jewish, also sharply projected, also multiply, as if in a hall of mirrors. It is precisely the multiple reflections of these images that confront us with so much paradox. The popular musical language of the songs brings otherness into focus, yet it defamiliarizes the familiar. The world the coachman enters comprised selfness and otherness.

JEWISH MUSIC AND THE FEMININE SACRED

Jewishness in music lies deeply embedded in traditional repertories, both sacred and secular, and these in turn express some of the most fundamental ontologies of Jewish music itself. In the music of the synagogue, Jewishness comes into being physically, that is, in the bodies of the worshipers and in the course of worship. It is through the body, with its capacity to serve as the vessel of song, that gender differences accrue to Jewish music, differences that powerfully amplify the potential for music to express the gendered aspects of Jewishness. To examine the physicality of Jewishness in music, it is necessary to begin at a deeper level of gender in Jewish sacred and religious practice, the level occupied by *shechina,* the feminine sacred. Shechina (Hebrew, שְׁכִינָה—literally, dwelling, as the dwelling presence of God) possesses specific archetypal characteristics, or *sefirot* (literally, enumerations). Shechina engenders additional metaphors of worship—for example, the Sabbath bride, who arrives in the Jewish community at the beginning of the Sabbath on Friday evening and whose presence embodies the union of the Jewish community during the Sabbath. With ritual and song, the men praying in the synagogue welcome the Sabbath bride, turning toward the back of the synagogue at a specific moment in ritual and escorting her with the Sabbath song "Lecha dodi" (Come, My Beloved) to the front of the synagogue (Summit 2000 traces the musical realization of "Lecha dodi" through different American synagogues).

The Sabbath is the moment in the week when the sense of Jewish community is most intense, and it is noteworthy that it is the moment in which gender distinctions and their musical expression are most extreme. Prayer in the synagogue, of course, is not relegated only to the Sabbath but is a daily component of community life. During the week, however, shechina occupies a ritual space outside the community; indeed, Shechina lives in exile during the week. The Friday Sabbath rituals in the synagogue only highlight this outsider status. First of all, shechina must enter the synagogue from the outside. In so doing, the feminine sacred enters into a space that has, during the week and literally at that moment on Sabbath eve, been occupied exclusively by men. During her entrance shechina comes from the west and moves toward the east, for the Jewish synagogue is oriented toward *mizrakh* (east), toward Jerusalem and the ingathering after diaspora (see chapter 3). We thus witness a much larger historical significance for the ritual of shechina's arrival and transformation of masculine ritual space into feminine sacred and narrative space.

The arrival of the Sabbath bride has sweeping metonymic significance, for she gives meaning to the community and its sustenance over time. Her arrival is the moment of hopefulness, of the reimagination of Jewish history in the Land of Israel. In traditional interpretations, shechina also occupies a metaphoric domain connected to rituals of reproduction. Her arrival and departure—and by extension her demarcation of domains of selfness and otherness—are ritually performed in the wedding ceremony. Shechina, in this sense, acquires the symbolic meanings of selfness through the community's ingathering in the home, synagogue, and wedding.

It is extremely significant that the symbolic Jewishness of shechina is that of the wedding, which therefore ritualizes the arrival of the Sabbath bride in preparation for union with the masculine sacred. The Sabbath, beginning on Friday at sunset and ending on Saturday night, also at sunset, is rich with these metaphors of wedding, union, and the reproduction of the community. The Sabbath is temporally and physically the space in-between, a time of ending and beginning, of arrival and departure, of celebrating the self as distinct from the other. The music of the Sabbath, both in the synagogue and in the home, celebrates and ritualizes the union in these spaces cohabited by the feminine sacred and the masculine sacred. Concepts of the feminine sacred contrast with those of the masculine sacred, and these take metaphoric form on the Sabbath with, for example, the welcoming of the Sabbath bride in different ways into the home, a feminized space, and into the synagogue, a masculinized space. The ritualized arrivals of the feminine sacred draw attention to the distinctions between self and other, for shechina resides normally in exile from the Jewish community during the week, and among the historical conditions for which she serves as a metaphor is diaspora.

In the Jewish historical imagination engendered by diaspora, the journey to the East, to the Eastern Mediterranean, produces the return to a timeless past, that is, an unchanged and unchanging world of Jewishness and a Jewish music that embodied timelessness and placelessness. This is what ethnomusicologists hoped to find when they began to collect Jewish music in the Mediterranean during the era of Jewish music collection (see chapter 5). By returning to and collecting Jewish music in Mediterranean communities, A. Z. Idelsohn, Robert Lachmann (Lachmann 1976), Friedrich Salomo Krauss, and Alberto Hemsi (Hemsi 1995) believed they might suture the diasporic gap between Jewish music as it was at a moment of biblical authenticity and as it remained, already Jewish in the Jewish communities of the East. Undermining theories about the unity of the Mediterranean was gender, more specifically the reality that women's music, though clearly anchored to local Jewish communities and ritual, failed to possess the criteria of Jewishness. To remedy this dilemma, women's music received its own space in the geography and history of eastern Jewish communities, a secular space, indeed, an exotic and sensually orientalized space.

I should like to turn briefly to the classic Jewish community imagined musically to connect the past to the present: the Yemenite community and Yemenite-Jewish music. In the modern Jewish imagination of the diaspora, Yemen—both because of its isolation at the southern part of the Arabian Peninsula and because

of its location on significant trade routes between Europe, Africa, and Asia—has been the site of an imagined authenticity that draws sharp lines between Jewishness and otherness. Early ethnomusicologists and music collectors, such as Abraham Zvi Idelsohn in the first volume of his *Thesaurus of Hebrew-Oriental Melodies* (1914), devoted their collections primarily to the music of men, drawing attention to the repertories of the synagogue, the *ḥeder* (boys school), and the *diwan* (space for male sociability in the home), a secular space in which repertories with classical Hebrew and Arabic genres are performed. Yemenite Jewish women sang in the vernacular, that is, in Yemenite Arabic or in the Judeo-Arabic of Yemen. Women did not sing in the synagogue, ḥeder, or diwan but rather used song in ritual settings, especially in rites of passage—notably weddings—and in the liminal community spaces between Jewish and Muslim cultures.

In modern discourse about the pastness of Jewish music, the Jewishness of male song is that of the sacred and the spiritual self; the Jewishness of women's music is that of reproduction and the physical body. The music of men becomes expressive through prayer and poetry; the music of women becomes expressive through social intercourse and dance. These distinctions, canonized at the time of the first encounters with Yemenite-Jewish music by Western ethnographers, persist in the visual and musical imagery of Yemenite-Israeli music today, shaping the meanings of modern Jewish music.

Quite specific genres of Mediterranean song emerge from the language practices of women and depend on the everyday nature of those practices. A central practice in Iraqi-Jewish women's music, for example, is the musical enactment of genealogies through pilgrimage (see Avishur 1986). Moroccan-Jewish women, too, are extraordinary for their worship at shrines to women saints, even when the veneration of these saints crosses gender lines (see Ben-Ami 1998). For Robert Lachmann, studying the Jewish communities on the island of Djerba, the discovery of "women's songs" was the fundamental paradigm of otherness within Djerba society, but it eventually led him to critique and dismantle the historiographic paradigm of authenticity (Lachmann 1976).

The geographical and historical spaces of Mediterranean Jewish musics are therefore sharply gendered, but that sharpness belies the crucial contestation of those spaces. Specific genres come to represent those spaces and their contestation, for example, ballads in the vernacular language of the Sephardic diaspora, Ladino. A distinctive musical language takes shape within these spaces, as in the male religious education of the Yemenite ḥeder. The gendered nature of sacred musical practices, such as the network of pilgrimage shrines and routes, remaps diaspora as a gendered, Jewish landscape. Music marks the presence of the feminine sacred as extraordinary and exceptional, but it does so by bounding an everyday world of difference. Such bounding of the everyday is deeply paradoxical, for we are accustomed to define the everyday as that which is not exceptional. The everyday, nonetheless, is a domain of contact, exchange, and movement away from a presumably authentic core. The everyday also forms as a cultural zone of transgressing the borders between self and other, hence facilitating the path of Jewishness into modern Europe from its peripheries.

JEWISHNESS IN MUSIC AND
THE WAGNER QUESTION

The Jews could never take possession of this art, until *that* was
to be exposed in it which they now demonstrably have brought
to light—its inner incapacity for life.

—Wagner 1995 [1869]: 99

With this powerful passage in the final pages of *Das Judentum in der Musik* (Jewishness
in Music), Richard Wagner attempted to foreclose the history of music for the Jews.
More to the point, he meant to suggest that Jews themselves, especially Jewish
composers of the early nineteenth century, had discovered the foreclosure of history
through an inability to internalize music, to map it on the inner, physical structures
of life and the body. Wagner's polemical writings, no less than his operas, unleashed
a flood of responses to the presence of Jewishness in music, pro and contra, which
remain unabated today. We follow these responses through Friedrich Nietzsche
and Thomas Mann, from the globalization of Wagner cults to the devastation of
Auschwitz (see Zelinsky 1983). The responses to Wagner's formulation of Jewishness
in music constitute a powerful discourse of modernity and modernism in music.

Attempts to identify Jewishness in music were not exclusively a matter of in-
veighing against the otherness. They emanated too from the aesthetic mirror of
selfness and were reflected in what might be called an "unknown reception history"
of Wagner criticism, "unknown" precisely because it would seem unimaginable to
many. It is not in fact reception history that I discuss here, but intellectual history,
or, more to the point of this book, the historiography of identity construction. Soon
after the publication of Richard Wagner's *Jewishness in Music*—the 1850 edition in
the *Neue Zeitschrift für Musik* did not include Wagner's name, whereas the 1869 edi-
tion differed in few other ways than the addition of Wagner's name as author—a
succession of responses to the composer's open racialization of music appeared in
Jewish communities throughout the world. Rather than rejecting Wagner's anti-
Semitism as baseless prejudice, most Jewish responses mounted counterarguments
affirming the possibility of Jewishness in music, using the same terms, if not case
studies, as Wagner and often embracing the racialization of music. Not an insignifi-
cant number of these Jewish responses deliberately employed Wagner's title or slight
variations thereof, and it is these that provide the basis for the present excursus.
Visible and influential contributions to the discourse on Jewishness in music often
appeared at times of foment and crisis in Jewish communities of the diaspora, and
these had the effect of canonizing a musical vocabulary of selfness, from which
Jewish music scholarship has failed to free itself (for a critique of music in modern
Jewish studies see Bohlman 2002b).

Tracing the trope of Jewishness in music through the disciplinary history of
Jewish music scholarship, I draw us closer to the contemporary dilemma confront-
ing the modern study of Jewish music, namely that it has become a field trapped
in a discursive space between Jewish studies, cultural studies, and the anthropology
of music. The ontology of Jewish music in modern scholarship is physically—and
racially—instantiated, derived from the surface of the body, especially through the

production of melody, but remapped on the inner landscapes of the body. Because the object reproduced by Jewishness in music has always existed in a historical time-lessness and geographical placelessness, critical reflexivity and comparative analysis became to a large degree impossible, and ethnography was reduced to discovering a cultural object whose existence was not open to question. Jewish music scholarship, even in a post-Holocaust, postmodern world, has been slow to discard the very language and racial imagery that have historically stigmatized Jewishness in music.

Why did many Jewish responses to Wagner actually embrace his language in order to discover and identify Jewishness in music? Stated more baldly: Why were these responses so willing to accept that Wagner got certain things right? Why, despite the aesthetic legacy of Auschwitz, voiced by Theodor Adorno, Paul Celan, and countless others, and despite the ban, official and unofficial, of Wagner in Israel, have Wagner's racial categories not proved to be so powerful as to demand total and unequivocal rejection? To begin answering these questions, I should like to observe that Wagner's racialization of music focused on four conditions but that none of these, when extrapolated to the rest of Wagner's writings and nineteenth-century writings on nation and race in music, was unique to Jews.

The four conditions of "Jewishness" posited by Wagner were: (1) melody and speech; (2) body and race ("inner spaces"); (3) lack of history; (4) lack of a land that allows for tradition. Wagner's polemic depended on an ethnography that was obviously flawed, so much so that readers failed to find the results plausible. His arguments about the spirituality of Jewish music, for example, rest on the following rhetorical question: "Who has not had occasion to convince himself of the travesty of a divine service of song, presented in a real Folk-synagogue?" (Wagner 1995 [1869]: 98–99). The question rests on a sort of willing tautology, for Wagner was only too well aware that hardly any of his readers had the vaguest idea about the ritual and music of the synagogue, "folk" or modern.

Wagner's conditions could more easily be interpellated than dismissed. The paradox of Wagner for Jewish music history and modernity is that he articulated specific conditions of otherness that Jewish critics wanted to redress in order to articulate new conditions of selfness in Jewish music. Wagner's construction of otherness could easily be dismantled and replaced with a new set of conditions for selfness. His language, so crucial to a late nineteenth-century aesthetic of music rooted in racial categories, at once created an opportunity and posed a dilemma for an emerging Jewish musical ethnography, for it became necessary and convenient to examine Jewish music by utilizing the ethnographic language of those who held Jewishness to be fundamentally racial.

One of the most pervasive ontological tropes shared by Wagner and the Jewish writers responding to him is that Jewish music, as distinctively logogenic, is entrapped by language and speech and thus can never be liberated from the Jewish body as pure or absolute music. The Jewishness of song—that is, the arias of Jewish opera composers or cantillation and recitation in the synagogue—further encumbers it, as incomplete music, from entering history. The putatively logogenic quality of Jewish song emerges as a trope—which is extended to song in the synagogue, for example, to *te'amim* (cantillation marks, tropes), the non-pitch-specific notational system for reciting Torah—for ritual and the cyclicity of Jewish liturgical music.

Cantillation therefore refers to history, especially when enacted in the diaspora, but it does not signify history, being powerless as incomplete music to do so.

A second and related trope holds that Jewish music is not created as an act of individual will but rather is reproduced through performance. Paradoxically, Wagner held that the capacity of Jewish composers only to reproduce made it possible for them to enter European music history at a moment of historical collapse, in the 1830s and 1840s, in order to fill the void that opened after Beethoven's death in 1827. In short, Wagner's claim that Jewishness allowed only for the reproduction of music opened the historical door, emancipating Jewish music from ritual and recalibrating it as Western, if undesirably so.

The incapacity of Jewishness in music to allow for creativity did not mean that new forms of Jewishness in music could not arise. The third trope held that Jewish musicians were essentially *bricoleurs,* who assembled their performances from bits and pieces, borrowing or stealing when need be. Jewishness in music thus transformed Jewish musicians into professionals *par excellence.* For Wagner this meant the undermining of a European political economy into which he had hoped to gain entrance, but for early Jewish music scholarship this led to the recognition of entirely new musical activities and repertories. The klezmer musician depended on bricolage in order to thrive as a professional and to participate in a much more extensive history of music that connected Jewish music to the European public sphere. Whereas klezmer was celebrated for its creativity, the same musical trope when used to characterize Jewish composers marked a historical malignancy, which spread unchecked across modernity.

The final shared trope was the conviction that Jewishness in music represented the historical *longue durée,* thereby a rootedness in the land of Israel. For Wagner, this meant that Jewish music could never properly lay claim to Westernness; for Jewish music ethnographers, this meant that Jewish music could be retrieved archeologically to construct a modern history. Beginning in the 1890s, the rescue effort took the form of increasingly intensive collecting in the Yishuv, where, as the writers examined below believed, the most profound Jewishness in music awaited unearthing. The Zionist and nationalist imperatives of Jewish music scholarship—in other words, the representation of Jewish music as teleologically bound to Israeli music—needed no other context than the Wagnerian notion of a music historical *longue durée.*

HEINRICH BERL: JEWISHNESS AS EXTREME MUSICALITY

Through a remarkable connection in the bloodline the Jew is the inflexible human being *par excellence.* He does not *see* things in their totality; rather he *looks* at them in their essence. In the final analysis, it is the capacitiy to objectify that is truly "lacking" for Jews. . . . If the Jew is necessarily an inflexible type, then he must be the opposite—the *most musical.* This follows directly from the evidence, for sculpture and music are no less basic oppositions as man and woman or day and night.

—Berl 1921/1922: 495–96

As World War I brought an end to the imperial parsing of Europe and Western music history, Jewish musicians and writers perceived a new possibility to enter the discursive spaces of a modern public sphere. It is hardly surprising that an explosion of writing about Jewishness in music should therefore follow quickly and flesh out an emerging Jewish aesthetic response to modernity and modernism. I draw the reader's attention to this explosion, not least because it leads both toward the founding of the State of Israel and to the Holocaust, and necessarily asks from an aesthetic perspective: How and why are these events related?

I begin with Heinrich Berl, who was a member of the circle of artists, theologians, and critics around Martin Buber. Berl, who wrote widely in history and political science, contributed two major works on Jewishness in music: in the early 1920s a set of essays in Buber's journal *Der Jude,* entitled *Das Judentum in der abendländischen Musik* (Jewishness in Western Music), and in 1926 a monograph with Wagner's exact title, *Das Judentum in der Musik.* In the earlier series of essays, Berl wrestles directly with Wagner and his categories, raising them first to demonstrate their shallowness, but then turning them inside out to show that such categories could usefully engender a set of arguments. If Jewish musicians demonstrate a greater penchant to reproduce than to invent music, so Berl argues, this tendency reveals that they are the people whose musical predilections and talents lie closest to the core of music-making. In the spirit of cultural Jewishness that infused the Buber circle, Berl not only accepts the charge that Jewishness in music inevitably embodied traditions from the East and from Asia: He rejoices in this easternness and then proceeds to explain the popular influences moving across European music in the 1920s as evidence of the richness of Eastern influences. Berl returns Jewish music to history, albeit the history of his own era, thereby relying on an aesthetic argument that renders it atavistic.

J. E. DE SINOJA: JEWISHNESS AND THE MIRROR OF ANTI-SEMITISM

> The Jewish race has grown, despite all the attacks and persecution it has endured during the course of millennia; its spiritual superiority, which is the primary reason for the jealousy and hatred it engenders, will continue to protect it from destruction, and it will not cease growing, in spite of the many unpleasant and damaging effects of the agitation stirred up by Wagner and his cohorts.
>
> —de Sinoja 1933: 280–81

If Wagner racialized music by locating Jewishness in it, J. E. de Sinoja confirmed and undergirded the racialized presence of music by claiming that European music had become fundamentally Jewish despite Wagner. De Sinoja's *Das Antisemitentum in der Musik* (Anti-Semitism in Music), published in Switzerland in 1933, attempted a sweeping rebuttal of Wagner by documenting the growing contributions of Jews in European music. De Sinoja's aim, like Heinrich Berl's, was to turn Wagner's arguments inside out by showing in case after case that history had proved Wagner's predictions false. In almost 300 pages de Sinoja traces the reception history of *Das*

Judentum in der Musik, showing that more rational minds had prevailed and that for each act of mythologizing Wagner's anti-Semitism, there had been an equivalent rebuttal. De Sinoja had himself lived through that reception, and he reveals that he himself had rebutted the attempts to racialize music, one after another, in an effort that culminated in this final monograph. He effectively argued against the possibility of music to signify racial hatred, showing instead that the attackers of Jewishness in music had failed to anchor their racialization in science. In 1933 it was fully evident that Wagner's Jewishness in music was really anti-Semitism in Wagner's own music, and that the true Jewishness in music lay in the future and the ineluctable growth of, in de Sinoja's words, the "Jewish race."

SALO B. LEVI AND SALLI LEVI: JEWISHNESS
AND THE ZIONIST IMPERATIVE

> Two criteria are fundamental to the existence of Jewish music,
> just as they are to any people: It is not only necessary to nurture
> the greatest strength from the soil of the maternal landscape, but
> it is also crucial to recognize the race from which Jewishness
> came into being, and to which it, despite the centuries of wan-
> dering, remains internally bound—recognition, that is, of a race
> rooted in western Asia.
> —Salo B. Levi 1929?: 1–2

For the World Centre for Jewish Music in Palestine, which was the first Jewish music society in mandatory Palestine, the reformulation of a tract on *Jewishness in Music* provided the cornerstone for a new Jewish world. At several stages during the 1920s and 1930s, the World Centre's founder, Salli Levi, worked and reworked texts on Jewishness and music, eventually drawing upon them to establish the organization that should provide a means of attracting all Jewish musicians to Israel during the era of most acute crisis in Jewish history (cf. S. B. Levi 1929 and S. Levi 1936; see Bohlman 1986).

Of all the writers responding to Wagner cited in this chapter, no one employed rhetoric closer to Wagner's than did Salli Levi. Racial arguments were fundamental to his argument, and the ways in which he constructed notions of race and music were remarkably close to the historically biologistic models common to German and Nazi theorists. Race stemmed from the historical rootedness of a people (*Volkstum;* literally, folkness) in a specific geography. The World Centre for Jewish Music, shaped by a Zionist imperative, returned music from the outside, from the diaspora, to the inside of Jewish history, and in this way true Jewishness could finally reassert itself in music (Bohlman 1992). With Jewishness reasserted, history was made whole, fulfilling Wagner's ultimate wish.

JEWISHNESS IN MUSIC: ETHNOGRAPHIES OF
SELFNESS IN A WORLD OF OTHERNESS

Throughout their essays, pamphlets, and books, the rhetoric shared by Wagner and his detractor/respondents stressed the ontological interiority of music: das Judentum

in der Musik, Judaism *in* music; Jewishness *in* music. We encounter a concern for perceiving the *inner* landscapes of music, and the *Innigkeit* and *innerness* of music, its aesthetic capacity to reside *within* history. Music was racialized from within, and history was given its structural wholeness from within. In these ways music was constantly afforded its objective status, the very Jewishness that Wagner, Berl, de Sinoja, Levi, and countless other critics sought. Jewish music was thereby invented in part through the employment of discourses about Jewishness. The common trajectory of a history driven by Jewishness in music was outside in. To achieve that trajectory, Wagner's own racialization of music was turned inside out but hardly abandoned; if race had provided a means of locating Jewish music outside history prior to the nineteenth century, it was seized upon to return Jewish music to history in the twentieth, both before and during the Holocaust. The Holocaust was inscribed into and by that history of Jewishness in history.

As practice embodied within history, Jewish music survived the Holocaust and, paradoxically, achieved a new ontological status precisely as Jewish musical scholars had projected it would and must: in Israel, on a uniquely Jewish cultural landscape. It is hardly surprising, then, that Jewish music scholars were driven by the desire to represent the uniqueness in Jewish music and to make Jewish music unlike any other music, thereby ensuring its capacity to survive. To do so, Jewish musical ethnographers mapped concepts of selfness on music itself, insisting that Jewishness could be instantiated in music. In making Jewish music unlike any other music, Jewish music historians perforce employed a comparative discourse that made Jewish music just like other musics, removing it from ritual time and the surface of the body and locating it in the modern nation-state.

Zionism embraced Jewish song from its beginning. Even before the institutionalization of modern Zionism at the first official act of organization, the 1897 Basel Congress, song had provided Zionists with a source of Jewishness. Proto-Zionist student organizations had edited songbooks. Sources and repertories had been identified, and editorial procedures were in place. At Basel in 1897 congress organizers had gathered five songs in a booklet, and from the First Congress on, song would be inseparable from the communal culture and political ideology of Zionism. At the Second Zionist Congress the organizers adopted a published book, not only for use at the congress itself but also for distribution to diaspora communities afterwards (published as Verein "Jung Zion" 1898). The songs in the earliest Zionist collections were choral and communal to embody the collective experience of the movement at the moment of its most palpable performance at the congresses. Song-made-Jewish thus acquired the potential to instantiate a social collective, with songs such as "Gaudeamus igitur" (best known today as the theme in Brahms's *Academic Festival Overture*), which circulated in Hebrew translation in the earliest songbooks (for the use of song by late nineteenth-century social organizations, see Schwab 1973).

For early Zionism, song was proving to be a slippery signifier of Jewishness. What kind of Jewishness did it or could it signify? The Jewishness implicit in religious community? The disparate Jewishnesses of diaspora? A Jewishness that was synonymous with nationalism? A Jewishness with the power to unleash ethnic mobilization? For the early Zionists who embraced song, the answers to these questions

were anything but clear. What was clear was that the time to act was upon them, and that song had an extraordinary power to realize Zionism's vision of a Jewish nation-state.

By the end of the nineteenth century, political song, with Jewish texts, had become one of the most powerful agents for the mobilization of Jewish identity and for the articulation of Jewish nationalism. Paradoxically, the role and function of song in early Zionism remain uncertain, even troubling to many cultural historians, for the real identity of early Zionist song is hard to pin down. By and large, early Zionist song did not use explicitly Jewish texts, especially those in Hebrew. When song appears in the Yishuv and modern Israel, however, cultural historians revel in its use of Hebrew, as if it were created out of the full cloth of the past. Song played a powerful role in the shaping of Zionism not because it leveled the differences among the polyphonic voices of the past, but rather because the sounding of song in performance reified a moment at which the unity of the nation takes precedence over its differences.

This acoustical moment of the nation-through-performance is temporally bounded, if not fleeting, yet it accrues power and added meaning through its reproducibility. Accordingly, searching for song to give voice to the nation—to mobilize the nation in a moment of what Benedict Anderson calls "unisonality"—is of profound significance (Anderson 1991: 132). Song was the ideal medium for conveying the message of Jewish solidarity, and the early Zionists knew so. Song possessed all the attributes of specific identity and remained semiotically open-ended, thus capable of signifying whatever one might choose for it. Such qualities of song reflect the themes that permeate the early history of Zionism, thereby transforming nineteenth-century topoï of Romantic nationalism and German idealism into specific subjectivities of twentieth-century Zionism. Song provided a template for *both* Jewishness *and* nationalism; song, in other words, had the power to speak to all Zionists in a common language.

The nationalist themes of Zionist song existed long before the Zionist movement had institutionalized itself. These themes become the basis of one of the first proto-Zionist songbooks, whose publication in 1894 preceded the first Zionist Congress by three years. The small volume, *Lieder-Buch für jüdische Vereine* (Songbook for Jewish Social Organizations), edited by the early Zionist and librarian at the University of Berlin, Heinrich Loewe, appeared in a practical chapbook format, clearly recalling a student songbook for the Jewish university organizations that adopted it (Loewe 1894). On one hand Loewe's *Lieder-Buch* reflected the trend of many social and professional organizations to gather songs as a means of inspiring group solidarity. On the other, Loewe undertook a project with the specific Jewish dimensions of time and place. He wanted his *Lieder-Buch* to serve "Jewish organizations" in the plural, among them the student group he founded in 1892, "Jung Juda" (Young Judah), as well as later student organizations, such as the "Vereinigung für jüdisches Studierenden" (Association of Jewish Students, also founded by Loewe) and the "Kartell jüdischer Verbindungen" (Cartel of Jewish Organizations). Loewe meant his songbook to lay the groundwork for a new social agency for Jewish song, and he asserted in his "Foreword" that the songbook was breaking radically with existing traditions.

The attempt to edit a songbook for Jewish organizations is such an entirely new un-
dertaking—one without any precedent whatsoever—that it would appear necessary
to offer a few words of introduction. . . . This Jewish songbook does not pretend
to offer a scientific lesson, rather it can keep only a single task in mind. Indeed, the
synagogue is not the only place we learn about ourselves, nor do we learn only from
the struggles against our enemies. Instead, it is in our lives, our total existence, and for
that we raise our voice in celebration, joy, and song: "Juden sind wir, wollen es bleiben,
bis in alle Ewigkeit" [We are Jews, and we'll remain that way forever]! ("Foreword"
in Loewe 1894)

The songs in Loewe's songbooks weave "Volk" and "Nation" together, explicitly
constructing an image of the nation as the product of an ethnic group that song
mobilizes. The interplay of metaphors for the nation in Figure 8.1, "Mein Volk"
("My People"), is indeed remarkable, ranging from nationalist images of the nation
as a "beloved" ("Liebling"), evoking even the arrival of shechina in the synagogue
on the Sabbath in verse 1 to the French Revolution in verse 3 to Israel at war
throughout, but especially in verse 2.

English Translation

1. My people are my beloved, what I have, my very blood,—
I long for nothing else,
That Judah's nation be well protected
And that we be its gallant protectors!

2. To struggle and fight for Jacob's nation
And to lead the people of Judah to war,
Young Israel knows no better purpose,
Than to lead Israel in victory.

3. My life is devoted to my people,
My people are my happiness and well-being,
And freedom and equality and brotherhood
Should belong to Israel forever.

4. I hear my people, and my people hear me,
I'm only one part of them,
My people are my all, my pleasure, my honor,
My people are my holiness and my fortune.

5. Yes, Judah's nation will be well protected,
Young Israel will be its protector,
My people are my beloved, what I have, my very blood,
I long for nothing else!
"Mein Volk"/"My People" (Loewe 1894)

Loewe was both right and wrong when he claimed that there was no real prec-
edent for his *Lieder-Buch*. The book was in fact a synthetic product of the editor's
imagination; Loewe invented it. No single element—text or melody—is new, but
virtually every combination thereof is. It contains only two songs in Hebrew, and
these appear in an appendix. The first was a song for Hanukah, and as such the
only song with overtly religious connotations. The second was the most canonic of
all student songs, "Gaudeamus igitur," translated from Latin into Hebrew, which
effectively recanonized it for inclusion in future Zionist songbooks.

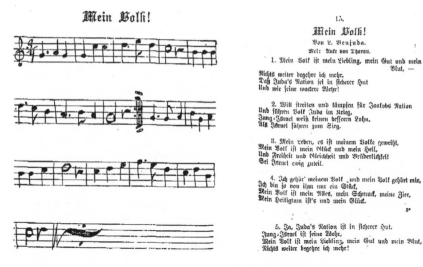

FIGURE 8.1 "Mein Volk"/"My People." (Source: Loewe 1894)

Loewe's *Lieder-Buch* provided the basis for most Jewish songbooks, Zionist or with other ideological leanings, for the next two decades, until World War I. The organization of its contents (e.g., into genres such as *Heimatlieder* [songs of the homeland], explicitly representing the land of Israel as the homeland) was embraced by virtually every subsequent songbook (see, e.g., Zirker 1905(?); Eliasberg 1913; Glaser 1914). Similarly, it served the early Zionist leaders, for the Jewishness projected by its cosmopolitan character was embraced at Zionist congresses and in off-shoot Zionist songbooks as an embodiment of Jewish nationalism. The songs in the new Jewish songbooks functioned this way not because they were old, but because they were new. It was their difference that made them so very traditional.

The ideologues searching for Jewish political songs at the end of the nineteenth century had to confront more than a few paradoxes. Folk song, the tool of Romantic nationalism, was broadly held to be something ancient and oral, whereas cultural Zionism was progressive and modern. Folk song connected the present to a distant past, indeed, a timeless past, but—and this was the dilemma for early Zionists—it did so through a history of practice and oral tradition that survived in the present. The paradox was all too obvious: The song of the ancient past was Hebrew song, but the song of the present was not.

The absence of Hebrew texts in vernacular, contemporary song also created another set of paradoxes, several of them quite mundane or even practical. Hebrew texts did not lend themselves easily to text underlay: The music ran in one direction (left to right), the Hebrew text in the opposite. Whereas this might sound like a problem that could easily be resolved by an editorial committee with the appropriate authority, it was not. In fact, it vexed those involved with establishing the printing conventions of the Yishuv through the 1920s (see Hirshberg 1995: 78–92).

The poison of popularity, in other words popular song, was also a dilemma for the ideologues searching for political song. Jewish popular song throve in the nineteenth

century, ranging from broadsides to stage music, but it throve because it was formed of hybridity rather than authenticity. It was impure, all the more so because it depended on parodies of traditional Jewish culture and traded in stereotypes of Jews and by Jews. Confronted with this paradox, the early Zionist editors and ideologues chose to address it creatively and synthetically. They sought a new calculus for determining what song could be, and in the spirit of their age they did so systematically, consciously identifying what they would need to do to invent political song.

Collecting, identifying, editing, and arranging Jewish songs all preceded the official organization of Zionism and the Zionist congresses in the late nineteenth and early twentieth centuries. These were the steps of fabricating, indeed, of inventing Jewish political song. These steps, derived from other processes of inventing Jewish music (see chapter 4), compressed the history of oral transmission, and they transformed the songs from the past into metonyms for the present and future. Song was the ideal language for giving voice to Zionism, and it is hardly surprising that the movement's architects and intellectual leaders seized upon it from the beginning. Song not only arose from an existing common culture, but was malleable enough to lend itself to the molding of a new common culture. The common experience of song exposed a shared past and provided the language for a shared future. Language was the crucial metaphor, for language not only afforded song pride of place in the aesthetic domains of Zionism, but opened up those domains for every Jew, regardless of background.

What was the common culture of Jewishness that political song came to evoke? It would be possible to answer this question in many different ways. During the early decades of Zionism, that common culture was in almost every way unexpected. Above all, it was a common culture with deep fissures in it, and it was precisely for that reason that song had the power to resuture the parts to form a common whole. The common culture of Jewish song cut across the fissures between East and West. It embraced repertories in Yiddish, German, and Hebrew. Other languages also occurred, but with less frequency. By the 1920s, however, English, Hungarian, and Slavic languages were beginning to play visible roles. Jewish song also embraced the dialects and hybrid forms of these languages. The common culture of Jewish song thus did not begin with common language, but it aspired toward it, and music paved the way for reaching the common language, which in turn powerfully and publicly embodied a common Jewishness.

RESISTIVE JEWISHNESS IN MUSIC

Political and popular song was born of protest against the censor. When pamphlets and poems were banned, song became the vehicle for the suppressed voice. When the burning of books silenced the written traditions of literature, song sustained the poignancy of opposing viewpoints through oral tradition. During the first half of the twentieth century, when Jewish artists and intellectuals contributed so trenchantly to the rise of modernism, it is hardly surprising that Jewish popular song was called upon so frequently to keep vital the counterpoint between the arts and politics, especially on the eve of the Holocaust, when the public presence of Jewishness in Central Europe had never been greater.

Political song reveals and resolves a paradox: Jewish political songs multiplied in the early twentieth century, especially in the period immediately after World War I, when Jewish writers and poets such as Karl Kraus, Kurt Tucholsky, and Peter Hammerschlag were turning to song texts with some of their most biting political critique. Jewish political songs had been the products of different historical and political moments, beginning at the end of the nineteenth century, accelerating toward and culminating in the conflagration of Jewish literature in the early 1930s. Together, Jewish political songs narrate a history of resistance to the attempts to destroy freedom of expression through censorship, brutality, and, at the most extreme moments, book-burning. Because of their common response to the repression of ideas, Jewish political songs collectively narrate a distinctive history of modernity. Jewish popular songs responded to political moments that were fragile, moments when singular, public events, such as the book burnings on May 8, 1933, on the Opernplatz in Berlin, could serve as the trigger for holocaust.

Jewish political song openly set itself up as a target for censorship and public criticism, thereby drawing attention to the political work Jewish poets and musicians could do—the responses to censorship and to the oppression by the powerful of one or many groups in society—and in so doing they reached as many sectors of society as possible. Political songs escaped laws that banned them and actions intended to remove them from circulation by becoming popular, that is, by winning over exactly the audiences whose voices were silenced through censorship. As popular songs, the political poetry of turn-of-the-century cabaret songsmiths, Weimar satirists, and exiled writers during the Nazi era created a collective art form that was at once ephemeral and immediate.

Political figures not only were the victims of the social criticism in much popular song, but there were many who even contributed to it. Theodor Herzl (1860–1904), for example, founder of the Zionist Movement and a Budapest and Viennese feuilletonist very much in touch with the popular press, wrote skits intended for the popular stage and the cabaret. Herzl's "Im Speisewagen" (In the Dining Car) depicts a conversation between a group of characters possessing different social ranks who meet in the dining car of an express train from Vienna to Berlin via Prague (published posthumously in Herzl 1935: 420–35). A one-act satire—Herzl calls it an "elegiac farce"—such a play might easily have found its way to a Zionist cabaret in the 1920s. Socialist writers who banded together as collectives recognized in the cabaret stage a potential for adding volume and unity to their common cause. Explicitly socialist messages found their way into the satires and cabaret songs from the interwar period, and indeed it was for their socialist and communist sympathies, no less than their Jewishness, that poets such as Peter Hammerschlag and Hanns Eisler were so frequently subjected to political censorship (see the discussion of Hammerschlag's "Love Song to a Proletarian Girl" in chapter 7).

From the 1880s until the 1930s, Jewish cabaret and popular song underwent several patterns of growing politicization. Until World War I, the political appeared most frequently in specific themes, particularly those that took aim at anti-Semitism and the absence of equal opportunity in the workplace. In the wake of World War I the politicization of the Jewish stage became more explicit. There were Jewish-socialist cabarets, for example, and these were different from Zionist

cabarets. During the 1930s, when the Jewish communities of Germany faced official restrictions, Jewish cabaret throve. Accordingly, the politicization of Jewish popular music accelerated, transforming the genres of popular music into complex forms of political response in the Holocaust.

The poetry, plays, and books by political writers, such as Karl Kraus and Kurt Tucholsky, as well as by non-Jewish writers, such as Bertolt Brecht and Erich Kästner, provided targets for Nazi ideologues and censors, but ironically they also attracted the attention of some of the finest composers of the day. Why ironically, one might ask? Because it was the same message that both censors and composers were hearing. The one wanted to extinguish the life in that message, the other endeavored to renew its life whenever it was in peril. Peril, however, was a condition that was by no means foreign to the poets and composers. In song after song peril is rendered explicit. The destruction of literature is assailed for what it is; censorship is decried for what it does; the threat to freedom of expression is fought by freeing expression through song. Political songs required an activist stance and a conviction that the accomplishments of art resist destruction. We find that stance and conviction in abundance in the new repertories of Jewish political songs created for the cabaret stage, the musical theater, and the new media, such as recording and radio, that were embraced by Jewish musicians in the 1920s and 1930s (see chapter 9).

The potency of political song to mobilize the political lies in the ways it mixes genre. By turning genres inside out and juxtaposing them in unexpected ways, the songsmith and composer unleash the play of parody and double entendre. Tunes move malleably from one repertory to another, or from folk to popular to classical genres, and in so doing they expose meanings that might not have been originally apparent. Those elements that at first hearing seem innocent often contain some of the most cutting social critique. A text that at one moment seems cloyingly nostalgic launches a full-fledged social commentary the next. The satirical and the serious intersect, as do the lament and the love song. Hybrid genres challenge the censor, because their "real meanings" are difficult to pin down. The moment everything seems to make sense, the political songsmith slips into another style or skirts the subject that is too obviously suspect. Chameleon-like, Jewish political song acquires its power as more and more hybridity accrues to it.

When examining the ways in which genre undergoes processes of hybridization in political song, we begin by taking the idea of genre in its rather literal sense. The genre lying at the heart of many political songs is the ballad, the strophic narrative form that unfolds as a series of dramatic scenes. The ballad contains a cast of characters who are stereotyped and idealized, who are then mixed with a real and historical cast of characters. Ballads rely on hybridity in still other ways. They rely on the common practice of connecting folk song in oral tradition to popular and art song in written tradition. The songs in many popular ballads circulated first on broadsides, where the best of them dovetailed with popular tunes and found their way to the top of the charts (see chapter 7). Recognizing the pregnant moment resulting from the cross-fertilization of the oral and the written, poets such as Bertolt Brecht, Kurt Tucholsky, and the composers with whom they collaborated, such as Paul Dessau and Hanns Eisler, deliberately employed genres at the nexus of folk, popular, and art song, not just the ballad but also the *Moritat* (moral tale, hawked as a

street song, as in Eisler's setting of Brecht's "The Ballad of the 'Jewish Whore' Marie Sanders"; New Budapest Orpheum Society 2002: track 15). With each new genre and style, the songs resonated for new audiences and more diverse publics.

The frequent presence of humor in Jewish political songs also contributes to the ways in which they mix genres and engender complex meanings. Humor provided a means of keeping ideological opposition alive on the popular stage, allowing performers to chronicle the lives of the working class and the poor, or of urban immigrants escaping pogroms and political repression of Eastern Europe. In many political songs the listener meets individuals whose follies have placed them in improbable situations, where their actions are greeted by laughter, but also by serious reflection on the tribulations that have been inflicted upon them. Humor, the stock in trade of cabaret troupes in the metropole, seldom remains isolated in the political songs. The songs stir a full range of emotions, which together make it possible for audiences to identify with the songs and their everyday worlds, all the more so in the 1930s, when all genres of Jewish music theater underwent extensive politicization.

The poets of the 1920s and 1930s crafted an aesthetic that aimed at rescripting events that seemed extraordinary so that they were quotidian. To match the shift of the political to the everyday in the poetic texts, composers of political song also forged musical styles and vocabularies that would enhance the sense that the poems and music belonged to the people and gave voice to their concerns. Best known of the attempts to provide the everyday poetics of the political with a musical context was musical *neue Sachlichkeit* (glossed as new objectivity) during the interwar period. Working with musical materials that stressed the familiar and the accessible, composers on the eve of the Holocaust, such as Weill and Eisler, crafted melody and harmony that possessed the ring of the popular, drawing audiences to their song repertories with their textual clarity and steadfastness of purpose.

In many respects, Jewish political songs created on the eve of the Holocaust have become songs of the twentieth century. There are numerous reasons that many of the songs composed by Kurt Weill and Hanns Eisler remain strikingly familiar: In one way or another, these songs found their way to the stage, where a few even became hit songs. The stage claimed by Jewish political song had both general and specific meanings, literal and figurative forms, that we will trace through the final chapter of this book. From the end of the nineteenth century until the 1930s, the one stage that would pick up many of these songs was the cabaret, with its mixture of skits, satirical and sentimental songs, and parodies of scenes from operas and operettas alike. The sensibility of cabaret runs through all the songs, for it was a theatrical venue that attracted Kurt Tucholsky and Bertolt Brecht in the 1920s and 1930s just as seductively as it did the creators of broadsides in fin-de-siècle Vienna and Berlin.

Succeeding in the world of the popular stage, of course, meant that a song had to be flexible. Cover versions were the rule rather than the exception, and parody and stereotype left no one's sensibilities unchallenged. The stage allowed tradition to be historicized no less than bowdlerized. It was on the popular stage, moreover, that the most serious issues of the day were clothed in such ways that they would be recognizable to the audience while remaining opaque to the censors looking

for hidden meanings. The composers of Jewish political song fully recognized the popular potential of the stage and the political implications it held for Jewish music. The hybridity of popular-song genres for the stage was revolutionary precisely during the era of the 1920s and 1930s, and beyond in the exile of the 1940s, when the music for the cabaret found new homes on the stage of the American musical and the Hollywood film.

From their composition and dissemination to their performance and reception, Jewish political songs frequently had to tread a thin line between the sanctioned and forbidden, and between the legal and illegal. They also negotiated social and ethnic religious differences, particularly the distinctions between what was perceived as Jewish and what was not. Whereas some political songs adapted from oral tradition probably circulated almost exclusively in Jewish popular culture, many are the products of remarkably fruitful collaborations between Jewish and non-Jewish musicians and writers. Such collaborations as those between Hanns Eisler or Kurt Weill and Bertolt Brecht should not remain without remark, for they so richly reveal that the sources for political music in the twentieth century lay in collapsing the social distinctions between selfness and otherness. Their political message transformed the stage into a modern social mirror.

The Jewishness of Jewish political songs, indeed, often remained open to question, not so much for religious as for political reasons. For what kind of public were they intended? Just how did the Jewish and non-Jewish intersect and designate that public? To what extent were questions about race and religion being forced to the central position in the pre-Holocaust agendas of rising fascism? Was it really possible to distinguish between self and other? These were the questions tackled by Jewish political musicians, and they were the issues confronted head-on by the traditions of Jewish musical theater that we encounter in the next chapter.

The metaphors and tropes of modern Jewish history run through Jewish political songs, transforming them into a path through prejudice and peril alike, especially in the 1930s and 1940s, when they resisted the changing public sphere of Germany and Austria. The rise of Jewish political song charts the course of a historical journey, fraught at every turn with detour and displacement, yet ironically following the path also familiar to people accustomed to discovering their "homeland in the book," which by the 1930s was increasingly becoming a utopian public sphere. Exile and its persistent counterpart in Jewish history, diaspora, also found their way into the domains of Jewishness that political songs documented in the 1930s, transforming them into the songs of exile and survival, and investing Jewish music with truly modern and modernist agendas of Jewishness.

CHAPTER NINE

<center>━━◈◈◈━━</center>

STAGING JEWISH MUSIC

Das Klabrias, das Klabrias,	Klabrias, klabrias
Das ist doch ein Vergnügen,	It really is a joy,
Besonders wenn man Glück hat,	Especially if one's lucky,
Thut schöne Karten.	Getting a winning hand.
‖: Das Klabrias, das Klabrias,	‖: Klabrias, klabrias,
Das ist auch unser Alles.	It's everything we have.
Jetzt empfehlt sich	Now it's time for
Schnass und Compagnie	Blows and camaraderie
Und auch der Simon Dalles. : ‖	And also for Simon Dalles. : ‖

—Adolf Bergmann, *Die Klabriaspartie/
The Game of Sheepshead,* Final
Chorus (Veigl 1992:39)

With a rousing chorus the actors of the Budapester Orpheumgesellschaft (Budapest Orpheum Society) brought the most popular Jewish satire of fin-de-siècle Vienna to a close. Like the songs in other epigraphs opening the chapters of this book, *Die Klabriaspartie* (The Game of Sheepshead) was a hit in its day, in fact long thereafter. Many factors surely accounted for its popularity, some obvious, others intangible. The one-act skit, with six scenes in the original version that Adolf Bergmann sold to the Budapester Orpheumgesellschaft, had at best a loose plot, in which three card players appeared in a Viennese coffee house to play several hands of *Klabrias* (from the Yiddish, *klaberjass,* a game roughly comparable to sheepshead). The three card players, the Jewish Simon Dalles (Yiddish, poverty), the hen-pecked Jonas Reis, and the Czech Prokop Janitscheck, use the Klabrias game to comment on life in general and on Vienna's Jewish Leopoldstadt neighborhood in particular. Depending on the cover version or improvised variant of the skit, the card players are joined by the tavern keeper, Reis's wife, Dowidl Kibitz, a local from the Yiddish-speaking neighborhood, and sundry other guests. Jokes and satirical commentaries are punctuated throughout by couplets, songs, and choruses, most famously by the play's signature hit song, "Die Klabriaspartie."

The Budapester Orpheumgesellschaft, the most influential and long-lived Jewish theatrical troupe in Vienna, brought *Die Klabriaspartie* to the boards over 1,000 times, and the play served as a springboard for the careers of two of the most famous members of the troupe, Ferdinand Grünecker and Heinrich Eisenbach (for a recording of the latter playing Simon Dalles, see Eisenbach n.d.). The skit and its songs spread to Jewish theater and cabaret companies across Central and East Central Europe, performed in Budapest, from which the playwright, Adolf Bergmann, had come, and in Berlin, where it was no less a hit for the Herrnfeldtheater, the most popular Jewish stage of the German capital (see below). Estimates of the total number of performances exceed 5,000 (Wacks 2002: 57–58), and contemporary observers celebrated the fiftieth anniversary of its circulation (Hannak 1931). One hundred twenty-five years after the Klabrias players dealt their first hand, *Die Klabriaspartie* continues to provide a powerful symbol for historicizing, in part reviving, the Jewish cabaret tradition that exploded across European stages just as musical and Jewish modernism had reached the stage of European history (Wacks 2002: 56–63; New Budapest Orpheum Society 2002).

The allegory that permeated *Die Klabriaspartie* depended on caricature that was often crass and crude. No one doubted that the world of the card game exposed the world of Jewish modernity that most spectators recognized as their own. It was a world made possible by immigration to the metropole. Dalles, Reis, and Janitscheck had fictionally all arrived at the same Vienna North Train Station, before settling into the multicultural world just down the Taborstraße, along which stood the theaters and hotels that were home to the Budapester Orpheumgesellschaft and many other Jewish troupes (Dalinger 1998a). The six scenes of the play mixed Yiddish, Viennese German, and bits and pieces from the vernacular discourse of the linguistic microcosm in the Leopoldstadt. The first time the play's signature song is sung, it is clear that for the card players "Klabrias is everything in the world." Better to gamble than to pay for *Barches,* for Sabbath bread, or *challa* (Veigl 1992: 24). The financial reality of card playing and gambling debts, which too had become facts of life in the metropole, were lost on no one, for poverty was personified by the eponymous Simon Dalles, "poverty" and "misery" himself.

The form and familiarity of *Die Klabriaspartie* depended on an aesthetic made possible by the very mobility of fragments. Songs moved into and out of the play as couplets. The relative absence of plot afforded an interchangeability of characters. Stereotype and caricature were hardly subtle, and thus they also generated distance and spawned the mobility that permitted translation to the Jewish stage in Berlin, Budapest, and elsewhere. Distance and proximity played off each other. The characters on the stage both were and were not the spectators in the audience. The play juxtaposed self and other, Jews and non-Jews, Jews "like us" and Jews "like them." So brilliantly did self and other mix in the play's narrative fabric that *Die Klabriaspartie* entered the very history of the modernity it mirrored. In the opacity and familiarity of its songs, the play sustained that history, from the 1880s, when the traveling theatrical troupes such as the Budapester Orpheumgesellschaft and the Herrnfeld Brothers were first arriving from Eastern Europe, until the 1930s, when the Jewish cabarets and theaters of the metropole were staging their final acts and the card players of *Die Klabriaspartie* were dealing their final hand.

JEWISH CABARET—POPULAR MUSIC ON THE
STAGE OF MODERNISM

"Koschere Gstanzeln!"

Heinrich Eisenbach

Die Tanten sein Godl'n	Old ladies are godparents
Die Steyrer die jodl'n	Styrians, they yodel
Die Zigeuner die fiedl'n	Gypsies, they fiddle
Und ich wer jetzt jüdl'n!	And now I'll sing in Jewish jargon!
‖ : Jodler : ‖	‖ : Yodeling : ‖
E Katz is ka Spatz	A cat is no sparrow
Und e Spatz is ka Katz	And a sparrow is no cat
Denn wenn e Spatz wär a Katz	Because if a sparrow were a cat
Wär de Katz doch e Spatz!	The cat would still be a sparrow!
‖ : Jodler : ‖ . . .	‖ : Yodeling : ‖ . . .
Der Jud der e Jud is	The Jew, he's a Jew
Der Jud is e Jud	The Jew is a Jew
Der Jud der ka Jud is	The Jew who's not a Jew
Der Jud is ka Jud!	That Jew is not a Jew!
‖ : Jodler : ‖	‖ : Yodeling : ‖
Ich hätt in der Oper	I should've gone to the opera
Sogar singen soll'n	Even to sing there
Doch hat man mir leider	But instead someone
Die Stimmbänder g'stohl'n.	Stole my vocal cords.
‖ : Jodler : ‖ . . .	‖ : Yodeling : ‖ . . .
Mei' Schwester spielt Zither	My sister plays the zither
Mei' Bruder Clar'nett	My brother clarinet
Und ich spiel mit Schickses	And I play with the goyish girls
Aber was sag ich net.	But that I'll not admit.
‖ : Jodler : ‖ . . .	‖ : Yodeling : ‖ . . .
Doch jetzt hör ich auf	Now, I'll come to the end
Denn die Gestanzerln sein aus	For the stanzas are over
Denn sonst geht am End' noch	Otherwise, I'll not reach the end
Die Gall Ihne 'raus!	Until you've lost your patience!
‖ : Jodler : ‖	‖ : Yodeling : ‖

There can be no question that Jewish popular music was music for the stage, and it is from its position on the stage that it mirrored the transformations wrought

by modernity. The public performance of Jewish music led to the emergence of new kinds of spectatorship. The public and the popular intersected in increasingly complex ways. The most popular of all stages for Jewish popular music was the cabaret. Throughout the following sections I refer to the cabaret using both general and specific terms, as Jewish cabaret or simply as cabaret. The general and the specific overlap, for the Jewish contribution to the cabaret tradition in European popular music was fundamental to how the cabaret came into existence as the soft underbelly of modernism. In the beginning, however, it was cabaret that opened a new space for the critical encounter between urban Jews and the modernity of the metropole.

The popularity of broadsides was predicated on the very possibility that Jewish music could find its way beyond the Jewish neighborhood and into the public sphere of the metropole. Entry into the public sphere, as we witnessed from the texts of the songs themselves (see chapter 7), was not without its risks. To minimize those risks, the creators of popular song turned to a liminal space, the stage. The importance of the stage as a space of transition was not left to chance. We see it in the printed images at the heads of the broadsides, in which the main characters in the songs stand on the stage, lest we forget that they are caricatures (chapter 7). The *Gestanzel* (literally, stanza) unfolded as a chain of verses, improvised so that stereotyped images would fly by, catching the listener's attention because they were so ridiculous and nasty. A tradition from rural Austria, the Gestanzel found a modern home in the cabaret, where some of them, such as the "Kosher Gestanzel" by the early star of the Budapester Orpheumgesellschaft, Heinrich Eisenbach, seemingly and seamlessly fitted the patter common to the Jewish cabaret stage. Eliminating the stereotype in such popular genres would eliminate the genre itself.

The stages for Jewish popular music fell into two distinctive domains. The first was characterized by more traditional forms of Jewish music, transformed however through professional performance. In the more traditional venues at the city's peripheries or immigrant neighborhoods Jews performed for Jews largely within the Jewish community. The second shifted the site of performance to the boundaries between Jewish and non-Jewish communities, hence between private and public spheres. Characterizing the first type of new stage was Yiddish musical theater and operetta. Theatrical troupes and tunesmiths would move to a part of the metropole that had a growing Jewish population, such as Vienna's Leopoldstadt or New York City's Lower East Side, and there they would set up shop to produce musical works for a common culture and a common language, Yiddish (see Dalinger 1998a). It would be too simple to say that the popular music on the first type of stage was more Jewish than that on the second. In both cases, music itself underwent a process of metaphysical emancipation, in which it was no longer tied to religious or social function. The most common prototype and theme for the Yiddish theater was the *purimshpil* (Yiddish, Purim play). Yiddish musical theater relied on biblical allegories and the popularization of biblical themes, but these were often mixed with modern themes, such as the secularization of tradition or immigration to the New World. Yiddish theater pieces represented immigration within Europe and emigration from Europe. The very mobility of theatrical troupes, moreover, meant

that many actors were acting out the themes of immigration and emigration from their own lives.

The music of the second type of stage reflected issues of Jewishness by drawing upon music in different ways. Rather than taking traditional music as its source, it relied on folk and folklike musics (*volkstümliche Musik*), on couplet and parody repertories, and, not surprisingly, on the hits from well-known operettas. Jewish themes were layered on top of these, often transforming them and making them "Jewish." The two versions of Gustav Pick's "Wiener Fiakerlied" with which chapter 7 begins illustrate the process of making a popular song without specifically Jewish associations—though indeed Pick was himself Jewish—into a song that symbolized Jewish social mobility.

Using the term "stage" to designate this site of transformation juxtaposes both literal and metaphorical meanings. Performance of most popular genres literally required a stage. Couplets, Yiddish theater songs, and broadsides became famous in part when singers and publishers could make direct associations with the stage. Singers too were often professionally engaged as actors, known by their stage names to an admiring public. Publications of the songs—as broadsides hawked on the street or as sheet music—depicted performances taking place on a stage, complete with footlights, curtains, and backdrop. The inscription of the stage in the music itself was metaphorically significant because it signaled the practices of spectatorship unleashed by Jewish popular music. The audiences witnessed a Jewish music that was separated from religious or social function, and in which an ontological wedge was consciously pushed between "Jewish" and "song" (Bohlman 1994; Bohlman 2003).

Among the Viennese Jewish intellectuals and writers who most publicly drew attention to the crisis of tradition and modernity by turning to the stage was Karl Kraus (1874–1936). Best known as the author of the literary journal *Die Fackel* (The Torch), Kraus experimented with many different genres of writing, and he was acutely interested in exploring the fissures between oral and written tradition. In 1916, during World War I, he began to organize performances he called public readings (*Vorlesungen*). The settings resembled cabaret in many ways. Kraus might read scenes from Shakespeare or from his own critical texts. He juxtaposed poetry and satire. And increasingly by the mid-1920s, during which time the public readings moved into the chamber music hall of the Vienna Musikverein, Kraus wove songs and arias from operettas and popular stage works into his evenings, thus unabashedly turning the evenings into cabaret-like performances (for complete texts of plays, with musical arrangements of the couplets within them, see Kraus 1992: 83–195; cf. Kraus 1996).

The popular Jewish stage became a site of emancipation for the music itself. That emancipation and the popularity associated with it also extended to the music of the synagogue at the end of the nineteenth century, the era when Jewish cantors became famous for their voices, taking center stage, often with lavish robes, but with increasingly lavish performances. It was hardly surprising that more than a few great cantors of the era, such as Yosele Rosenblatt (e.g., in *The Jazz Singer*), enjoyed fame as singers of cantorial and popular repertories (see Bohlman 1994).

Musicians and actors collaborated to perform Jewish popular music long before the time for which we have specific records of their identities. Among the first musicians were no doubt the forerunners of klezmer musicians, and chief among the actors were probably the traditional wedding and festival merrymakers (*badkhanim;* sing., *badkhan*). Both klezmorim and badkhanim were professionals at least as early as the seventeenth century, and as professionals they moved from community to community, negotiating the boundaries between the private and public spheres. The first popular musicians to whom visibility and even fame accrued began their careers as traditional performers in Eastern Europe and then succeeded in winning over audiences in Central Europe in the mid-nineteenth century. The Broder Sänger (Brody Singers) were a troupe from Brody, in Galicia, whose milieu was the café and the inn, but in the mid-nineteenth century they took their skits and songs on the road to Poland, Romania, and Russia (Dalinger 1998a). Until the 1860s, they were the model for all aspiring Jewish popular musicians and actors. From the 1860s until the end of the nineteenth century that mantle was taken over by the Brothers Herrnfeld, a theatrical troupe with origins in Budapest, who extended their tours increasingly into East Central and Central Europe. In the early 1880s the repertories of the Brothers Herrnfeld were so well known that they were gathered in 1888 as an anthology, which today remains one of the earliest surviving publications of Yiddish songs (see Dalman 1891). When they settled in Berlin soon thereafter, they would turn from Yiddish songs to *Jargon* (dialect) theater, casting authenticity aside and replacing it with caricature and set pieces for the stage (Sprengel 1997: 90–93).

Jewish popular musicians were mobile, traveling especially from the provinces to the metropole, and therefore it was the newly forming outer districts that became the entrepôt for the musicians who transformed the traditional and provincial into the modern and urban. Theaters and dance halls of all kinds sprouted up on the outskirts of European cities in the second half of the nineteenth century, serving particularly the entertainment needs of a new bourgeoisie, within which the growing Jewish middle and upper-middle classes were increasingly visible. The suburban theaters were home to the couplet, a genre of popular song characterized by its mobility and flexibility. Singers could take couplets with them, inserting them into just about any skit and making a few quick adjustments so they would appeal to any audience.

The Jewish cabaret formed at the convergence of a musical tradition based on couplet-singing and a theatrical tradition arriving with theater troupes from Eastern Europe. The first Jewish cabaret troupe to win widespread popularity in Vienna was the Budapester Orpheumgesellschaft, which traced its origins to Budapest, from which its founders, M. B. Lautzky and Josef Modl, had come after first enjoying success in Budapest's numerous popular theaters, or "Orpheums." The cabaret embodied many different genres of popular song and entertainment. Music, because of its capacity to bear multiple meanings—its semiotic slipperiness—enhanced the genres of Jewish popular song, allowing for the formation of cabarets that served specific constituencies. The distinction between themes and genres in Jewish cabarets that were political and those that were socialist or even Zionist proved not to be very great at all. For these reasons, the cabaret attracted Jewish writers, critics,

intellectuals, and musicians such as Karl Kraus, Kurt Weill, Hanns Eisler, and Arnold Schoenberg.

Just as Jewish couplets negotiated a space between folk and popular traditions, so too did they depend not only on the growing presence of Jews as Viennese musicians and musical consumers but also on the reaction of non-Jews to a growing Jewish population (see the essays in Botstein and Hanak 2003). Jewish couplets were often about the relation between Jews and non-Jews and about the dynamic shaping of the modern city that this relation engendered. The epicenter of the Jewish cabaret scene in Vienna was its Second District, or Leopoldstadt, the very urban geography of which facilitated the burgeoning presence of the popular Jewish stage. The Leopoldstadt's main streets radiated out from the Vienna North Train Station, the point of disembarking for immigrant Jews, but also for Czechs, Slovaks, Poles, and Ukrainians (see Beckermann 1984). The Second District was the center of popular entertainment in the fin-de-siècle metropole, the Prater. The architecture of popular culture in the Second District provided a geographical counterpart to the monumental architecture of government and power that circumscribed the First District with the Ringstraße (Schorske 1980: 24–115).

The cabaret had a seductive attraction for diverse audiences, but also for modernist composers such as Arnold Schoenberg, who composed several sets of songs for the "Überbrettl" cabaret, at which he played. Jewish cabaret survived World War I and even throve into the 1920s and 1930s, when it proliferated and assumed new forms, especially political and socialist cabaret. For Jewish cabaret performers in Vienna it was only a short distance from the socialist cabaret to the Marxist cabaret and, following a different trajectory, to Zionist cabaret. Hanns Eisler, Bertolt Brecht, and Kurt Weill all recognized the expressive opportunities that such cabarets opened for their political songs. More tragically, it was also but a short distance from Jewish cabaret to the cabaret of the Holocaust, such as the cabaret in the Jewish ghettos of Poland or in the concentration camps (see Migdal 1986; *Der letzte Schmetterling* 1992; Schumann 1997). Jewish cabaret survived the Holocaust, sometimes through a genealogy of performers who lived in exile, such as Gerhard Bronner, who composed covers for songs such as the "Love Song to the Proletarian Girl" (see chapter 7), sometimes in the revived cabaret scenes of European urban centers, but more commonly in other forms of the musical stage, be they vaudeville, Tin Pan Alley, or the modern genres of the musical whose genealogy began with Yiddish theater and the Jewish cabaret.

Detached from the functions of folk song and of life in Eastern Europe, Jewish popular music claimed no single music culture of its own but rather it led to the formation of a network that in turn served to connect the most disparate sectors of an emerging European culture of modernity. It was a network of poets and tunesmiths, musicians and actors, printers and engravers, cabaret troupes and elite literati, who together found that popular music provided an outlet for their creativity. That network formed a distinctive dramatis personae for Jewish stage music during the half century of musical modernism prior to the Holocaust. The dramatis personae, sometimes a motley troupe, has sustained its performances on the larger stage of modern history, and as we engage ourselves with music for the Jewish stage, so too do we stand to engage ourselves with that history.

JEWISH THEATER

Prologue

GOD: Quiet! Adam, I'm sending you down there to Vienna,
and there you've got a job to do. First, buy your wife some nice
lotions and cremes, and second, write a revue for the "Jüdisches
Künstlerkabarett."

—Prologue in Abisch Meisels's *Fun Sechisstow
bis Amerika* [1927], in Meisels 2000: 32

With the voice of God ringing in their ears, the audience at the opening of
Abisch Meisels's *From Sechistów to America* on February 3, 1927, sat back to
enjoy a Yiddish revue that would quickly become one of the hits of the inter-
war period. In slightly less than three months, that is, until April 25, 1927, there
would be 23 performances of the play, many greeted by glowing press reviews.
Already in earlier performances the reasons for its success would be clear. *From
Sechistów to America* was a full-length play, which was to some degree excep-
tional, for Yiddish, as well as German-language and Yiddish dialect theater, was
slow to find its way to the stages of the Leopoldstadt in full performances. On
one hand there had long been agreements and accompanying legal restrictions
whereby a theater troupe was granted the right to use the stage of a hotel or
theater only if it would present a potpourri of skits, songs, and other brief acts.
On the other hand the success of Jewish theater had depended on the ways in
which scenes and songs could be shuttled from one performance to the next,
one stage to another.

Meisels's play struck a compromise, one that brilliantly addressed the expecta-
tions of his audiences. He too would craft a text constructed of movable scenes and
songs, but he would strike a balance between the fragments available for a varieté
and a narrative that would speak to his audiences with familiarity. Meisels was per-
fectly suited to accomplish just this goal, because he was one of them, a Galician
Jew born in 1893 in the eastern part of the Austro-Hungarian Empire and raised
in a cantor's family. He had immigrated to Vienna just prior to World War I after
apprenticeship in Czernowitz as a watchmaker. In Vienna he found his way to the
stage, and already in 1916 he saw one of his stage works performed at the Wiener
Jüdisches Theater. Active in the theatrical life of the Leopoldstadt, he learned the
stock repertory and acquired the necessary skills to mix and remix it for the differ-
ent Jewish stages of the metropole.

The story of *From Sechistów to America* was also familiar to the audiences of the
Jüdisches Künstlerkabarett (Jewish Artists' Cabaret), one of Vienna's most impor-
tant theaters, located on the Prater Street. According to the plot, a family from the
Galician shtetl learns of an inheritance that it will receive from American relatives,
but only if they travel to America to receive it. The journey takes them through
Vienna, where they sojourn longer than expected, thereby making the play far
more about Jewish culture in Vienna than that in Galicia or America. In the better-
known version of the play—two were regularly performed, the second called *Off
to Tel Aviv*—the family arrives in America and receives its inheritance, which turns

out to be much smaller than they were led to believe. The setting of the final scene in the second version can be devised from the version's title: The riches in the Yishuv, in comparison with those in America, would be of a different order.

The survival of two versions does not necessarily point toward two distinct audiences, one more Zionist than the other. *From Sechistów to America* is a Yiddish play about possibilities, literally and figuratively, the various choices open to Jews in the Austrian-Hungarian Empire in the wake of its collapse. The play itself may chart one or two larger historical paths, but the success of the play itself, clearly designated as a "revue," depended far more on the frequent detours from which the actors are asked to choose. Travel itself assumes many forms, from carts to railroads to journeys by foot with the "Eternal Jew," one of the characters in the play, whose companion turns out to play a role called "Time." The play's scenes are movable, but thematically they are fixed in content if not in order.

The most variable element in the review is the music, which functioned to announce the many narrative detours in the plot and to resolve them. The music—a collection of couplets, ensembles pieces, Wienerlieder, and Yiddish folk songs—provided the tissue connecting *From Sechistów to America* with other theaters and theatrical traditions. In more instances than not, the performance instructions left by Meisels in the script do not make it clear exactly what song would have been sung at a given moment. What is clear is that his actors and audiences knew exactly what to perform and expect at the moment. Whereas the text of the revue, which survives in both versions at the YIVO Institute for Jewish Research in New York City, employs a type of standard Yiddish used for the Yiddish press, and therefore not literary Yiddish, the music entered the play from oral tradition. Accordingly, *From Sechistów to America* at once becomes cabaret and play, varieté and theatrical allegory. Its appeal relies on familiarity with stage works and traditions that had preceded it, and for some of those responding to it, the revue provocatively pointed toward genres just breaking through into the public sphere, especially the filming of Yiddish theater and musicals. A revue that appeared during a moment of transition, *From Sechistów to America* consciously staged the transition through its diverse, even contradictory, performances.

Setting the Scene

It was on the stage of the Jewish theater that Jews witnessed the comedy and conflict mirrored in their own encounter with modernity. The plays, skits, and musicals that multiplied in the Jewish theaters of the metropole in the late nineteenth century revealed a new willingness to present the otherness of self in the public sphere, first in theaters that were located in the rapidly growing Jewish quarters, but by the turn of the twentieth century on stages that themselves had migrated to the very center of the city. The benefactor of a long tradition of theater, the modern Jewish stage nonetheless underwent a transformation of massive proportions when relocated to the city. The dramatis personae of stock characters multiplied, as did the availability of actors and singers capable of playing those characters. The repertory of stock scenes, skits, and satires underwent a process of cross-fertilization, proliferating and procreating as totally new genres of theater. Traditional music too gave

way to cosmopolitan repertories. All of this took place at a moment during which the myths of the past were recast and played out as modern Jewish history.

The languages of Jewish theater, literally and figuratively, were crucial to the forms theater took in the metropole. There were two ways to render spoken language Jewish and to allow it to attract Jewish audiences from across the social spectrum of the cosmopolitan immigrant community: staging plays in Yiddish or staging them in Jargon, that is, dialect. These two ways charted different roads toward modern Jewish identities. Yiddish theater was itself more of an import tradition, arriving from Eastern Europe with Yiddish-language theatrical troupes, some, like the Broder Sänger, who had been arriving in the cities of Central Europe since the mid-nineteenth century. Yiddish theater was by no means always dramatic or serious, but it did not rely extensively on comedy. Its subject matter was close to home and familiar for the Yiddish-speaking audiences. Biblical themes and characters, often dressed in modern clothing, were common. The breakdown of traditional life, especially in the shtetl of Eastern Europe and in the immigrant family, was present in one way or another in most Yiddish plays. Larger forms, both theatrically and musically, reflected the extent to which Yiddish theater had paralleled the emergence of classical Yiddish literature. From the moment it appeared in the metropole, Yiddish theater included operetta, especially the works Abraham Goldfaden and the playwrights and composers he influenced. Jewish audiences could and did aspire to the Jewishness that framed the plays and operettas of Yiddish theater.

Jargon theater employed spoken and musical languages in quite different ways. Jargon was an artificial language, created for comic songs and comedy on the stage. In the everyday world, the Jargon of the stage was no one's vernacular, which meant that on the stage it could effectively serve as the vernacular for the Jewish other: It was "their" language, not "ours." The Jargon of skits and songs achieved its meanings by being circulated through written traditions. Because of the ways it provided a template for inscribing the language, the broadside served as the first musical setting for Jargon, and in the context of the broadside Jargon drew upon melodic patterns to fix public meanings of Jewishness. These meanings, in turn, accompanied the characters in the broadsides to the musical stage, where they spoke the languages that had been artificially affixed to the pages of songs circulating about the urban streets. The creators of Jargon theater were little interested in serious drama, and the overwhelming majority of their plays were comedies, many of them funny precisely because of the linguistic playfulness they permitted and encouraged. Just as Jargon was a language artificially manufactured from fragments—words and phrases that drew attention to themselves because they did not fit into normal discourse—so too did Jargon theater provide the ideal setting for musical forms built from fragments, the potpourris and couplets that throve on improvisation and variation. The Jewishness of Jargon theater sent mixed messages, some insulting and aggravating, others so ridiculous as to be unbelievable. The stage of Jargon theater contained a backdrop for Jewish otherness, exposed for the ways it failed to respond to modernity.

The distinctiveness of Jewish theater traditions is evident even in the general patterns of theater history in Berlin and Vienna. Jewish theater in the metropolitan capital of the German Empire appeared on the scene in the 1880s, already cut

from relatively whole cloth. With the consolidation of the empire in 1871, Berlin itself quickly became a cultural magnet, and its artistic and economic enterprises attracted an enormous population from the peripheries of the empire to the center. Jewish theater did not develop first in the outer areas of Berlin, the villages that were quickly becoming suburbs, but rather it quickly established itself near the center of the city in the liminal zone between the Scheunenviertel, home to immigrant Jews, and the Alexanderplatz, symbolically the cultural center. The first Jewish theaters came into view because they occupied substantial, sometimes even quite elegant, buildings in this zone, especially along Alexander Street. The designs and blueprints for the theaters of Quarg's Vaudeville-Theater (Sprengel 1997: 15–16) and the Herrnfeldtheater (Sprengel 1997: 54) depict elaborate structures with inner courtyards, roof gardens, and ample seating. Such theaters may have depended on Jargon productions, the songs of which circulated on broadsides, but they drew heavily on visiting troupes, blockbuster shows of Yiddish operetta, especially those by Abraham Goldfaden and other Romanian and Ukrainian composers, several of whom (e.g., Josef Weinstock) took up residence in Berlin. The centralization of Jewish theater in Berlin produced a history with many ironies. The proximity to the center of the city exposed the Jewishness of the productions (e.g., through the use of Hebrew characters in playbills announcing Yiddish operettas) to official criticism and sanction. That same proximity would later play a role after 1933 as Berlin's Jewish theaters provided a core for the theatrical and musical life of the Jüdischer Kulturbund.

The Jewish theatrical scene in Vienna contrasted in as many ways as possible. Vienna's Jewish quarters provided venues for the *Kleinkunst* (glossed as the art of the miniature). Jewish theater in Vienna appeared first at roughly the same time as that in Berlin—the Budapester Orpheumgesellschaft was established as a permanent ensemble in 1889—but the tendency toward large halls with elaborate performance facilities never really took root. Cabaret troupes moved from hotel to hotel, from stage to stage. Varieté companies shuttled between the Prater entertainment park in the summer season and the coffee houses and taverns along the Prater Street in the off-season. The mobility of Jewish theater in Vienna reflected the complex directions of mobility for the metropole's Jews. Eastern European and Yiddish-speaking immigrants settled into the working and service classes. There were others, among them musical professionals, for whom Vienna was a way station, for shorter or longer periods, on an immigration to the west, especially to the United States. For still others, mobility meant social and musical mobility in Vienna itself, the career trajectories of Gustav Mahler or Heinrich Schenker, for instance. Jewish life in fin-de-siècle Vienna reflected the multicultural mix of an empire and an era in rapid transition, and it is hardly surprising that the transition found its way frequently to the Jewish stage (Botstein and Hanak 2003).

Intermezzi

The Jewish stage of the late nineteenth and early twentieth century was unimaginable without music. Music serves a complex medium for inventing modern Jewish theater itself. Music was called upon to play many different roles in a theatrical

production. In its most limited presence, it filled the spaces before, between, and after individual scenes or skits, keeping the audience occupied and entertained. Minimally, a piano and a pianist were necessary for this role, but even when music was sparsely used, it additionally relied on actors and singers willing to perform during the intermezzi. The pianist might also have appeared on stage, but he or she was also responsible for arranging the songs and the music for the skits and scenes so that there was sufficient repertory. The pianist contributed to the theater also as a musical director, a position that demanded basic knowledge of compositional techniques and considerable skill as an arranger and improviser.

During the heyday of Jewish theater in the Jewish metropoles of Europe a pianist and a singer rarely sufficed. Theaters that hoped to attract the largest audiences and to do so repeatedly engaged an instrumental ensemble, which were abundant in the neighborhoods in which Jewish theater thrived. Generically, such ensembles were known as *Salonorchester* (salon orchestras) or *Salonkapellen* (salon bands), and they played in the cafés, dance halls, and entertainment establishments throughout the Leopoldstadt in Vienna or the Scheunenviertel in Berlin. The instrumentation of such ensembles varied according to where they played and which genres they accompanied (for a contemporary's description of the musical tradition of which he was a part, see Koller 1931).

Already during the first decade of the Budapest Orpheumgesellschaft's residence in the hotels around the Prater in Vienna, its salon orchestra included eight to ten musicians: at least three violins, a bass violin, a harmonium, a flute, and percussion, but usually with an additional stringed instrument and a few extra wind instruments (Wacks 2002: 141). Less commonly, but by no means rarely, Jewish theaters employed choruses, perhaps with a half dozen male and female voices, especially when they produced multi-act Singspiels or operettas. Larger ensembles were increasingly engaged as the major theater companies expanded, which made it possible to attract traveling companies such as the Eastern European ensembles that would perform Abraham Goldfaden's Yiddish operettas, or works by Viennese and Budapest operetta composers, Jewish and non-Jewish (Sprengel 1997: 23–26; Wacks 2002: 142–43).

The most successful theater companies were able to support their own house bands, but even within these, membership and instrumentation were fluid, and the director of a Salonkapelle was responsible for making sure that the ensemble fitted the performance, whether it was a loose collection of skits and Wienerlieder or a full-fledged operetta. Many musicians were journeymen, albeit within urban and cosmopolitan contexts. This was the case with Maurus Knapp of Kittsee along the Austrian, Hungarian, and Slovak border, who performed locally at weddings and other events in Burgenland's Jewish villages (see chapter 1) but strove to make his musical career in Vienna playing entertainment music.

A substantial aura of musical specialization surrounded Jewish theater musicians and accounted for the fame achieved by the best musicians. Some specialties derived from theatrical roles—comic versus romantic roles, dance acts versus acrobatics—and others derived from musical genres and repertories—couplets versus Wienerlieder, comic songs versus Singspiel arias. It is possible to gain some sense of the various roles by looking at the playbills of the time. The following dramatis

personae appeared on an advertisement for a "family program" by the Herrnfeld Brothers in Berlin's Parodie-Theater in the early 1890s (Sprengel 1997: 49):

Clara Herrnfeld—Actress
Mr. Adolphi-Sollé—Singer of waltzes and songs
Bertha Bertholdi—Original Viennese couplet singer
Egon Hauthong—Comedian, singing and playing character roles
Ella Herrnfeld—Actress
Mr. S. Sobosj—Composer and imitator
Clara Birkholtz—"Costume maid"
Herrnfeld Brothers—Salon humorists
Jolan Kowatz—International singer
Max Lützow—Orchestra director

If the musicians and actors were not able to do it all, they were able to do a little of everything, in some cases a lot of everything. Whether hired because of an ability to speak rapidly in various accents, dialects, or languages—a prerequisite for Jargon theater—actors also had to sing. The musicians, whether composers, arrangers, or instrumentalists, had occasion to take to the stage and demonstrat ᵖrowess as actors. The musical demands were considerable, for Jewish theater enjoyed success only as long as its shows were fresh and its set-pieces continued to attract curiosity through the insertion of new scenes and the variations possible because of improvisation. Posters and playbills again reveal the welter of programs produced by the Jewish theater troupes. During the summer season of 1906, when the Budapester Orpheumgesellschaft played at the Tivoli Theater in the Prater amusement park, for example, each evening contained two separate satires played by the troupe, with solo performances inserted throughout: During the course of the week there were fourteen "original satires," including *Die Klabriaspartie* (Wacks 2002: 178).

Monday:	*Der Sherlock Holmes von Wien*
	Der Fall Windl
Tuesday:	*Die getrennte Gattin*
	Zur Hebung der Sittlichkeit
Wednesday:	*Der blaue Fleck*
	In der großen Garnison
Thursday:	*Eine pikante Erfindung*
	Herkulestropfen
Friday:	*Das Wunderkind*
	Eine Juxheirat
Saturday:	*Eine Parthie Klabrias*
	Der Hoteleinsturz
Sunday:	*Attermiether*
	Budapest bei Nacht

In the heyday of Vienna's Budapester Orpheumgesellschaft, new programs were created as often as every two weeks. A new program required writers capable of turning out new scenes and arrangers adept at working up covers for popular songs. Most received some monetary compensation for their efforts, but for the most part payments for new skits and songs brought little extra money. Accordingly, the most successful musicians worked quickly, turning out new works at the feverish pace that most audiences expected of Jewish theater.

The demands on theater musicians notwithstanding, there were also positive facets that attracted some of the best musicians and actors of cosmopolitan Central and East Central Europe. The traces of the best actors of the day survive on early recordings, which, while not abundant, reveal a remarkable range of talent and nuance. The most notable members of troupes such as the Budapester Orpheumgesellschaft—Heinrich Eisenbach, Hans Moser, Armin Berg, and others—directly and indirectly influenced the subsequent generation, many of whom apprenticed with them—Karl Farkas, Fritz Grünbaum, and Gerhard Bronner, to name some of the most famous (Georg Wacks discusses many of the early recordings that have been rereleased on CD in Wacks 2002; among the CDs on which recordings of the subsequent generation are available are *Kabarett aus Wien* 1991; *Viennese Instrumental Music* 1994; and *Populäre jüdische Künstler* 2001). The next section presents brief case studies of three of the most notable of these musicians.

Dramatis personae

Arnold Schoenberg. As he approached the watershed that would lead him to extend the tonality of his earliest compositions, Arnold Schoenberg (1874–1951) found himself pulled to the popular stage and its music. Initially, cabaret attracted Schoenberg not so much because of the ways popular music subverted the prevailing social hierarchies of the day, but rather because of the modernist potential of the young poets associated with the Literary Cabaret in Berlin. Schoenberg's initial explorations of cabaret began in 1900, while he was still in Vienna and received a collection of poems by Berlin poets, the *Deutsche Chansons,* or *Brettl-Lieder* (literally, songs for the *Brettl,* or little boards, which in the context of cabaret suggests something like "taking to the boards"). The Literary Cabaret did not primarily attempt to create a new popular stage for its poetry, but rather it turned to popular culture to inspire a new literary movement. Schoenberg experimented with the *Brettl-Lieder* as a means of exploring the performative and aesthetic space opened by the cabaret, a space that quickly acquired biographical meaning for his own life.

Probably within months of receiving the texts of the *Brettl-Lieder,* Schoenberg began to compose settings of them for piano and voice. The songs appeared during 1901 in quick succession, at first probably not intended for a single group or collection, but by the end of the year the seven songs for voice and piano known as *Brettl-Lieder* were probably complete. Several are undated, suggesting that Schoenberg was more concerned with performance than publication at the time. A few of the songs surely found their way to the popular stage quickly. The "Arie aus dem Spiegel von Arcadien" (Aria from the Mirror of Arcadia), to a text by Emanuel Schikaneder, for

example, was initially included in the repertory for the "Jung-Wiener Theater zum lieben Augustin" (Young Viennese Theater of Dear Augustine).

It was not by chance that Schoenberg met Ernst von Wolzogen, director of the Berlin cabaret company Überbrettl when it was touring Vienna in September 1901. Serving as music director of the Überbrettl at the time was one of Vienna's outstanding cabaret composers, the young Oscar Straus, who managed by the end of 1901 to secure a position for Schoenberg as *Kapellmeister* (director of the ensemble). Schoenberg followed the company to Berlin, where he remained—as a cabaret performer—until 1903. Throughout his life the Vienna-Berlin axis would prove to be one of the routes traveled by Schoenberg as he sought increasingly modernist directions for his music. That he first charted that route as a theater musician might well have left a greater impact than hitherto recognized on what modernism came to mean for the composer.

Robert Stolz. At the turn of the twentieth century, as the German and Austro-Hungarian empires began the slow waltz of their decline, the boundaries between cabaret and operetta began to blur. The two theatrical traditions historically had much in common, not least in their reliance on stereotype and stylized performance (Czáky 1996). Both relied on a mixture of genres, shorter spoken scenes, and set musical pieces. Operetta, however, employed narrative in distinctive ways, extending the stories in individual scenes in such a way that the operetta as a whole could tell a relatively unified story. Composers, arrangers, and writers for the cabaret stage often strove to achieve the larger unity of a single operetta, especially during the waning years of imperial Central Europe, when the musical resources at their disposal were increasing.

Robert Stolz (1880–1975), one of the most influential figures of Viennese operetta in the post-Strauss era, entered the scene of Jewish cabaret and Jewish theater at the moment of its transition during the decline of empire, and his move to the Budapester Orpheumgesellschaft during World War I provides an occasion to examine the shifting boundaries of Jewish stage music at that time. Stolz was not Jewish, and his musical background resembled almost not at all that of the other Budapesters and most Jewish theater musicians. Born in Graz, the son of well-known musicians, Stolz received the best music education possible in both Vienna and Berlin. He began his career conducting at provincial houses in the Austro-Hungarian Empire, first in Maribor (Slovenia) and then in Brno (Moravia). During the first decade of the twentieth century he began to focus his own compositional activities on operetta, and by 1907 he had assumed the post of music director at the Theater an der Wien in Vienna.

Stolz's career would seem to have nothing to do with the Jewish musical stage, but during World War I he found a favorable home with the Budapester Orpheumgesellschaft. It might well be that his earliest activities with the Budapesters were a sort of moonlighting during the early years of the war—he directed the première of his *Die anständige Frau* (The Dependable Wife) in 1916, and in the same year he composed "oriental foxtrots" to be inserted in Otto Hein's *Salome* (Wacks 2002: 232)—but the collaboration between operetta composer and Jewish cabaret troupe intensified with each year of the war. In 1918 the Budapesters premièred three new Stolz operettas, and he directed the first performances of several other works.

Despite the pressures of World War I on the actors and musicians in the Buda-pester Orpheumgesellschaft—a number entered military service—the cabaret com-pany weathered the war years, and there can be little doubt that the transformed scale of productions and the collaboration with musicians outside the Leopoldstadt theatrical circuit accounted for survival. Works with larger forms, such as operetta, had also left less room for the Budapesters' stock-in-trade, the farces and one-actors, as well as for other entertainment acts, and the company's fare by 1919 bore little re-semblance to the prewar repertory. From May 18 to June 17, 1919, the Budapester Orpheumgesellschaft performed its last productions, a double bill including Robert Stolz's *Der Kerzenfabrikant* (The Candle Manufacturer) and Alexander Tretitsch's *Familie Rosenstein* (The Rosenstein Family); on June 18, 1919, the Cabaret "Hölle" (Hell) took to the boards on which the Budapesters had played the night before, and after this date the troupe never again appeared as the Budapester Orpheumge-sellschaft (Wacks 2002: 236).

Robert Stolz as one of the dramatis personae of Jewish musical theater is both a symptom and a symbol. His active presence in the best-known Jewish cabaret of the day reveals the degree to which the boundaries between the Jewish community and the public sphere had become permeable. Performing for and premièring his newest operettas with the Budapester Orpheumgesellschaft was for Robert Stolz not a matter of slumming. His career as a composer of operetta took off after World War I, and he moved to Berlin in 1924, taking up a position at a Berlin cabaret. It was through the context of Berlin cabaret that he established connections with the growing film industry, which then further afforded him the opportunity to compose his most famous film scores. Eventually, in 1940, Stolz too reached Hol-lywood, where he remained through World War II, returning to Vienna in 1946 and composing for revues and musical films through the remainder of his long life. The history of the musical, the operetta, and film music would surely have been very different if Robert Stolz had not found a welcome home with a Jewish cabaret troupe at one of the most critical stages of his life.

Friedrich Holländer. One of the most celebrated composers of the first generation of film music, Friedrich Holländer (1896–1976) began his creative career moving from one theater and cabaret to the next, acquiring the musical malleability that would serve him throughout his career. The son of the operetta and satire com-poser, Victor Holländer, Friedrich grew up in a world in which the reality and the fantasy of the musical stage intersected. After early composition studies with Engelbert Humperdinck, Holländer turned to the creation of stage works at the age of 22. He enjoyed success immediately, contributing music to performances by the most notable actors and producers of post–World War I Germany, among them Max Reinhardt and Karl-Heinz Martin. In 1919 Reinhardt enlisted Holländer for his new political cabaret, the "Schall und Rauch" (Sound and Smoke), which be-came the first in a steady of stream of theater-music projects with which Holländer associated himself throughout the Weimar Period until his emigration in 1933.

Characteristic of Holländer's stage works was the remarkable variety of their subject matter and musical style. He collaborated with poets and playwrights whose works were serious political critiques, and he explored the wide-ranging possibilities

of popular song and dance during an age when new media, not least cinema and sound films, were transforming the stage. Both drama and comedy attracted his attention, and he was equally brilliant when composing popular songs made famous by Marlene Dietrich or sound tracks for films directed by Josef von Sternberg (e.g., *Der blaue Engel*, 1930) or in his exile years by Billy Wilder (e.g., *A Foreign Affair*, 1948), also a Jewish exile. In his stage works, Holländer collaborated with Ernst Toller, Else Lasker-Schüler, and Bruno Frank, among others. In his chansons and cabaret songs he collaborated with Walter Mehring and Willy Prager, but he is perhaps best remembered as a song composer through his collaborations with Kurt Tucholsky.

In interwar Germany the theatrical stage provided Holländer with his most important opportunities to experiment with text and style. During the early 1920s he associated himself with a number of different cabaret ensembles and troupes, among them the Weintraubs Syncopaters and Café Größenwahn. He also established his own ensemble, Friedrich Holländer und seine Jazz-Symphoniker (Friedrich Holländer and His Jazz Symphony Orchestra). The mid-1920s witnessed several critical transitions, among them Holländer's concentrated effort to compose entire "Kabarett-Revuen" (cabaret revues), which provided the first step to his work with sound film in the 1930s. Such transitions remained crucial to Holländer's development, the first as the initial stage toward founding Holländer's own cabaret, the "Tingel-Tangel-Theater," a catalyst for realizing his career in Hollywood after exile in 1933. In 1955 Holländer returned to Germany and to intensive work with popular theater, especially the "Kleine Freiheit" (Little Freedom) in Munich. At the beginning of the twenty-first century, Holländer's songs are central to a canon for the revival of German-language cabaret and theater music. The mobility of song genres and the malleability of his compositional techniques serve revival in the present no less than they paved the way from the Jewish stage to the film music so crucial for the transformation of Jewish musical modernism in the 1920s and 1930s.

THE MUSICAL FILM AS FRAME FOR
TRADITION AND MODERNITY

Musical theater at the end of modern Jewish music history reached both its climax and denouement with the advent of the film musical. The early history of the film musical and its importance for the Broadway stage and Hollywood film musical are well-known, especially the seminal position of films such as *The Jazz Singer* (1927), the first sound film. What is important to recount at this point is not just the Jewish context of *The Jazz Singer*, but also the thematic presence of music as the site for the conflict between tradition and modernity. The musical paths opened for the character of Jakie in the film lead him into the traditional Jewish community or into the public sphere, where modern music, jazz, is all the rage. For this brief excursus into Jewish musical film, moreover, the crucial lesson of *The Jazz Singer* is that it does not stand out as exceptional. It uses music, narrative, and the stage in ways that connect it to the Jewish theatrical genres that preceded it and the Jewish films that followed it into a golden age of Jewish musical film-making that lasted until 1938.

The musical genres of the Jewish stage underwent the transition to Jewish musical films almost seamlessly. The plots of films relied on potpourri and pastiche, which is to say, the same stock of characters and musical genres as for the theaters of the metropole. The narrative topoï were familiar to the audiences: the challenge to family life, the breakup of the traditional shtetl, the escape from poverty in Eastern Europe and the journey to the West, immigration to the promised land, either the United States or the Yishuv. Many films unfold as plays on the stages of Berlin, Vienna, or Kraków. Broadsides and couplets alternate, as do love songs and choral ensembles. Tradition relies on its characteristic genres, especially hassidic *niggunim* (textless melodies) and biblical cantillation, and modernity seduces the listener with hit songs and the display of a star singer's successes.

By the late 1930s, Jewish film had fully traditionalized the Jewish stage within the modern medium of sound film. Perhaps no other film reveals this phenomenon quite so unequivocally as Joseph Green's 1938 *A Brivele der Mamen* (A Letter to Mother). With a screenplay by Mendel Osherwitz and music by Abe Ellstein, *A Brivele der Mamen* takes as its narrative source the most widespread genre of broadside song from the nineteenth and twentieth centuries: the song in which the mother, abandoned by her family members who are in search of modernity, longs for the letter that will metaphorically reunite the family in tradition. Not only does the broadside itself provide a title and a persistent refrain at each moment of tragedy in the film, but performance of the song at the end of the film provides the moment of recognition, the recovery of selfness when mother and son discover each other after years of separation through immigration.

The story of *A Brivele der Mamen* resembles that of Abisch Meisels's *From Sechistów to America* and *Dem Hazzns Kindl* (The Cantor's Child), as well as countless plays and operas for the Yiddish stage. The journey from the shtetl to the metropole follows numerous routes, but ultimately it is the journey from the past to the present. Neither tradition nor modernity provides all the answers to the dilemma of the Jewish family in modern Europe. For those left behind in the village, conditions steadily worsen. For Dobrish, the eponymous mother of *A Brivele der Mamen,* it is necessary to watch her two older children disappear into modern Europe; her daughter marries and resettles in Odessa, while her older son becomes a soldier for the Austro-Hungarian army and dies a hero during World War I. These characters were, however, stereotyped roles, as are the comic roles of the tailor and his wife, who provide stability even as they act out ridiculous set pieces in the film. In the end it is music that brings everything together: the narrative, the different paths of Jewish immigrants, the conflicts between tradition and modernity. The film stages its own moment of resolution, the performance of the most familiar song in the Jewish broadside tradition, sung by the long-lost younger son, Arele, under the stage name Irving Bird, in a theatrical context that no viewer in 1938 would fail to understand as the staging of selfness.

On the Jewish popular stage, musicals are often about musicals, in other words about the making of music itself and the ways in which the musical becomes a site for enacting a play within the play. The actors on the stage play characters who in real life might appear to be very much like themselves. From its beginnings, Yiddish film seized on the possibilities for presenting musicals about music. Technically it

took full advantage of the mobility of songs and set pieces that were at once mobile and familiar in a number of different settings. Musical films about music-making provided an ideal genre for juxtaposing the traditional and the modern. Traditional music and traditional theater provided familiarity and a point of departure, but the modernity of the new Jewish stage, particularly its potential to present musical stars as the heroes of the day, drove the plot by portraying the economic and social mobility open to Jews who might follow their fantasies to the musical stage. The star potential that was open to a Jewish musician could not be more striking in the plot of the first Jewish musical film, *The Jazz Singer,* and it accompanied the making of musical films until they settled in Hollywood in the decades after World War II, not least among them the figure of Judy Garland in *A Star Is Born.*

There is little that is subtle in the Jewish musical film about music and musicals. Their titles usually make an eponymous quality clear from the start. *Dem Hazzans Kindl* (The Cantor's Child) and *Der Purimspilr* (literally, The Purim Actor, but often glossed as The Jester), both filmed in 1937, are unequivocal about the significance of the title characters: Traditional actor and film actor are the same, a mixture of self playing self to create the imagination of the other. The two films lend themselves to comparison because of the ways they extend the stock-in-trade methods of Jewish theater and film in the final years of their efflorescence. Mobility, migration, and musical theater underlie the themes and plots of both films. Of the two films, *Der Purimspilr* grew more directly out of Yiddish theater and the nascent Yiddish film tradition. It was filmed in a Polish studio, complete with a shtetl set that was used for other Yiddish films in the mid- and late 1930s, though in virtually every way the film was more international—or transnational—than it was Polish. It was a story about an actor who associates himself with a traveling Jewish theatrical troupe, more as a drifter than as a regular member. The film follows him as he enters an East European village, falls in love with a shoemaker's daughter, and finally must leave her behind as the troupe moves to its next destination, the city where the possibilities for an actor are many times greater. In the course of the film, the Purim actor plays many different roles, from the traditional role for which the film is named—the Purim play, based on stories from the biblical book of Esther, is the most traditional of all Jewish plays—to more comic roles in a circus. One set of roles connects him to Jewish religious narratives, the other allows him to escape from them and become a true comic and entertainer. The differences between the two roles, however, are by no means clear; indeed, they remain confused and confusing against the backdrop of the Galician shtetl. The Purim actor's freedom, ironically, is ensured only by his ability to remain mobile and to flirt with tradition along the uncertain boundaries of modernity.

For the cantor's son in *Dem Hazns Kindl,* success is both friend and foe. The film begins in the classically mythic shtetl of Belz, in which the local cantor's son, Shloimele, has been invited by a traveling theatrical troupe to play the role of a child in the play they are presenting during their brief residence. The local cantor, a model of traditional propriety, will have none of this, and he forbids his son from taking on the role. As the troupe leaves the shtetl for the city, the boy runs after them, eventually traveling with them to the utopian world of America. At first the promise of America falls short, and Shloimele must struggle to make end's meet. While

working as a janitor, however, he is overhead singing, and his voice is discovered by one of the stars of the Yiddish musical stage, Helen. They quickly become partners in a somewhat ambiguous musical and amorous relationship. Though Shloimele's fame originally rests on performances of traditional secular songs, such as "Mein Shtetele Belz" (My Shtetl Belz), it is his cantorial voice and repertory, inherited from his father but mediated through the radio, that pave the way to American stardom via a tour by rail across the entire continent. On the occasion of his parents' fiftieth wedding anniversary, Shloimele decides it is time to return to Belz, where he falls in love with his childhood friend Rivke and is therefore forced to make a decision between the traditional life of the Old World and the great musical career awaiting him in the New World.

The themes and tropes of the two films are remarkably similar at many points; indeed, they are also remarkably similar to the themes and tropes of *The Jazz Singer,* which had preceded them by a decade. The plot is an amalgamation of stock figures and standard scenes; the musical texture is that of a potpourri, with some set pieces fitting the drama effectively, others barely at all; traditional and popular music, sacred and secular song, insert themselves into the same musical score, and musicians from traditions inside and outside Jewish music take their places diagetically on the stage. Both films rely on the transnational themes of modern Jewish history, both in the film narratives and in the execution of the films themselves. *Der Purimspilr* was filmed in Poland, but it relied on actors from the United States, who were brought to the set to play the shtetl tradition of the previous generation. The musical score and the songs were the creations of Nicholas Brodsky, an Eastern European who had acquired his musical craft writing for the popular stage in Vienna before immigrating in the late 1930s to the United States, where he built a modestly successful career in Hollywood. *Dem Hazns Kindl* plays between two worlds, but as a film it bears the earmarks of the Yiddish stage of New York City, where it was filmed. Alexander Olshanetsky's musical score has absorbed many Americanisms, especially a subtle feel for jazz and for the encroachment of vaudeville into the klezmerlike ensembles that play in the film. Music sharply marks the differences between the two worlds of the cantor's son and thus functions crucially to provide frames for the interplay between tradition and modernity.

The two films contrast in the ways they portray the interrelation between self and other. The wandering Purim actor, played by Zygmund Turkow, is fully traditional, even in his ultimately unsuccessful struggle to win over the shoemaker's daughter. In several layers of Jewish myth he also plays the role of Ahasver, the "Wandering Jew" of the diaspora and the Persian king in the Purim play. Moishe Oysher, the star of *Dem Hazns Kindl,* plays himself in the film, the plot of which, though filled with stereotype and musical set pieces, paints his life in vague biographical strokes. The cantor's son may well have lived the life of a modern Jewish everyperson, which fitted the conventions of the Yiddish stage and Jewish film, but the film does little to mask the fact that Oysher is playing himself. Accordingly, his exaggerated selfness—singing songs for which he was already famous—stood out against the theatrical backdrop of otherness.

Films of Jewish musical theater and the Jewish musicians who created them faced very different fates during the period that began with the rise of fascism

and culminated in the Holocaust. For some—Hanns Eisler, Nicholas Brodsky, and Friedrich Holländer, for instance—the exile to Hollywood actually brought many professional and musical advantages. Their contributions to the history of film music in the United States and, after World War II, again in Europe were crucial. For other stage and musical composers, however, exile did not prove to be an option, and both they and their works were drawn into the maw of censorship and destruction, even when the questions of Jewishness were invisible in the public sphere.

One of the most striking cases of a composer who was seemingly incapable of responding to the possibility that he and his stage works would be regarded as Jewish was Léon Jessel (1871–1942), a Jewish operetta and popular-song composer, whose métier became stage genres that glorified the regional and national culture of Germany. He was a marvelous craftsman of *Heimatlieder* (songs of the homeland), and these lent themselves to incorporation into stage works and then, in the 1930s, to *Heimatfilm* (homeland film). Already in 1917, at the height of World War I, Jessel composed the operetta that would make his career, *Schwarzwaldmädel* (Black Forest Girl), which enjoyed immediate success during the war and then continued to find its way into countless productions through the Weimar period and thereafter into the Nazi period and World War II. *Schwarzwaldmädel,* the plot of which glorified the innocence of its heroine, made a deft transition from stage to film, first in the 1930s and then immediately after World War II, when it contributed significantly to national reconstruction as the first postwar film. *Schwarzwaldmädel* remained one of the most revered symbols of a musical stage work stripped of its public Jewishness. Ironically, Jessel himself failed to perceive the eventual consequences of his own embrace of Germanness: he died in 1942 while in Gestapo custody. His works for stage and screen raise questions about what Jewish music for the stage can and cannot achieve, and about how the mediation of film does or does not project identity on the music, its creator, and the audiences who embrace it as their own (Dümling 1992).

ENDSPIEL—THE MUSICAL STAGE OF
THE HOLOCAUST

Hello, hello!
You're now going to hear:
The Emperor of Atlantis,
a kind of opera with four scenes. . . .
The first scene takes place somewhere;
The characters of Death and Harlequin are looking on from
the wings, taking account of Life, which no longer knows how
to laugh, and observing Death, which can no longer weep in a
world that has forgotten how to take joy in life and to give itself
over to death. Hello, hello! Let's begin!
—Viktor Ullmann, *Der Kaiser von Atlantis,* Prologue

A Loudspeaker intones the invitation to the Empire of Atlantis, drawing the audience into the unreal world where life and death have lost meaning but have yet to become totally dysfunctional. In 1943 the invitation to Atlantis would have been

cruelly yet ironically welcoming for the residents of the German concentration camp at Terezín, a small baroque city in northwestern Bohemia, better known as Theresienstadt, the name given to it when it was first built as a garrison town for the Austro-Hungarian Empire. The world portrayed as Atlantis was for these residents all too familiar, for it was the world they had come to inhabit in the concentration camp. It was a world of the stage, which, when experienced as opera, was no longer unequivocally their own. Its location was somewhere; its historical moment was sometime. Its characters too were familiar and strange, constituted by the selfness and otherness of modernity.

The world that might have been realized on the stage of Terezín's former Sokol Hall, or Czech community center, brought to life a dramatis personae that, for the cosmopolitan residents of the concentration camp, represented the surfeit of historical and personal narratives that converged in the real world of the camp itself. The opera both heightened the sense of reality, mediated by the Loudspeaker's crackling invitation, and provided a brief moment in which that reality was transcended through the experience of the opera itself, a moment of transcendence that, precisely because *The Emperor of Atlantis* would never reach the stage in Terezín, would epitomize the musical and dramatic engagement of the camp's stage works with the two characters waiting in the wings: Death and Harlequin.

The Prologue to Viktor Ullmann's *The Emperor of Atlantis* sets the stage and establishes the conditions for the moments of transcendence that follow in the opera itself, and with which I close this chapter on music for the Jewish stage by setting the stage for the concentrated moment, on the operatic stage, of the transcendence that lay at the core of Jewish modernism. With Ullmann's *The Emperor of Atlantis,* composed in 1943 to a libretto by Peter Kien, we reach a moment of historical disjuncture, the crisis of modernity, at which the musical stage of the Holocaust and of the final stages of modern European Jewish history give voice to the lived-in world of Jews trapped in, yet resisting, the telos of the end of time. No other operatic work allows us to hear those voices so fully as Viktor Ullmann's *Der Kaiser von Atlantis.*

In the course of this closing section I open a discursive space for the voices of Terezín by drawing first upon Viktor Ullmann's voice: his music and writings from Terezín. I do this not only to draw the reader closer to the rich, poetic voice of Ullmann and ultimately to its fullest expression in *The Kaiser of Atlantis,* but also to let him draw us closer to the aesthetic world of Terezín. At the beginning of the twenty-first century we do not—and of course cannot—experience Terezín as a concentration camp, but in fact we can experience the music and the other forms of artistic creativity that gave alternative meanings to that world.

I turn first to one of the last utterances of Ullmann's voice, his review of a children's concert probably from the middle of 1944, only weeks before his deportation to Auschwitz.

Rudolf Freudenfeld and his choir, whose performance in Hans Krása's *Brundibár* we can't forget, this time performed Czech and Hebrew folk songs in different arrangements (by Gideon Klein, Adolf Schächter, Otokar Sín, J. B. Förster, etc.). Freudenfeld is a real pedagogue and a fine musician; we can be thankful to him for the largely not-so-easy, but cleanly learned and courageously sung three- and four-voice choruses, in

which both the singers, big and small, displayed real discipline, but also for his loving devotion to the children of Theresienstadt. . . . The best praise a critic can offer is probably that he heard his own arrangements of Hebrew melodies in an immaculate performance. (Ullmann in Schultz 1993: 41)

The aesthetic language of Ullmann's review is like that in any review, not pretending that the primary issues are not musically and aesthetically centered. He praises the children for their hard work and points out a few spots where the repertory was not entirely suited for the chorus, especially the songs adapted from the German singing-society tradition. He describes a world in which it is almost natural that children should be singing operas—Hans Krása's *Brundibár*—and performing new works in Hebrew (for a modern recording of *Brundibár* and reflections on the musical life of Terezín by survivors see Krása 1999). Ullmann draws us in this review into an everyday world of musical experiences, and it is that everydayness that we find most difficult to understand. It is an everydayness, nonetheless, that is crucial to the transcendence that the musical stage in Terezín made possible.

Turning now to Viktor Ullmann's own voice, I should like briefly to sketch four moments of transcendence, moments when the musical stage of the concentration camp shaped alternative meanings of Jewishness. Those meanings run like leitmotifs through modern Jewish history, and accordingly through the chapters of this book. From the outset I want to suggest that these transcendent moments are distinctive through the ways in which they concentrated the experiences of the Terezín residents, largely Jewish Central and East Central Europeans, who were empowered to experience a new selfness in these moments at the end of modernity.

AESTHETIC VOCABULARIES OF TRANSCENDENCE

The more one looks at Ullmann's writings and compositions, the more a common set of themes gives unity to his thinking and creative activity during his years in the concentration camp (see, e.g., Klein 1992; Schultz 1993). It is as if new metaphorical connections between his thinking as a composer and his life as a concentration-camp resident had coalesced. The special forms and functions of this unity were palpable above all because *The Emperor of Atlantis* was a work for the musical stage. The connections form the grid that ultimately supports the processes of transcendence that connect *The Emperor of Atlantis* as modern and modernist opera to audiences at the beginning of the twenty-first century.

One of the most striking transcendent techniques employed by Ullmann was his metaphorical connection of music to language through the formal processes of polyphony and fugue. In this way he transformed compositional craft into narrative functions, extending the meanings presented on the stage to metaphor within the music itself. For Central European composers of the early twentieth century, fugue represented the ultimate compositional form. I refer to fugue as ultimate both because it represented the highest craft for the composer and because it often came at the end of a larger compositional project, thereby symbolizing the culmination of a composition, the closing gesture of time. These are the qualities that we find

also in perhaps the most famous Holocaust poem, Paul Celan's "Todesfuge" (Death Fugue; see Celan 1983; Felstiner 1995).

The counterpoint that Ullmann weaves between language and music also has historical dimensions, and this point brings us to the second of Ullmann's aesthetic practices for the stage. By drawing the listener always to the complex temporal aspects of music, Ullmann uses music and poetry to create alternative temporal worlds. We witness this technique strikingly in *The Emperor of Atlantis,* in which time and history as measures of human society and human mortality are suspended. The suspension of war and death serves as one of the voices in Ullmann's dramatic texture as it might in the musical texture of a fugue. Again, the narrative potential of fragments is redeployed on the stage, forcing us to ask ourselves whether Ullmann is really layering music's temporal metaphors on top of the concentration camp's historical metaphors.

The final aesthetic device I introduce to close this chapter on music for the Jewish stage is irony in its most extreme form: parody. Parody results from the ways in which music masks meaning, and here too we see the functions of counterpoint and the alternative temporal and historical narratives at play. Parody, directly and indirectly, has thematically connected all the sections in this chapter, from cabaret to stage to film. In *The Emperor of Atlantis* parody is very evident throughout, cutting across the cultural life of Terezín. Cabaret and the modernist experiments that relied on parody were also present in the concentration camp, where they empowered musicians and audiences to move between the real and staged worlds of the camp itself. Parody was essential to Ullmann's poetry and to the world created through music in Terezín.

Transcendent Moment #1: Remembering the Past and Escaping Tradition

All these aesthetic practices work together in the first transcendent moment set on the concentration camp stage, a moment that provides the final closure of the opera itself, the "Finale" of *The Emperor of Atlantis.* The power of the final choral section lies in its imagery of death as welcome, a power, however, that acquires its meaning as a force of transcendence. The music of the "Finale" creates numerous routes for the transcendence to follow, but most profoundly it is the music that embodies the real transcendence. The "Finale" is a setting—we might even say a parodistic setting—of Johann Sebastian Bach's chorale setting of "Ein' feste Burg" (A Mighty Fortress). For the Terezín audience—for the aesthetic world of Central European Jewry—the historical meanings in "Ein' feste Burg" were as real as they were contradictory. Composed by Martin Luther, the chorale melody "Ein' feste Burg" signified not only German Protestantism but also the persistent anti-Semitism in the Christianity of Central Europe.

At first hearing, the "Finale" sounds simple and straightforward, as if these qualities constitute its sublimity. Ullmann, however, deliberately alters the simplicity of the chorale, its *Bar-Form* of AAB, by using the devices that open the possibilities for transcendence. The B section (*Abgesang*) begins with a canon in counterpoint: "Teach us never to ignore the yearnings of our brothers." The customary use of organ to set the chorale is rendered ironically through an orchestration that uses harmonium (pump organ), guitar, banjo, and snare drum, as if to stage the work in a cabaret by using the instrumentation found in a salon orchestra in the 1920s or 1930s.

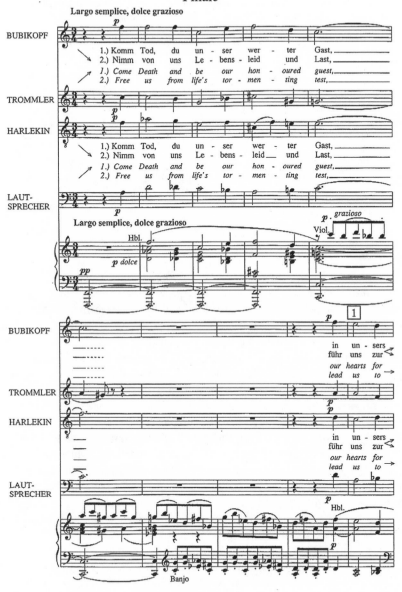

Ullmann consciously chose to allow music's allegorical presence in the poetry to draw the listener into an uncanny past. During his Terezín internment he also wrote poetry, additional fragments that would also embellish his works for the musical stage. These poems too locate music in history and evoke the metaphors that are redolent of Jewish identity.

Viktor Ullmann, *"Der tiefste Schmerz kann zu Musik nicht werden"/"The Deepest Pain Cannot Become Music"*

The deepest pain cannot become music,
No word alters that pain,
It does not assume its shape from the rock of the earth –
It remains in muffled silence.
Thus, I bear silent sadness about the saddening silence,
That I missed,
And it is silent, that it only hums,
What I dreamed.
The deepest pain cannot go back
Into the farthest time,
It strikes the wounds, that now deadly burn:
It has passed!
(German original in Klein 1995: 108)

Viktor Ullmann remained intensively creative throughout his years in the concentration camp. Not only did he compose and write reviews and poetry during his years of internment, but he left us with numerous unfinished projects from his final months. Incompleteness asserts itself most powerfully in the works for the musical stage, those projects that Ullmann created from fragments, hoping to find ways they might find their way to the stage, or beyond that, surviving in ways that might benefit from incompleteness. The aesthetics of incompleteness provide both a way of understanding a transcendent moment and a way of coming to grips with the opera, which itself was incomplete because it did not and could not receive a performance in Terezín.

Ullmann was quite active well into the summer of 1944, with numerous large- and small-scale works dating from this period. At this time he was working not only on a Joan of Arc opera, but also on the second symphony, which he was able largely to complete, with the exception of the fugal final movement. The monodrama *Die Weise von Liebe und Tod des Cornets Christoph Rilke* (The Chronicle of the Life and Death of the Standard-Bearer Christoph Rilke) dates from his final weeks at Terezín, with the piano-vocal sketches of the monodrama based on Rainer Maria Rilke's great prose-poem about the utter destruction of war.

The story of Ullmann's *Chronicle* itself is told from a number of different perspectives and in a number of different voices. Textually, the poet and author Rainer Maria Rilke employs different genres as well: traditional narration, fragments from letters, dream sequences, and battle chronicles. Compositionally, Viktor Ullmann reaches in many directions, borrowing tunes and shaping them, sometimes grotesquely, sometimes with exquisite beauty, to portray the Central European past and the horrors of war that had so often consumed it. The *Chronicle,* as the story of the ultimate destruction and final tragedy of war, is one of the most allegorical of all Ullmann compositions.

For Viktor Ullmann, the allegory would be deeply personal, as if the monodrama he created would also stage the final moments of Terezín itself. From his sketches we know that Ullmann completed enough of the score for The *Chronicle* in early autumn 1944 to include a dedication for his sister's birthday on September 27. Some time during the first week of October 1944, Ullmann and all the other musicians and actors whose lives and works filled the stages of Terezín were deported to Auschwitz, where they were killed on the day of their arrival, probably October 16. By the end of October 1944 the German authorities declared Terezín *künstlerfrei* (cleansed of its artists).

Transcendent Moment #2: Circus/Commedia dell'arte/Cabaret

The path of transcendence that suspends or delays finality seems paradoxical, and it is. As paradox, however, it intersects with a second transcendent moment. Throughout this chapter we have examined the complex ways in which the popular stage had increasingly provided a forum in which European society confronted its own otherness, its own differences, and it is hardly surprising that the Jewish presence on the popular stage played a more visible role until the turn of the century, when, in many ways, the cabaret stage of Berlin, Vienna, and Budapest was dominated by Jewish artists. Some of the songs from the Terezín cabaret stage survive, most of them in the tradition of cabaret, contrafacts, or covers of songs that moved into and out of oral tradition (many are collected in Migdal 1986). Like the example transcribed below, "Theresienstadt, die schönste Stadt der Welt" (Theresienstadt, the Most Beautiful City of the World), most of the cabaret songs from the camps and the ghettos turned a mirror toward the audiences, reflecting the distorted world about them and making it possible to remember the European world turned inside out that was inseparable from Jewish modernism. "Theresienstadt, the Most Beautiful City of the World" unfolds as a catalogue of the daily activities that, according to the text, make life in the concentration camp delightful, such as waiting in line for hours to get food or to go to the bathroom. With the stinging satire of cabaret, misery is stood on its head, and those in the audience are given the chance to laugh at themselves. But then, at the end of the final stanza, the singer steps back from the music and declaims what all know already: "Theresienstadt was never the most beautiful city in the world."

"Theresienstadt, die schönste Stadt der Welt" / "Theresienstadt, the Most Beautiful City in the World"

It's well-known that everything has two sides,
Let's call one side light, the other side darkness,
If you look at things from the sunny side,
Even the ugliest things can seem as if they're marvelous,
So, today, we want to look at things
As if they were bathed in sunshine, and why not,
When one is able to keep our very own motto in mind:
Then Theresienstadt will be the most beautiful city in the world.

Because you poison yourself, worrying that there's no postman here,
Because you make yourself sick that there's no salad growing for you,

Because you don't see any flowers growing in the fields,
For that reason, Theresienstadt seems spoiled for us,
Therefore we convince ourselves that orchids are growing in the ghetto,
And that to "go for a stroll" means waiting for two hours to use the toilet,
Just imagine that you are receiving a Wienerschnitzel instead of the usual slop:
Then Theresienstadt will be the most beautiful city in the world.

For just a moment, imagine that you're again at home,
Take a trip out to Grinzing or to Barrandov,
While at the theater in the evening, pay a visit to the bar,
Where there's sherry-cobbler, gin, and real caviar,
If your child puts her little hands around you in a hug,
If you're feeling as if it's to think about the next addition to the family,
If you could again do something that just feels good:
Then Theresienstadt will be the most beautiful city in the world.

When your years wear on,
And you find yourself surrounded by new, youthful life,
In your heart you yearn for so very much,
Then, one day, your youngest grandchild asks:
"Tell me, grandpa, did you enjoy the days of your youth?"
Shaking, you find yourself saying, with tears welling in your eyes:
"No, my child—Theresienstadt was not the most beautiful city in the world."
Then Theresienstadt will be the most beautiful city in the world.

THE AESTHETICS OF OTHERNESS CONFRONTED
IN THE MIRROR OF ART

It would be an exaggeration to claim that *The Emperor of Atlantis* is cabaret. None-theless, its conception and the plans for its performance left by Ullmann in the score and in his writing reveal that the opera's own sense of paradox depends on a shared sensibility for the popular stage (see Kift 1998). The use of stock figures from the Italian commedia dell'arte would have been entirely familiar to Terezín audiences, as would the ways in which these figures intensified the irony of *The Emperor*'s story.

Cabaret and commedia dell'arte in Terezín functioned metaphorically as different surfaces of a mirror reflecting and refracting the dilemma of selfness and otherness. The Jewish residents of Theresienstadt confronted their Jewishness, their selfness, because they had to do so, but the images they saw reflected by the cabaret or by the figures of commedia dell'arte were contradictory. For musicians and artists such as Viktor Ullmann and Peter Kien, the self in the mirror was masked also by the otherness of cosmopolitanism, and *The Emperor Atlantis* and other compositions provided ways of stripping away that mask and confronting the *Doppelgänger* (alter ego) in the following poem by Viktor Ullmann.

Viktor Ullmann, "Döppelganger des Dichters"/"Alter-Ego of the Poet"

It was fantastic how he
Entered into the Elysian fields,
The goddess of youth offers wine,
Angels stand round about.

He takes a closer look—
They were his odes
That Hölderlin
Bore through the breezes

Wings, which fluttered
Upwards to the crystal,
Where the clear chorus
Sang, as one, its fugue.

Christ-Uranus
Received him
And light washed through
A new wheel of fate.

Still, on earth there crawls—
A melancholy companion,
Whom nothingness achieves,
But a lonely Scapinell.

(original German in Klein 1995: 103–4)

Transcendent Moment #3: Jewishness in the Music of Terezín

"Alter Ego of the Poet" distills much of what we might understand about transcending the burden of duality of selfness and otherness. The poem's mirror does not, however, suggest an isolated transcendence, isolated, that is, from the transformation of the poet, the musician, and the artist in the concentration camp into a different domain of selfness. One of the most remarkable transformations revealed by the aesthetic works created in Terezín was the palpable uncovering of new layers of Jewish sensibility and subjectivity. There was a return not just to Jewish themes, but to an entirely new attempt to collapse the distance between high modernism and the Jewishness that bound together the residents of Terezín. Composers and poets learned Hebrew and Yiddish, and they began to explore the folklore and folk culture of the shtetl and of the devout ḥassidim who lived among them. For many of the creative artists, such as Viktor Ullmann, the incorporation of Jewish themes was not simply a return to their youthful years, but rather meant entering into a virtually foreign aesthetic realm.

We ask ourselves, then, what did being Jewish in Terezín really mean? There were, of course, significant spiritual dimensions. And for many, such as Viktor Ullmann, there were intellectual dimensions that complemented and expanded the spiritual dimensions. The convergence of these dimensions coalesced around the third type of transcendent moment: the reframing of other as self as an intensification of Jewishness in the music of Terezín (for the biography of Alice Herz Sommer, one of the most extraordinary survivors of the camp, see Müller and Piechocki 2006).

With virtually no Jewish education whatsoever, Viktor Ullmann turned to Jewish themes in his Terezín compositions and developed a style of setting Eastern European Yiddish poetry that emulated the arranged folk songs that had increasingly become popular after World War I. One of the clearest cases of a composition in which Ullmann confronted his own Jewishness was the set of *Three Yiddish Songs* (*Březulinka,*

Op. 53) from 1944. In "Berjoskele," the first song in the set, we encounter a song about the estrangement of the poem's narrator, facing the confusion of the modern world. That confusion disrupts the coming of age, the discovery of identity, and the decision to cross borders demanded by rites of passage. The song itself juxtaposes the foreign elements of Jewish modernism, indeed, in the magnificent simplicity that loses neither its feel of a Yiddish folk song and Ullmann's own expressionism. In so doing, it juxtaposes the ironic presence of the two larger communities of Jews, kept apart by history but gathered into a single community in Terezín.

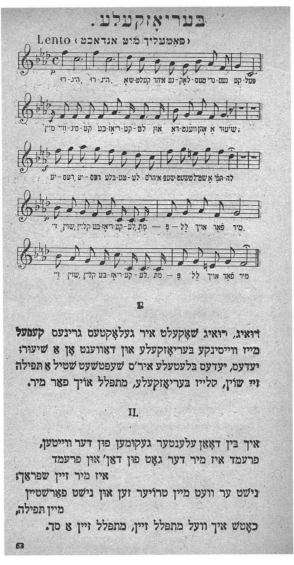

FIGURE 9.2 Yiddish folk song: "Berjoskele"/"The Little Birch." (Source for Viktor Ullmann setting: Kipnis n.d.: 63–64)

ביז איך וועל אזוי מיר אויסגיין
אין דער שטיל אין מזרח-ווינקעל...

.

מאַי קאַ משמע לן דער זייגער?
וואָס'זשע לאָזט ער מיר צו הערען
מיט זיין געלבען ציפער-בלעטעל,
מיט זיין קלינגען, מיט זיין שוועראַ?

ס'איז אן אָנגעשטעלטע כלי,
ס'האָט קיין לעבען, קיין געפילען,
קומט די שעה, דאָ מוז ער שלאָגען
אָן זיין רצון, אָן זיין ווילען...

.

מאַי קאַ משמע לן מיין לעבען?
וואָס'זשע לאָזט עס מיר צו הערען?
פוילען, וועלקען אין דער יוגענט,
פאַר דער צייט פאַרעלטערט ווער.

עסען טעג און שלינגען טרערען,
שלאָפען אויפ'ן פויסט דעם האַרטען,
טויטען דאָ די „עולם הזה"
און אויף עולם הבא ווארטען..

FIGURE 9.2 (continued).

"Beryoskele"/"The Little Birch"

1. Ruhik, ruhik shokelt ir geloktes
grines kepl,
Mayn wayssinke beryoskele un davent
on a shir,
Yedes, yedes bletele irs sheptshet shtil
a tfile,
Say schoyn, kleyn beryoskele, mispalil
oych far mir.

1. Peacefully, peacefully rock your
little green-braided head,
My little white birch, who prays
without peace.
Each little leaf quietly makes a
wish,
Dear little birch, accept my prayer
among these.

2. Ich bin do an elenter gekumen fun
der waytn,
Fremd is mir der got fun dan un
fremd is mir sayn shprach,

Nisht er vet mayn troyer sen un nisht
farshteyn mayn tfile,
Chotsh ich vel mispalil sayn, mispalil
sayn a sach.

2. I've come poor and miserable from
afar.
The God of this place is foreign to
me, and his words are also
strange.
He will not see my sadness, or under-
stand my wishes,
If I too pray like you, ceaselessly.

3. Fun waytn marev hot sich troyerik
farganvet
In di dinne tzvaygelech a roser, tzarter
shtral,
Un a shtiln kush geton di bletelech,
di kleyne,
Velche hobn dremlendik gehorcht
dem nachtigal.

3. From faraway in the west a gentle
red glow
Has begun sadly to find its way into
your narrow branches.
It quietly kisses all the soft, tiny
leaves,
Dreamily, they listened to the
nightingale's song.

4. Fun di wayte felder is a vintele
gekumen,
Un dertzelt di bletelech legendes on
a shir,
Eppes hot in hartzn tif bay mir genu-
men benken,
Say shoyn, kleyn beryoskele, mispalil
oych far mir.

4. A wind blew here across the wide
fields,
Surely it told the leaves many
stories.
Longing begins to arise, deep from
within the heart,
Dear little birch tree, please pray also
for me.

(Text and melody from Jaldati and Rebling 1985: 54 and 251–52)

Transcendent Moment #4: Creating for the Next Generation

The transcendent moment composed by Viktor Ullmann for children in *The Emperor of Atlantis* occupies the first part of the opera's sixteenth scene. The transcendence of this moment is heightened because Ullmann focuses everything from his techniques and vocabulary of transcendence on a critical collapse of history. The opening is sung by Harlequin and the Drummer Girl, who employ the familiar

imagery of the circus and children's songs—and of the cabaret's irony. The world proclaimed by the emperor has become dysfunctional, and the opera's narrative will reverse its direction after this moment of revelation made poignant by the images and imagination of childhood gone wrong. In the opera, it is Harlequin, the embodiment of Life, who assumes the role of the children. As the last line of the children's bedtime song makes so clear, the moment has come to "put on the little red dress again, and to sing the song again from its beginning." Confronted with a choice between the dystopia of an adult world and the utopia of a child's world,

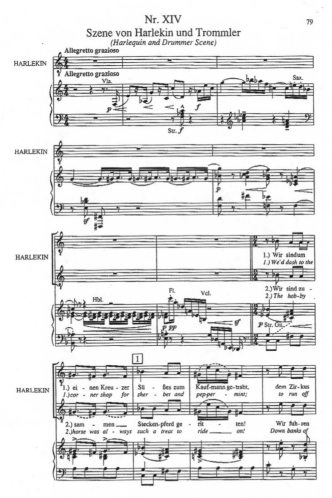

FIGURE 9.3 Viktor Ullmann: "Wir sind um einen Kreuzer Süßes zum Kaufmann getrabt"/ "For a Few Cents We Ran off to Buy Candy." (From the *Emperor of Atlantis* [1943], scene 14). Ullmann, *Der Kaiser von Atlantis,* English translation by Sonja Lyndon, © 1993 Schott Music GmbH & Co. KG, Mainz. All Rights Reserved. Used by permission of European American Music Distributors LLC, sole U.S. and Canadian agent for Schott Music.

Harlequin exits to the seemingly safe world of childhood, the world they themselves enact in the opera's fourteenth scene, Figure 9.3.

The music for the Terezín stage complicates our understanding of the aesthetic modernism that was so essentially formed from Jewish contributions to the music of Central Europe during the decades preceding the Holocaust. It complicates our understanding of modernism because it so baldly asks us to consider just how extensively that modernism really was Jewish. And yet, if modernism itself denies any given selfness—and surely a selfness as complex and contradictory as Jewishness in the arts and in music—we are left with a historical dimension of enormous proportions. We are also left with a new set of historical conditions with which to perceive the transcendence that modernism unleashed on the stage at Terezín. It was crucial to the musical transcendence emerging in the musical works for the Terezín stage that it disentangled the distinctions between self and other, thereby empowering music and drama in Terezín and in the other concentration camps to create meaning in new ways. It is no less crucial for us, if we are to understand the full power and meaning of transcendence on the musical stage of the Holocaust, to let music also disentangle the distinctions between selfness and otherness.

EPILOGUE: AFTER JEWISH MUSIC

On May 28, 2003, the New Budapest Orpheum Society, a self-described "Jewish cabaret ensemble," based in Chicago and an ensemble in residence at the University of Chicago, traveled to Washington, D.C., to perform a concert at the United States Holocaust Memorial Museum. The occasion for the concert was the opening of a new exhibit at the museum, "Fighting the Fires of Hate: America and the Nazi Book Burnings," which itself coincided with the anniversary of the organized book burnings in Germany 70 years earlier, in May 1933. Through the choice of repertory, the research into banned and burned song texts from the 1920s and 1930s, and the revitalization of Jewish song marking the explosive rise of fascism on the eve of the Holocaust in 1933, the New Budapest Orpheum Society consciously evoked the paradox of a historical moment in which Jewish music throve while it faced great peril. Success was predicated on the ways Jewish music throve engaged modernism in the early 1930s, challenging and shaping European history, inventing modernity and reinventing tradition. More specifically, the concert commemorated the poetry of Bertolt Brecht, Kurt Tucholsky, and Erich Kästner, and the songs of Hanns Eisler, Edmund Nick, and Kurt Weill. The program also included songs by Gustav Pick, Peter Hammerschlag, and Friedrich Holländer, not least among them "The Jewish Coachman's Song" and "Love Song to a Proletarian Girl."

Commemoration dovetailed with celebration as the New Budapest Orpheum Society emphasized the historical resilience and resistance of Jewish popular and political song. The concert narrated a history that stopped short of claiming the passing of tradition and the death of modernity. Instead the musicians preferred to emphasize survival and the implementation of new narratives as Jewish music embarked upon new historical paths in the 1930s, in the common leitmotif of the exhibit and the concert, "as a phoenix rising from the ashes."

No one could doubt that the songs of the evening wore survival and resistance on their sleeves. Many addressed political and moral opposition to the rise of fascism in interwar Central Europe head on. The song texts by Bertolt Brecht and Kurt Tucholsky were relentless in their social critique, and there could be little doubt just why the activist composer Hanns Eisler chose to set "The Ballad of the

'Jewish Whore' Marie Sanders" and "The Trenches" as protest songs. More subtle and less well known were the poems of the great author of German children's literature Erich Kästner (1899–1974), his "Well Furnished Morals," though their biting social criticism and satire left little doubt why Kästner's books (e.g., *Fabian*) were burned in May 1933. Exile was writ large across the songs, especially those written and composed in exile, such as the Hanns Eisler/Bertolt Brecht *Hollywood Songbook,* which barred no holds in its brutal baring of the themes of exile: flight, suicide, the futility of homecoming.

The audience at the United States Holocaust Memorial Museum was no stranger to the themes of the concert and the exhibit, even if certain sets and repertories were not familiar to them. Their own life histories and the histories of their families intersected with this music. As always at the U.S. Holocaust Memorial Museum, there were survivors in the audience. There were probably few who did not have personal experiences that connected them to survivors and survival. Familiarity informed the evening and connected the audience to the Jewish cabaret ensemble on stage. Familiarity revealed itself in fragments and in the ways the songs and texts, as fragments, fitted together as musical memorial and monument. In the tradition of the popular Jewish stage, the songs employed potpourri and pastiche. Brecht and Eisler had famously developed a popular aesthetic in which they reused themes and reassembled snatches of melody. The bits and pieces were obvious, and the composers and poets did not leave their fragmentary qualities open to question. Often they fitted by not fitting, by exposing the seams and fissures of historical moments left incomplete and exiles interrupted. In 1933 and then in the years of approaching holocaust, these songs responded not to the telos of modern history but rather to its truncation. Seventy years later a Jewish cabaret ensemble sutured them together in a performative moment, which memorialized a historical moment brought to an end by destruction.

The New Budapest Orpheum Society, after considerable debate, had decided to perform the program in German, even though it regularly performs and records with English and American lyrics for its Central and East Central European cabaret repertory (New Budapest Orpheum Society 2002). The ensemble's programming decisions necessarily responded to vastly different audiences, from the Chicago-area synagogues at which it most often performed to the unambiguously secular contexts of a Broadway venue, such as Symphony Space in February 2006, or the YIVO Institute for Jewish Research in September 2006. So subtle were the meanings of song transposed to the contexts of Jewish cabaret that the danger of a misstep was always imminent.

The New Budapest Orpheum Society was therefore fully aware of the risks of performing in German on an evening such as this one: Losing the audience was insignificant in comparison with the possibility that German could be offensive to those frequenting the Holocaust Museum. To ameliorate the possibility of offending, complete texts and translations for all the songs were provided on a 38-page insert, a formidable reading assignment, especially in a darkened auditorium. It hardly mattered, however, for this audience followed intently. They knew the narratives that ran through these songs; the histories that they told were intimately familiar. Language would not be an encumbrance.

The familiarity of the songs notwithstanding, the concert posed more questions than it answered. There were questions of ownership: Familiarity was not the same as ownership, especially when the material was available only in fragmentary forms. There were questions of identity: Jewish composers, poets, and themes were abundant, but there was a substantial non-Jewish counterpoint. Bertolt Brecht and Erich Kästner, after all, were not Jewish, even if Brecht, for one, collaborated extensively with Jewish musicians throughout his life. There were questions about exile: Hanns Eisler, for example, had been driven into exile by conditions in fascist Germany, but his return to East Germany was the result of the reactionary politics of the American House Committee on Un-American Activities. And there were questions about history and counterhistory: The cabaret ensemble was drawing together many different historical strands, in fact, for the first time, for this program was a departure from anything the New Budapest Orpheum Society had previously performed. In this context, while these songs were commemorating an event that occurred seventy years earlier, and they were juxtaposed and musically arranged to represent a Jewish cabaret, were they directly engaging history or were they really removed from history, relegated to the role of virtual Jewish music removed from the past? Finally, there were questions of place: Where were Germany, Austria, and the other fascist lands of the 1930s, in which music, literature, and art, both Jewish and non-Jewish, were banned because of their affinities, that is, a commonness borne by their otherness.

My New Budapest colleagues and I really did think about all these questions as we took to the boards on May 28, 2003. We had pondered them in our own ways, some of us from our perspectives as non-Jews (mezzo-soprano Julia Bentley and I myself, the artistic director of the Jewish cabaret ensemble), others because of their personal Jewish experiences in Eastern Europe (Ilya Levinson, musical director) or on the American Jewish stage (baritone Stewart Figa). The modernity to which we would attempt to give wholeness through the very invention of cabaret performance was extremely important at this moment, when Jewish music would expose the history from which it had been inseparable.

JEWISH MUSIC TODAY

"Even in Berlin, klezmer has tradition and roots. And this profound passion, the very dynamic of this music has class. This project's going to be a hit! You'll see," said Wolf as he blew smoke rings toward the ceiling. . . .

"Berlin is the Paris of the East," Wolf continued. "The Jews always belonged to Berlin, just like the Brandenburger Gate to Prussia. I'm telling you: Gather up the Jews, and you'll make a film that'll explode! People will eat it up!"

The producer was quiet for a moment and appeared to be thoughtful. Then he said:

"But there aren't very many Jews, I mean, over the past forty years they haven't had much importance in Berlin." He was pleased with the contradiction and smiled broadly.

—Kara 2003: 372

> The klezmer phenomenon in Europe has a sound for all seasons;
> it is a complex, at times hodgepodge, mixture of good time
> music and . . . conscious use of Jewish motifs to make a politi-
> cal or emotional point. . . . Increasingly, however, as the past re-
> cedes, new audiences and new, younger, performers emphatically
> reject metaphoric overtones and claim fulfillment simply in the
> music itself.
>
> —Gruber 2002: 186

> One must hope that, today, Yiddish music has been able to gain
> something from its traditional origins, and that it can engage
> with them instead of battle over competition or sentimen-
> tal cults—that Yiddish music will be part of a vital musical
> dialogue.
>
> —Eckstaedt 2003: 326

Three stories are most commonly told about Jewish music in Central and Eastern Europe today, at the beginning of the twenty-first century, when European reunification has been official for almost two decades, the Cold War has taken the form of anecdotes for most younger than middle age, and the Holocaust has become the history of grandparents, most of them deceased.

In the first story, Jewish music is exotic, all the more so because of its patina of pastness. Jewish music has become popular music, commoditized world music and *Weltmusik,* available for consumption whenever a concert organizer or public culture broker wants to spice up a festival or celebrate the successes of the New Europe. There is perhaps no sampler of national styles on the world music circuit that does not have a half dozen klezmer tunes and Yiddish songs in the multicultural mix (see, e.g., *Klezmer* 2000; *World Music* 2001). Where Jewish music comes from in the first story is ultimately unimportant. It is the music of the here and now. It has the appeal that every record producer dreams of tapping. You can find it on the Internet and learn it by jamming at festivals and music camps all over the world. Jewish music today is great music, and that is reason enough for giving it a place on the stage of the present. Its real quality, then, lies in the fact that Jewishness is not what makes it great or limits its audiences. What better way to honor the music of the ancestors, after all, than to show the ways in which their music rose above the destruction of another time and place? In the postmodern twenty-first century, Jewish music is Our Music, devoid of the otherness that would only tether it to someone else's past.

The second story is one of wonderment and befuddlement. Jewish music today is the product of revival, particularly the folk-music revivals that began in Europe in the 1960s and accelerated as sites for criticizing all that a divided Europe failed to achieve. The music of revival privileged otherness in all forms: students and guest workers, communists in Western Europe and capitalists in the East, minorities and other peoples without nations, Roma and Jews. Jewish music arose naturally, if not authentically, from the revival, and it was hardly surprising that non-Jews performed it in public far more than did Jews. That wasn't the point. With the explosion of klezmer music on the eve of reunification in 1989, however, it was exactly the point. The second story is about non-Jews playing

Jewish music in the places where the Holocaust virtually eliminated all Jewish communities. It is a story about music Ruth Ellen Gruber calls "virtually Jewish," which has been fundamental to "reinventing Jewish culture in Europe" (Gruber 2002). For the most part, the actors in the second story play fictional roles: Klezmer musicians play in the German metropole, where their real Jewish ancestors, if they had any, would never have played; Yiddish songs thrive in settings where the language was scorned a century ago; young Jewish musicians from America and old Rom musicians from Eastern Europe become the sources of authenticity.

The third story is the freshest and the most recent. Its narrators come from a new generation, and they are interested in telling their own stories, which are imbued with hopefulness about their future. The actors in the story are both Jewish and non-Jewish—admittedly more the latter than the former—but they do nonetheless take to the stage together. In the third story, musicians want to put glitter and guilt behind them, instead going about the serious business of getting a contemporary Jewish music right. Doing that means learning languages, especially Yiddish and Hebrew, and it also means scholarly study, whenever and wherever that is possible. Revitalization rather than revival provides themes for the third story—in other words, the desire to discover the vitality of a tradition that can live in the present rather than an urge to salvage one that had already died in its own day. Jewish music today therefore thrives in places that simply did not exist a century ago, or even a decade ago. The resources are there in new public archives, new programs of academic study, and the newest, most accessible media, and all these sources remove the encumbrances of the past that would keep Jewish music from enriching today's musical landscapes.

Although it has not been the primary purpose of this book to tell a story about Jewish music today, it closes with an epilogue that is—as is suggested by the moment from the ethnographic present with which I rhetorically begin the epilogue—a reflection on the stories of the present. If there is a fourth story that emerges from the epilogue and the historical chapters that preceded it, that story relies on the following rhetorical strategies. The narratives of the fourth story are historicist, and they concern themselves with the possibility that the present is substantively not radically different from the past. If the first three stories focus on the newness of Jewish music today, the fourth story leaves open the possibility that Jewish music today shares much with its past. If the first three stories employ the vocabulary of postmodern discourse—virtual culture, hybrid and transnational musics, cross-cultural collaborations—the fourth story relies more on modernist discourse, which seeks to represent the ways in which Jewish music has expressed complex and contradictory conditions for centuries. The fourth story by no means minimizes the destructive forces brought to bear on Jewish music and its modern history. Instead, narratives accrue to the fourth story that reveal the ways in which Jewish music responded to modernity even when it was at its most destructive during the Holocaust. In the fourth story, the end of modernity and modernism did not bring about the end of Jewish music. If they had, the debates and disagreements about Jewish music that are today so crucial would long ago have subsided. The postmodern present would have come into being after Jewish music.

EXIT FROM HISTORY AS ENTRANCE
INTO HISTORICISM

Jewish music did respond to the end of modernity and the concomitant destruction of Jewish culture in Central and Eastern Europe, and accordingly its stories form complex counterhistorical fabrics today. That this situation is paradoxical and counterintuitive goes without saying, but the exit from history in the 1930s has proved to be crucial to the historicism we witness today. The capacity of music to represent and to effect the denial of history has been crucial to the historiographic approaches I have employed throughout this book. In ritual practice, music recalibrates time, bringing about the shift from historical to ritual time. The musical modernism to which Jewish music contributed in such diverse ways at the beginning of the twentieth century denied history in different ways, juxtaposing or collapsing it, thereby leading to claims that music need not adhere to the extramusical contexts. We witness here a case illustrating one of the now classic explanations of modernism in science and the arts, namely the creation of symbol systems that are entirely self-referential. The ahistoricism that in turn provided a precondition of modernism was entirely familiar to the musicians who took the collapse of European history with World War I as a moment to make new claims on music's capacity to deny the past in order to recover the present, with all its contradictions.

As Jewish music acquired a greater presence and importance in European Jewish culture, it increasingly provided possibilities to deny modernism. With the twentieth century, attempts to discover and document Jewish music expanded rapidly. From 1880 a terminology for identifying Jewish music was not just full-fledged, but it increasingly acquired more and more nuance and it made music increasingly more distinct and distinctive in Jewish culture and history. As banally remarkable as this idea may seem, because Jewish music was called Jewish music, it was arrogated to a new ontological position in the European imagination. Unwittingly accepting Adorno's pronouncement, we sometimes assume and often state quite unassailably and unequivocally that history could never be the same after the Holocaust. A rupture of unimaginable proportions took place, and everything that followed was different. It was this rupture and the questions that it raised about how history unfolds after the Holocaust that brought about the historiographic recalibration of historicism.

Musical change and the shifting meanings of Jewishness in music did not diminish after the Holocaust. Indeed, the processes of change affecting Jewish music after the Holocaust and leading to its invention and reinvention have proliferated in almost unchecked fashion. The many processes that move away from the teleology of Jewish music history are particularly significant in Europe today, precisely because they so powerfully reconfigure history. The denial of history as its reconfiguration: unquestionably there is an inherent paradox, but this is the nature of the historicism that accounts for the identity of Jewish music today (see Baumann, Becker, and Woebs 2006).

Historicism is not a single process but rather many, and for that reason we witness its presence in post-Holocaust Jewish music across a complex range of musical traditions. Revival is one of the most striking and widespread forms of historicism,

and Jewish music today would be difficult to fathom had revival not been rallied in so many different genres and traditions. So important is revival for klezmer music that there is a synonymous relation between the two. It has indeed become very common to condense the two, speaking of the klezmer revival as if it were a single phenomenon. Perhaps the true mark of revival in klezmer music is the fact that it has created contexts for klezmer to spread and intersect with other musical revivals. There is considerable differentiation between and among revivals; the American revival has an entirely different sound from the English, German, or Hungarian revival. As a revived Jewish music, klezmer lends itself to objectification and transformation into musical languages for jazz, classical music, or rock. Even in authenticated media, such as rereleases of early recordings (e.g., *Yikhes* 1991), klezmer acquires power in the present through its potential to historicize. Even earlier than klezmer, Yiddish song underwent revival in German-speaking Europe. Yiddish song, once revived, spread in multiple directions. Not only did it fulfill the requirements of political song, say, in the performances of German singer-songwriter Wolf Biermann, but it also embellished the repertories of soloists and choruses devoted to Jewish sacred music.

In historicized forms, Jewish music lends itself to various forms of memorywork and the processes that channel it. Monuments, memorials, and museums spread across Europe in a dense historical network, connecting the sites of the Jewish past and reinventing them as contemporary sites for the making and remaking of memory. Connecting all such forms of memorywork is their explicit aim to locate history in the public sphere. All the questions arising from the Jewish past are therefore opened to debate. The more public the forms of memory, the more controversial the building of a monument or museum becomes (see Young 1993; Kirsch 2003). Jewish music, in contrast, often enters the controversies as a mollifying voice, as if the memorywork it does offers compromise. Long before there was agreement on the architectural design for the Berlin Jewish Museum, perhaps the most controversial of all Jewish museums in Europe, Jewish musicians were engaged to perform at cultural functions for the museum, or even for the public discussions about the meaning of the museum itself. Whether because of Daniel Liebeskind's high modernist design or the postmodern curatorial agendas, the Berlin Jewish Museum was controversial because of the ways it participated in Berlin's present. The sound of klezmer bands and chamber ensembles playing works by composers killed in the Holocaust, in contrast, provided a historicist patina that was acceptably Jewish for everyone. Similarly, at the May 2005 dedication of the equally controversial Berlin "Monument for the Murdered Jews of Europe," musical ensembles, real and virtual, performed, among them the chorus of the "White Stork Synagogue" of Wrocław, whose members are overwhelmingly non-Jewish, though they take their name from a decaying Polish synagogue whose congregation is so tiny that religious services are possible only in the prayer room of a neighboring building.

Some of the ways in which Jewish music enters the European public sphere today owe much to the recent political developments and postmodern phenomena. More than do many European folk- and popular-music repertories, for example, Jewish music lends itself to the internationalism and border-crossing that are now fostered by the European Union. Folk-music ensembles seeking financial support

for tours frequently point to the presence of a set of Jewish pieces in their programs as justification for funding. Doing so is hardly remarkable, because broadening an ensemble's repertory is a sure way to deflect accusations of nationalism. Jewish musicians have also found their way to the New Europe via the festival circuit. As festivals increasingly depend on international audiences and tourism, advertising the performances of klezmer bands and the inclusion of Yiddish or Ladino vocal ensembles is a sure way to boost attendance.

By extension, the festivalization of European vernacular music has fully enveloped Jewish music. At the beginning of the twenty-first century there may well be no major European city that does not have several Jewish music festivals every year. Some of these, such as the Kraków Festival of Jewish Culture, already have substantial histories and have been attracting streams of Jewish music pilgrims since the mid-1980s (Gruber 2002: 45–47). Others began more traditionally, taking root first as a public event with religious and ritual significance but blossoming into citywide affairs. The annual Vienna Jewish Festival initially provided a way of celebrating a cluster of May holidays—Shavuot, Holocaust Remembrance Day, Israeli Independence Day—on the small street in front of the Stadttempel (City Synagogue), but by the late 1990s it had outgrown the modest food and book stalls and the small stage for local musicians in the Judenplatz, and it moved the entire festival to the Palais Liechtenstein, with its capacious and elegant chambers and its more-than-ample courtyard for concerts.

If indeed there are more sites for the performance of Jewish music in Europe today, we might wonder whether there is more Jewish music and whether more Jewish musicians perform it. The three stories above, of course, would respond in different ways to these questions. Just as Jewish music has become more fully integrated into the popular world music scene, it is hardly surprising that the Jewish musicians engaged in memorywork and performing at festivals are more international. Some American klezmer groups play more often in Europe than in the United States. Some of Europe's most distinguished klezmer musicians are Americans who have taken up semi-permanent residence abroad. In classical music too the famously generous support for music and the arts in Germany and Austria has attracted new Jewish works, such as the Israeli-American Shulamit Ran's opera *Between Two Worlds* (a setting of *The Dybbuk*) for the Bielefeld opera in Germany.

Questions about the Jewishness of music and musicians converge in the spread of Jewish choralism. Tradition and cosmopolitanism converge in the European Jewish chorus of the twenty-first century. The overwhelming number of choruses began within traditional and sacred institutions, the synagogue of the metropole or even in rabbinical and cantorial training academies such as those in Paris, Budapest, and Moscow. Some choruses claim unbroken tradition from before the Holocaust—the Karl Goldmark Choir of Budapest was part of the rabbinical academy located in that part of the Budapest ghetto that was never completely closed by the fascist government of Hungary—but most of them revel in the fact that their own founding in the late 1980s or early 1990s has paralleled the revitalization of European Judaism. Jewish choruses strive to be as visible as possible: They participate in tours and festivals; they release and market CDs; they organize public events that draw attention to the historical *longue durée* of Jewish music; they actively expand the

borders of their repertories to secular and international repertories; they commission new compositions; and they collaborate with Jewish instrumental musicians on a regular basis.

Arguably, Jewish choralism is the most Jewish of all *lieux de mémoire* today. The connection of Jewish choruses to the synagogue is unequivocal, and their claim to Jewishness reflects their sense of community. The Jewish chorus, however, narrates fragments from all three stories about Jewish music today, some of them about the many non-Jewish choristers they attract, others about the wild hybrids of local ḥazzanut and Israeli popular music that makes their concerts appealing to Jews and non-Jews alike. At the rehearsals of every Jewish chorus in Europe today, it remains an open question what will come after Jewish music.

Jewish music in Europe today lives and relives through historicism. Since the reunification of Europe, no less than in the six decades or more since the Holocaust, Jewish music has increasingly come to function as a means of performing the past. Jewish music retrieves Jewishness from the past and resituates it in the present, filling a historical void. This historicism-as-performance is possible because of the fragmentation of Jewish music. Fragments of melody and text, meaning and identity, move freely from one repertory to the next. Tradition is open to negotiation. The Jewishness of music is all the more important because there is no clear way of resolving what it might be. The historicism explicit in European unity and narrowing the cultural gap between east and west serves as familiar turf for Jewish music, empowering it to move from more private spaces into the public spaces of the reunified New Europe. In essence, Jewish music is possible again because it is so very public.

The historicism of the twenty-first century may not be substantially different from that of the early modern seventeenth century or the eighteenth-century Haskala. Jewish music entered modernity at those historical moments also as fragments, and it was challenged by discussions about its Jewishness. Jewish music today draws us to the discourses of European history in many of the same ways it did before and during modernity. As Europeans, Jewish and non-Jewish, seek to rethink and reimagine what European selfness has meant historically and can mean today in a unified New Europe, Jewish music is crucial to the picture and its wholeness, not because Jewish music assumes place in the selfness, but rather because it contrasts through its complex otherness, an otherness inseparable from European and Jewish identities.

BIBLIOGRAPHY

Adorno, Theodor W. 1976. *Introduction to the Sociology of Music.* Trans. E. B. Ashton. New York: The Seabury Press. Orig. publ. 1962.

_____. 1992. *Mahler: A Musical Physiognomy.* Trans. Edmund Jephcott. Chicago: University of Chicago Press.

Am-Urquell: Monatsschrift für Volkskunde. 1890–1896. Vols. 1–7.

Anderson, Benedict. 1991. *Imagined Communities: Reflections on the Origin and Spread of Nationalism.* 2nd ed. London: Verso and New Left Books.

Andics, Hellmut. 1988. *Die Juden in Wien.* Vienna: Kremayr & Scheriau.

Anonymous. 1938. *Überlieferte Alt Wormser Synagogen Melodien.* Manuscript in Jüdisches Museum, Worms, Germany.

Appadurai, Arjun. 1996. *Modernity at Large: Cultural Dimensions of Globalization.* Minneapolis: University of Minnesota Press.

_____, ed. 1986. *The Social Life of Things.* Cambridge: Cambridge University Press.

Applebaum, Anne. 1994. *Between East and West: Across the Borderlands of Europe.* New York: Pantheon.

Arbusow, Leonid. 1963. *Colores Rhetorici: Eine Auswahl rhetorischer Figuren und Gemeinplätze als Hilfsmittel für akademische Übungen an mittelalterlichen Texten.* 2nd ed. Göttingen: Vandenhoeck und Ruprecht.

Aristotle. 1951. *Aristotle's Poetics.* Trans. E. Rhys. New York: Everyman's Library.

Arnim, Achim von, and Clemens Brentano. 1806 and 1808. *Des Knaben Wunderhorn.* Heidelberg: Mohr und Zimmer.

Aschheim, Steven E. 1982. *Brothers and Strangers: The East European Jew in German and German Jewish Consciousness, 1800–1923.* Madison: University of Wisconsin Press.

Avenary, Hanoch. 1976. *The Ashkenazi Tradition of Biblical Chant between 1500 and 1900.* Tel-Aviv: Tel-Aviv University, Faculty of Fine Arts. (Documentation and Studies, 2)

_____. 1985. *Kantor Salomon Sulzer und seine Zeit: Eine Dokumentation.* Sigmaringen: Jan Thorbecke.

Avishur, Yitzhak. 1986. *Shirat ha-nashim: Shireh 'am be'aravit-yehudit shel yehudeh 'irak.* Or Yehuda: Iraqi Jews' Traditional Culture Center, Institute for Research on Iraqi Jews.

Baselgia, Guido. 1993. *Galizien.* Frankfurt am Main: Jüdischer Verlag.

Bauer, Susan. 1999. *Von der Khupe zum Klezkamp: Klezmer-Musik in New York.* Berlin: Piranha. Book and CD.

Baumann, Max Peter, Tim Becker, and Raphael Woebs, eds. 2006. *Musik und Kultur im jüdischen Leben der Gegenwart.* Berlin: Frank & Timme. (Kulturwissenschaften, 2)

Baumgartner, Gerhard. 1988. *Geschichte der jüdischen Gemeinde zu Schlaining*. Stadtschlaining: Österreichisches Institut für Friedensforschung und Friedenserziehung.

———, Eva Müllner, and Rainer Münz, eds. 1989. *Identität und Lebenswelt: Ethnische, religiöse und kulturelle Vielfalt im Burgenland*. Eisenstadt: Prugg.

Beckermann, Ruth, ed. 1984. *Die Mazzesinsel: Juden in der Wiener Leopoldstadt, 1918–1938*. Vienna: Löcker.

Ben-Ami, Issachar. 1998. *Saint Veneration among the Jews in Morocco*. Detroit: Wayne State University Press.

Benčíková, Ivona. 1993. "Príspevok k štúdiu jamočných piesní na Slovensku." *Slovenský národopis* 41: 44–54.

Bendt, Vera. 1997/1998. "Erinnern und Leben." In Jüdisches Museum der Stadt Wien, ed., *Über Erinnerung*, pp. 37–58. Vienna: Verlag Christian Brandstätter.

Benjamin, Walter. 1982a. *Das Passagen-Werk: Aufzeichnungen und Materialien*. Ed. Rolf Tiedemann. Frankfurt am Main: Suhrkamp. (Gesammelte Schriften, 5)

———. 1982b. H ["Der Sammler"]. In idem, *Das Passagen-Werk: Aufzeichnungen und Materialien*, pp. 267–80. Frankfurt am Main: Suhrkamp.

Beregovski, Moshe. 1982. *Old Jewish Folk Music*. Ed. and trans. Mark Slobin. Philadelphia: University of Pennsylvania Press.

Berl, Heinrich. 1921/1922. "Das Judentum in der abendländischen Musik." *Der Jude* 6: 295–305. (first article in a series published in *Der Jude*).

———. 1926. *Das Judentum in der Musik*. Stuttgart: Deutsche Verlags-Anstalt.

Bhabha, Homi K. 1994. *The Location of Culture*. New York: Routledge.

Birnbaum, Eduard. 1976. "Franz Schubert as a Composer of Synagogue Music, Written in Commemoration of the 100th Anniversary of His Birth." Trans. Eric Werner. In Eric Werner, ed., *Contributions to a Historical Study of Jewish Music*, pp. 228–40. Philadelphia: KTAV Publishing House. Orig. publ. 1897.

———. 1978. *Jewish Musicians at the Court of the Mantuan Dukes (1542–1628)*. Tel-Aviv: Tel-Aviv University, Faculty of Fine Arts. (Documentation and Studies, 1). First published in 1893 as: *Jüdische Musiker am Hofe von Mantua von 1542–1628*. Vienna: M. Waizner. In: *Kalender für Israeliten für das Jahr 5654*.

Birnbaum, Nathan. 1989. *Die jüdische Moderne: Frühe zionistische Schriften*. Augsburg: Ölbaum-Verlag. Reprint of articles, 1893–1905, which appeared together in 1910. Czernowitz: Birnbaum und Kohut.

Bloemendal, Hans. 1990. *Amsterdams Chazzanoet: Synagogale Muziek van de Ashkenazische Gemeente*. 2 vols. Buren: Frits Knuf.

Blümml, E. K., and Friedrich S. Krauss, eds. 1906. *Ausseer und Ischler Schnaderhüpfel*. Special edition of *Der Volksmund*, 3. Leipzig: Deutsche Verlagsaktiengesellschaft.

Bohlman, Philip V. 1986. "The Archives of the World Centre for Jewish Music in Palestine, 1936–1940, at the Jewish National and University Library, Jerusalem." *Yuval* 5: 238–64.

———. 1987. "The European Discovery of Music in the Islamic World and the 'Non-Western' in 19th-Century Music History." *The Journal of Musicology* 5 (2): 147–63.

———. 1989a. *"The Land Where Two Streams Flow": Music in the German-Jewish Community of Israel*. Urbana: University of Illinois Press.

———. 1989b. "Die Volksmusik und die Verstädterung der deutsch-jüdischen Gemeinde in den Jahrzehnten vor dem Zweiten Weltkrieg." *Jahrbuch für Volksliedforschung* 34: 25–40.

———. 1992. *The World Centre for Jewish Music in Palestine, 1936–1940: Jewish Musical Life on the Eve of World War II*. Oxford: Oxford University Press.

———. 1993. "Musical Life in the Central European Jewish Village." In Ezra Mendelsohn, ed., *Modern Jews and Their Musical Agendas*, pp. 17–39. Special issue of *Studies in Contemporary Jewry* 9. New York: Oxford University Press.

———. 1994. "Auf der Bima—Auf der Bühne: Zur Emanzipation der jüdischen Popularmusik im Wien der Jahrhundertwende." In Elisabeth T. Hilscher and Theophil Antonicek, eds., *Vergleichend-systematische Musikwissenschaft: Beiträge zu Methode und Problematik der systematischen, ethnologischen und historischen Musikwissenschaft*, pp. 417–49. Tutzing: Hans Schneider.

———. 1995. "Musik als Widerstand: Jüdische Musik in Deutschland 1933–1940." *Jahrbuch für Volksliedforschung* 40: 49–74.

———. 1996a. "Pilgrimage, Politics, and the Musical Remapping of the New Europe." *Ethnomusicology* 40 (3): 375–412.

———. 1996b. "The Akedah and the Embodiment of Music: On the Origins of Music in Jewish Thought." *Makorot/Sources* 2: 52–58.

———. 2000. "To Hear the Voices Still Heard: On Synagogue Restoration in Eastern Europe." In Daphne Berdahl, Matti Bunzl, and Martha Lampland, eds., *Altering States: Ethnographies of Transition in Eastern Europe and the Former Soviet Union*, pp. 40–60. Ann Arbor: University of Michigan Press.

———. 2002a. "Inventing Jewish Music." In Eliyahu Schleifer and Edwin Seroussi, eds., *Studies in Honour of Israel Adler*, pp. 33–74. Special Issue of *Yuval* 7. Jerusalem: The Hebrew University Magnes Press.

———. 2002b. "Music." In Norman Goodman, ed., *The Oxford Handbook of Jewish Studies*. Oxford: Oxford University Press.

———. 2003. "'Dramatis personae' eines Endspiels—Jüdische Popularmusik in der Öffentlichkeit der Habsburger Monopole." In Leon Botstein and Werner Hanak, eds., *Quasi una fantasia: Juden und die Musikstadt Wien*, pp. 92–105. Vienna: wolke.

———. 2004a. *The Music of European Nationalism: Cultural Identity and Modern History*. Santa Barbara, Cal.: ABC–CLIO.

———. 2004b. "Before Hebrew Music." In Michael Berkowitz, ed., *Nationalism, Zionism and Ethnic Mobilization of the Jews in 1900 and Beyond*, pp. 25–59. Leiden: Brill.

———. 2005a. *Jüdische Musik—Eine mitteleuropäische Geistesgeschichte*. Vienna: Böhlau. (Schriften zur Volksmusik, 21)

———. 2005b. "Frauenstimme/Frauenkörper—Zur Ontologie der jüdischen Musik." In Gerlinde Haid and Ursula Hemetek, eds., *Die Frau als Mitte in traditionellen Kulturen: Beiträge zu Musik und Gender*, pp. 53–71. Vienna: Institut für Volksmusikforschung und Ethnomusikologie. (Klanglese, 3)

———. 2007. "The Age of Jewish Music Collecting." In James P. Cassaro, ed., *Music, Libraries, and the Academy: Essays in Honor of Lenore Coral*, pp. 81–103. Middleton, Wis.: A-R Editions, Inc.

———, ed. 2008. *Jewish Musical Modernism, Old and New*. Chicago: University of Chicago Press.

———, and Ruth F. Davis. 2007. "*Mizrakh*, Jewish Music and the Journey to the East." In Martin Clayton and Bennett Zon, eds., *Music and Orientalism in the British Empire, 1780s–1940s: Portrayal of the East*, pp. 95–125. Aldershot: Ashgate. (Music in Nineteenth-Century Britain)

———, and Otto Holzapfel. 2001. *The Folk Songs of Ashkenaz*. Middleton, Wis.: A-R Editions. (Recent Researches in the Oral Traditions of Music, 6)

———, and Mark Slobin, eds. 1986. *Music in the Ethnic Communities of Israel*. Special issue of *Asian Music* 17 (2).

Botstein, Leon, and Werner Hanak, eds. 2003. *Quasi una fantasia: Juden und die Musikstadt Wien*. Vienna: wolke.

Boyarin, Jonathan. 1992. *Storm from Paradise: The Politics of Jewish Memory*. Minneapolis: University of Minnesota Press.

Braudel, Fernand. 1986. *Civiltà e imperi del Mediterraneo nell' età di Filippo*. Turin: Einaudi.

Braun, Joachim. 2002. *Music in Ancient Israel/Palestine: Archeological, Written, and Comparative Sources*. Trans. Douglas W. Stott. Grand Rapids, Mich.: William B. Eerdmans.

———, Vladimir Karbusický, and Heidi Tamar-Hoffmann, eds. 1995. *Verfemte Musik: Komponisten in den Diktaturen unseres Jahrhunderts*. Frankfurt am Main: Peter Lang.

Braungart, Wolfgang. 1985. *Bänkelsang: Texte—Bilder—Kommentare*. Stuttgart: Reclam.

Brednich, Rolf Wilhelm. 1974–1975. *Die Liedpublizistik im Flugblatt des 15. bis 17. Jahrhunderts*. 2 vols. Baden–Baden: Valentin Koerner.

Brenner, David A. 1998. *Marketing Identities: The Invention of Jewish Ethnicity in* Ost und West. Detroit: Wayne State University Press.

A Brievele der Mamen. 1938. *A Brievele der Mamen*. Directed by Joseph Green. Music by Abe Ellstein. Available on video as Ergo 725.

Brod, Max. 1916/1917. "Jüdische Volksmelodien." *Der Jude* 1: 344–45.

———. 1976. *Die Musik Israels*. 2nd ed. Cassel: Bärenreiter. Orig. publ. 1951.

Buber, Martin. 1949. *Die Erzählungen der Chassidim*. Zurich: Manesse.

———. 1985. *Pfade in Utopia: Über Gemeinschaft und der Verwirklichung*. Heidelberg: Verlag Lambert Schneider. Orig. ed. 1947.

Buhmann, Heide, and Hanspeter Haeseler. 1986. *Das kleine dicke Liederbuch: Lieder und Tänze bis in unsere Zeit*. 4th ed. Schlüchtern: Eigenverlag Heide Buhmann und Hanspeter Haeseler.

Burt, Raymond L. 1990. *Friedrich Salomo Krauss (1859–1938): Selbstzeugnisse und Materialien zur Bibliographie des Volkskundlers, Literaten und Sexualforschers mit einem Nachlaßverzeichnis*. Vienna: Verlag der Österreichischen Akademie der Wissenschaften. (Mitteilungen des Instituts für Gegenwartsvolkskunde, 3)

Cahan, Judah Loeb. 1957. *Yiddishe Folkslider mit Melodies*. New York: YIVO—Yiddish Scientific Institute.

Celan, Paul. 1983. *Gesammelte Werke*. Ed. Beda Allemann and Stefan Reichert, with Rolf Bücher. 5 vols. Frankfurt am Main: Suhrkamp Verlag.

de Certeau, Michel. 1976. "L'Énonciation mystique." *Recherches de science religeuse* 64 (2): 183–215.

Cohen, Judith R. 1993. "Sonography of Judeo-Spanish Song (Cassettes, LPs, CDs, Video, Film)." In Isaac J. Lévy and Rosemary Lévy Zumwalt, eds., *Sephardic Folklore: Exile and Homecoming*, pp. 49–55. Special edition of *Jewish Folklore and Ethnology Review* 15 (2).

Cohen, Richard I. 1998. *Jewish Icons: Art and Society in Modern Europe*. Berkeley: University of California Press.

Comaroff, Jean, and John Comaroff. 1991. *Of Revelation and Revolution: Christianity, Colonialism, and Consciousness in South Africa*. Vol. 1. Chicago: University of Chicago Press.

Csáky, Moritz. 1996. *Ideologie der Operette und Wiener Moderne: Ein kulturhistorischer Essay zur österreichischen Identität*. Vienna: Böhlau Verlag.

Dalinger, Brigitte. 1998a. *Verloschene Sterne: Geschichte des jüdischen Theaters in Wien*. Vienna: Picus Verlag.

———. 1998b. "'Jüdaly mit dem Wandersack' bricht 'auf nach Tel Aviv': Zionismus und populäres jiddisches Theater." *Das jüdische Echo: Zeitschrift für Kultur und Politik* 47: 250–56.

Dalman, Gustaf H. 1891. *Jüdischdeutsche Volkslieder aus Galizien und Russland*. 2nd ed. Berlin: Evangelische Vereins-Buchhandlung. (Schriften des Institutum Judaicum in Berlin, 12). 1st ed. 1888.

Davis, John. 1993. "Modelli del Mediterraneo." In Tullia Magrini, ed., *Antropologia della musica e culture mediterranee*, pp. 89–106. Bologna: Società editrice il Mulino.

Davis, Ruth. Forthcoming. *The Lachmann Archive for Oriental Music*. Middleton, Wis.: A-R Editions. (Recent Researches in the Oral Traditions of Music, 9)

Daxelmüller, Christoph. 1986a. "Max Grunwald and the Origin and Conditions of Jewish Folklore at Hamburg." *Proceedings of the Ninth World Congress of Jewish Studies*, part 2: 73–80.

————. 1986b. "Jewish Popular Culture in the Research Perspective of European Ethnology." *Ethnologia Europaea: Journal of European Ethnology* 16 (2): 97–116.

————. 1987. "Die deutschsprachige Volkskunde und die Juden—Zur Geschichte und den Folgen einer kulturellen Ausklammerung." *Zeitschrift für Volkskunde* 83 (1): 1–20.

————. 1994/1995. "Dr. Max (Meïr) Grunwald, Rabbiner, Volkskundler, Vergessener: Splitter aus der Geschichte des jüdischen Wiens und seines Museums." *Wiener Jahrbuch für jüdische Geschichte, Kultur und Museumswesen* 1: 89–106.

Debus, Karl Heinz, et al. 1981. *Geschichte der Juden in Speyer*. Speyer: Bezirksgruppe Speyer des Historischen Vereins der Pfalz.

Deutsch, Walter, and Rudolf Pietsch, eds. 1990. *Dörfliche Tanzmusik im westpannonischen Raum*. Vienna: A. Schendl. (Schriften zur Volksmusik, 15)

Dohrn, Verena. 1991. *Reise nach Galizien: Grenzlandschaften des alten Europa*. Frankfurt am Main: S. Fischer.

Dreo, Harald, Walter Burian, and Sepp Gmasz, eds. 1988. *Ein burgenländisches Volksliederbuch*. Eisenstadt: Verlag Nentwich-Lattner.

Dreo, Harald, and Sepp Gmasz, eds. 1997. *Volksmusik im Burgenland: Burgenländische Volksballaden*. Vienna: Böhlau Verlag. (Corpus musicae popularis austriacae, 7)

Dümling, Albrecht. 1992. *Die verweigerte Heimat: Léon Jessel—Der Komponist des "Schwarzwaldmädel."* Düsseldorf: Der kleine Verlag.

Eckstaedt, Aaron. 2003. *"Klaus mit der Fiedel, Heike mit dem Bass . . .": Jiddische Musik in Deutschland*. Berlin: Philo Verlag.

Efron, John M. 1994. *Defenders of the Race: Jewish Doctors and Race Science in Fin-de-siècle Europe*. New Haven, Conn.: Yale University Press.

Egger, Margarethe. 1989. *Die Schrammeln in ihrer Zeit*. Vienna: Österreichischer Bundesverlag.

Eichborn, W. J., ed. 1834. *Sammlung der die neue Organisation des Judenwesens in Großherzogthum Posen betreffenden Gesetze, Instrulationen, Rescripts, usw. in deutscher und zugleich hebräischer Schrift*. Posnan: B. L. Monash.

Eilberg-Schwartz, Howard, ed. 1992. *People of the Body: Jews and Judaism from an Embodied Perspective*. Albany: State University of New York Press.

Elazar, Daniel J., and Stuart A. Cohen. 1985. *The Jewish Polity: Jewish Political Organization from Biblical Times to the Present*. Bloomington: Indiana University Press.

Elbogen, Ismar. 1993 [1913]. *Jewish Liturgy: A Comprehensive History*. Trans. Raymond P. Scheindlin. Philadelphia: The Jewish Publication Society; New York: The Jewish Theological Seminary of America. Trans. of *Der jüdische Gottesdienst in seiner geschichtlichen Entwicklung*. 3rd ed. Frankfurt am Main: J. Kauffmann Verlag. Repr.: Hildesheim: Georg Olms Verlag, 1995.

Eliasberg, Ahron, ed. 1913. *Die jüdische Gemeinschaft*. Berlin: Jüdischer Verlag.

Eliasberg, Alexander. 1918. *Ostjüdischer Volkslieder*. Munich: Georg Müller.

Elsner, J., and R. Cardinal, eds. 1994. *The Culture of Collecting*. London: Reaktion Books.

Engel, Carl. 1864. *The Music of the Most Ancient Nations, Particularly of the Assyrians, Egyptians, and Hebrews; with Special Reference to Discoveries in Western Asia and in Egypt*. London: William Reeves.

Ernst, August. 1987. *Geschichte des Burgenlandes*. Vienna: Verlag für Geschichte und Politik. (Geschichte der österreichischen Bundesländer)

Fabian, Johannes. 1982. *Time and the Other: How Anthropology Makes Its Objects.* New York: Columbia University Press.

Farmer, Henry George. 1940. *The Sources of Arabian Music: An Annotated Bibliography of Arabic Manuscripts Which Deal with the Theory, Practice, and History of Arabian Music.* Bearsden: The author.

Felstiner, John. 1995. *Paul Celan: Poet, Survivor, Jew.* New Haven, Conn.: Yale University Press.

Fiedler, Jiří. 1991. *Jewish Sights of Bohemia and Moravia.* Prague: Sefer.

Fink, G. W. 1831. *Erste Wanderung der ältesten Tonkunst als Vorgeschichte der Musik, oder als erste Periode derselben.* Essen: G. D. Bädeker.

Fischer, Jens Malte. 2000. *Richard Wagners 'Das Judentum in der Musik'—Eine kritische Dokumentation als Beitrag zur Geschichte des Antisemitismus.* Frankfurt am Main: Insel.

Flam, Gila. 1986. "Beracha Zephira—A Case Study of Acculturation in Israeli Song." *Asian Music* 17 (2): 108–25.

Franzos, Karl Emil. 1877–1878. *Vom Don zur Donau: Neue Culturbilder aus "Halb-Asien."* 2 vols. Leipzig: Duncker & Humblot.

———. 1929. *Die Juden von Barnow.* Stuttgart: J. B. Cotta'sche Buchhandlung.

———. 1988. *Erzählungen aus Galizien und der Bukowina.* Ed. J. P. Strelka. Berlin: Nicolai.

Freeden, Herbert. 1987. *Die jüdische Presse im Dritten Reich.* Frankfurt am Main: Jüdischer Verlag bei Athenäum.

Friedmann, Aron. 1904. *Der synagogale Gesang.* Berlin: C. Boas Nachf.

Fritsche, Peter. 1996. *Reading Berlin 1900.* Cambridge, Mass.: Harvard University Press.

Frühauf, Tina. 2003. "Jüdisch-liturgische Musik in Wien: Ein Spiegel kultureller Vielfalt." In Leon Botstein and Werner Hanak, eds., *Quasi una fantasia: Juden und die Musikstadt Wien,* pp. 77–91. Vienna: wolke.

———. 2005. *Orgel und Orgelmusik in deutsch-jüdischer Kultur.* Hildesheim: Georg Olms Verlag. (Netiva)

———. 2008. *The Organ and Its Music in German-Jewish Culture.* New York: Oxford University Press.

Fuchs, Manfred. 1990. Interview with the author.

Funkenstein, Amos. 1994. "Reform und Geschichte: Die Modernisierung des deutschen Judentums." In Shulamit Volkov, ed., *Deutsche Juden und die Moderne,* pp. 1–8. Munich: R. Oldenbourg Verlag.

Gerson-Kiwi, Edith. 1938. "Jerusalem Archive for Oriental Music"—"Wege und Ziele des Jerusalemer Archivs für orientalische Musik." *Musica Hebraica* 1–2: 40–42.

———. 1980. *Migrations and Mutations of the Music in East and West: Selected Writings.* Tel Aviv: Tel Aviv University, Department of Musicology.

Gilman, Sander L. 1991a. *Inscribing the Other.* Lincoln: University of Nebraska Press. (Texts and Contexts, 1)

———. 1991b. *The Jew's Body.* New York: Routledge.

Gilroy, Paul. 1993. *The Black Atlantic: Modernity and Double Consciousness.* Cambridge, Mass.: Harvard University Press.

Ginsburg, Shaul M., and Pesach S. Marek. 1901. *Evreiskie narodnye pesni v Rossii.* St. Petersburg: Voskhod.

Glaser, Karl, ed. 1914. *Blau-Weiß Liederbuch.* 1st ed. Berlin: Jüdischer Verlag.

Goehr, Lydia. 1992. *The Imaginary Museum of Musical Works: An Essay in the Philosophy of Music.* Oxford: Oxford University Press.

Goitein, S. D. 1967–1993. *A Mediterranean Society: The Jewish Communities of the Arab World as Portrayed in the Documents of the Cairo Geniza.* 5 vols. Berkeley: University of California Press.

Gold, Hugo. 1970. *Gedenkbuch der untergegangenen Judengemeinden des Burgenlandes.* Tel-Aviv: Olamenu.

Goldmark, Karl. 1922. *Erinnerungen aus meinem Leben.* Vienna: Rikola Verlag.

Gradenwitz, Peter. 1996a. *The Music of Israel: From the Biblical Era to Modern Times.* 2nd ed., rev. and expanded. Portland, Ore.: Amadeus Press.

———. 1996b. "'So singet uns von Zijons Sang!'—Jüdische Musik und Musiker in ihrer Umwelt." In Andreas Nachama, Julius H. Schoeps, and Edward van Voolen, eds., *Jüdische Lebenswelten.* Vol. 1: *Essays,* pp. 185–202.

Greenblatt, Stephen. 1991. *Marvelous Possessions: The Wonder of the New World.* Chicago: University of Chicago Press.

Grözinger, Karl-Erich. 1987. "Himmlische Gerichte, Wiedergänger und Zwischenweltliche in der ostjüdischen Erzählung." In Karl-Erich Grözinger, Stéphane Mosès, and Hans Dieter Zimmermann, eds., *Kafka und das Judentum,* pp. 93–112.

Grözinger, Karl-Erich, Stéphane Mosès, and Hans Dieter Zimmermann, eds. 1987. *Franz Kafka und das Judentum.* Frankfurt am Main: Jüdischer Verlag bei Athenäum.

Gruber, Ruth Ellen. 1992. *Jewish Heritage Travel: A Guide to Central and Eastern Europe.* New York: John Wiley and Sons.

———. 2002. *Virtually Jewish: Reinventing Jewish Culture in Europe.* Berkeley: University of California Press.

Grunwald, Max. 1924/1925. *Mattersdorf.* Special edition of *Jahrbuch für jüdische Volkskunde.*

———. 1936. *Vienna.* Trans. Solomon Grayzel. Philadelphia: The Jewish Publication Society of America.

Habermas, Jürgen. 1962. *Strukturwandel der Öffentlichkeit: Untersuchungen zu einer Kategorie der bürgerlichen Gesellschaft.* Neuwied: Hermann Luchterhand.

Hahn, Joachim. 1988. *Erinnerungen und Zeugnisse jüdischer Geschichte in Baden-Württemburg.* Stuttgart: Konrad Theiss Verlag.

Haid, Gerlinde. 1999. "'. . . mit Grazie und nicht ohne Humor.'" In Nora Schönfellinger, ed., *"Conrad Mautner, grosses Talent,"* pp. 67–90.

Hannak, Jacques. 1931. "Fünfzig Jahre 'Klabriaspartie.'" *Arbeiter-Zeitung* (January 1): 13.

Harel-Chosen, Sarah, ed. 1994. *Otsarot genuzim: Osfe omanut yehudit mi-Galitsiyah me-ha-muze'on le-etnografyah ve-le-omanuyot bi-Levov* (Rediscovered Treasures: Judaica Collections from Galicia, from the Lvov Museum of Ethnography and Crafts). Tel Aviv: Beth Hatfutsot.

Harrán, Don. 1999. *Salamone Rossi: Jewish Musician in Late Renaissance Mantua.* Oxford: Oxford University Press.

Heine, Heinrich. 1987. *Der Rabbi von Bacherach.* Munich: Goldmann. Orig. publ. 1840.

———. 1997. *Prinzessin Sabbat: Über Juden und Judentum.* Ed. Paul Peters. Bodenheim: Philo Verlag.

Hemsi, Alberto. 1995. *Cancionero sefardí.* Ed. with an Introduction by Edwin Seroussi. Jerusalem: The Jewish Music Research Centre, The Hebrew University of Jerusalem.

Herder, Johann Gottfried. 1778/1779. *"Stimmen der Völker in Liedern"* and *Volkslieder.* Leipzig: Weygandsche Buchhandlung.

Herrmann, Wilhelm. 1954[?]. *Musizieren um des Musizierens Willen: 125 Jahre Mannheimer Liebhaber-Orchester.* Mannheim: Kessler Verlag.

Herzberg-Fränkl, Leo. 1898. "Die Juden." In *Die österreichisch-ungarische Monarchie in Wort und Bild.* Vol. 19: *Galizien,* pp. 475–500. Vienna: Kaiserlich-königliche Hof- und Staatsdruckerei.

Herzfeld, Michael. 1991. *A Place in History: Social and Monumental Time in a Cretan Town.* Princeton, N.J.: Princeton University Press.

———. 1997. *Cultural Intimacy: Social Poetics in the Nation-State.* New York: Routledge.

Herzl, Theodor. 1896. *Der Judenstaat: Versuch einer modernen Lösung der Judenfrage.* Leipzig: M. Breitenstein.

————. 1935. *Altneuland.* Berlin: Jüdischer Verlag. Orig. publ. 1904.

Hess, Jonathan M. 2002. *Germans, Jews and the Claims of Modernity.* New Haven, Conn.: Yale University Press.

Hirsch, Erika. 1996. *Jüdisches Vereinsleben in Hamburg bis zum Ersten Weltkrieg: Jüdisches Selbstverständnis zwischen Antisemitismus und Assimilation.* Frankfurt am Main: Peter Lang. (Judentum und Umwelt, 63)

Hirsch, Lily. 2006. "Imagining 'Jewish Music': Der Jüdische Kulturbund and Musical Politics in Nazi Germany 1933–1941." Ph.D. dissertation, Duke University.

Hirschler, Gertrude, ed. 1988. *Ashkenaz: The German Jewish Heritage.* New York: Yeshiva University Museum.

Hirshberg, Jehoash. 1995. *Music in the Jewish Community of Palestine, 1880–1948: A Social History.* Oxford: Oxford University Press.

Hobsbawm, Eric. 1983. "Mass-Producing Traditions: Europe, 1870–1914." In Eric Hobsbawn and Terence Ranger, eds., *The Invention of Tradition*, pp. 263–307. Cambridge: Cambridge University Press.

————, and Terence Ranger, eds. 1983. *The Invention of Tradition.* Cambridge: Cambridge University Press.

Hödl, Klaus. 1991. *"Vom Schtetl an die Lower East Side": Galizische Juden in New York.* Vienna: Böhlau Verlag. (Böhlaus Zeitgeschichtliche Bibliothek, 19)

————. 1994. *Als Bettler in die Leopoldstadt: Galizische Juden auf dem Weg nach Wien.* Vienna: Böhlau Verlag. (Böhlaus Zeitgeschichtliche Bibliothek, 27)

Hsia, R. Po-chia. 1988. *The Myth of Ritual Murder: Jews and Magic in Reformation Germany.* New Haven, Conn.: Yale University Press.

Idelsohn, A. Z. 1914–1932. *Hebräisch-orientalischer Melodienschatz.* 10 vols. Berlin: Benjamin Harz.

————. 1914. *Gesänge der jemenitischen Juden (zum ersten Male gesammelt, erläutert und herausgegeben von A. Z. Idelsohn).* Vol. 1: *Hebräisch-orientalischer Melodienschatz.* Jerusalem: Benjamin Harz.

————. 1917. *Phonographierte Gesänge und Aussprachsproben des Hebräischen der jemenitischen, persischen und syrischen Juden (= 35. Mitteilung der Phonogramm-Archivs-Kommission der Kaiserlichen Akademie der Wissenschaften in Wien).* Vienna: Alfred Hölder.

————. 1922a. *Gesänge der babylonischen Juden.* Vol. 2: *Hebräisch-orientalischer Melodienshatz.* Jerusalem: Benjamin Harz.

————. 1922b. *Gesänge der persischen, bucharischen und daghestanischen Juden.* Vol. 3: *Hebräisch-orientalischer Melodienschatz.* Jerusalem: Benjamin Harz.

————. 1923. *Gesänge der orientalischen Sefardim.* Vol. 4: *Hebräisch-orientalischer Melodienschatz.* Jerusalem: Benjamin Harz.

————. 1925. "Songs and Singers of the Synagogue in the Eighteenth Century: With Special Reference to the Birnbaum Collection of the Hebrew Union College Library." *Hebrew Union College Jubilee Volume, 1875–1925*, pp. 397–424. Cincinnati: Hebrew Union College.

————. 1929a. *Jewish Music in Its Historical Development.* New York: Holt, Rinehart and Winston. 1st Schocken ed., 1967.

————. 1929b. *Gesänge der marokkanischen Juden.* Vol. 5: *Hebräisch-orientalischer Melodienschatz.* Jerusalem: Benjamin Harz.

————. 1932a. *Der Synagogengesang der deutschen Juden im 18. Jahrhundert.* Vol. 6: *Hebräisch-orientalischer Melodienschatz.* Leipzig: Friedrich Hofmeister.

————. 1932b. *Die traditionellen Gesänge der süddeutschen Juden.* Vol. 7: *Hebräisc-orientalischer Melodienschatz.* Leipzig: Friedrich Hofmeister.

_____. 1932c. *Der Synagogengesang der osteuropäischen Juden*. Vol. 8: *Hebräisch-orientalischer Melodienschatz*. Leipzig: Friedrich Hofmeister.

_____. 1932d. *Der Volksgesang der osteuropäischen Juden*. Vol. 9: *Hebräisch-orientalischer Melodienschatz*. Leipzig: Friedrich Hofmeister.

_____. 1932e. *Gesänge der Chassidim*. Vol. 10: *Hebräisch-orientalischer Melodienschatz*. Leipzig: Friedrich Hofmeister.

_____. 1935. "My Life." *Jewish Music Journal* 2 (2): 8–11. Repr. in *Yuval* 5 (1986): 18–23.

_____. 1951. *Sepher shirat yisrael: The Jewish Song Book, for Synagogue, School and Home, Covering the Complete Jewish Religious Year*. 3rd ed., enlarged and rev. Cincinnati: Otto Zimmerman and Sons.

Israelitische Kultusgemeinde, ed. 1988. *Der Wiener Stadttempel: Die Wiener Juden*. Vienna: J & V Edition.

Jaldati, Lin, and Eberhard Robling. 1985. *Es brennt Brüder, es brennt: Jiddische Lieder*. Berlin: Rütten & Loening.

Jiddische Erzählungen. 1984. *Jiddische Erzählungen von Mendele Mojcher Sforim, Jizchak Lejb Perez, Scholem Alejchem*. Zurich: Manesse.

John, Eckhard. 1991. "Musik und Konzentrationslager: Eine Annäherung." *Archiv für Musikwissenscahft* 48: 1–36.

Jüdisches Museum der Stadt Wien, ed. 1997/1998. *Über Erinnerung*. Special edition of *Wiener Jahrbuch für jüdische Geschichte, Kultur und Museumswesen* 3. Vienna: Verlag Christian Brandstätter.

Kalmar, Ivan Davidson. 2001. "Moorish Style: Orientalism, the Jews, and Synagogue Construction." *Jewish Social Studies* 7 (2): 68–100.

_____, and Derek J. Penslar, eds. 2005. *Orientalism and the Jews*. Waltham, Mass.: Brandeis University Press.

Kara, Yadé. 2003. *Selam Berlin*. Zurich: Diogenes.

Karas, Joža. 1985. *Music in Terezín, 1941–1945*. New York: Beaufort Books.

Karpinski, Igor. 2003. "Das Werk Alexander Lokschins und die nationale jüdische Tradition." In Ernst Kuhn, Jascha Nemtsov, and Andreas Wehrmeyer, eds., *"Samuel" Goldenberg und "Schmuyle": Jüdisches und Antisemitisches in der russischen Musikkultur*, pp. 187–203. Berlin: Verlag Ernst Kuhn.

Katz, Ruth. 2003. *"The Lachmann Problem": An Unsung Chapter in Comparative Musicology*. Jerusalem: The Hebrew University Magnes Press.

Kaufmann, Fritz Mordechai. 1919. *Vier Essais über ostjüdische Dichtung und Kultur*. Berlin: Welt Verlag.

_____. 1920. *Die schönsten Lieder der Ostjuden*. Berlin: Jüdischer Verlag.

Keil, Martha, ed. 1995. *Jüdisches Stadtbild: Wien*. Frankfurt am Main: Jüdischer Verlag.

Dem Khazzns Kindl. 1937. *Dem Khazzns Kindl*. Directed by Sidney Goldin and Ilya Motyleff. Available on video as Ergo 767.

Kift, Roy. 1998. "Reality and Illusion in the Theresienstadt Cabaret." In Claude Schumacher, ed., *Staging the Holocaust: The Shoah in Drama and Performance*, pp. 147–69. Cambridge: Cambridge University Press.

Kipnis, M. n.d. *Folkslider: Konzert-Repertoire*. Warsaw: Di Welt.

Kirsch, Jan-Holger. 2003. *Nationaler Mythos oder historische Trauer? Der Streit um ein zentrales "Holocaust-Mahnmahl" für die Berliner Republik*. Cologne: Böhlau Verlag. (Beiträge zur Geschichtskultur, 25)

Kittler, Friedrich A. 1990. *Discourse Networks, 1800/1900*. Trans. Michael Metteer, with Chris Cullens. Stanford, Cal.: Stanford University Press.

Klampfer, Josef. 1966. *Das Eisenstädter Ghetto*. Eisenstadt: Burenländisches Landesarchiv. (Burgenländische Forschungen, 51)

Klein, Hans-Günter, ed. 1992. *Viktor Ullmann—Materialien*. Hamburg: Von Bockel Verlag.

Klenovský, Jaroslav. 1994. *Židovské památky Mikulova*. Mikulov: Regional Museum of Mikulov.

Knapp, Maurus. n.d. Manuscript in the possession of Alexander Knapp, London.

Kohlbauer-Fritz, Gabriele. 1993. "Zur Geschichte der Juden in Lemberg." In Hans Bisanz, ed., *Lemberg/L'viv, 1772–1918: Wiederbegegnung mit einer Landeshauptstadt der Donaumonarchie*, pp. 17–21. Vienna: Eigenverlag der Museen der Stadt Wien.

———. 1994/1995. "Judaicasammlungen zwischen Galizien und Wien: Das Jüdische Museum in Lemberg und die Sammlung Maximilian Goldstein." *Wiener Jahrbuch für jüdische Geschichte, Kultur und Museumswesen* 1: 133–45.

Koller, Josef. 1931. *Das Wiener Volkssängertum in alter und neuer Zeit*. Vienna: Gerlach & Wiedling.

Kraus, Karl. 1992. *Theater der Dichtung: Nestroy—Zeitstrophen*. Frankfurt am Main: Suhrkamp. (Karl Kraus Schriften, 14)

Krauss, Friedrich S. 1890. *Das Minnelied des deutschen Land- und Stadtvolkes*. Hanau: Karl Schustek.

Krekovičová, Eva. 1998. *Zwischen Toleranz und Barrieren: Das Bild der Zigeuner und Juden in der slowakischen Folklore*. Frankfurt am Main: Peter Lang. (Studien zur Tsiganologie und Folkloristik, 21)

Kuhn, Ernst, Jascha Nemtsov, and Andreas Wehrmeyer, eds. 2003. *"Samuel" Goldenberg und "Schmuyle": Jüdisches und Antisemitisches in der russischen Musikkultur*. Berlin: Verlag Ernst Kuhn. (Studia slavica musicologica, 27)

Labsch-Benz, Elfie. 1981. *Die jüdische Gemeinde Nonnenweier: Jüdisches Leben und Brauchtum in einer badischen Landgemeinde zu Beginn des 20. Jahrhunderts*. Freiburg im Breisgau: Verlag Wolf Mersch.

Lachmann, Robert. 1929. *Musik des Orients*. Breslau: Ferdinant Hirt. (Jedermanns Bücherei)

———. 1974. *Die Musik im Volksleben Nordafrikas* and *Orientalische Musik und Antike*. Jerusalem: Magnes Press of the Hebrew University. (Yuval Monograph Series, 2)

———. 1976. *Gesänge der Juden auf der Insel Djerba*. Jerusalem: Magnes Press of the Hebrew University. First publ. 1940. (Yuval Monograph Series, 7)

Landmann, Salcia. 1985. "Das Volkslied der Juden." *Jahrbuch für Volksliedforschung* 30: 93–98.

———. 1995. *Mein Galizien: Das Land hinter den Karpaten*. Munich: Herbig.

Lappin, Eleonore. 2000. *Der Jude: Die Geschichte einer Zeitschrift*. Tübingen: Mohr Siebeck.

Lautarchiv of the Humboldt Universität zu Berlin. www.hu-berlin.de/lautarchiv.

Lemm, Manfred. 1992. *Mordechaj Gebirtig: Jiddische Lieder*. Wuppertal: Edition Künstlertreff.

Lenneberg, Hans. 1991. Personal communication. October 15.

Levi, Erik. 1994. *Music in the Third Reich*. New York: St. Martin's.

Levi, John. 1997. "About the Recordings." In Avner Bahat, ed., *The Musical Tradition of the Jewish Reform Congregation in Berlin*, pp. 4–5. Tel-Aviv: Beth Hatefutsoth.

Levi, Salli. 1936. "Erschaffung des Wentzentrum für jüdische Musik in Palästina." (Typescript)

Levi, Salo B. 1929[?]. *Das Judentum in der Musik*. Frankfurt am Main: Frankfurter zionistischer Vereinigung.

Levy, Isaac. 1963. *The Synagogue: Its History and Function*. London: Vallentine and Mitchell.

Lévy, Isaac J., and Rosemary Lévy Zumwalt, eds. 1993. *Sephardic Folklore: Exile and Homecoming*. Special edition of *Jewish Folklore and Ethnology Review* 15 (2).

Lind, Tore Tvarnø. 2003. "The Past Is Always Present: An Ethnomusicological Investigation of the Musical Tradition at Mount Athos." Ph.D. dissertation, University of Copenhagen.

Loewe, Heinrich, ed. 1894. *Lieder-Buch für jüdische Vereine*. Berlin: Hugo Schildberger.

Lortat-Jacob, Bernard. 1995. *Sardinian Chronicles*. Trans. Teresa Lavender Fagan. Chicago: University of Chicago Press. (Chicago Studies in Ethnomusicology)

von der Lühe, Barbara. 1998. *Die Musik war unsere Rettung! Die deutschsprachigen Gründungsmitglieder des Palestine Orchestra*. Tübingen: Mohr Siebeck. (Schriftenreihe wissenschaftlicher Abhandlungen des Leo Baeck Instituts, 58)

Lyß, Julia. 2007. "Jüdische Selbstwahrnehmung im 19. Jahrhundert: Der Komponist Louis Lewandowski." M.A. thesis, Humboldt-Universität zu Berlin.

Mack, Michael. 2003. *German Idealism and the Jew: The Inner Anti-Semitism of Philosophy and German-Jewish Responses*. Chicago: University of Chicago Press.

Maderthaner, Wolfgang, and Lutz Musner. 1999. *Die Anarchie der Vorstadt: Das andere Wien um 1900*. Frankfurt am Main: Campus Verlag.

Malino, Frances, and David Sorkin, eds. 1991. *From East and West: Jews in a Changing Europe, 1750–1870*. Oxford: Blackwell. Repr. as *Profiles in Diversity: Jews in a Changing Europe, 1750–1870*. Detroit: Wayne State University Press, 1998.

Mamele. 1838. *Mamele*. Directed by Joesph Green. Music by Abe Ellstein. Available on video as Ergo 720.

Manuel, Frank E., and Fritzie P. Manuel. 1979. *Utopian Thought in the Western World*. Cambridge, Mass.: Belknap Press of the Harvard University Press.

Marks, Elaine. 1996. *Marrano as Metaphor: The Jewish Presence in French Writing*. New York: Columbia University Press.

Matwejewa, Julia. 2003. "Der Pianist und Kulturpolitiker David Schorr (1867–1942)—ein Porträt." In Ernst Kuhn, Jascha Nemtsov, and Andreas Wehrmeyer, eds., *"Samuel" Goldenberg und "Schmuyle": Jüdisches und Antisemitisches in der russischen Musikkultur*, pp. 119–49. Berlin: Verlag Ernst Kuhn.

Maurer, Lutz. 1999. "An der schönen blauen Donau." In Schönfellinger, ed., *"Conrad Mautner, grosses Talent,"* pp. 27–48.

Mautner, Konrad. 1909. "Unterhaltungen der Gößler Holzknechte." *Zeitschrift für österreichische Volkskunde* 15: 162–69.

———. 1910a. *Steyerisches Rasplwerk: Vierzeiler, Lieder und Gasslreime aus Goessl am Grundlsee: In Wort und Weise gesammelt, aufgeschrieben und mit Bildern versehen*. Vienna: Stähelin und Lauenstein.

———. 1910b. "Die Ausseer Tracht." *Zeitschrift für österreichische Volkskunde* 16: 145–59.

———. 1918. "Der Volksliederreichtum der Monarchie." *Zeitschrift für österreichische Volkskunde* 24: 97–104.

Max, Joseph, and Cäsar Seligmann. 1930. "Orgelstreit." *Jüdisches Lexikon*, columns 601–4. Berlin: Jüdischer Verlag.

Meisels, Abisch. 2000. *Von Sechistow bis Amerika/Fun Sechisstow bis Amerika: Eine jiddische Revue/a rewi*. Vienna: Picus Verlag.

Meyer, Michael A. 1979. *The Origins of the Modern Jew: Jewish Identity and European Culture in Germany, 1749–1824*. Detroit: Wayne State University Press.

———. 1988. *Response to Modernity: A History of the Reform Movement in Judaism*. New York: Oxford University Press.

Migdal, Ulrike. 1986. *Und die Musik spielt dazu: Chansons und Satiren aus dem KZ Theresienstadt*. Munich: Piper.

More, Thomas. 1965. *Utopia*. London: Penguin. Orig. publ. 1516.

Morgenstern, Soma. 1999. *Funken im Abgrund*. Trilogy of novels. Vol. 1: *Der Sohn des verlorenen Sohnes*. Vol. 2: *Idyll im Exil*. Vol. 3: *Das Vermächtnis des verlorenen Sohnes*. Berlin: Aufbau Taschenbuch Verlag.

Móricz, Klára. 2001. "Sensuous Pagans and Righteous Jews: Changing Concepts of Jewish Identity in Ernest Bloch's *Jézabel* and *Schelomo*." *Journal of the American Musicological Society* 54 (3): 439–92.

Mosse, George L. 1974. "Tod, Zeit und Geschichte: Die völkische Utopie der Überwindung." In Reinhold Grimm and Jost Hermand, eds., *Deutsches utopisches Denken im 20. Jahrhundert,* pp. 50–69. Stuttgart: W. Kohlhammer.

———. 1997. "Personal Reflections." In Avner Bahat, ed., *The Musical Tradition of the Jewish Reform Congregation in Berlin,* pp. 6–9. Tel-Aviv: Beth Hatefutsoth.

———. 1999. *Confronting History: A Memoir.* Madison: University of Wisconsin Press.

Muensterberger, Werner. 1993. *Collecting, an Unruly Passion: Psychological Perspectives.* Princeton, N.J.: Princeton University Press.

Müller, Melissa, and Reinhard Piechocki. 2006. *Alice Herz-Sommer, "Ein Garten Eden inmitten der Hölle": Ein Jahrhundertleben.* Munich: Droemer Verlag.

Nadel, Arno. 1916–1917. "Jüdische Volkslieder" (in 9 parts), *Der Jude* 1 (2): 112–22; 1 (3): 182–94; 1 (4): 255–67; 1 (5): 326–39; 1 (7): 465–79; 1 (9): 623–30; 1 (10): 691–700; 1 (11): 759–71; 1 (12): 834–46.

———. 1923. *Jüdische Liebeslieder (Volkslieder).* Berlin: Benjamin Harz.

———. 1938. *Zemirot shabbat: Die häuslichen Sabbatgesänge.* Berlin: Schocken.

Nathan, Hans, ed. 1994. *Israeli Folk Music: Songs of the Early Pioneers.* Madison, Wis.: A-R Editions. (Recent Researches in the Oral Traditions of Music, 4)

Naumbourg, Samuel. 1874. "Étude historique sur la musique des Hébreux." *Agudath Shirim: Recueil des chants religieux et populaires des Israélites* 1874: xliii–xlvi.

Nemtsov, Jascha. 2004. *Die Neue Jüdische Schule in der Musik.* Wiesbaden: Harrassowitz Verlag.

———, ed. 2006. *Jüdische Kunstmusik im 20. Jahrhundert: Quellenlage, Entwicklungsgeschichte, Stilanalysen.* Wiesbaden: Harrassowitz Verlag.

Nettl, Paul. 1923. *Alte jüdische Spielleute und Musiker.* Prague: Josef Flesch.

———. 1963. "Rossi, Salamone." In *Die Musik in Geschichte und Gegenwart.* Vol. 9: 944–48. Cassel: Bärenreiter.

Noll, William. 1991. "Economics of Music Patronage among Polish and Ukrainian Peasants to 1939." *Ethnomusicology* 35 (3): 349–79.

Nora, Pierre. 1984–1992. *Les lieux de mémoire.* Paris: Éditions Gallimard.

Oron, Michael. 1987. "Kafka und Nachman von Bratzlaw: Erzählen zwischen Traum und Erwartung." In Karl-Erich Grözinger, Stéphane Mosès, and Hans Dieter Zimmermann, eds., *Kafka und das Judentum,* pp. 113–21.

Österreichische Akademie der Wissenschaften, ed. 2005. *The Collection of Abraham Zvi Idelsohn (1911–1913).* 3 CDs and a CD-ROM. Accompanying book, with essays by Philip V. Bohlman and Edwin Seroussi, and transcriptions by Amnon Shappira. Vienna: Verlag der Österreichischen Akademie der Wissenschaften. (Tondokumente aus dem Phonogrammarchiv der Österreichischen Akademie der Wissenschaften, 9)

Pearce, Susan M. 1992. *Museums, Objects and Collections: A Cultural Study.* Leicester: Leicester University Press.

———. 1998. *Collecting in Contemporary Practice.* London: Sage.

Peretz, L. 1898. "Judendeutsche Volkslieder aus Rußland." *Der Urquell* 2 (N.F.) (1): 27–29.

Pertinaz, Doc. 1996. *Homo collector.* Barcelona: Pandora. (Futura ediciones)

Peters, F. E. 1994. *The Hajj: The Muslim Pilgrimage to Mecca and the Holy Places.* Princeton, N.J.: Princeton University Press.

Petzoldt, Leander. 1982. *Bänkellieder und Moritaten aus dre Jahrhunderten.* Frankfurt am Main: Fischer Taschenbuch Verlag.

Pfannkuch, Wilhelm, and Gerhard J. Winkler. 2001. "Goldmark, Karl." In Stanley Sadie, ed., *The New Grove Dictionary of Music and Musicians.* 2nd ed. Vol. 10: 98–100. London: Macmillan.

Philo-Lexikon. 1935. *Philo-Lexikon: Handbuch des jüdischen Wissens.* Berlin: Philo Verlag.

Planer, John H. 1998. "Introduction to the Birnbaum Collection." Unpublished paper delivered at the conference, "Music, Spirit and Scholarship: The Legacy of Eduard Birnbaum," November 22–23.

Pollack, Herman. 1971. *Jewish Folkways in Germanic Lands (1648–1806): Studies in Aspects of Daily Life*. Cambridge, Mass.: MIT Press.

Pollack, Martin. 1984. *Nach Galizien—Von Chassiden, Huzulen, Polen und Ruthenen: Eine imaginäre Reise durch die verschwundene Welt Ostgaliziens und der Bukovina*. Vienna: Christian Brandstätter.

Preßl, Hans. 1999. "Zwischen Fotzhobl und Wiener Salon." In Nora Schönfellinger, ed., *"Conrad Mautner, grosses Talent,"* pp. 91–111.

Pressler, Gertraud. 1995. " . . . 'an echt's Weanakind'? Zur Gustav Pick-Gedenkfeier am Wiener Zentralfriedhof." *Bockkeller: Die Zeitung des Wiener Volksliedwerks* 1 (1): 6–7.

Der Purimspilr. 1937. *Der Purimshpilr*. Directed by Joseph Green. Music by Nicholas Brodsky. Available on Ergo 715.

Quinzio, Sergio. 1995. *Die jüdischen Wurzeln der Moderne*. Trans. Martina Kempter. Frankfurt am Main: Campus Verlag.

Reischauer, Martina. 1999. "Lebendiges Erbe: Der Mautner Handdruck." In Nora Schönfellinger, ed., *"Conrad Mautner, grosses Talent,"* pp. 134–47.

Reisenfeld, Robin. 1992. *The German Print Portfolio, 1890–1930: Serials for a Private Sphere*. Ed. Richard A. Born and Stephanie D'Alessandro. London: Philip Wilson Publishers.

Reiss, Johannes. 1995. *Hier in der heiligen jüdischen Gemeinde Eisenstadt: Die Grabinschriften des jüngeren Friedhofes in Eisenstadt*. Eisenstadt: Österreichisches Jüdisches Museum in Eisenstadt.

———. 1997. *Aus den Sieben Gemeinden: Ein Lesebuch über Juden im Burgenland*. Eisenstadt: Österreichisches Jüdisches Museum.

Reiterits, Anton. 1988. *Dörfl: Gebrauchsmusik in einem burgenländischen Ort*. Ed. Walter Deutsch and Helga Thiel. Eisenstadt: Burgenländisches Landesmuseum. (Wissenschaftliche Arbeiten aus dem Burgenland, 80)

Rosenberg, Felix. 1888. *Über eine Sammlung deutscher Volks- und Gesellschaftslieder in hebräischen Lettern*. Braunschweig: Eugen Appelhaus.

Rosenfeld, Morris. 1902. *Lieder des Ghetto*. 6th ed. Berlin: Hermann Seemann.

Roskies, David G. 1999. *The Jewish Search for a Usable Past*. Bloomington: Indiana University Press.

Rösler, Walter, ed. 1991. *Gehn ma halt a bisserl unter: Kabarett in Wien von den Anfängen bis heute*. Berlin: Henschel.

Rossen, Jane Mink, and Uri Sharvit. 2006. *A Fusion of Traditions: Liturgical Music in the Copenhagen Synagogue*. Odense: University Press of Southern Denmark.

Rossi, Salamone. 1995–2003. *Complete Works*. Ed. Don Harrán (Corpus mensurabilis musicae, 100, 13 vols. in 14 (Neuhausen-Stuttgart: Hänssler-Verlag for the American Institute of Musicology).

Roth, Joseph. 1978. *Die Flucht ohne Ende: Ein Bericht*. Munich: Deutscher Taschenbuch Verlag.

———. 2001. *Kaffeehaus-Frühling: Ein Wien-Lesebuch*. Ed. Helmut Peschina. Cologne: Kiepenhauer & Witsch.

Rupp-Eisenreich, Britta, and Justin Stagl, eds. 1995. *Kulturwissenschaften im Vielvölkerstaat: Zur Geschichte der Ethnologie und verwandter Gebiete in Österreich, ca. 1780 bis 1918*. Vienna: Böhlau. (Ethnologica Austriaca, 1)

Sacher-Masoch, Leopold von. 1892. *Jüdisches Leben in Wort und Bild*. Mannheim: J. Bensheimer.

Sachs, Curt. 1924. *Musik des Altertums*. Breslau: Ferdinand Hirt. (Jedermanns Bücherei)

Said, Edward W. 1978. *Orientalism*. New York: Random House.

Salmen, Walter. 1991. *". . . denn die Fiedel macht das Fest": Jüdische Musikanten und Tänzer vom 13. bis 20. Jahrhundert*. Innsbruck: Edition Helbling.

Schedtler, Susanne, ed. 2004. *Wienerlied und Weana Tanz*. Vienna: Löcker Verlag. (Beiträge zur Wiener Musik, 1)

Schiller, David M. 2003. *Bloch, Schoenberg and Bernstein: Assimilating Jewish Music*. Oxford: Oxford University Press.

Schmidt, Esther. 1998. "Die Idee von Professionalismus in der musikalischen Welt des Judentums: Wien im neunzehnten Jahrhundert und die Gründung der Österreichisch-ungarischen Cantoren-Zeitung." M.A. thesis, University of Vienna.

Schneider, Albrecht. 1991. "Psychological Theory and Comparative Musicology." In Bruno Nettl and Philip V. Bohlman, eds., *Comparative Musicology and Anthropology of Music*, pp. 293–317. Chicago: University of Chicago Press.

Schneider, Peter Joseph. 1834. *Biblisch-geschichtliche Darstellung der hebräischen Musik*. Bonn: Verlag der Oberländischen Buch-, Kunst- und Musikhandlung von Dunst und Comp.

Schönberg, Jacob. 1926. *Die traditionellen Gesänge des israelitischen Gottesdienstes in Deutschland*. Nuremberg: Erich Spandel.

_____. 1947. *Shireh eretz yisrael*. Jerusalem: Hoza'ah ivrit. Orig. publ.: Berlin: Schocken Verlag, 1938.

Schorske, Carl E. 1980. *Fin-de-siècle Vienna: Politics and Culture*. New York: Alfred A. Knopf.

_____. 1996. *Eine österreichische Identität: Gustav Mahler*. Vienna: Picus Verlag. (Wienervorlesungen im Rathaus, 51)

_____. 1998. *Thinking with History: Explorations in the Passage to Modernism*. Princeton, N.J.: Princeton University Press.

Schultz, Ingo, ed. 1993. *Viktor Ullmann: 26 Kritiken über musikalische Veranstaltungen in Theresienstadt*. Hamburg: Von Bockel Verlag. (Verdrängte Musik, 3)

Schumann, Coco. 1997. *Der Ghetto Swinger: Eine Jazzlegende erzählt*. Ed. Max Christian Graff and Michaela Haas. Munich: Deutscher Taschenbuch Verlag.

Schwab, Heinrich W. 1973. "Das Vereinslied des 19. Jahrhunderts." In Rolf Wilhelm Brednich, Lutz Röhrich, and Wolfgang Suppan, eds., *Handbuch des Volksliedes*. Vol. 1: *Die Gattungen des Volksliedes*, pp. 863–98. Munich: Verlag Fink.

Sebald, W. G. 1991. "Westwärts-Ostwärts: Aporien deutschsprachiger Ghettogeschichten." In W. G. Sebald, *Unheimliche Heimat: Essays zur österreichischen Literatur*, pp. 40–64. Salzburg: Residenz Verlag.

Sendrey, Alfred. 1970. *The Music of the Jews in the Diaspora (up to 1800): A Contribution to the Social and Cultural History of the Jews*. New York: Thomas Yoseloff.

Seroussi, Edwin. 1993. "Sephardic Music: A Bibliographical Guide with a Checklist of Notated Sources." In Isaac J. Lévy and Rosemary Lévy Zumwalt, eds., *Sephardic Folklore: Exile and Homecoming*, pp. 56–61. Special edition of *Jewish Folklore and Ethnology Review* 15 (2).

Sforim, Mendele Mojcher. 1978. *Die Reisen Benjamin des Dritten*. In *Jiddische Erzählungen*, trans. Leo Nadelmann, pp. 1–121. Zurich: Manesse.

Shacham, Nathan. 1990. *Rosendorf Quartett*. Trans. Mirjam Pressler. Frankfurt am Main: Dvorah Verlag. Orig. Hebrew ed. 1987.

Shahar, Natan. 1978. "Ha-malhin ba-kibbutz, makomo be-seder ha-hevrateh ba-kibbutz ve-yatzirato ha-musikalit" (Musical Life and the Composer on the Kibbutz: Historical and Socio-Musical Aspects). M.A. thesis, Bar Ilan University.

_____. 1989. "The Eretz-Israeli Song 1920–1950: Socio-Musical and Musical Aspects" (in Hebrew). Ph.D. dissertation, Hebrew University of Jerusalem.

_____. 1993. "The Eretz Israeli Song and the Jewish National Fund." In Ezra Mendelsohn, ed., *Modern Jews and Their Musical Agendas.* Special issue of *Studies in Contemporary Jewry* 9: 78–91. New York: Oxford University Press.

Shepard, Leslie. 1978. *The Broadside Ballad: A Study in Origins and Meaning.* Hatboro, Penn.: Legacy Books.

Simplicissimus. 1896–1944. Online edition of the literary magazine. http://www.simplicissimus.com/

Singer, Kurt. 1934. No Title ["Sinn und Zweck des Kulturbundes Deutscher Juden" . . .]. *Monatsblätter Kulturbund Deutscher Juden* 2 (2) (February): 1.

de Sinoja, J. E. 1933. *Das Antisemitentum in der Musik.* Zurich: Amalthea-Verlag.

Slobin, Mark. 1989. *Chosen Voices: The Story of the American Cantorate.* Urbana: University of Illinois Press.

_____. 2000. *Fiddler on the Move: Exploring the Klezmer World.* New York: Oxford University Press. (American Musicspheres)

Sollors, Werner, ed. 1989. *The Invention of Ethnicity.* New York: Oxford University Press.

Sorkin, David. 1987. *The Transformation of German Jewry, 1780–1840.* New York: Oxford University Press.

_____. 1996. *Moses Mendelsohn and the Religious Enlightenment.* Berkeley: University of California Press.

Spitzer, Shlomo. 1995. *Die jüdische Gemeinde von Deutschkreutz.* Vienna: Böhlau Verlag.

Sprengel, Peter. 1997. *Populäres jüdisches Theater in Berlin von 1877 bis 1933.* Berlin: Haude & Spener.

Ssabanejew, Leonid. 1927. *Die nationale jüdische Schule in der Musik.* Vienna: Universal-Edition.

Stauben, Daniel. 1986. *Eine Reise zu den Juden auf dem Lande.* Trans. Alain Claude Sulzer. Augsburg: Ölbaum Verlag. Orig. publ. 1860.

Steinberg, Michael P. 2008. "Charlotte Salomon's Modernism." In Philip V. Bohlman, ed., *Jewish Musical Modernism, Old and New.* Chicago: University of Chicago Press, 125–52.

Stern, Fritz. 1961. *The Politics of Cultural Despair: A Study in the Rise of the Germanic Ideology.* Garden City, N.Y.: Anchor Books.

_____. 1987. *Dreams and Delusions: The Drama of German History.* New York: Alfred A. Knopf.

Sulzer, Salomon. 1865. *Schir Zion: Gesänge für den israelitischen Gottesdienst.* 2nd ed. Leipzig: M. W. Kaufmann. Orig. publ. 1841.

Summit, Jeffrey A. 2000. *The Lord's Song in a Strange Land: Music and Identity in Contemporary Jewish Worship.* New York: Oxford University Press. (American Musicspheres)

Süß, Hermann. 1980. "'Der Graf von Rom,' ein altes deutsches Volkslied und sein jiddischer Druck aus dem 17. Jahrhundert." *Israelitische Kultusgemeinde Fürth* (September): 18–24.

Tal, Josef. 1980. Interview with Philip V. Bohlman. November 20.

_____. 1985. *Der Sohn des Rabbiners: Ein Weg von Berlin nach Jerusalem.* Weinheim Berlin: Quadriga Verlag.

Ullmann, Viktor. 1943. *Der Kaiser von Atlantis, oder die Tod-Verweigerung,* Op. 49. Libretto by Peter Kien. Mainz: Schott, 1993. Piano-vocal score.

Ulrich, Johann Caspar. 1768. *Sammlung jüdischer Geschichten, welche sich mit diesem Volk in dem XIII. und folgenden Jahrhunderten bis auf MDCCLX. in der Schweitz von Zeit zugetragen: Zur Beleuchtung der allgemeinen Historie dieser Nation herausgegeben.* Basel. Reprint: Farnborough: Gregg, 1969.

Urquell, Der: Eine Monatsschrift für Volkskunde. 1897– . Vol. 1– . New series of *Am-Urquell.*

Veigl, Hans. 1986. *Lachen im Keller: Von den Budapestern zum Wiener Werkel: Kabarett und Kleinkunst in Wien.* Vienna: Löcker Verlag.

_____, ed. 1992. *Luftmenschen spielen Theater: Jüdisches Kabarett in Wien, 1890–1938*. Vienna: Kremayr & Scheriau.

Verein "Jung Zion." 1898. *Lieder zum Fest-Commers des II. Zionisten-Kongresses*. Basel: Verein "Jung Zion."

Vinkovetzky, Aharon, Abba Kovner, and Sinai Leichter. 1983–1987. *Anthology of Yiddish Folksongs*. 4 vols. Jerusalem: Magnes Press of the Hebrew Universsity.

Vishniac, Roman. 1999. *Children of a Vanished World*. Ed. Mara Vishniac Kohn and Miriam Hartman Flacks. Berkeley: University of California Press.

Volkov, Shulamit, ed. 1994. *Deutsche Juden und die Moderne*. Munich: R. Oldenbourg Verlag. (Schriften des Historischen Kollegs, Kolloquien, 25)

Wachstein, Bernhard. 1926. *Urkunden und Akten zur Geschichte der Juden in Eisenstadt und den Siebengemeinden*. Vienna: Wilhelm Braumüller.

Wacks, Georg. 2002. *Die Budapester Orpheumgesellschaft: Eine Varieté in Wien 1889–1919*. Vienna: Verlag Holzhausen.

Wagner, Richard. 1984 [1850]. "Ha-yehedut be-musica." In Rina Litvin and Chazi Shelach, eds., *Mi mephachad mi-Richard Wagner?—Hivtim shonim shel damot she-nevia be michlokat*, pp. 203–18. Jerusalem: Keter.

_____. 1995 [1869]. "Judaism in Music." In Wagner, *Judaism in Music and Other Essays*. Trans. William Ashton Ellis, pp. 75–122. Lincoln: University of Nebraska Press.

Weill, Gotthold. 1925. "Die Juden." In Wilhelm Doegen, ed., *Unter fremden Völker—Eine neue Völkerkunde*, pp. 257–61. Berlin: Otto Stollberg, Verlag für Politik und Wirtschaft.

Weisser, Albert. 1983. *The Modern Renaissance of Jewish Music: Events and Figures, Eastern Europe and America*. New York: Da Capo. Orig. publ. 1954.

Werfel, Franz. 1982. *Cella oder der Überwinder*. Frankfurt am Main: S. Fischer Verlag. Manuscript fragment from 1938–1939.

Werner, Eric. 1943/1944. "The Eduard Birnbaum Collection of Jewish Music." *Hebrew Union College Annual* 18: 397–428.

_____. 1959. *The Sacred Bridge: The Interdependence of Liturgy and Music in Synagogue and Church during the First Millennium*. New York: Columbia University Press.

Wiese, Christian. 1999. *Wissenschaft des Judentums und protestantische Theologie im wilhelminischen Deutschland: Ein Schrei ins Leere?* Tübingen: Mohr Siebeck. (Schriftenreihe wissenschaftlicher Abhandlungen des Leo Baeck Instituts, 61)

Winkler, Gerhard, ed. 2006. *Musik der Juden im Burgenland*. Eisenstadt: Wissenschaftliche Arbeiten aus dem Burgenland.

Wischenbart, Rüdiger. 1992. *Karpaten: Die dunkle Seite Europas*. Vienna: Kremayr und Scheriau.

Wolf, Eric R. 1982. *Europe and the People without History*. Berkeley: University of California Press.

Wolf, Johannes. 1913–1919. *Handbuch der Notationskunde*. Leipzig: Breitkopf & Härtel.

Wolff, Larry. 1994. *Inventing Eastern Europe: The Map of Civilization on the Mind of the Enlightenment*. Stanford, Cal.: Stanford University Press.

Wolpe, Stefan. 1939. "Music, Old and New, in Palestine." *Modern Music* 16 (3): 156–59.

Wurm, Hans. 1939. "Der 'Judenpolka.'" *Das deutsche Volkslied* 41 (7): 98–99.

Young, James E. 1993. *The Textures of Meaning: Holocaust Memorials and Meaning*. New Haven, Conn.: Yale University Press.

Zelinsky, Hartmut. 1983. *Richard Wagner, ein deutsches Thema 1876–1976: Eine Dokumentation der Wirkungsgeschichte*. Berlin: Medusa.

Zimmermann, Heidy. 2000. *Tora und Shira: Untersuchungen zur Musikauffassung des rabbinischen Judentums*. Berne: Peter Lang. (Schweizerische Musikforschende Gesellschaft, 40)

Zirker, Max, ed. 1905[?]. *Vereinsliederbuch für Jung-Juda.* Berlin: Jüdischer Buch- und Kunstverlag.

Zobel, Moritz. 1936. *Das Jahr des Juden in Brauch und Liturgie.* Berlin: Schocken Verlag. (Bücherei des Schocken Verlags, 55/56)

Zunz, Leopold. 1832. *Die gottesdienstlichen Vorträge der Juden, historisch entwickelt: Ein Beitrag zur Alterthumskunde und biblischen Kritik, zur Literatur- und Religionsgeschichte.* Berlin: A. Asher.

_____. 1855. *Die synagogale Poesie des Mittelalters.* Berlin: Julius Springer.

_____. 1875–1876. *Gesammelte Schriften.* 3 vols. Berlin: Louis Gerschel Verlagsbuchhandlung. Repr. 1976, Hildesheim: Georg Olms.

DISCOGRAPHY

Altmeister des Humors. 1990. *Altmeister des Humors: Fritz Grünbaum, Karl Farkas, Franz Engel.* Preiser Records PR 90066.

Altmeister des Wienerliedes. 1991. *Altemeister des Wienerliedes.* Preiser Records PR 90082.

Ammersfeld, Anita, Gerhard Bronner, and Ethan Freeman. 1997. *Ich hab' kein scharfes Messer: Jüdische Lieder und andere Weisheiten.* AEJ CD E1718.

Beth Hatefutsoth. 1997. *The Musical Tradition of the Jewish Reform Congregation in Berlin.* 2 CDs and accompanying booklet, with texts and commentary by George L. Mosse et al. BTR 9702.

Budowitz: Klezmermusik des 19. Jahrhunderts. 1997. Koch 3–1261–2.

Burgenland. 1993. Vol. 1: *Tondokumente zur Volksmusik in Österreich.* Accompanying booklet ed. Sepp Gmasz, Gerlinde Haid, and Rudolf Pietsch. Vienna: Institut für Volksmusikforschung.

Eisenbach, Heinrich. n.d. *Heinrich Eisenbach: Über ihn lachten unsere Großväter.* Preiser Records PR 9846 (LP). Original recordings from ca. 1913.

Eisler, Hanns. 1998. *The Hollywood Songbook.* Matthias Goerne, voice; Eric Schneider, piano. Decca 460 582–2.

Kabarett aus Wien. 1991. *Kabarett aus Wien.* Preiser Records PR 90081.

Klezmer. 2000. *Klezmer—Jewish Traditions: Shtetl Roots and New World Revival.* The Rough Guide RGNET 1047 CD.

Klezmer Music: A Marriage of Heaven and Earth. 1996. Ellipsis Arts 4090.

Klezmer Pioneers. 1993. Rounder CD 1089.

The Koenigsberg Tradition: The High Holidays. 1990. Beth Hatefutsoth BTR 8601.

Kozlowski, Leopold. *The Last Klezmer.* Global Village CD 168.

Krása, Hans. 1999. *Brundibár: Eine Oper für Kinder.* 2 CD set. Cassel: EDA Records. EDA 15.

Kraus, Karl. 1996. *Karl Kraus liest: Goethe, Shakespeare, Offenbach, Raimund.* Preiser Records PR 90319.

Der letzte Schmetterling: Kabarett und Lieder aus Theresienstadt. 1992. Ruth Frenk, mezzo-soprano; Karin Strehlow, piano. Erasmus producties WVH 037.

The Musical Tradition of the Jewish Reform Congregation in Berlin. 1997. 2 CDs and booklet, with commentary by George L. Mosse et al. Beth Hatefutsoth. BTR 9702.

Muzsikás. 1993. *Máramaros: The Lost Jewish Music of Transylvania.* Rykodisc Hannibal HNCD 1373.

New Budapest Orpheum Society. 2002. *Dancing on the Edge of a Volcano: Jewish Cabaret, Popular and Political Songs 1900–1945.* 2 CDs, plus book by Philip V. Bohlman. Cedille Records CDR 9000 65.

The New Jewish School. 1999. *The New Jewish School.* Jascha Nemtsov, piano. Vol. 2: *Across Boundaries: Discovering Russia 1910–1940.* Berlin: EDA Edition Abseits. EDA 014–2.

The St. Petersburg School: Music for Cello and Piano. 1998. Uri Vardi, cello; Uri Tsachor, piano; Magai Shaham, violin. Beth Hatefutsoth 9801.

Spagnolo, Francesco. 2001. *Italian Jewish Musical Traditions from the Leo Levi Collection (1954–1961).* Jerusalem and Rome: Jewish Music Research Centre and Accademia Nazionale di Santa Cecilia. AMTI CD 0102. (Anthology of Musical Traditions in Israel, 14)

Ullmann, Viktor. 1994. *Der Kaiser von Atlantis.* London 440 854–7. (Entartete Musik)

World Music. 2001. *World Music: Music from Denmark 2001.* MX PCD 0201.

Yikhes: Frühe Klezmer-Aufnahmen von 1907–1939. 1991. Trikont US-0179.

Zawinul, Joe. 2000. *Mauthausen: . . . vom großen Sterben hören. Chronicles from the Ashes.* ESC Records EFA 03666–2.

INDEX